PIMLICO

707

MISS ANGEL

MISS ANGEL

The Art and World of Angelica Kauffman

―――――――

ANGELICA GOODDEN

PIMLICO

Published by Pimlico 2005

2 4 6 8 10 9 7 5 3 1

Copyright © Angelica Goodden 2005

Angelica Goodden has asserted her right under the Copyright, Designs
and Patents Act 1988 to be identified as the author of this work

First published in Great Britain by
Pimlico 2005

Pimlico
Random House, 20 Vauxhall Bridge Road,
London SW1V 2SA

Random House Australia (Pty) Limited
20 Alfred Street, Milsons Point, Sydney,
New South Wales 2061, Australia

Random House New Zealand Limited
18 Poland Road, Glenfield,
Auckland 10, New Zealand

Random House South Africa (Pty) Limited
Endulini, 5A Jubilee Road, Parktown 2193, South Africa

The Random House Group Limited Reg. No. 954009

A CIP catalogue record for this book
is available from the British Library

ISBN 1-8441-3758-9

Papers used by Random House UK Limited are natural,
recyclable products made from wood grown in sustainable forests.
The manufacturing processes conform to the environmental
regulations of the country of origin

Typeset by Deltatype Ltd, Birkenhead, Merseyside
Printed and bound in Great Britain by
Mackays of Chatham

Contents

Acknowledgements

Both St Hilda's College and the University of Oxford gave me time off teaching to work on this book, and the Faculty of Medieval and Modern Languages at Oxford generously helped to finance the study trips to Italy, Austria, Germany and Switzerland that shored up the writing of it. I am as grateful to them as I am to all the people – art historian friends, curators, librarians, cultivated readers, colleagues and former students – who showed me pictures, gave me references, supplied me with material, put me up or simply badgered me to get on with things, particularly Hermann Mildenberger, Linda Whiteley, Vera Baird, Peter Waterhouse, the late Maria Fehringer and the whole *Galerie der starken Frauen* who thought the project worth pursuing. Rosalind Porter at Pimlico, too, was far gentler and more reassuring than the typescript or I ever deserved. One debt of thanks, however, is less straightforward. Although it is conventional for authors to clear everyone but themselves of responsibility for what they have written, I cannot help blaming Robert and Lesley Goodden for unwittingly engineering the coincidence of names that first made me interested in Angelica Kauffman. The deficiencies and inadequacies of the book that has resulted, on the other hand, are entirely my own fault.

Translations too are mine, unless otherwise indicated.

List of Illustrations

Chapter One

A Craze

A word was coined in the 1770s or early 1780s to describe the condition of people stricken with a fever that was sweeping like an epidemic across London and places further afield. Nearly everyone succumbed to its effects, but almost no one wanted to be cured of them. The cause of the outbreak was a continental artist who had come to England in 1766 with the self-styled Lady Wentworth, a diplomat's wife who had decided to be her patron and chaperone, inviting the young woman to live in her house just off Berkeley Square, introducing her to polite society and singing her praises in all the elegant drawing-rooms of London's West End. To judge by her existing reputation at home and abroad, however, the protégée was already as good at self-promotion as she was at painting. She had sent a portrait of David Garrick to be exhibited in London ahead of her arrival, an event which led one critic to declare that at the age of twenty-five she had 'burst upon the hemisphere of painting as a luminous wonder'.[1] Yet Angelica Kauffman,[2] as the meteor was called, had been dazzling Europe for years, and it took her very little time to add England to her conquests. An engraver who spent his days preparing plates from her work found a term for the general delirium: 'The whole world,' he remarked, 'is Angelicamad.'[3]

Despite her youth she was used to being celebrated, but she had never known such adulation before. She quickly became such a vital part of fashionable London life that, according to one witness, she shared 'with hoops of extra magnitude, toupees of superabundant floweriness, shoe-heels of vividest scarlet and china monsters of superlative ugliness, the privilege of being the rage'.[4] Her work was everywhere: in portraits and historical scenes, engravings and etchings, on painted furniture and porcelain, teapots, fans, snuff boxes, commodes and every other accompaniment to civilised Georgian life; and the more diverse the objects stamped with her inimitable mark,

1

the greater her celebrity became. As source and creator she was a superstar before the word was invented, an artistic phenomenon, a woman so adaptable and astute that she could use the technical and industrial developments of the day to multiply her work, sell it cheaply and disseminate it along with her fame and influence across the civilised world. Yet at the same time she was canny enough to realise that a part of her cachet derived from her apparent unworldliness, a devotion to her art seemingly so absolute that the concerns of material and business life barely touched her being. She was, in other words, a living contradiction in a century of paradox, an age of matter as well as mind, of lucre as well as sensibility; for she could be an Angelica and a Kauffman (or *Kaufmann*, a merchant or businessman) at one and the same time, binding together female mystique and 'male' commercial-mindedness in a way that had never been seen before.

A century after her arrival in England, Anne Thackeray, the daughter of William Makepeace Thackeray and future step-aunt of Virginia Woolf (who uses her as the model for Mrs Hilberry in *Night and Day*), would write a novel about Angelica that showed how powerfully she still appealed to the English imagination. Invited to dinner at the London home of Sir John and Lady Leslie, Stratford Place, Anny was impressed by a painting of a mythological scene on the dining-room ceiling. Her host told her that it was by Angelica Kauffman, though that may have been untrue: most of the interior decoration once attributed to her is now thought to have been executed by other hands. Anny, in any case, cared less about precise authorship than about Angelica herself, whose fascinating and exciting story Sir John proceeded to relate. After that it seemed a matter of course that she should retell it in novel form, even though she felt too dispirited to start work immediately.

What had struck her imagination, apart from a pretty ceiling? In the first place, Angelica's life was one of drama and romance, the life of a *Wunderkind* brought up in Switzerland, Austria and North Italy, who as a young woman had painted Grand Tourists in Rome and Naples, followed her clientele to England, engaged in various alleged flirtations, survived a disastrous marriage, enjoyed the protection of George III and Queen Charlotte (and later of Marie-Antoinette's sister, the Queen of the Two Sicilies), painted a gallery of famous sitters that included Garrick, the Duchess of Devonshire, Emma

2

Hamilton and Goethe, and become a name all over the civilised world. Yet Anny thought she perceived similarities between her own experiences and Angelica's – their frustrated search for love, their whimsical natures, their recurrent bad judgement and their attempts to find solace in artistic creation.[5] Angelica was certainly the greater artist, as Anny would have admitted, but her reputation had declined over the sixty or so years since her death, years in which Georgian elegance gradually gave way to Victorian heaviness and Angelica's delicate images came to seem fey and frivolous. Nor, as it emerged, was Anny really eager to restore her subject to the rank she had once occupied as an artist, however much she instinctively liked her. Reason, or what appeared to be reason, overcame spontaneous attraction, and Angelica stood condemned for being vapid, too easy on the eye, simply too undemanding for a serious and moralistic age.

Anny's *Miss Angel* (the name Sir Joshua Reynolds gave Angelica) starts by describing the meeting in Venice with Lady Wentworth, the semi-detached wife of the British Resident in Venice, John Murray. Angelica is 'adopted' by the Resident's wife, who has decided to return to England without her husband, and who can already see the glory that will be reflected on her as the protector of this talented young woman. Angelica moves around the West End, settles in Soho and starts to enjoy the years of prosperity when, as Anny puts it, she 'lived and ruled in her May-Fair kingdom'. *Miss Angel* ends with her triumphant election in 1768 to membership of the fledgling Royal Academy, the only woman founder member apart from the Swiss flower-painter Mary Moser.

It is after this, according to Anny, that things begin to go wrong. Angelica endures 'a mid-life of storm and shadow' that anticipates the sad final years, when 'tears and languor dimmed those bright azure eyes and overmastered the brave spirit that we must all respect and recognise'.[6] But this is not Anny's story. *Miss Angel* prefers to linger over her phenomenal success among the English upper and middle classes, where countless homes boasted their Kauffmans – a portrait or a picture of nymphs and cupids, perhaps, a print of a scene from Shakespeare or Sterne, a piece of decorated china, a watch case, a length of fabric or a tea-waiter bearing her designs. It all served to show how wrong Anny was to think that she had found a kindred spirit

in her heroine. Angelica far outstripped her in public influence and newsworthiness.

This is not to say that she always welcomed the public attention she received. Slander naturally attended women of achievement, particularly if they were attractive: it was society's way of telling them that their success was a product of their sex and identity, which might turn against them as often as work to their advantage. The proper lady and the woman artist made uneasy bedfellows in the social and commercial world that Angelica and her contemporaries inhabited. Besides, when their adoptive milieu was as strait-laced as the court of King George III and Queen Charlotte, the need for them to check scurrilous rumour by living blameless lives was particularly acute. Yet the importance of self-presentation in fashionable society paradoxically meant trading on advantages such as attractiveness and grace that laid them open to attack by the envious or indiscreet. To be as newsworthy as Angelica wanted to be, one had to play the world at its own game; and the desire to sell oneself, even respectably, inevitably had some unwelcome consequences.

Anny's Miss Angel may be married to her brush, but she still toys (as gossip said the real-life Angelica did) with the idea of wedding England's leading painter Sir Joshua Reynolds, whom she rushes to see within a few days of arriving in London. The scandal-mongers – for a woman artist must always be of particular interest to the gossip industry – have divided opinions about the likely outcome, but when Angelica either is disappointed in her hopes or rejects Reynolds's advances they find another, juicier story: for she quickly becomes fatally entangled with a different man, a charming adventurer and impostor staying at Claridge's and calling himself Count de Horn. She marries him in haste and quickly repents of it (not least because her husband is alleged to be a bigamist), but continues to move in elevated circles, as a society portraitist in search of a clientele must do. She meets Dr Johnson and other members of London's intelligentsia, and mingles with the aristocracy. When she is commissioned to paint the Queen's portrait, she has arrived: in her mid-twenties she has all, or most, of London at her feet.

Many people speak of her talent, humility and attractiveness, though others deny them all. The art historian Johann Joachim Winckelmann admires her looks ('I think she can be called a beauty'); the Danish

4

statesman Count Andreas Petrus von Bernsdorff disagrees, but says that her face appears admirable when it is properly attended to; while another Dane, Helfrich Peter Sturz, observes that although she is 'by no means a perfect beauty', she is 'nevertheless captivating in her figure and her entire manner':

> The character of her face belongs to the type Domenichino painted [...], shy and full of meaning. [...] One is not made fleetingly aware of her, but she holds the observer's gaze; there are moments, indeed, when she makes a deeper impression, when she is seated at her harmonica [sic], singing Pergolesi's *Stabat Mater*, lifting her great soulful eyes to heaven [...], and she becomes the mesmerising image of St Cecilia.[7]

Angelica depicts herself in a range of portraits over the years, usually in an idealised form that makes her seem quite untouched by the passage of time. As a result, hostile or disaffected critics attack her self-image as they challenge the other versions of her character that are bruited in society, particularly the notion that she is by nature virtuous. To the rest of society, on the other hand, modesty is her second name.

But if modesty is indeed at the heart of her being, it is not always in quite the way they imagine. The demands of propriety partly explain her apparent ignorance of anatomy, traditionally regarded as a great weakness in her work; for women were forbidden to study from the living model, and so seemed condemned to inferiority as artists of the human form (traditionally the focus of the 'highest' genre of painting). Zoffany's famous picture of the London Royal Academicians gives a graphic image of this systematic exclusion. It shows the male academicians gathered round a nude life model – the professor of anatomy, Dr William Hunter, is scanning the model's muscles with particular attention – while the two female members, Mary Moser and Angelica Kauffman, are allowed to be present only as portraits hanging on the wall. Moreover, the women's faces are so blurred as to be virtually unrecognisable, reduced almost to the status of studio furniture, whereas the men's are so clearly delineated that they can all be identified. Zoffany is unambiguous both about the irrelevance of the opposite sex to such occasions and about the superior status men were automatically accorded,[8] although the fact that he gives Angelica an

uncharacteristically harsh expression may possibly signal his (as well as her) indignation at this exclusion.

When she came to live in London in 1766 the rumour spread that Angelica had brazenly hired an employee of the Royal Academy to pose privately for her to overcome this professional disadvantage, although when he was asked about the matter many years later the eighty-year-old former model, Mr Charles Cranmer, replied that he had never exposed more than his arms, shoulders and legs, and that Angelica's father had anyway been in constant attendance.[9] Such deprivation may explain why Anny should call Angelica's nymphs 'somewhat dislocated beings'; she never, as far as we know, had sight of the whole living male body, whose naked appearance Hunter is examining so intently in Zoffany's picture.

Perhaps she could have been less conformist, especially since other women artists seem to have responded more boldly to restrictive convention. The venturesome ways of the Prussian artist Anna Therbusch, for instance, are described in Diderot's 1767 *Salon*:

She said to herself, I want to paint, and she said it well. She formed a notion of modesty that was just, she placed herself intrepidly before the nude model; she did not believe that vice has the exclusive privilege of undressing a man.

Then she attempted a portrait of Diderot himself. 'When the head was done it was a question of doing the neck, and my collar concealed it, which rather irritated her.'

To stop her being irritated I went behind a curtain, undressed and appeared before her like an academy model. I wouldn't have dared to suggest it to you, she said, but you have done well, and I thank you. I was naked, stark naked. She painted me, and we chatted with a simplicity and an innocence worthy of primeval times.

Since, given the sin of Adam, one cannot control all the parts of one's body as one does one's arm, and there are parts that want to do things when the son of Adam doesn't want to, and don't want to do things when the son of Adam does; in the event of such an accident I should have remembered what Diogenes said to the

young wrestler: *My dear boy, fear nothing, I am not as wicked as that.*[10]

One might have thought that, as a German speaker, Angelica, like Anna Therbusch, had particular reason to feel the iniquity of excluding women from life classes, since the German word for life study, *Akt* (from the Latin *actus*), underlines the essential function of potential movement in all such study. In so doing, of course, it also inevitably highlights the inadequacies of the statues and other inanimate models that were regularly used in teaching the physiology and anatomy of the human form to both sexes. When Angelica, after sketching Raphael's naked Adam in the Vatican, incorporated the study into her 1773 picture of *Telemachus at the Court of Sparta*, she cannot but have been dissatisfied with the deadening process of making art out of other bits of art in this way, rather than making it (as Diderot wanted it made) out of life. Equally, the gift of life drawings that she received as a young woman from Pompeo Batoni could do no more than supplement her existing limited store of frozen images, not act as a substitute for copying from real beings.

One of Angelica's contemporaries, the journalist Anthony Pasquin, remarked in connection with this overall difficulty:

> [Women's] situation in life, and compulsive delicacy, prevents them from studying nudities, and comparing these studies with muscular motion, though without such aid, they cannot do more than this lady has effected, which is, to design pretty faces and graceful attitudes, without any authority from nature to warrant the transaction . . .[11]

(Anna Therbusch's delicacy was obviously less 'compulsive', whatever compulsive means in this context.) The poet Peter Pindar, reflecting on Angelica's tendency to paint feminine-looking men, declared: 'Her dames, so Grecian, give me such delight!/But, were she married to such gentle males/As figure in her painted tales,/I fear she'd find a stupid wedding-night'[12] – lines that incidentally seem an uncanny anticipation of Angelica's allegedly unconsummated first marriage to the *soi-disant* Horn. Friedrich von Schlegel[13] observed in the same spirit that her youths looked as though they were yearning for bosoms

and maidens' hips,[14] and Goethe's friend Johann Heinrich Meyer simply called them girls in disguise.[15]

Like other Victorians, Anny regarded Angelica as 'over-praised, over-loved, deceived and satisfied', declaring that she

> was no great genius, as people once thought, no inspired painter of gods and men. Her heroes stand in satin pumps and feathered toques [...]; one laughs at them, but one loves them too ...

The final concessive clause presumably explains how, despite everything, she came to be seduced by a dining-room ceiling and Sir John Leslie's story into writing a Kauffman novel, though not a very good one.

But Angelica seemed to most of London and English society in the second half of the eighteenth century unquestionably the real thing. Her continental reputation, first as a child prodigy and then as an accomplished Grand Tour portraitist and history painter, preceded her, and she intended to exploit it to the full. If that meant suffering the effects of jealous and malicious tattle, she would still have the consolation of money, fame and excellent connections. Her haste to visit Reynolds so soon after she arrived in London may have been a *faux pas* to set tongues wagging, but a painting by the artist Nathaniel Hone that seemed to lampoon their relationship could have been more damaging still. However, it was swiftly removed from the walls of the Royal Academy when Angelica declared herself mortally offended by it, because then, as later, she made people want to look after her. After the débâcle of her first marriage – or, again, because of it – when the scale of Horn's deception emerged and he had to flee the country, she continued to meet with enormous public and private support. Resolving to mend matters by doing what she knew best, she worked harder than ever to maintain an unblemished reputation, and the adoration she provoked suggests that she largely succeeded.

As a young girl, the apple of her widowed father's eye, she had led a narrow and protected life, which explains at least part of her ingenuous nature. The protectiveness had continued during the years abroad when she was regularly accused – by jealous rivals or disappointed lovers? – of being a flirt. In England the accusations continued, and perhaps she should have paid more attention to them. But, cherished

as she was, the complexity of human relations seemed to pass her by.

There remain serious questions to ask about the craze she inspired. What made her seem so remarkable that people wanted to adopt and care for her? Where is the real woman to be found beneath the layers of Georgian adulation and Victorian mockery? Was she genuinely outstanding as a painter at a time when few women were professional artists, let alone successful ones, or was she found seductive simply because (as Goethe seems to have thought) she did surprisingly well what her sex was meant to be relatively unskilled at? Was there more to her than modishness, the ability to stay ahead of the game? The Kauffman look came to seem as definitive of her age as the style of Robert Adam did, but appeared more vulnerable to the passing years. If Angelica was as popular a decorative designer as she was a portraitist, particularly beloved of well-born women whose domestic interiors she adorned and whose faces she painted (and probably adorned too), was she ever more than decorative? And did her success condemn her in the eyes of her detractors simply because graceful, decorative painting seemed 'merely' female – though many men, including her second husband, were outstandingly good at it too – rather than positively and 'intellectually' male? In other words, was her work undervalued or critically dismissed for being pretty and charming, as beguiling as her person was said to be, but with no real substance to it?

If so, she was the victim of injustice. As an artist she was bold and adventurous enough to succeed in creating an entire industry from what she did, an industry based on the new techniques of mass production and replication that enabled the eighteenth century to bring the good taste of an elite to the multitude. This modest woman seems never to have worried that broadcasting her work might cheapen it, because there was nothing self-admiring about the pride she took in her art. On the contrary, she appeared to rejoice in possessing popularising instincts that could so happily be harnessed to the technological developments of the day, for although she lived and worked at the start of the machine age, her graceful images seemed to palliate its deadening effects. But she knew too that there had to be more than popular acclaim to her artistic and social acceptance. She

9

understood that a special contract also bound her to an elevated and exclusive adoptive world, the world of those who could actually commission and afford original art, and that she must provide it with decorous images that were pleasing to the noble eye. For this she would receive the appropriate fee as well as the homage due to her person. Clients and sitters seemed more than pleased with the arrangement.

Yet it is difficult to believe that she did all this with quite the gentle yieldingness that was normally attributed to her. Must there not have been an iron fist inside her velvet glove, a ruthless professionalism half-hidden behind her apparent docility? Was she perhaps a secret egotist, banishing from her emotional and practical world everyone who could not be useful to her, subordinating everything to her obsessive need to create? Was she governed by a self-concern that overrode mere self-belief, driven by something resembling the bad *amour-propre* that her Swiss compatriot Rousseau contrasted with good, life-affirming *amour de soi*? Why does the image of Angelica left by her first biographer, the writer, collector and connoisseur Giovanni Gherardo De Rossi, sometimes unsettle as it tries to exalt? *Nomen est omen*: for if there is an Angelica myth to match the invented worlds of her art, a myth about superhuman gifts, goodness, beauty and spiritual purity, there is also a Kauffman reality, which lies rather (or equally) in her commercial instincts, imperfect looks, opportunism and undeniable artistic weaknesses. She should be viewed dispassionately as well as forgivingly or rapturously.

After all, she never captivated everyone. There were always dissenters among the Angelicamad, people who thought the craze for her work as absurd as it was aesthetically indefensible. James Northcote, who could not get over the disabling fact of her gender, seems to be damning more than the predictable deficiencies of her training when he remarks:

It was not [. . .] that women were not often very clever (cleverer than many men), but there was a point of excellence which they never reached. Yet the greatest pains had been taken with several. Angelica Kauffman had been brought up from a child to the art, and had been taken by her father (in boy's clothes) to the Academy to learn to draw [a story that seems to be apocryphal];

but there was an effeminate and feeble look in all her works, though not without merit. There was not the man's hand, or what Fuseli used to call a 'fist' in them; that is, something coarse and clumsy enough, perhaps, but still with strength and muscle. Even in common things you would see a carpenter drive a nail in a way that a woman never would; or if you had a suit of clothes made by a woman, they would hang quite loose about you and seem ready to fall off.[16]

This helps to explain the common view of her work as quintessentially feminine, precious and slightly amateurish, possessing a charm that made her devotees excuse technical ineptness, but encouraged non-devotees to launch personal and sometimes savage attacks. It would have been strange, after all, if the fairytale fragility of her world had always provoked compliance, or if the dissection of her weaknesses had always led to the mild conclusion that she could not be expected to succeed at certain things that her sex debarred her from studying. Yet she was manifestly not what Northcote described as one of those 'meteors of fashion which we see suddenly rise and as suddenly fall';[17] she benefited more than she suffered from being a prolonged craze, as the creators of new and exciting pleasures often do.

Besides, even Pasquin, who thought her work monotonous and implausible, still judged her 'perhaps the most fascinating woman in Europe';[18] the besotted philosopher and writer Johann Gottfried Herder, almost echoing him, called her 'perhaps the most *cultivated* female in Europe';[19] and the parliamentarian and 'friend of the people' John Wilkes assured his daughter Fanny that Angelica was 'the first painter in Europe; and her paintings are allowed to have the grace of Raphael, the warmth of Correggio's colouring, and the delicacy of Guido [Reni]'.[20] If she herself was a byword for moderation, extravagant praise was heaped on her wherever she went. In the 1780s one of her self-portraits would be hung next to Michelangelo's in the Uffizi, yet as early as the mid-1760s England thought it knew exactly what her exalted rank was:

> Holbein, Van Dyck, Rubens and Lely came
> To present fortune and immortal fame;
> But none e'er crossed my all-surrounding sea

So dear to my fair daughters and to me.[21]

But may she be dear *rather than* immortal, dear *because not* immortal?

There remain many reasons other than artistic ones to be interested in Angelica, as she herself reluctantly acknowledged. When her first marriage collapsed in extraordinary circumstances[22] she was left poorer and emotionally scarred, but remarkably undamaged in social and professional terms. A reputation for maidenliness and even virginity clung to her throughout her life, partly, perhaps, because of the allegation that her first husband was impotent as well as a bigamist, yet in her youth she had been publicly linked with the painters Nathaniel Dance and Henry Fuseli (who himself was also linked with Mary Wollstonecraft) as well as Reynolds, and would later be similarly associated with the future revolutionary Jean-Paul Marat and many others. Since she was both pious and fastidious, these stories are unlikely to be true, or if true to have meant very much.

Yet she was too constantly in the public eye, and too consistently presented herself in her portraits as ravishing, to escape all imaginative scrutiny. Indeed, perhaps the very ambiguity of some of her best portraits encourages such speculation – the knowing way she painted the secretive, psychologically complex Winckelmann, the *jolie laide* bluestocking Cornelia Knight, or the charming and misleadingly innocent-looking Lady Elizabeth Foster, a member of the eighteenth century's most famous *ménage à trois*. Certainly the popularity of Angelica's 'life' in more or less openly fictionalised treatments from the early nineteenth century to our own day suggests that many enthusiasts have felt drawn and intrigued by the apparent straightforwardness, but actual complexity, of her person.

However, this very popularity prompts a degree of caution in anyone who attempts to write about her now. First of all, the legacy of obloquy both bequeathed by and heaped upon her early twentieth-century biographers Lady Victoria Manners and Dr G. C. Williamson must be faced up to, since views on art in general – and women's art in particular – have greatly evolved since their book was published. Yet the relevance of biography to our understanding of female artists should still be insisted on, however questionable such an approach may seem in the light of post-modern trends in criticism – almost as quaint,

old-fashioned and whimsical, in fact, as some of Angelica's own creations. One reason why the art of women painters has traditionally been interpreted, and may continue to be interpreted, in the light of their characters and lives (Louise Vigée Le Brun's[23] coquettishness and snobbery, for example, or Angelica's dedicated virginity) is simply that the constraining or occasionally liberating facts of personal circumstance mattered and matter more to women bent on artistic greatness than they did and do to men, shaping their achievement in ways that are specific to their sex.

In the eighty years since the publication of Manners and Williamson's work – probably still the best-known book about Kauffman in English – a great deal has been discovered about her activities as a painter, her employment or otherwise as an interior decorator and designer, her relations with leading figures of the day, and the economic and other professional realities that a woman of her class and ambition faced in the eighteenth century, particularly in the context of incipient industrial revolution. Far from striking the civilised world like a bolt from the blue, she had been thoroughly prepared for her grand entrance, both trained (in so far as that was possible at the time for a woman) and managed by a proud father who was himself a lesser artist but an effective promoter, and who directed his energies at drawing his gifted daughter to public attention. The conditions that made her what she was have become more visible in the twenty-first century than ever before, and it seems the right moment to attempt a fresh account of them.

Yet there is another constraining circumstance, one that affects her biographer as its reverse did Angelica herself. The inviolability of her person was so important to her – paradoxically, given the public dimensions of her career – that many facts relating to her life remain frustratingly obscure. She complained bitterly about biographical distortion (burning nearly all her papers before she died), and for a sociable creature with a wide circle of friends and acquaintances seemed tantalisingly elusive even to those who were closest to her. On the face of it, seeking the space where her life met her art may seem a rash as well as hopelessly traditional enterprise, particularly since Angelica painted a number of pictures showing people and situations quite foreign to her own experience. But her art did not emerge from outside herself, however greatly it was shaped by external conditions. It

was a collaboration (or, as Goethe complained apropos of her 'effeminate' portrait of him, a collusion) between reality and her imagination. This is the foundation of the phenomenal world I wish to explore.

Chapter Two
Father and Daughter

In 1780, after fourteen lucrative years in England, Angelica decided to move back to Italy. Although her public mourned her as they might have done a wayward daughter, a lost icon or a wandering star, some of them also felt betrayed. Their shock or indignation seems to have arisen from the belief that Angelica was really theirs, an asset of whom they could justly be proud, almost an honorary native; and yet the precise nationality of this glamorous journeywoman remained a matter of dispute. The German travel writer and poet Johann Isaac von Gerning observed in 1802, two decades after Angelica had left England for good, that 'Most of her paintings go to England, and the British honour her as a second compatriot',[1] and to this day the *Dictionary of National Biography* endows her with British citizenship. On the other hand, the fact that her face appeared on the hundred-schilling note until the mid-1970s suggests that there must be an Austrian connection too, even though the nearest she ever came to living in Austria itself was to settle from time to time in Habsburg dominions of what is now Italy.

She had actually been born in Switzerland of a Swiss mother and an Austrian father, but received most of her artistic education on Italian soil. As early as 1769 the critic and polygraph Giuseppe Baretti, denying the charge that eighteenth-century Italy was devoid of artistic talent, announced: 'Nor have yet the Italians any urgent need to rush abroad for improvement [. . .] as long as they can spare for England their Angelicas, Ciprianis, Bartolozzis and Zuccarellis'[2] (all of whom had by then found employment in London). Accordingly, the British remained reluctant to let her go. In a letter of 1 January 1773 Reynolds wrote to the diplomat Sir William Hamilton, apropos of a project to decorate St Paul's Cathedral with religious paintings by native painters, that she was 'looked upon as an English artist',[3] although the doggerel from the *Public Advertiser* that likened her to Holbein, Van Dyck,

Rubens and Lely called her a 'pleasing guest' in the country. Mrs Piozzi, the former Mrs Thrale, was sure both of what Angelica was not, nationally speaking, and of her appeal to races apart from her own. 'I must not quit Rome,' she resolved in April 1786, '[. . .] without a word of Angelica Kauffman, who, though neither English nor Italian, has contrived to charm both nations.'[4]

To the founder of modern art history, Winckelmann, the matter seemed more straightforward. 'My portrait,' he wrote in 1764, 'is being painted by a strange person, a German paintress.'[5] This is the same description of Angelica as the Rome-based antiquarian Daniel Crespin had given a year before to a Scottish correspondent, James Grant: 'We have a little German paintress lately come here from Florence, where she had acquired great fame and whose pencil, they say, would merit no less patronage than her person, her voice, her manner and her sense are sure to please'.[6] Winckelmann's letter inaccurately claims that Angelica was born in Costnitz, but goes on to observe that since she accompanied her father to Italy at an early age she is equally fluent in Italian and German, despite speaking the latter like a Saxon. He was obviously unfamiliar with the sing-song accent of Switzerland.

In eighteenth-century terms, of course, she was indeed German, since the word 'deutsch' referred as much to language as to geography and culture. (Paradoxically, Angelica would later be described as much more fluent in Italian and English than in her first language.) In any case, the art world then recognised few national boundaries. Angelica's pan-European success was a product of her linguistic and cultural adaptability as well as of her undoubted talent, and her cosmopolitanism was typical of her enlightened times.

Yet for some reason she disliked owning up to her Swiss roots. The first lines of the will she drafted in 1803 made her birth in Chur, her mother's home town, sound like something she was ashamed of: 'I, Maria, Anna, Angelica Kauffman from Schwarzenberg in the Bregenz Woods, [. . .] (accidentally born in Chur in Graubünden) . . . '[7] Not only is the qualification disingenuous; the statement 'from Schwarzenberg' is as close to fiction as the transformations she routinely effected on canvas, since the plain fact is that she had scarcely ever been to her father's birthplace, a small village in the north-west corner of Austria. Given that one's last testament is rarely the best place for propagating half-truths, one wonders what Angelica was trying to say.

Whatever it was, it clearly mattered to her. The story of her Austrian origins is one that she continued to embroider over the years of her celebrity, painting portraits of herself in regional costume and proclaiming an affinity that was real only in sentimental and imaginative terms. Moreover, with the passage of time what had once seemed an insignificant detail about her past acquired a depth of psychological meaning that gave it an importance out of all proportion to the facts or untruths recollected. Thus the Danish poet Friederike Brun mentioned how upset Angelica had been at the modernisation of access to 'her' village (that is, the village that she seems to have visited only three times in her life):

> she was sad at discovering that there was now a road to Schwarzenberg instead of the narrow footpath of old. 'Let us pray that innocence and truth do not hasten out of the country by that route!' she added with a sigh.[8]

From her glorious house in Rome by the church of Trinità dei Monti Angelica wrote to her cousin Casimir about how she longed to taste the plain, healthy food of the homeland again: 'Oh! How often I wish I could have some good Bregenz Woods butter – but sadly we are too far away . . . '[9] And, as a point of accuracy, she always had been too far away.

There must be more to this than mere idealisation. It is true that Angelica was experiencing an artistically enhanced version of the homesickness that Germaine de Staël's *De l'Allemagne* ironically attributes to Swiss-born exiles forced to earn their living away from their native land:

> People talk a great deal about an air played on alpine horns, and which made such a powerful impression on the Swiss that they would leave their regiments when they heard it to return to their homeland. [. . .] If it were sung by Italian voices, one's imagination would be quite intoxicated by it; but perhaps such a pleasure would generate ideas that were foreign to the simplicity of the country. One would start wanting the arts, poetry, love, whereas one actually needs to be satisfied with rest and rustic life.[10]

17

'Ironically', because Germaine no more wanted to re-embrace her Swiss origins than Angelica did, though the reasons for their reluctance differed. Germaine was an intellectual and a society hostess, banished by Napoleon from her beloved Paris and confined to a country whose torpor she could not help contrasting with the brilliant culture she had known before her exile. This was true and searing grief, whereas Angelica's *Heimweh* for Austria, not Switzerland, was obviously unreal in all but figurative terms. The concept of native 'belonging' that she cultivated, like many of the images she presented in her work, was heightened and intensified for the purpose of self-affirmation as well as artistic persuasion. It may not have been precisely calculated, but it was still less transparent than she wanted it to appear.

Most of her acquaintances respected the fiction, and some were entirely taken in by it. Again, Friederike Brun states categorically that 'Angelika Kauffmann was born in the Bregenz Woods', and after retailing other inaccuracies continues:

> she would love to end her days there, if the climate were less raw: 'for people live as innocently as children there!' she added, describing in heartfelt tones the habits of the simple mountain people and their picturesque costumes . . .[11]

Angelica had made a roughly similar claim to her English friend Cornelia Knight about retiring to England, and both should be taken with a pinch of salt. The nostalgia seems of a piece with other aspects of her manufactured world, where upset is tempered and decorous fantasy prevails. Such memories had little to do with the hard realities of professional life to which she also subscribed, and in whose midst she flourished.

The account Rossi gives of Angelica's early promise could have been taken from any eighteenth-century 'life' of an artist – of Rosalba Carriera, Anton Raphael Mengs or Louise Vigée Le Brun, for instance. Its model is Vasari's sixteenth-century *Lives of the Artists,* where the dawning of genius is regularly detected in childhood scribbling and sketching. Rossi's account of the way the young Angelica doodled, or how she adorned with flourishes and motifs the letters of the alphabet her artist father taught her, is simply a statement of the norm in

18

'prodigy' literature, where it foretells a promising artistic future. All children scribble, of course; only with hindsight does it indicate that a vocation has been sealed. Unless he was a fanciful man, Johann Joseph Kauffman probably concluded no more from these early signs than that his daughter might be a useful assistant to him sometime in the future.

Louise Vigée Le Brun's memoirs recall an exactly similar situation in her own childhood, describing how she sketched as though her life depended on it:

> I doodled constantly and everywhere; my exercise books, and even those of my companions, were filled in the margins with little heads either face-on or in profile; on the dormitory walls [of her convent] I sketched figures and landscapes in charcoal, which, as you may imagine, meant that I was often in disgrace. Then at break-time I would draw on the sand everything that entered my head. I remember at the age of seven or eight drawing by lamplight a bearded man, which I have always kept. I showed it to my father, who exclaimed in transports of joy, 'You are to be a painter, my child, if ever there was one'.[12]

Eventually there came a time when Johann Joseph, faced with the same realisation as Louis Vigée, decided to train his daughter seriously.

A self-portrait Angelica painted at the age of twelve, an image which in its solemn-faced plumpness is extremely winning, is the earliest direct evidence we have of her talent. She shows herself holding a sheet of music that bears the legend 'MDCCLI [. . .] In my thirteenth year I painted this and the picture of my father and lady mother, Morbegno, Valtellina'. ('MDCCLI' must be an incomplete notation, as Angelica turned twelve only in 1753.) The picture of her parents has been lost, and although other images of Johann Joseph Kauffman survive, none can be found of his wife Cleofea Luz (or Lutz, or Lucin). Whether or not this is pure accident, in poetic terms the loss of her mother's likeness seems almost as inevitable as the preservation of her father's. To Johann Joseph, Angelica owed not just her preliminary training as an artist, but also her later marketing as a star. Cleofea, on the other hand, disappeared from her daughter's life before the glory days began,

and is unmentioned in any of Angelica's surviving letters. Furthermore, Angelica's will bequeathed nothing to any of her mother's surviving relatives, if indeed there were any; the main beneficiaries of her generosity throughout her life as well as after her death were either Kauffmans by birth or marriage or members of her second husband's family.

Since she was fifteen when Cleofea died, it is hardly likely that Angelica forgot about her. Perhaps she found her memory too painful to preserve, although in an age when mortality rates were high and the familiarity of death was a commonplace, that too may seem improbable. Much stranger is the fact that she also tried to block out the memory of Chur, the town indelibly associated with Cleofea, and where her father had met and married her. The uncompromising reference to Angelica's 'accidental' birth there seems to carry a hint of blame, as if Cleofea, despite being the daughter of a midwife, had planned her confinement carelessly and so imposed a kind of territorial disloyalty on her daughter. Yet there was nothing accidental in Angelica's birth away from Schwarzenberg. It was all, in fact, her beloved father's doing.

He was a typical journeyman painter who travelled to wherever he could get work, and who was forced to set practical concerns above regional loyalty. In spring every year men like him went from the Bregenz Woods to Switzerland, France, South Germany and Bohemia to build and decorate churches, monasteries, convents and homes, finding employment as masons, bricklayers, *stuccadores*, gilders and painters.[13] No more than his daughter could Johann Joseph have survived professionally by staying put all his life in an isolated corner of rural Austria, and other members of his immediate family seem to have felt the same: his younger brothers Simon and Anton would settle in Alsace and Lorraine and similarly make names for themselves as artists. But long before they did so Johann Joseph had left for the canton of Graubünden, where he was working from 1736 at the latest, and where he married Cleofea in November 1740.

Chur's *Altstadt* still preserves some handsome old buildings dating from the fifteenth to the seventeenth centuries. One of them, the arcaded fifteenth-century town hall, backs onto the Reichsgasse. It was in this street, at number 57, that Angelica was born on 30 October 1741.

It was not dislike for Chur – a town she left as an infant, and of which she cannot have retained any first-hand memories – that made her claim a village in the Vorarlberg as her true home, but a specific sense of indebtedness. Angelica's desire to emphasise her bond with a father rather than a mother recalls another tradition established in Vasari's *Lives*, where the teachers of painting are always men who are honoured for the vital instruction they give the young prodigies in their charge. Vasari's *Life* of Raphael anticipates Rossi's account of Angelica in this way, describing the father who nurtured and advertised his son's genius effectively despite his own modest skills. Prodigies, Rossi announces in the same spirit, can happily dispense with artistic greatness in their instructor, provided he is a skilled strategist: Johann Joseph's inferiority as a painter[14] did not stop him being a first-class impresario for his daughter. Neither was precisely the case, but the mythic structure of the artist's 'life' made both appear unquestionable facts.

This order of priorities seems to hold in other arts too, for example where the *Wunderkind* is a musician rather than a painter. Thus Mozart's mother appears in a picture by Nepomuk della Croce as a mere portrait on a wall, looking down on her musical family just as Angelica and Mary Moser look down on the Royal Academicians in Zoffany's painting, present only on sufferance and in practical terms effectively denied. In this sense it seemed poetically just, too, that when Frau Mozart did involve herself actively in her son's musical life by accompanying him to Paris, she died; for symbolically as well as actually, she did not really count. Cleofea Luz was an absence like Frau Mozart, lacking her husband's and child's specific talent and dying before her time; and as Mozart 'had' to be born in Salzburg rather than in his mother's native village of St Gilgen, so Angelica 'should' have been born in Schwarzenberg. As a result of all these pressures an almost painfully close bond existed between her and her father, and they were reluctant to allow others to intrude upon their union. Perhaps Angelica regarded her will as the right and final place to tell the world, which sometimes doubted it, how much she owed to Johann Joseph, celebrating him with as much devotion as he had brought to celebrating her. It is only a hypothesis, but no less persuasive for the fact that Johann Joseph seems never to have felt the same devotion to Schwarzenberg as his daughter, despite having lived there for years.

The important thing is that he did not deny his birthplace as she denies Chur.

In 1739, within three years of leaving his native village, he was offered the job of court painter to the Prince-Bishop of Chur, Josef Benedikt de Rost. There was nothing particularly grand about the title – such positions were quite freely given, and carried no salary – but it shows that he was thought good enough at what he did, mostly painting portraits and copying Old Masters. (If a story told by Mary Moser is true, in London he would occasionally try to pass off copies he had made of Angelica's paintings as originals by her, but his draughtman-ship and use of colour gave the game away.)[15] He had a knack for making connections, too, one that Angelica seems to have inherited, though Cleofea's gentle birth may have played its part too. She belonged to a noble but impoverished family, the de Canobias, and Angelica's godmother was a Baroness de Rost.

Although Angelica would be given the baroness's names, Anna and Maria, as tokens of the family's gratitude to her, the Christian name she used throughout her life was a traditional one in Chur. It was also the name of a nun belonging to the ruling de Salis family, who were influential patrons of Johann Joseph and later of Angelica. Indeed, the de Salises probably helped Johann Joseph to get work when his employment was over, since they were a powerful family in the Valtellina. In the summer of 1742 the Kauffmans moved to this province, which had been ruled as a Graubünden dependency for more than two centuries. They settled in Morbegno – now an industrialised conurbation, then a small, pretty place – where they were still living when Angelica painted her solemn self-portrait in 1753.

As biographical material goes, it is as informative as any of the other records she left behind. For a woman so publicly known by her own age, she took enormous and perverse care to deny others any help in interpreting her life. There are a few letters – mostly those she sent rather than received – but no diary. The remaining evidence is documentary: one birth and two marriage certificates, a list of paintings, the record of various professional honours done to her, and a will. Apart from these there are the paintings themselves and the recollections of others.

The picture of her parents may be lost, but the early self-portrait seems tacitly to recall them both in its dual reference to painting and music, a pairing that would later prove immensely fertile in the construction of Angelica's own artistic myth. Morbegno was a music-mad town, with a conservatory established by the son of the painter Pietro Ligari, and Angelica, whose singing would be praised by Crespin and Winckelmann, was bound to flourish there. But although she is shown holding a sheet of music, the inscription on its lower half also proclaims her identity as a painter. If music was what she had learnt from her mother, painting was her father's concern, which means that the portrait may be read as a form of homage to both of them. What seems superfluous information in the picture itself, then, lends it great biographical richness, because the union of painting and music is presented as natural and uncontroversial; only later in Angelica's life will it be made to appear troubling and problematic.

The way this subject-matter is presented makes it seem all the more conventional. It is a rendering of a distinctly *gendered* commonplace, for many other self-portraits of female artists with musical attributes or instruments suggest the significance of music as a defining element in the woman painter's personality. Sophonisba Anguissola (who seems to have invented this theme), Titian's daughter Marietta Robusti, Catherine van Hermessent and Lavinia Fontana all show themselves at the harpsichord, Rose Ducreux paints herself playing a harp, and a later self-portrait of Angelica at Saltram has her holding a guitar. Very few male self-portraits, by contrast, depict the subject as a practising musician, probably because men were officially allowed to train as painters and nothing else. The 1753 picture calmly announces a happy league – 'I can paint *and* sing' – precisely because no stated preference is yet being demanded. Although as time goes by Angelica's first talent, her father's art, will gain her allegiance and win her fame, the other will never be forgotten. While Cleofea is alive, music may happily continue to advance its claims.

Perhaps the portrait invokes Cleofea in other ways than simply through the theme of music. While surviving pictures of Johann Joseph Kauffman show him as a thin-faced man with a straight nose, the young Angelica has a round face (Joseph Moser's memoir describes it as 'of the Grecian oval, which the reader knows rather inclines to the round')[16] and a tip-tilted nose. Though the chubbiness may simply be a

23

mark of her youth, the roundness is perhaps inherited from her mother. Angelica's later self-portraits transform her into a regular, even glamorous beauty, but other likenesses – particularly those by artists who were not especially well disposed towards her – suggest that she simply beautified herself on canvas as she matured in real life. Of course, rather than betraying the coquettish penchant for self-flattery that her detractors alleged, this may simply illustrate her belief that painting is properly the domain of ideal representation, as her admirer Catherine II of Russia agreed: idealism, she thought, was an entirely positive feature of Angelica's art. Goethe, on the other hand, strongly disapproved of Angelica's preference for fiction over fact in portraiture, despite calling his own autobiographical account *Dichtung und Wahrheit*, Poetry and Truth. Probably Angelica saw such adaptation as merely symbolic.

Yet for all its apparent openness, the 1753 picture is also vaguely disquieting. Its apparent honesty may be a form of testimony to Cleofea, but there is also something provocatively self-flattering about the image. Apart from anything else, the child seems older than her years in both worldly elegance and artistic accomplishment. Rousseau's hugely influential pedagogical novel of 1762, *Emile*, would later caution against the habit of treating children like grown-ups rather than seeing childhood as a discrete stage in itself, but Angelica's self-portrait unabashedly blends the external signs of maturity with the half-formed features of youth. Or is her painted self simply doing what all children enjoy doing, dressing up? (If so, it would provide one of the very few indications there are that Angelica ever enjoyed playing childish games.) Is she even mocking an incipient female taste for self-beautification as she decks herself out à la Pompadour in a silvery-blue dress decorated with pink ribbons and trimmings, powdering her wig, plucking her eyebrows and wearing rouge? The black band round her neck also echoes the style favoured by Louis XV's mistress, while the loose-fitting ruffled sleeves are the height of fashion. Overall, there is a degree of sophistication that the artist's tender years call into question. Perhaps Angelica is saying not just that she is both painter and musician, but also that she is at once young and old.

How good a painting is it? It has been favourably compared with Gainsborough's self-portrait between the ages of eleven and thirteen, and despite its surface smartness it is a memorably intimate portrayal,

disarming and even faintly amusing in its defiant childish seriousness. As evidence of Angelica's talent it was obviously impressive enough to persuade others to commission their portraits from her, though part of the interest it provoked was undeniably due to the remarkable youth of the artist. There were definite attractions to being painted by a prodigy.

According to Rossi, the industrious and dedicated Angelica liked studying and copying prints, models and pictures in her father's studio as much as other girls did playing with dolls.[17] Why should she have had a childhood at all, he seems to be asking, when so much more could be gained by accelerating her growth to maturity? Whether or not this was her parents' view, it seems clear that she did not enjoy what is called a normal upbringing. Rossi tries to present it as happy –

When her parents themselves called her for some recreation or relaxation, [. . .] she appeared joyful for a moment; but then, very quickly becoming bored, called for her pencil and brushes and returned to work[18]

– but it seems to have been remarkably friendless. Later on she would acquire avuncular patrons, a troop of 'venerable old men', as Rossi describes them, who sat to her when she was barely in her teens and showered extravagant praise on her, but she very rarely spent any time with her own age group. We may think in this connection of her later sitter Germaine de Staël, another father-adoring and precocious talent whose preferred companions in her girlhood were the middle-aged or elderly philosophers and Encyclopaedists who attended her mother Suzanne Necker's salon in Paris, and who was finally prescribed a friend of her own age when she fell ill in her mid-teens and was ordered to recuperate in the country. Like Angelica, she was an only child, a prime qualification in the prevailing mythology for genius status, at least in women. When it combined with a father-fixation, sublimity was virtually guaranteed.

Angelica's comfortable place in the family, the orderliness of her driven young life, might have been threatened by a mysterious event in 1750. Johann Joseph returned from a trip to Lake Constance with a

boy whom he introduced as 'Cousin' Joseph, and who was to be raised as a member of the family. No one told Angelica at that stage that the sixteen-year-old was really her father's son by a previous wife, Sibylla Lohrin; nor was she informed that Sibylla had apparently died in 1740, the same year as Johann Joseph remarried.[19] Given the length of time that he had been living and working in Graubünden, he must have deserted his first family within two years of his son's birth.

Although Joseph would later accompany Angelica and her father on their journeys through Austria and Italy, he chose to stay behind in Milan when they travelled further south. In 1767 Johann Joseph invited him to London to live with them, but Joseph, who was then thirty-three, declined. Thereafter all contact between father and son, and half-sister and half-brother, seems to have ceased, and Joseph fades out of Angelica's story as completely as Cleofea had done.

All this is suggestive of a particular life strategy as well as a narrative angle. The plan conceived by Angelica and her father, at least until her first taste of living alone in London, demanded that they form a partnership in which each could be exclusively devoted to the other. Beyond that they saw only wasted effort and pointless intrusion. Angelica's habit of working with every particle of her being, of studying with the same intentness an indifferent engraving and a glorious Old Master, meant that she grew up with a philosophy of self-improvement that verged on the obsessive. To spend time unprofitably – whatever that meant – seemed reprehensible to her if it took up a part of the day that could be turned to more constructive use. No matter that the discipline and determination which she brought to copying master-pieces in Florence and fulfilling commissions in Rome and London would eventually make her ill; what counted in the present was achieving, honing, getting things done. Since relaxation and human intercourse could apparently contribute nothing to this, her childhood and adolescence were spent in a sealed-off space that provided her with everything she wanted or thought she needed, and where every achievement was a means to a glorious artistic end. Even at the height of her fame she relied on this same principle, that routine was what mattered and work must brook no interruption.

How could Joseph have competed? Angelica was only eight or nine when he joined the family, but at some point Johann Joseph must have been made aware that his daughter possessed unusual artistic gifts. The

26

fact that his son would become a competent artist himself, employed as a court painter in Mainz and Aschaffenburg, was almost incidental. Whatever Joseph might have learnt from his father, he was obviously never allowed to function as male offspring in a family traditionally did; he was seen as an intruder, unfit to steal his father's attention away from his half-sister and probably feeling that he was present only on sufferance. He could contribute nothing to Angelica's brilliant future career, and as a result her biographers barely mention him.

The difficulty of integrating the families of two marriages is of course notorious, and the residual bitterness felt by the deserted party even more so. Had Joseph's relation to Angelica been announced to her as soon as the boy arrived in Graubünden, it would have been painfully apparent that Johann Joseph had been a neglectful as well as a good father, an uncaring husband as well as a responsible one. If he had a vested interest in being a better father to Angelica – who seemed likely to be the future breadwinner – than he had been to Joseph, the boy must seem a potential embarrassment to him. In that case one wonders why he had been introduced into the family at all, particularly given the likelihood of his revealing his true origins to his half-sister. Perhaps Cleofea had insisted on her husband's trip to Lake Constance, and Johann Joseph simply insisted on silence in return.

This hypothesis is given some support by a portrait Angelica painted of her father sometime after 1761, which shows a handsome man, but with a stern look that hints at secretiveness. His decisive nose and clear brow, on the other hand, suggest something else, the determination with which he subordinated everything to steering his daughter's progress. Although the painted image conveys his daughter's respect and love for him, neither respect nor love can block her insight into Johann Joseph's character. And perhaps the insight reflects her distinctive ability as a face-painter, given that intuitive awareness of this kind was often thought to be an essentially feminine quality, something that made women – if they were to paint anything other than flowers – particularly effective as portraitists.[20] Men with the meaning look of Johann Joseph do not allow chance circumstance to deflect them from their intention, even at the cost of human suffering, and even though the determination they hope to conceal is apparent to (some) others.

Of course, many of the men Angelica paints in the course of her career are far less robust and single-minded than this, just as some

27

women – such as Angelica herself, despite appearances – are far more determined and forceful than the traditional, passive view of their sex suggests. All the same, it is obvious why she should have been particularly preoccupied in later life with portraying melancholy, deserted and bereft women, including mothers. She knows that even essentially good and well-intentioned men, like her father, treat women badly, even though other men – like her half-brother Joseph – may suffer desertion and desolation too. With such realisations Angelica has already gathered some of the conceptual material that will inform her ambiguous presentation of the sexes in later life, an inclusive view that emphasises their native weaknesses as well as strengths. All the same, she will generally give female suffering priority over male.

Yet it is perfectly possible that she never knew the facts that her half-brother rehearsed in a twelve-page letter written in March 1808, the year after her death, and in which he declared that he had been brought up single-handedly by his mother because her husband was 'always away'. Joseph received nothing from his father's estate, and so had had hopes of being a beneficiary of his half-sister's: 'she would at least have remembered me as a brother in her will, even if the true relationship had not been known to her' (an ambiguous formulation that leaves the reader uncertain whether or not she did know). Since there had been no bequest, 'my hopes and attention are now fixed on my father's residue, which formed part of Angelica Kauffman's fortune'.[21]

On the evidence of his letter, Joseph never discovered the precise circumstances that doomed him a second time to exclusion from the family unit, and they could never have been articulated clearly by father or daughter. Put simply, the son was irrelevant to the grand design. Just as the father's loyalties remained with his daughter, therefore, so hers remained with him. That meant, among other things, remaining loyal to Schwarzenberg.

In the early 1750s the family moved to Lake Como, where they stayed for more than a year. There was plenty in Como to allure Angelica, although it lacked great works of art. The town was prosperous: it was a centre of silkworm breeding (Como retains a silk-weaving industry to this day), and this was the century of silk – silk for drawing-rooms, silk

for hangings, silk for upholstery and silk for costumes. Silk barons had built great villas by the lake, and at this time, before the outbreak of the Seven Years War, the town seemed a haven of prosperity and stability. The Kauffmans must therefore have hoped that it would yield suitable artistic patronage.

Angelica was enchanted by the place. Many years later she would write:

> My friend, I realise why Como is always in my thoughts. Como was the place which in my youth made me taste the keenest pleasures. I saw rich palaces, fine coaches, pretty boats, a splendid theatre; I felt I was seeing paradise.[22]

She was busy in paradise too, apparently with contract work. Rossi mentions the impression she made on the Archbishop of Como, Monsignor Maria Agostino Nevroni, who asked her to do his portrait:

> This prelate was a venerable old man of imposing figure, with noble colouring and bright eyes; his chin was adorned with a long white beard; and so he offered the paintress a model of handsome old age, but very difficult to capture.[23]

Despite this, the portrait – now lost – evidently succeeded, and Nevroni's praise naturally led to other commissions.

Angelica, Rossi writes, read widely during her time in Como, and listened to the conversation of learned men. But the enthusiasm of benevolent patriarchs proved to be of crucial importance: for when another venerable cleric, the Suffragan Bishop of Milan, Cardinal Pozzobonelli, asked to be painted by her, he became so charmed by her manners and youth that he offered her his protection, ensuring that she had access to the private as well as public collections in Milan itself. This was a vital concession, for Angelica badly needed resources that Como could not supply, Old Masters in particular. Johann Joseph needed a new environment too, no doubt because Angelica's earnings could not yet support the family. So the Kauffmans moved to Milan in late 1754 or 1755, at a time when the city was experiencing an economic boom. Here Angelica followed the pattern she would observe throughout her industrious life, absorbing new resources by

29

diligent study and copying (the 1767 *Künstlerlexikon* by the art critic and writer Heinrich Rudolph Füssli remarks, indeed, that by the time she settled in Milan she had already become famous as a copyist). Milan made available the introductions that were essential to her progress.

The grand scheme was working, even though there were elements in life that could not be specifically planned for, experiences that proved vital simply through accumulating and enriching her artistic knowledge. Exposure to masterpieces was gradually teaching her that development might come about by other means than sheer effort: for Angelica there was shock as well as delight, for instance, in finding herself face to face with the gorgeously coloured masterpieces of the Lombard school for the first time. Given the ravages of time, admittedly, they were not always gorgeous. The deterioration of Leonardo's *Last Supper*, for example, had first been noticed in the early 1500s, and the work had already undergone several of the inept restorations it would suffer over the following centuries. Many years after Angelica's stay in Milan, Louise Vigée Le Brun groaned at the sight of such a wonderful painting 'so altered':

> It was first covered with plaster; then various areas were painted over. Yet one could judge what this beautiful composition had been before these disasters, since viewed from a certain distance it still produced an admirable effect. Since then [1789] I have heard that this masterpiece has been degraded in quite another way. I was told that during Bonaparte's last wars in Italy the soldiers amused themselves firing bullets at Leonardo da Vinci's *Last Supper*! Cursed be the barbarians![24]

Napoleon would not seize Milan until 1796, so for the time being great art seemed safe. But as Louise suggests, well-meaning insensitivity could do just as much damage as deliberate vandalism.

Johann Joseph, ever aware of commercial possibilities, knew that his daughter's potential as the family's breadwinner meant making a concerted effort to promote her. Courtly favour, he realised, could do much to spread her fame. He therefore encouraged Angelica to copy portrait heads in the palace of the Habsburg-appointed governor of Milan, Duke Rinaldo di Modena d'Este, which she duly did, and a

'stampede' of courtiers wanting her work predictably ensued. Johann Joseph had himself obtained some commissions to restore wealthy townspeople's houses, for whatever the promise of Angelica's *succès d'estime* her earnings could not yet support the family. But the surety she seemed to offer for the future meant that it was vital for her to continue making contacts and trading on her cachet as an attractive and gifted young artist.

By now she had become thoroughly used to the wandering painter's life. She had still never been to Schwarzenberg, but was making other moves to compensate for her accidental birth in Chur. She continued to win admirers for her talent, and her prospects seemed settled. But on 1 March 1757 Cleofea suddenly died.

We do not know why, or whether the death was expected. Rossi refers to it briefly, but Angelica's future brother-in-law and memorialist Giuseppe Zucchi not at all. Rossi remarks that if one were talking of any other daughter

> one might have been able to say that she left her helpless in the world; but Angelica, at the age of sixteen [actually fifteen], was already capable, without any other guidance, of the most sage conduct; so although such a loss was painful to her heart, it was not harmful to her education.[25]

He describes Johann Joseph as having been more affected by Cleofea's death than his daughter, and anxious to move away from a place that held so many memories. Of course, his move may have been strategic as well as sentimental; perhaps he had already received the commission that would soon engage both him and Angelica in the Vorarlberg. In any case he must have felt that he could not accept work that would take him away for an unspecified time from his daughter.

Angelica certainly grieved deeply too, but some of the grief was expressed later on, and indirectly. Translated into images that resolved her ambiguous feelings – part denial, part affirmation – about Cleofea, it restored the missing portrait of her mother by an act of creative imagination. Converting the immediacy of experience into the transposed form of art was a kind of catharsis, and symbolic or conventionalised images distanced her from suffering. As an artist she

31

could deal with death only metaphorically, using referential equivalents such as the urn or the grave for what she dared not depict; and her work almost never referred to dead or dying women (the *Death of Alcestis* is one notable exception), despite the fact that grieving, deserted or bereaved females are so often her subjects: Ariadne, Dido, Poor Maria, and many more. The fearfulness of upset that prevented her throughout her career from satisfying demands for the sublime and the terrifying is another indication of the trauma that artistic creation could not overcome. Two pictures she would later sell in Venice, *Queen Eleanor on the Point of Death* (having sucked poison from her husband Edward I's wound) and its pendant showing the recovered Eleanor, constitute the perfect Kauffman resolution: sorrow followed by rejoicing.

The same purpose is served by the images of maternity in her art and life, images that are essentially removed from direct experience. It was not merely besotted admirers like Herder who celebrated her purity in ways that suggest her detachment from brute experience, almost her sexlessness; others called her an angel-woman who appeared to exist on a higher plane than mortals, untouchable but inspiring. Such a creature could never beget children (and so could never depict herself in the narcissistically maternal way that Simone de Beauvoir's *Le Deuxième Sexe* criticises in Louise Vigée Le Brun), but might diffuse an aura that almost did duty for them. This is precisely how the mature Angelica appeared to her friends, ministering and consoling, giving strength and offering support. Such a persona suited her need to love others protectively, but without the potential pain or burdensome responsibility of deep commitment, and it made legitimate a devotion to work that might otherwise have seemed too exclusive. In this way both work and life generated occasions that, lacking some of the troublesome or troubling elements of reality, were fulfilling as limited forms of human contact – Angelica's acts of kindness towards younger artists of both sexes, her cultivation of soul-friendships, her tending of the sick, even her rescuing of the abandoned and bereft. All these things enabled her to express her humanity, but with an essential degree of detachment.

But for now father and daughter needed to take practical steps to enable them to cope with Cleofea's loss. It is hardly surprising that the

refuge of Schwarzenberg should have suggested itself. Schwarzenberg was unconnected with Cleofea, and therefore devoid of the sad associations preserved in Milan, Chur and other places in which they had lived as a family, but it would provide the support that a widower and a motherless girl needed. It was alluring simply as the home village of Kauffmans.

It is a picturesque place that can have changed relatively little since Angelica's day, uninsistent enough to be an appropriate shrine to the memory of this most understated artist, yet full of echoes – the plaque and the portrait bust by Christopher Hewetson in the church, some paintings, the memorabilia in the Schwarzenberg museum. These keep her present, as does the fact that dozens of Kaufmanns (as the surname is now spelt) still live in the village. It preserves other names as well – that of Eduard Mörike, for example, who stayed at the typical Bregenz Woods inn, the Hirschen, which was built the very year of Angelica's arrival, and Schubert, who is fêted in the village's annual Schubertiade. Most importantly, it retains an identity and a link with the past of the kind Angelica herself would have approved, for to this day the costume of 'her' region and village, which she commemorates in a number of self-portraits, can be seen on the women leaving church after Sunday mass. There are other tokens too of a past she loved and whose continuation she feared for. One is the annual *Alpabtrieb* (the bringing down of cattle from their mountain pastures), where the animals are colourfully draped, the herdsmen and milkmaids wear regional costume, and everyone dances.

The area is good walking country too, with pretty villages dotted along winding roads and panoramic views of the major peaks of the Vorarlberg. The house in which Angelica and her father would stay belonged to her cousin Michael and stood 'in the meadow' ('an der Wies'); but Angelica's later recollections of having had to walk for three hours to mass suggest that it cannot have been anywhere near the village itself. Or perhaps it was, since the people of Schwarzenberg were forced to worship elsewhere when fire seriously damaged their church. The fire had been one reason, perhaps the main reason, for bringing her and her father to Schwarzenberg: Johann Joseph had been commissioned to redecorate the church, and his daughter helped him with the task.

In later life Angelica admitted that she had been shocked, after her

elegant existence in Como and Milan, at having to share meals at her cousin's table with smelly peasants, but added: 'Anyone who had then told me what distinguished people I should one day dine with – can he tell me now that I shall never return to eating with a goatherd?'[26] In fact she would remain a humble pragmatist throughout her life, whatever the 'unbelievable treasures' – Goethe's phrase – she lived amidst when she settled in Italy for good in the 1780s. Returning to her roots reminded her of the losses as well as gains brought by personal and professional success.

Johann Joseph's main job, offered to him by the Bishop of Constance, was to paint the ceiling of the reconstructed building. Angelica's was to decorate the walls of the nave and chancel with frescos after Piazzetta's *Heads of the Apostles,* and a local tradition has it that she made some of the apostles' faces into likenesses of Bregenz Woods acquaintances. For nearly a century these heads looked down upon the congregation, until a fatal desire for modernity led to a painter being hired to refashion the interior of the church in the new gothic style, and Angelica's work was whitewashed over. Only in 1929 was it retrieved, appearing fresh and undamaged after its seventy-five-year concealment.[27]

Since there was no prospect of a professional future for Angelica in and around Schwarzenberg, she and her father returned to Milan when the church commission was finished. But she still wanted to give artistic expression to her commitment to the place. It took the form of two self-portraits, completed in 1757 and 1759 respectively, in which she wears the regional costume, the first resembling the 1753 picture in containing no overt reference to her activity as a painter, and the other (her first portrait to be displayed at the Uffizi) showing her with paintbrush and palette.

The slight provinciality of this second work is part of its charm, though Angelica would later be so embarrassed by it that she did another self-portrait for the Florence gallery. The original combines familial and regional loyalty with a proud statement of professionalism. Angelica holds a maulstick in her right hand and a palette and brushes in her left, with a box of colours beside her and an easel bearing a half-painted canvas beyond. Artistic preoccupations would fully reassert themselves when she and Johann Joseph returned to Italy; but in a

later Bregenz Woods portrait painted in 1781, on her second and final trip to Schwarzenberg, she would omit the marks of her profession altogether. Probably she no longer saw the need to advertise it.

Although it is possible to see this first Uffizi portrait as simply marking Angelica's commitment to paternal painting rather than maternal music, to read it as declaring a final severance from Cleofea makes no moral or poetic sense. If a preference for painting did mean relinquishing a musical career, it was not at the price of love for someone she had lost. There may be some truth in the story of her 'Herculean' choice between painting and singing, which allegedly occurred when she met a young man around 1760 who tempted her with stories of the easy celebrity that music offered, and was then persuaded by Count Firmian's chaplain that a career in painting would be morally sounder and longer-lasting; for in the years after Cleofea's death her daughter was still being drawn by the power and promise of music. But she had to decide on one or the other as her life's work. When that decision had been taken, it was time to leave Milan for a second time and head south on another artistic journey.

Chapter Three

'A Little German Paintress'

Count Karl Gotthard Firmian, Empress Maria Theresa's plenipotentiary minister in Lombardy from 1759 and a Maecenas, music lover and copperplate engraver, was described by Winckelmann as 'the most complete man you will ever become acquainted with in all your travels, and perhaps in your entire life'.[1] It was lucky, then, that Angelica had got to know him in Milan. He provided her with a sheaf of recommendations for her travels when she left the city – to officials, to courtiers and potentates, to Winckelmann and to Winckelmann's employer in Rome, Cardinal Alessandro Albani.

First, as a matter of course, she went to Parma to see the Correggios, with their glowing colour, lyrical sweetness, sentimental elegance and captivating charm. To judge by the fact that later in life she would often be compared with this artist, in negative as well as positive terms, the impression his works made on her was considerable. Wilkes's comparison is enthusiastic ('her paintings are allowed to have [. . .] the warmth of Correggio's colouring'), but the hack Pasquin, reportedly a 'polecat', a 'literary ruffian and a nuisance in society',[2] is predictably hostile about this aspect of her art:

> There are persons who have madly affirmed that she is equal to Correggio, but to such writers I disdain to reply. [. . .] There are few acknowledged enemies more destructive in their malignity, than an intemperate and injudicious defender often proves, by labouring to make that appear gigantic which is in verity but of common magnitude, and advancing assertions with boldness which are obliged to recede with reluctance from the tests of severe truth.[3]

Perhaps it is just as well, in that case, that Angelica was determined to expose herself to as many other painters as possible. She started by

36

moving onwards to Bologna, which meant exchanging Correggio for the Carracci, Albani, Reni, Domenichino and Guercino. If for her the place was defined primarily in terms of its art collections, for others it had a more prosaic significance. Bologna, though one of North Italy's oldest and most beautiful cities, was for Mrs Piozzi

at first sight a very sorrowful town, and has a general air of melancholy that surprises one, as it is very handsomely and regularly built; and set in a country so particularly beautiful that it is not easy to express the nature of its beauty.[4]

But 'melancholy' was a word she attached to many Italian towns or their surroundings, especially Rome's Campagna. Predictably enough, she thought only Naples so pullulating with life as to be positively gay.

In some ways Bologna augured well for a girl of Angelica's ambition. Apart from anything else, it had an undeniable record of nurturing outstanding women. Two famous female artists, Lavinia Fontana and Elisabetta Sirani, were natives of the city, and Sirani is buried in the same chapel of the church of San Domenico as Reni. The ancient university where Petrarch had studied was renowned in the eighteenth and early nineteenth centuries for its remarkable female professors, the mathematician and scientist Laura Bassi and the professor of Greek Clotilde Tambroni. But there were other factors that seemed at least potentially favourable to Angelica's fruitful development in the town. In the seventeenth century its university had acquired an anatomy theatre, which added to the notoriety it had enjoyed since the fourteenth as the first school where human dissection was practised. This particular scientific bias, along with Bologna's woman-friendliness, ought to have been Angelica's great chance, her opportunity to correct the ignorance of human anatomy that critics recurrently noted in her work, and to an extent it was. She studied for several months at the Accademia Clementina, a public academy that admitted women as well as men, and in due course was awarded its diploma.

The director of the Accademia was Ercole Lelli, whose striking anatomical figures support the baldacchino above the reader's chair in the theatre. He set great store by the study of this subject, which he lectured on at the university. Even if he did not instruct Angelica directly, she must have been influenced by the focus of his teaching.

But, disappointingly, students of both sexes at the Clementina drew from plaster casts (admittedly far more than Johann Joseph had been able to provide his daughter with in her girlhood) rather than from life. Even if they had observed the living model, propriety would have forbidden women to be present, and Angelica would still have been denied the chance to observe Pasquin's 'muscular motion'. Although she was a model of decorum throughout her life, even she might occasionally have been tempted to breach it for the sake of her beloved art.

Whether or not she should have stayed longer in Bologna, she was anxious to proceed to Florence. Here she had set herself a specific programme to follow. 'Madame Marianne Angelica Kauffmann, pittrice tedesca' is entered as number 153 in the register of the Florentine Accademia del Disegno for 1762,[5] but again it is uncertain whether she received any instruction in return for her fee. And what sounds like a privilege accorded to her was probably nothing of the sort: although she was given a private room to copy paintings in, this was a concession to her sex rather than a mark of special treatment. Again, she would be spared, or denied, the spectacle of naked male models at the life classes that men students freely attended.

When she was not studying at the Accademia or copying paintings, which she spent most of her time doing, she formed acquaintances, made contacts and did some original work. According to Giuseppe Zucchi,

> Young as she was, and at an age when the body needs much sustenance to grow, she endured hunger and underwent long fasts [. . .]. Although of slender build, she had a strong, healthy constitution, and she never suffered the discomforts her sex is liable to. [. . .] When she returned to her guesthouse she took her evening meal. But her zeal did not abate until the day was over, for after some brief interruption, devoted either to music or to reading, she resumed drawing for another hour or two before retiring.[6]

Yet despite the limitations placed on her activity, there were consolations. The opportunity to copy masterpieces was a privilege, but it was not always seized for disinterested reasons. Zucchi may insist

that Angelica's versions were done less for financial profit than for the sake of knowledge, but the fact remained that copies which, like Angelica's, were often confused with the originals were highly saleable.[7] Besides, even if she herself was not driven by the desire for money, her father probably was. Later on Goethe would regret her obsession with working beyond financial need, implying that she did so at the behest of another man, her miserly husband:

> She is not happy as she deserves to be, given her truly great talent and the fortune she adds to daily. She is tired of painting to sell, and yet her old husband finds it altogether delightful that good money can be earned for often rather little work. She would now like to work to please herself, with more trouble, care and study . . .[8]

The ideal compromise between supporting her household and enjoying the freedom to work unencumbered by domestic matters, which she later owed to Antonio Zucchi's attentive stewardship, would always be precarious. But even in her adolescence, in all her youthful single-mindedness, there were signs of the keen businesswoman in the making.

The ethics and philosophy of copying were complex. Reynolds regarded this activity as 'a delusive kind of industry',[9] and listed only six among his own works (all done in the spring or summer of 1750, while he was in Italy). He had no interest in painting replicas to sell to Grand Tourists who wanted a taste of Italy's art treasures at home, preferring to fill his notebooks with sketches of Old Master paintings as a store of ideas to work from later. In general, however, eighteenth-century taste did not jib at the concept of replication, partly because original masterpieces were seemingly becoming harder and harder to track down and then buy. On 12 September 1761 Horace Mann, the British Resident in Florence, wrote to Horace Walpole:

> I thought last night that I should succeed in getting one of the most capital pictures at Rome by the means of Mr Strange [John Strange, the British Resident in Venice from 1774 to 1786, was passionately fond of painting, especially Venetian painting of the

fourteenth to eighteenth centuries, and was active as a dealer]: nothing less than the Magdalene of Guido in the Barberini Palace [. . .]. The lady of the house has already found means privately to dispose of some, in the room of which other copies actually pass there [*sic*] for originals.[10]

Northcote would write to his brother some years later about 'one or two miserable wretches who are sycophants [to cursed antiquarians supplying the collecting needs of travelling *Milordi*, and] make all the copies for the English nobility at very small prices'.[11] The Président de Brosses, in more tolerant spirit, remarks in his *Lettres familières écrites d'Italie* that 'I care nothing for originals of Old Masters, for certain reasons known to me; I have no regard for originals by minor masters; I prefer fine copies of famous pictures, whose prices I can afford'.[12] It is true that he is scathing about the credulousness of Englishmen on the Grand Tour – 'They are robbed, they are tricked, they are sold pastiches or copies as originals' – but what he is attacking is simply the so-called art lover's inability to distinguish good from bad, or his proneness to pay over the odds for unacknowledged forgeries. The copy per se is not condemned. William Hazlitt is still subscribing to this aesthetic in 1824 when, following a visit to Stourhead (which possesses many copies of High Renaissance and early seventeenth-century Italian master paintings), he writes: 'After the cabinet pictures of Fonthill even a good copy of a Guido is a luxury and a relief to the mind'.[13]

The biggest copying enterprise of the time, and the most famous, was that undertaken on behalf of the Earl of Northumberland for the Gallery of Northumberland House in London, which was demolished in 1874. The Earl had approached Horace Mann in Florence in 1752 to ask him to procure full-size replicas of several Renaissance paintings for display in his town house, and Mann had obliged by commissioning them. Masucci copied Reni's *Aurora*, Batoni did the *Feast of the Gods* and *Council of the Gods* by Raphael, and Mengs his *School of Athens*, while Costanzi was chosen for Annibale Carracci's *Triumph of Bacchus and Ariadne*. Walpole thought that only Mengs's work (now in London's Victoria and Albert Museum) was successful, and called the remaining replicas mediocre; indeed, he regarded the entire project as a bad idea. But in its scope and conception it was

in keeping with the enlightened spirit of the age, which held that copies of masterpieces, when not intended simply to gratify their owners, could lead to the improvement of contemporary art and taste.[14]

Angelica's versions are now exceedingly difficult to trace, though her will mentions that she copied a Rembrandt in the Galleria Clerini. (A young Baltic nobleman, Count Lynar, reported from Florence that on 28 June 1762 he went early to 'the gallery' – the Uffizi – and admired the beautiful copies of 'Mlle Marianne Kauffmännin', who was staying in the city with her father and whom he had previously encountered in Milan.)[15] In March the following year Crespin, writing from Rome about the little German paintress 'lately come here from Florence', would mention that she 'has made some copies [...] deemed excellent, has brought one with her of a Rembrandt, of great merit . . . '

It was a good time to be engaged in such business. The Seven Years War had just ended, and travellers were flocking to Italy. Particularly to those who, unlike Angelica, were not working busily, Florence was considered the most pleasant place for tourists on the southern side of the Alps. There were unbelievable artistic riches, the climate was benign, and society was cultivated. The Medicis had been such outstanding patrons of the arts that when Franz Stephan of Lorraine (Maria Theresa of Austria's husband) came into possession of Tuscany he had to promise that nothing that adorned the city or elevated the spirit of its inhabitants would be removed.

It was, as it still remains, a concentrated, compact place, its churches, galleries and libraries all assembled as close to one another as its coffee houses and theatres. Social life was both easy and intense, and Angelica had little difficulty in advertising her presence. She may have been helped by knowing the Anglo-Italian Hadfield family, who had been running a number of inns patronised mostly by the British since the 1740s. Writing to his brother from 'Carlo's' (Charles Hadfield's) in December 1767, Sir Lucas Pepys announced that

Almost all the English live in this house and considering all things we do not pay very extravagantly. Everybody pays 2s 6d a day for his apartment, not quite 4s for his dinner, 8d for his breakfast or tea, 1s fire, and if any chooses supper it is 1s 6d. This is very

41

reasonable considering noblemen and all live in the same manner.[16]

In turn, many of the guests at 'Carlo's' were or became acquaintances of Angelica's, even if they stayed there after she had left the city – Dr John Morgan (1764), James Boswell (1765), the collector Charles Townley (1772 and 1773) and the painter Thomas Jones (1776). The Hadfields' daughter, Maria, would become Angelica's protégée in England, where she married the artist Richard Cosway.[17]

One of Angelica's fellow-students at the Florentine academy was the American Benjamin West. Most Americans, unlike many of the British, who came to Italy at the time were doing so for serious professional reasons. Angelica's later sitter John Morgan was continuing his medical training, and West was preparing himself for the brilliant career that would culminate in his presidency of the Royal Academy of Arts in London. His influence on Angelica has probably been exaggerated. If, as he claimed, she learnt from him the principles of composition and colour combination, along with the importance of outline, it is most likely to have been simply through his transmission of the doctrine he himself had had from Mengs. At this time West's art was little more advanced than Angelica's own.[18]

Arriving in Italy in the middle of 1760, he had immediately made the acquaintance of various members of Rome's art colony – Cardinal Albani (who on hearing that West was from North America had instantly concluded that he must be a Red Indian), the painter-antiquarian Gavin Hamilton, Mengs, and Angelica's future admirer Nathaniel Dance. He was advised to go to Florence for medical attention and probably met Angelica after his recovery there. West was adept at finding patrons, and may have put some of them Angelica's way. Joseph Farington's diary contains the brief comment 'West saw her at Florence, and recommended her to many commissions – from the Duke of Gordon &c.'[19] She certainly did a portrait of Alexander, Duke of Gordon in 1762, and through him was presumably later introduced to his wife Jane Maxwell, the redoubtable fourth duchess, whom she painted in London.

Rumour had it that the Quaker West was in love with Angelica. It seems unlikely: he was engaged to a 'Miss Sewel [Shewell] of Philadelphia', and was a punctilious man. The fact that Angelica

painted his portrait twice proves no more than does the existence of a careful pencil drawing that she did of him a year later in Rome. They were following the same route of learning over Italy, and probably knew even in Florence, where they both successfully cultivated an English clientele, that their careers would take them to London. West, however, left Italy three years earlier than Angelica.

In 1762 she completed a portrait of the artist for the Uffizi, which shows him in the neat, simple costume of a Quaker, whereas the drawing has him in the tightly buttoned doublet with lace collar and slashed sleeves of her favourite Van Dyck style. (This kind of costume had started appearing in English painting in the 1730s, and in the 1750s Batoni adopted it for many of his English clients.) In his partyish outfit West looks alert and serious, but at the same time slightly cagey, even apprehensive. It is a sympathetic yet critical picture that manages to suggest both the self-confidence of the budding star and the uneasy wondering of the apprentice. Angelica, so often associated with the depiction of women, was remarkably good at capturing the vulnerability of sensitive men. Even so, her insight here conveys more understanding than affection.

The same tendency is often present in her self-portraits, however flattering they appear: she challenges the beholder, both confirming the status she has achieved and playfully suggesting that it is as much a trick of artistic vision as a real attainment. Nor do they always supply the information they initially appear to contain, as a picture she did of herself at about this time reveals. It seems to glow out of its frame with a confident Venetian richness, but had actually been completed well before she reached Venice in 1766. Her early years in Graubünden and what is now upper Italy, together with the probable influence of the Venetian-trained painter Cesare Ligari (whom she had met in Como), are enough to account for its virtuoso effect. Her clothes are handled with a playful, almost flirtatious lightness, and her hair is powdered as in the 1753 self-portrait, but to wholly different effect. Loosely combed back, it conveys nothing of the earnest, dressed-up solemnity of her girlish image, instead advertising a newly adult self. Indeed, no other self-portrait of hers is so teasingly feminine, with the low décolleté covered with a veil, the pink shawl and the bright confidence that her sunny expression confirms. She may not be precisely beautiful – Angelica has not yet perfected the formula of her changeless dark-

haired loveliness – but she is, as so many contemporaries said of her, endlessly attractive. Although she holds a pencil, she does so too prettily for it to look like a serious drawing-instrument.

Angelica's achievements in Florence were more considerable than the usual references to her having 'mostly copied' might suggest. On 10 October 1762, just short of her twenty-first birthday, she was elected to the Accademia del Disegno (the oldest academy in Italy), which seemed a mark of her acknowledged status as an artist. Five days before that she had been made a member of the Accademia Clementina in Bologna; but when the Principal, Gregorio Casali, signed her diploma he forgot to complete the correction of the standard masculine form of address to a feminine one, and Angelica stands as 'Valorissimo Signora'. Evidently there was little call for a female document of affiliation.[20] In 1765 her *cursus honorarum* would continue with her election to the Roman Accademia di San Luca, and three years after that she became a founding member of the Royal Academy of Arts in London.

Young female artists often owed their membership of such institutions to something other than mere talent – the protection of a highly placed man, for example, or the support of a father, brother or husband. Angelica had protectors like Firmian and her collection of venerable churchmen, but no real patron, no husband, and only an unacknowledged and uninfluential half-brother. Johann Joseph did not belong to any academy, and could scarcely help her cause in that respect. She had earned her own titles, which would be crowned in April 1782 by her reception at the Accademia of Venice as a professor. Domenico Tiepolo presided at the last meeting of the year there, when the decision was taken to exceed the usual number of professors (thirty-six) in Angelica's honour.

After Florence there could be only one destination. The next stage in Angelica's travels was noted by Richard Hayward's correspondent in Rome, probably in January: 'Miss A. Coffeman arrived at Rome from Florence, 1763'.[21] The approach to the city was famously dreary, giving no hint of the treasures that awaited the traveller. Chateaubriand could find little to say in favour of the Campagna, the surrounding terrain, offering the limp, tired 'imagine something of the desolation of Tyre

and Babylon', although he does admit that the whole has an 'inconceivable grandeur'.[22] Mrs Piozzi is characteristically brisk: 'The melancholy appearance of the Campagna has been remarked and described by every traveller with displeasure, by all with truth'.[23] Pre-Romantic and Romantic melancholy had to have a touch of poetry to it to fire the imagination, for otherwise it simply seemed a kind of barrenness; and the promise of Rome, surprisingly enough, was often insufficient to kindle the imagination. Germaine de Staël's Oswald, the hero of her novel *Corinne*, is the typically irresolute and melancholic male of early nineteenth-century French fiction, and he cannot be seduced by the environs of the eternal city:

> The deserts surrounding Rome, this terrain tired by glory and which seems to disdain to produce anything, are merely a wild, uncultivated stretch of land for the person who considers them only from the point of view of utility. Oswald, accustomed from childhood to the love of order and public prosperity, initially received a painful impression as he crossed the abandoned plains of the city that was once Queen of the world. [. . .] Lord Neville [i.e. Oswald] judged Italy like an enlightened administrator [. . . and did not feel] the effect which the Roman Campagna produces on the imagination when one is filled with memories and regrets, with the natural beauties and illustrious misfortunes, that cast an indefinable spell over this country.[24]

The lure of the city was obvious for lovers of art and antiquity, and, as a portraitist like Angelica well knew, as a mecca for the wealthy, who would probably wish their stay to be pictorially commemorated. By no means all of them, it is true, felt the enthralled veneration for its history that is conveyed by Edward Gibbon's description of his first morning there:

> After a sleepless night, I trod with lofty step the ruins of the Forum; each memorable spot where Romulus stood, or Caesar fell, was at once present to my eyes; and several days of intoxication were lost or enjoyed before I could descend to a cool and minute investigation.[25]

Artists such as Pompeo Batoni might flatter their clients by depicting them against a characteristic Roman background (which Angelica seldom did), but the Grand Tourist's interest in the glories that surrounded him was often routine. According to the Président de Brosses, many of the English had no idea where the Colosseum was, and simply spent their time consorting with fellow-countrymen in or around the Piazza di Spagna.[26] Batoni's dramatic and gorgeously coloured portraits flattered their subjects and invested them with a brio or a gravitas they often lacked in real life, while the setting – the implied closeness to the monuments of antiquity – disingenuously put the seal of eternity on their image.

Batoni was the prince of Roman portraitists when Angelica arrived, the Sargent of his age. No matter that his characterisation could be superficial, or that his romantically exaggerated backgrounds were constantly recycled; obtaining his services was almost de rigueur for the *jeunesse dorée* who descended on Rome. Being painted by him cost clients far less than a commission from London's leading portraitist Reynolds would have done: in the 1760s Reynolds's price for a full-length was 150 guineas, while Batoni's was £25. His sensuous images might be found offensive by the fastidious (among them Reynolds himself), but his rapid and vivid execution meant that he was swamped with orders. The Grand Tourist John Moore is predictably dismissive of this factory-like production in a genre of painting he valued little, and of the undiscriminating eagerness of Batoni's foppish patrons:

> There are artists in England superior in this and every other branch of painting to Batoni. They, like him, are seduced from the true walks of genius, and chained by interest to the servile drudgery of copying faces.[27]

But there were enough other tourists who lacked such austerity of taste to ensure his continuing prosperity.

Angelica was in no position to mount a challenge in the early 1760s; she merely called on him. Batoni returned the visit in the company of the young German Johann Fiorillo, who would later write a history of the graphic arts in Germany and the Netherlands, and who described

both the visit and Angelica's person in sympathetic, if slightly ironic, terms:

> Angelica Kauffman came to Rome in 1763. She was then 21 years old, not beautiful of feature, but with a fine figure and endowed by nature with an exceptional sweetness. Her father a tall, thin figure and not well regarded in Rome. When Batoni paid his visit he took me, at that time a youth of fifteen, with him. She behaved altogether charmingly, modest and respectful towards Batoni, who, after he had praised some portraits her father showed him, advised her to draw and copy after masters of the art, and even offered her some of his own drawings done in the Academy from the life model.[28]

Handing out drawings seems to have been something of a habit of Batoni's: even in his venerable old age he gave the painter Allan Ramsay's son John, travelling in Italy with his father between 1782 and 1783, some heads to draw from when he called at his studio.[29] For Angelica, Batoni's work was a useful alternative to life study (though it could never replace it), given that she was destined never to see 'muscular motion' in a class.

As this and other encounters suggest, her network of contacts was proving as helpful as it had been in Florence, and she seems not to have encountered the snobbery that Romans sometimes displayed. If the Roman *monde* could in certain respects be inhospitable, in others it was remarkably generous. Nowadays many of the noble palaces Angelica visited are owned by banks, but then they were family properties (like some of Rome's great churches). One rarely needed a personal invitation to visit them, though Angelica had Firmian's letters of recommendation just in case. There were unbelievable treasures to see in the various palazzi – the Giustiniani, the Farnese (the most magnificent Renaissance palace in Rome, and now the French Embassy), the Doria-Pamphilj (whose gallery at present houses the city's greatest patrician art collections), the Barberini (part of which is now a national gallery, housing Raphael's *Fornarina*), and the huge Colonna, a work of art in itself.

She may have used an introduction to Mengs's sister Theresa, who was married to the painter Anton von Maron, to visit and even lodge at

the house Mengs had vacated during his absence at the court of Spain, and which would one day be her own home. In 1763 Via Sistina 72, by the church of Trinità dei Monti, was filled with admirers and students of Mengs. The Marons, together with the painter Giovanni Battista Casanova, kept a hospitable house to which Mengs himself would eventually return, and where he was to die in 1779. Casanova, the brother of the adventurer Casanova de Seingalt and of the painter of battle scenes Francesco Casanova, was regarded by Winckelmann as the best draughtsman in Rome. Since he, along with Maron, became one of Angelica's closest friends there, it is possible that he gave her useful instruction in drawing.

Other contacts were even more important. In supplying Angelica with an introduction to Cardinal Albani, either directly or through Winckelmann, Firmian had provided her with an entrée to the cream of Rome's art-loving society. The *villeggiaturas* of the Villa Albani were famous: they occurred twice a year and lasted for weeks. Illustrious Romans and tourists would dine, dance and play there, wandering through rooms crammed with exquisite paintings and sculptures and taking refreshment as they promenaded in the villa's park. The sumptuous palace, today the Villa Torloni, provided the perfect background for the tastes of a man whom Winckelmann called the greatest connoisseur of antiquity in the world, and who had assembled a matchless collection of ancient Greek and Roman treasures as well as masterpieces of Renaissance and seventeenth-century art. The Cardinal's mistress, Countess Cheroffini, who herself possessed a splendid collection, presided over the gatherings, acting as patroness and chaperone to girls such as Angelica who could otherwise never have made an appearance there. As the Countess's daughters were famous singers, Angelica joined them in entertaining the assembled company (which explains how Winckelmann became acquainted with her 'virtuoso' vocal skills). Albani himself liked being surrounded with such agreeable creatures: he was far more interested in beautiful objects than in spiritual matters. Napoleon would later transport most of Albani's collection to France, and after he had been toppled from power King Ludwig of Bavaria transferred many of its choicest items to Munich. But in the 1760s it constituted one of the glories of Rome.

Winckelmann, the cobbler's son from Stendahl, was Albani's secretary and librarian, and had been in his employment since 1758.

Rome, he said a year before Angelica's arrival, had become his fatherland, whereas he found Naples offensively rowdy and Venice, after its initial captivatingness, vaguely unpleasing. Angelica's 1764 portrait of him confirms this sense of calmly belonging: it shows the great art historian inventorying an ancient bas-relief of the Three Graces in Albani's collection.[30] The picture was probably painted after a trip they made to Ischia that year with Johann Joseph Kauffman and the journalist and writer on art, Johann Heinrich Füssli. (This Füssli, incidentally, is not the artist of the same name who later settled in England under the name of Henry Fuseli, and whose cousin Rudolph was the author of the *Künstlerlexikon*, but a Zurich relative.[31] Fuseli himself was in England by March 1764, and did not visit Italy until the end of 1769.)

Angelica would do several variants of the work, originally painted for Fuseli's father Johann Caspar, and it seems to have been one of her favourites. One possible reason for this liking may have been her approval of Caspar Füssli's enlightened views on the education of women, particularly women artists:

If the female sex had the same opportunity to put themselves forward, and could enjoy the same advantages, the same education, as the male, we should have far more examples [of art] to display than now, and perhaps every bit as brilliant.[32]

It is more probable, though, that she valued it for its intrinsic qualities and because the sitter meant much to her. Well into the nineteenth century other artists relied on it as the standard representation of the antiquarian. Whether for reasons of Angelica's fresh, youthful perceptions or not, it has an uncluttered directness that gives it a force often lacking in other pictures of the great man, and epitomises the vital energy as well as the simplicity of her early style.

The portrait has been variously interpreted. One critic underlines its workaday aspect, the presentation of a serious employee in coarse clothes and unbuttoned shirt who has nothing of the refined aesthete about him.[33] Another, by contrast, is struck by Winckelmann's elegance, and calls the picture a 'homosexual sublimation',[34] though Angelica may have been ignorant of Winckelmann's sexual tastes. A

third considers that she seized an essential aspect of her subject, one grasped by no other portraitist:

> She possessed the art of capturing not just forms, but also a cast of mind; she knew how to discover the most telling physiognomical detail; she detected a painterly attitude that was peculiar to the subject, however infrequent; she perceived and devised a direction, a posture, a meditative look that eluded others; she arranged drapery, independently of *fashionable* taste, with *womanly* taste. So she captured one of those moments when grace infused Winckelmann's appearance.[35]

Contemporaries such as Friedrich von Matthisson [36] were struck by the resemblance of the portrait, which Caspar Füssli vouched for. But if one description that seems to be based on eye-witness reports is accurate, Angelica modified Winckelmann's appearance in certain respects:

> Winckelmann was of average height, without particularly standing out as well proportioned. He had a low forehead, a rather curved, sharp nose, small deep-set eyes which at first glance gave his physiognomy a rather gloomy aspect ('un air plus sombre qu'ouvert'); but there was a pleasant look playing about his mouth, although he had rather thick lips.[37]

Angelica's Winckelmann has a straight, round-ended nose, a high brow, moderately sized eyes and average lips. However 'like', the image has obviously been idealised. But the reception of her picture provided the breakthrough she had been waiting for. European gazettes began to talk about her extraordinary talent, and lists of contemporary artists, such as the *Künstlerlexikon*, praised her extravagantly.[38]

Winckelmann was possibly a decisive influence in more ways than one on her fame and artistic development. Aspects of Angelica's painting that have traditionally been criticised for their alleged ineptness, for instance, may actually owe something to his artistic doctrine and personal tastes. Is her fondness for painting effete-looking men as much an indication that she had fallen under his spell as

evidence that she had never studied the male nude from life? Perhaps, for Winckelmann enthusiastically praised the androgynous qualities of Greek sculptures such as the *Apollo Belvedere* and other softly contoured masculine forms, and Angelica was always happy to neutralise the implied threat of sexual assertiveness. Should her *Winckelmann* also be seen as offering a bold hint at half-concealed sexual tensions (though there is nothing effeminate about it)? We cannot be sure; but her portrait of the antiquarian is psychologically intriguing as well as technically accomplished, and Winckelmann, who called her 'a rare person [. . .] very proficient in oils',[39] must have been pleased with it.

At least two other works had preceded this *tour de force*. One is the portrait of a faintly disreputable Roman institution, Abbé Peter Grant. For nearly fifty years he lived in the city as an amiable busybody, a product of the Scots College, nominally head of the Scottish mission, but above all someone with contacts.[40] As early as 1744 Albani was warning visitors that they were not to be taken in by Grant's insinuating manner, but some refused to listen. The Scotsman Robert Adam called the Abbé 'dear old Grantibus', said that they were 'two brothers', and with Allan Ramsay and Robert Wood formed with Grant a Caledonian Club where they could converse in their 'ain mother tongue'. Others thought the Abbé a fraud, or at best a thoroughly unreliable agent. He gave his address as the 'Café anglais, place d'Espagne' (that is, the Caffè inglese in the Piazza di Spagna), which gives some idea of his devotion to conviviality rather than matters spiritual. He took both his clerical and his diplomatic duties lightly, unpersuasively explaining the two months he had needed to inform the mission of Pope Clement XIV's death, for example, in terms of the 'utter inconsolableness' he had felt at the news. Winckelmann's name for him, 'il introduttore', suggests what Grant was thought to be best at: networking and furthering people's ambitions, professional or otherwise, by making them known in the right circles. This may have been his attraction for Angelica.

Her portrait of Grant was paid for by a Mr Moray ('twenty zecchini'), who was perhaps a Grand Tour acquaintance. It was widely acknowledged that most travellers came insufficiently briefed for what they were to experience, which is where agents such as Grant could be useful. Robert Adam had wearily noted in December 1755 that there

were shoals of English pouring into Rome every day, 'great Lords, great fools and sensible gentlemen'.[41] James Barry reflected on the ease with which tourists could be dunned:

All the obscure corners of Rome are raked for old marble [...] to sell to such of the rich Inglesi whose passion for collecting antiques might outrun their knowledge of the merit and value of them. It would be endless to give an account of all the various ways in which our antiquarians and picture dealers, with their whippers in and dependants [...,] carry on the business of imposition; let it suffice to say that it is the most difficult thing in the world for any travelling gentleman who may be inclined to purchase to avoid the springes and the nets that are so artfully laid for them.[42]

Daniel Webb would ruefully remark in the preface to his *Inquiry into the Beauties of Painting*, later to be translated into German by Fuseli:

The persons for whom I write are our young travellers who set out with so much eagerness, and little preparation; and who, for want of some governing objects to determine their course, must continually wander misled by ignorant guides, or bewildered by a multiplicity of directions. The first error I have taken notice of is the extreme eagerness with which they run through the galleries and churches *nimium vident, nec tamen totum*. A few good pictures, well considered, at such intervals as to give full time to range and determine the ideas which they excite, would in the end turn to much better account.[43]

But more usually the new arrival would be taken on, for better or worse, by a *cicerone*. Grant was far from being the most impressive member of this band.

Ciceroni could normally serve as agents for artists in need of publicity, as well as showing visitors the Grand Tour sights. Like Angelica's future banker Thomas Jenkins, Grant kept painters' works for display in his room and professed to serve their interests enthusiastically. In the words of Thomas Jones, for years such men

had the guidance of the taste and expenditure of our English cavaliers [. . .]. Each of these gentlemen had his party among the artists, and it was customary for everyone to present a specimen of his ability to his protector. These specimens were hung up in their respective rooms of audience for the inspection of the cavaliers who came.[44]

The *cicerone* could, as Daniel Webb's words imply, exert enormous influence, educating the ignorant sprigs who came to Italy to an appreciation of art that is reflected in some of the greatest aristocratic collections of Great Britain. One of the most celebrated was the Scotsman James Byres, a deliberate guide who took Gibbon round the sights of Rome for what his charge called an exhausting and unbroken eighteen weeks (though he probably meant eight). Byres provoked mixed reactions in his clients. By 1781 Thomas Clarke was beginning to be 'rather sick' of him, despite conceding that 'if a man wants to be au fait with every triglyph and medallion in Rome he is your man'. He found Byres both intelligent and highly disagreeable. In 1784 the Reverend Thomas Brand wrote that he was 'very well satisfied with Byres', yet called him 'a sad peevish fellow and would quarrel with his own shadow'.[45] But he was clever at buying, procuring Poussin's *Seven Sacraments* for the Duke of Rutland and the Portland Vase for Sir William Hamilton. On the other hand, Reynolds and others were shocked by the fraud Byres had perpetrated to secure the *Seven Sacraments*, having each painting secretly copied and then substituting the copies for the originals in the Bonapaduli collection. The originals were then shipped to Britain as copies, and Byres unblushingly continued to take Grand Tourists to see the 'Poussins' in the Palazzo Bonapaduli. Reynolds exposed the crime to the Duke (who paid £2,000 for his masterpieces), saying that such frauds would be repeated because of the extreme difficulty of exporting important works from Rome.

Other *ciceroni* were highly rated. One was the extremely learned Colin Morison, another Scot who had become absorbed by antiquity.[46] According to Grant, he 'knew all the classics almost by heart', but this devotion to intellect did not exclude other forms of feasting: Boswell declared that he had 'such a prodigious quantity of body that it would require at least two souls to animate it'. Winckelmann admired his

knowledge of Homer, and some regarded him as better qualified than Byres for the *cicerone*'s job. In February 1764 Grant was writing that Morison had been 'greatly employed being almost the sole antiquarian general to the British travellers' the previous winter, and by June the following year he was 'thriving mightily'. This is not to say that clients always found him pleasanter than Byres. Boswell did a six-day course in antiquities with Morison and found him 'ill humoured' and 'quite sulky', but in 1770 Dr Charles Burney admiringly called him 'one of the first and most sagacious antiquaries in Rome'. Some of the less principled among them were as adept at duping ignorant travellers to their own advantage as the painters they protected; indeed, according to Sacheverell Stevens's *Miscellaneous Remarks Made on the Spot, in a Late Seven Years' Tour through France, Italy, Germany and Holland* of 1756, they were often in league with one another. Abbé Grant fell midway between the duplicity of such *ciceroni* and the dour professionalism of men like Byres. In Angelica's portrait he simply looks like a self-satisfied sycophant, but some saw in him something more, and more threatening. William Patoun's *Advice on Travel in Italy* of 1766 cautioned that Grant was 'a good-natured officious creature, but is dangerous sometimes for his want of discretion, telling to the last comer everything he knows of the former'.

Since Crespin's letter to James Grant of Grant remarked that Angelica was taking English lessons in Rome, it may be assumed that she meant to expand her Grand Tour clientele. Her teacher was the Irishman Matthew Nulty, the 'old Nulty' described by one acquaintance as being 'very honest', but 'one of the strangest poorest kind of ingenious men that I ever met with'.[47] Like others who settled in eighteenth-century Italy he had begun his career as an artist – he worked in Venice and elsewhere as an itinerant fan-painter – but failed to make a living at it, and subsequently became an antiquarian, dealer and occasional language teacher. As an agent he prospered, making regular shipments of ancient and modern sculpture, vases, mosaics and paintings to England between 1758 and 1774. Thomas Jones trusted Nulty because he lacked 'that oily supple disposition necessary to the profession [of *cicerone*]' and disdained 'the little airs and pretensions to ancient erudition that most of these gentlemen assume', though according to Jones his honesty meant that he did not find much employment as an antiquary.[48] He would die in June 1778: in Jones's

words, after fourteen days' confinement he 'had the strength and resolution enough to crawl to the English coffee-house' where 'he sat all the afternoon – drank two half-pint tumblers of rum punch, conversed cheerfully – shook hands with us all round, and bid us adieu for ever – the next day he died'.

Many passing visitors to Rome, like Smollett, and even habitués like Flaxman, detested the English Coffee-House. Jones described it gloomily in 1776:

> For relief – there was no other alternative but flying to the English Coffee-House, a filthy vaulted room the walls of which were painted with sphinxes, obelisks and pyramids, from capricious designs of Piranesi, and fitter to adorn the inside of an Egyptian sepulchre than a room of social conversation. – Here – seated round a brazier of hot embers placed in the centre, we endeavoured to amuse ourselves for an hour or two over a cup of coffee or a glass of punch and then grope our way home darkling, in solitude and silence.[49]

It seems, however, to have suited Nulty's unpretentiousness.

Given that Angelica felt her English to be deficient when she arrived in London in 1766, the lessons that Nulty had started giving her three years before may not have continued for very long. But after she had left Rome for Naples on 6 July 1763, she would find herself more than ever in the company of English patrons. It was to be a decisive trip in more ways than one.

Chapter Four

Italian Journeys

By the sixteenth century Naples had become the largest conurbation in Europe – perhaps in the entire world – and the seventeenth and eighteenth saw further population increases. Although by the 1770s Rome would be Italy's second-biggest city with 158,000 inhabitants, Naples easily outstripped it with 337,000. Its size was all the more remarkable for the limited extent of the state and the poverty in which the lower classes lived; but perhaps the fertile and happy-go-lucky Neapolitans saw no reason to refrain from enjoying the only pleasure that cost them nothing, particularly as they seemed to inhabit a land of such plenty. Germaine de Staël, a woman of more bracing temperament, would later be irritated by this laissez-faire attitude: how, she wondered, could they simply let everything take its own course, as oranges and lemons fall from trees?[1] Goethe had the answer. Although writers such as Joseph Addison had stigmatised them for their *lazzaronismo* – the *lazzaroni*, or beggar class, had become a byword for indolence, corruption and thievery – Goethe's Italian journey taught him that the *dolce far niente* they lived by was a defensible philosophy:

> When one simply considers what a quantity of food the fish-filled sea provides, food which those people must lawfully nourish themselves with several days every week; how there is a superabundance of fruit and vegetables in all seasons; how the area around Naples has earned the name *Terra di lavoro* [not 'land of work', but 'land of agriculture'] and the whole province has for centuries borne the honorary title of 'happy country' [*campagna felice*]; it may readily be understood how easy it is to live there.[2]

In any case, the *lazzaroni* were not simply feckless prodigals. Since a popular rebellion against aristocratic privilege in 1647, they had given

rise to a fantastic legend, and were regarded as a political force. When their Spanish rulers tried to tax fruit, the populace's basic foodstuff, as a way of increasing revenue, they were answered by an uprising whose significance became archetypal. As Goethe saw, fruit had to be freely available for the *lazzarone* ethos to continue. But a French commentator, the Comte d'Espinchal, perceived the dangers as well as the political advantages of currying favour with them:

> The King protects the *lazzaroni* in order to be protected in turn, for they make the government tremble. One keeps them in check by favouring their idleness and not letting them go without bread or macaroni, or ice in summer. With such a horde and such enforcement of law and order, one lives in perpetual fear of being robbed at home. It is not prudent to leave one's key in the lock, or even put anything on the window-sill in the lower storeys. One is robbed here with amazing skill and with no hope of ever getting back what one has lost. Despite that, everyone uses the *lazzaroni*, and there is not a house that lacks its regulars.[3]

William Patoun, too, felt the need to caution against the unreliability of the natives. 'I need say nothing of choice of acquaintances at Naples. The Neapolitans in general, men and women, are reckoned the worst set of people in Italy. Indeed there are a few exceptions, but so very few that the less connection the better.'[4] Yet the Abbé de Saint-Non, whose celebrated *Voyage pittoresque de Naples* was published between 1781 and 1786, thought that the apparently rowdy and disreputable lives of most inhabitants concealed a rooted goodness:

> The Neapolitan populace is excessively noisy, but lighthearted and indolent in character; it is incapable [...] of pursuing revenge for long. You can win it over completely by escaping its first movement of rage. It takes little to calm it and little to satisfy it. More peaceful and good-natured than any other people, it has no interest in the affairs of government. Give a Neapolitan his basic needs, frugal but easily obtained, and he will never complain.

Poverty was not, of course, universal, but even where there was wealth

there was also brutalism. The Neapolitan palaces were enormously elegant, yet they coexisted with the most squalid of slums; the nobility was cultivated, yet also capable of horrific acts of violence and revenge. Saint-Non found some of the prevailing magnificence a matter of show, not substance:

> You come across huge, spacious palaces, richly furnished, but three-quarters of them are uninhabited. Families possess the most superb plate, but never serve food on it; and apart from a few houses which do things in the French style, everything that seems to indicate a state of the greatest ease is simply a display put on for one or two days a year [...]. Noblemen with vast incomes and the most dazzling households often lack the basic necessities [...]. From time to time the leading families have *ricevimenti*, of 300 or 400 people, where the most substantial food you are offered is a biscuit; nothing could be more brilliant than these *ricevimenti*, pages in embroidered costumes, jackets richly trimmed with silver braid, *maîtres d'hôtel* one is tempted to take for masters of the house, buffets with an inexhaustible supply of ices, sweetmeats and *rinfreschi* of every kind; but it is all like a firework display, and the very next day all this great splendour has disappeared.[5]

The main draw for many visitors to the city were the excavations at Pompeii and Herculaneum and the volcano that had both destroyed and preserved them. (Vesuvius was notably active in the eighteenth century, and there would be a famous eruption in 1766.) Classicism was of compelling interest to Angelica, sublime natural spectacle rather less so; but what she had initially come to the Kingdom of the Two Sicilies for was to fulfil a more prosaic commission. Not that she was immune to the sheer charm of a place which, in Boswell's words, smiled beyond all others: an artist so sensitive to tone could not but enjoy the prodigality of colour that surrounded her, the pastel houses, the majolica-tiled cupolas and bell-towers, the polychrome frescos and the inlaid marbles. But her paintings suggest that she had little feeling for the natural world, even if she was as impressionable to the glories of southern scenery as Germaine de Staël was often blind to them. Germaine famously declared that she would travel 500 leagues to have

a conversation with an intelligent man rather than throw open her window to see the sublime sweep of the Bay of Naples. For Angelica, however, work came before either scenic splendour or interesting talk.

However irksome she would find her connection with the royal family on a subsequent visit some twenty years later, on this occasion she had to approach it circumspectly. Her commission required her to copy works from the royal gallery at Capodimonte, which was as famous for its paintings as were the many churches of Naples, and for this she needed King Ferdinand IV's permission. (The great palace at Caserta, with its waterfalls, suites of rooms and terraces, designed by Luigi Vanvitelli to look like a Spanish Versailles, was still unfinished.) On 23 June 1763 she was given the leave she asked for, and by November was writing to Ferdinand to thank him for granting her access to his collection. She added a request to paint his portrait one day, but would do so only in 1782.

She did some original work as well as copying. In the same year she painted a portrait of Isaac Jamineau, who was the British Consul in Naples between 1753 and 1779. He seems to have been a difficult man, at least to judge by the negative reports of his contemporaries. Abbé Grant called him a 'French Jew', doubtless in response to Jamineau's own description of Grant as 'a damned rascal', and he was both tactless and pretentious: he had his own seal cut bearing a self-portrait with the consular fasces of ancient Rome, for example, which seemed inordinately boastful even at a time when all things antique were the rage. Emma, the luscious wife of Sir William Hamilton, later remarked that Jamineau was not celebrated for the quality of *truth*, though Dr Charles Burney found him to be a helpful man. Dr John Morgan, also contradicting the general view, regarded him as a friend and a connoisseur, and he was certainly a patron of the arts as well as one who, in common with many others, profited from the art export business. He sent quantities of antique sculpture to England, along with many paintings, and left a large trove to be auctioned at his death.[6] Angelica's picture of him is rather engaging, and it is true that both she and Benjamin West had reason to be grateful for Jamineau's patronage. In the portrait he appears informally dressed, behatted and reading a letter. He looks up from it at the spectator, half-smiles with

eyebrows raised, and seems to await a response[7] – but his reputation suggests that it would have had to be on his own terms.

Angelica is good at quizzical or ambiguous men (one thinks of the Winckelmann portrait, and also of her Garrick, done the same year), although she was often obliged to paint rather shallow and superficial ones; and she is particularly good at suggesting the psychological undercurrents of a personality. Her Jamineau looks casual and accessible enough, but there is something self-satisfied in his studied negligence. Although he may feel in control of his world, the painter hints at the precariousness of its balance.

Ischia was a fashionable luxury resort with healing hot springs and a worldly spa life that wealthy Neapolitans as well as leisured foreigners enjoyed. The artists who flocked there after them were mostly portraitists, but they were often attracted too to attempting light-hearted mythological scenes of the kind that had been newly uncovered at Herculaneum and Pompeii, and which seemed to beg to be given an eighteenth-century interpretation. Angelica may also have made her first attempts at etching on the island, where her friend Johann Friedrich Reiffenstein – an acquaintance from Florence days, and a notable engraver in his own right – was staying too. Both did engravings of Angelica's Winckelmann portrait the following year, but Reiffenstein's was far more accomplished. He was a friend and pupil of the art historian, as well as of Anton Raphael Mengs, would be Lessing's Roman guide in 1775, and was the agent both for a number of German principalities and for the Russian court. (It was thanks to Reiffenstein's efforts that most of Mengs's works ended up in Russia after the artist's death.) He acted as a kind of unofficial headmaster to the unruly pack of German artists who gathered in Rome between the 1760s and 1780s, and Angelica became devoted to him.

In February 1764 Johann Heinrich Füssli wrote about Angelica's activities in Naples:

her portraits are of such perfect truth, expression and draught-manship that she far outstrips all present-day foreign portraitists. I cannot remember seeing a finer portrait than the one of the actor Garrick (who is in Naples at the moment) by her.[8]

Garrick, on a two-year sabbatical from Drury Lane with his Austrian

wife, the ballerina Eva Maria Veigel, had stayed in Milan earlier on, and may have heard about Angelica from Firmian. The couple had previously been in Florence and Rome, where they would return after their Naples trip.[9] Rome rather disappointed them. Garrick had long been looking forward to seeing the city where 'the great Roscius exerted those talents which rendered him the wonder of his age', but was offended by the dirt everywhere and by the mucky appearance of the Tiber. Seeing the Colosseum and 'that glorious structure' the Pantheon changed his view, however. Naples greeted him fulsomely: the couple attended 'balls more than twice a week and parties innumerable', saw the sights and attended a performance by the King's actors at the San Carlo theatre. 'In short, we are in great fashion and I have forgot England and all my trumpery at Drury Lane.'[10]

The vast San Carlo auditorium drew thousands of visitors. In the following century Stendhal would write:

There is nothing in Europe, I do not say approaching it, but which can even give a remote idea of this auditorium. It is [...] a veritable *coup d'état*. It attaches the people to the King more than the best law could do; the whole of Naples is drunk with patriotism. The surest way to get yourself stoned would be to find some fault with it. As soon as you mention Ferdinand: 'He rebuilt the San Carlo [after a fire],' they say, so easy is it to make the people adore you. [...] Personally, when I think of the meanness and the *prudish poverty* of the republics I have seen, I feel thoroughly royalist.[11]

Ferdinand had shown a crucial awareness of the importance music had for the Neapolitans, and reconstructing the opera house was one of the cleverest political moves he ever made. The San Carlo epitomised music, and music compensated both for the barbarous ignorance of the people and – at least to the more socially refined – for the boorishness of their ruler.

Garrick was portrayed by many other artists during his Italian vacation, Batoni, Dance and the sculptor Nollekens among them. While one of Angelica's admirers, James Martin, thought Dance's picture rather too grave, Angelica's appealed by its slightly mischievous

liveliness. The mood it captures is underlined by some lines Garrick wrote as she was painting him:

> While thus you paint with ease and grace,
> And spirit all your own,
> Take if you please my mind and face,
> BUT LET MY HEART ALONE.

The elegant play on the now-archaic phrase 'to take a likeness' is as witty as Angelica's painting: her Garrick sits astride a chair, clasping its back as though using it as a shield with which to ward off attack. The pose as well as the portrait as a whole would make a strong impression on Sir Joshua Reynolds when Angelica sent *Garrick* to London for exhibition at the Free Society of Artists in 1765. He later borrowed its composition for the portrait of *Mrs Abington as 'Miss Prue'*, though the informality of the attitude was regarded as much less proper for a woman (even an actress) than a man. Indeed, it is permissible in Reynolds's picture only because Miss Prue, in Congreve's *Love for Love*, is a wanton rural ingénue, quite unabashed at being caught with her thumb in her mouth.

Most would judge Angelica's portrait to be better than the one by Batoni that now hangs in the Ashmolean Museum in Oxford. Batoni's portrait shows Garrick as a courtier, Angelica's as an actor who has forgotten his actorliness. The fluid lines of her composition, strongly contrasting with Batoni's stiffness, are a far more fitting testimonial to Garrick's skill at making his body 'speak' through gesture and movement, just as the elasticity of feature she somehow conveys is a more faithful record of Garrick's mobile physiognomy. She triumphantly succeeds in capturing the actor in blithe holiday mood.

A further picture she painted in 1764, either in Naples or in Rome, raises the question of Batoni's influence on her, or hers on him.[12] *Bacchus Discovering Ariadne, Deserted by Theseus, on Naxos* was her first 'subject' picture, and a milestone in her career as a history painter. (Mythological subjects counted as historical in the academic hierarchy of genres.) Batoni would paint a very similar picture on the Bacchus and Ariadne theme for the connoisseur and collector Sir Watkin Williams-Wynn, but his work was not finished until 1773. Given the avuncular nature of the advice Rossi reports Batoni as having given

Angelica earlier – that she should make a close study of drawing – as well as his established reputation, it seems unlikely that he would have imitated the work of the twenty-three-year-old. Indeed, it is perfectly possible that he never saw it: it was not engraved, and she did it as a private commission for a distant English patron, George Bowles of Wanstead Grove in Essex. Conceivably Batoni himself painted an earlier version of the Williams-Wynn picture, which Angelica saw when she visited his studio.[13] Whatever the case, other influences too are apparent in her version. Ariadne's trunk and legs have been closely modelled on the ancient sculpture of Ariadne in the Vatican's statue gallery, and the whole work exudes the spirit of the *seicento* (especially the Bolognese *seicento*) she had so avidly studied. There are hints of Reni and Domenichino; the smooth surfaces recall Mengs; and the large, plump, boneless forms remind us of Batoni's own work. But the charm and naivety of the picture are Angelica's own.

Her Ariadne may be compared with the later one by Louise Vigée Le Brun, who painted the picture for Sir William Hamilton to commemorate one of his wife Emma's famous 'attitudes'. Louise's Ariadne is sexily knowing, a courtesan who has been unexpectedly washed up on a deserted island, but who knows that help will not be long in arriving: she forbears to look at the horizon, where a tiny ship can be discerned, but smiles suggestively and waits. While Ariadne-Emma stretches out on the beach like a voluptuous kitten, Angelica's Ariadne reclines with beseeching grace on the immutable rocks, her plight suddenly lightened by a ray of hope. She is ambiguous too in her susceptibility, far more so than Louise's frolicsome courtesan: her uncovered breast peeps out alluringly at the advancing Bacchus, and his bright grace masks barely containable appetite. Ariadne is caught between desolation and deliverance, and Angelica's picture seizes her at the moment of apprehensive aspiration. She does not scan the radiant horizon, but gazes with Reni eyes and half-parted lips at the promising god.

At the beginning of 1764, on 8 January, Angelica had received a visit that would also be crucial to her ambitious career. James Martin's journal of his Grand Tour between 1763 and 1765 records of one Neapolitan day: 'Walked with Byng to Angelica's and saw her pictures

– portrait of Lord Exeter remarkably resembling'[14] (a view not shared by Exeter's wife, who called the picture a miserable likeness).

John Byng of Wrotham Park in Kent, who had been in Naples since the end of the previous year, would also be greatly struck by Angelica's work. He commissioned not only his portrait, which Angelica was able to set about before his departure in February, but also two history paintings. These he would never see completed – he died suddenly in Bologna on his return journey, in May – but they were added to his collection at Wrotham posthumously. In the portrait he is shown turning the pages of a book, *Le Pitture Antiche d'Ercolano* (1760), which signals the vigorous interest he took in the excavations at Herculaneum.[15] He looks smooth and collected, knowledgeable and far from ailing (in fact his protruding belly, buttoned inside a russet waistcoat, gives him an aspect of great solidity). The contrast with Angelica's portrait of Winckelmann, more interested than any Grand Tourist in the excavations, could hardly be clearer. Winckelmann is the scholar, his thin face and drab-coloured clothes marking him as a man of the mind; Byng is the intelligent dilettante, whose open book carries the admonitory sentence 'merita di essere guardata con rifessione' ('worth looking at with reflection')[16] – a pointed comment, perhaps, on the superficiality of the average Grand Tourist's inspection. He is a worldly man hoping to pass as a scholarly one; but his interest for us is that he was worldly and scholarly enough to commission two seminal works from Angelica, which would place the classical past firmly on the artistic map of the eighteenth century. These pictures, completed in 1765 after Angelica's return to Rome, are *Chryseis Returning to Her Father Chryses* and *Coriolanus Begged by His Mother Veturia and His Wife Volumnia to Renounce War against His People*. The subject of the first was taken from Homer's *Iliad* and the second from Livy. The Homeric scene is one among many recommended to painters by the Comte de Caylus, French antiquarian author of the handbook *Tableaux tirés de l'Iliade, de l'Odyssée d'Homère et de l'Enéide de Virgile*, and Angelica's painting was a practical contribution to the ongoing eighteenth-century debate about the respective provinces of literature and the visual arts.

Caylus was detested by writers such as Diderot for his aristocratic hauteur and for a species of anticomania which the *philosophes* regarded as too dry and undiscriminating to serve the cause of artistic

and intellectual progress. (Caylus, it must be said, felt a similar antipathy towards them.) Diderot's malevolent epitaph for the antiquarian, 'Ci-gît un antiquaire acariâtre et brusque./Ô qu'il est bien logé dans cette cruche étrusque!',[17] expresses his dislike pungently. As an art critic he mocked Caylus for offering history painters unsympathetic and unimaginative selections from classical authors, prescriptions that were out of touch with the true spirit of the ancient world. In contrast, Diderot says, artists found his own suggestions both pictorially fertile and germane to their artistic temperaments, which Caylus was simply incapable of understanding. Another *philosophe*, Jean-François Marmontel, was equally convinced of the anticomaniac's wrong-headedness. His memoirs reveal that he felt for him 'that type of natural antipathy which simple, true men always have for charlatanry'.

Still, the anticomaniac collected on a grand scale. He enjoyed the services of agents who, like the dealer Thomas Jenkins, supplied him with case after case of ancient relics (some of them stolen from Herculaneum), which filled his house until he decided to despatch the entire collection to the royal Dépôt des Antiques and start up collecting again. He may have lacked the fire and passion of Winckelmann, but Winckelmann insisted that the Count had been the first to define the taste of ancient peoples, and Caylus was as important a figure as Winckelmann himself in developing classical archaeology in the eighteenth century.[18] Perhaps because he was wealthy and well connected enough to found prizes and arrange patronage, painters did adopt many of his suggestions for pictorial subjects. After all, they were a convenient shortcut for busy men whose academic training might theoretically have introduced them to masterpieces of ancient Greek and Latin literature, but whose practical desire was to get on with the business of painting rather than spend time poring over the classics.

Angelica's selections were characteristic of her temperament and artistic taste. In the *Iliad* Homer describes how the abduction of Chryseis, the daughter of the priest Chryses, sparked Achilles' rage against her abductor Agamemnon, and so contributed to the tragic story of the destruction of Troy. Angelica chooses to show the moment of reunion between father and daughter. She does so with great simplicity and economy, not cluttering her work with ancillary detail as a version of the story by Benjamin West does: tension is past in her painting, and the focus on reconciliation allows the calm, internalised

emotions of woman to find gentle expression. It is a moving depiction of unspoken love, with Chryseis' downcast gaze and modest touching of her bosom almost reproaching her father for his urgent advance, and suggesting in this moment of truce that aggressive male energies – the fury of Achilles and the possessiveness of Agamemnon – must be repressed or otherwise quieted. The bright red of Chryses' cloak and the muted blues and greens of his daughter's robes reinforce the contrast between the sexes, as Angelica draws the spectator into an imaginative region where values are hinted at rather than loudly proclaimed. The values, of course, are gender-specific, the area filled by Chryseis' gentle silence one of those female counter-spaces she would recurrently depict in her subject pictures.

In the other work she presents her version of a story beloved in Roman history, and which for the artists Le Sueur, Le Brun, Poussin and seventeenth-century French classicism generally was the epitome of 'peinture morale'. Coriolanus, banished from Rome for his unyielding attitude towards the starving populace, goes to the Volsci, leads them against Rome and desists from overpowering the city only after hearing the pleas of his mother and wife. In revenge he is killed by the Volsci as a betrayer of the fatherland. Angelica's chosen moment shows him making to kiss Veturia as she asks him whether she should greet him as his mother or as a prisoner of war. Three women – the strong-willed Veturia, the imploring Volumnia and a weeping attendant or sister – fill the right half of the canvas, while Coriolanus and two of his soldiers occupy the left. As in *Chryseis Returning to Chryses*, but reversing the sequence, the opposition of male and female is articulated by a spatial divide, women on one side, either unmoving or repelling, men on the other, advancing and gesturing. Colour, too, once more spells sexual differentiation, with Coriolanus' red cloak (like Bacchus' drapery in the *Ariadne* picture) offset by the softer tones of the women's clothes.

The placating or beseeching woman warns the man of the danger that his impulsiveness represents, delivering a message not identical to that of the *Chryseis* picture, but related to it. Her stricture may be unspoken in each case, but both pictures show aggression (Agamemnon's, Coriolanus') flung back by the gentler sex as an impetus of corruption. In Angelica's work the theme of sacrifice to male urges is usually counteracted by a declaration of superior womanly virtue, as

66

the unspoken recesses of feeling that women guard triumph over the senseless action of the opposite sex. Yet as her aesthetic developed she would also underline the common ground shared by men and women, converging in their resistance to coarse assertiveness. It would be one of her achievements to show how the marginal – the womanly, the sexually indeterminate, the decorative, the ornamental – could as fittingly be made the material of art as the traditionally significant; how the peripheral might become central.

Angelica's portrait commissions continued despite her growing enthusiasm for historical paintings, which most of her British patrons regarded with some suspicion. Such work, it was generally thought, would never 'take' with the home public, however well it fitted into a European culture where different political and social circumstances prevailed. Even her portraits could displease, as Lady Exeter's comments on the so-called likeness of her husband suggest; but Lord Exeter seems not to have borne Angelica any ill will, to judge by the fact that he also bought her portrait of Garrick.

More faithful in appearance, at least on the evidence of pictures of him painted by other artists, was her 1764 portrait of John Parker, the future Lord Boringdon and heir to Saltram House, who was on honeymoon in Italy with his first wife. This work too was probably painted in Naples, though it is possible that Angelica had previously met Parker in Rome. The popular notion is that she was introduced to him by Sir Joshua Reynolds, and that Reynolds was thus responsible for what became the most important act of patronage she would enjoy as a history painter when several of her pictures were bought for Saltram. It seems more likely, though, that Parker helped to promote her friendship with Reynolds than the other way around. Reynolds was undeniably a close family friend who stayed often at Saltram, foxhunting, partridge-shooting and generally advising; he had helped Parker's father build up the Saltram collection, his subsequent advice contributed to making it of outstanding quality in John Parker's time, and his own works are among its most splendid adornments; but Angelica had plenty of other contacts and supporters.

When she returned to Rome in mid-April, or a little later, she and Johann Joseph moved into lodgings in the Via Condotti, just off the Piazza di Spagna and therefore conveniently close to many Grand

67

Tourist haunts.[19] Not everyone liked the area, it is true. Winckelmann, who lived near the Piazza in the Palazzo Zuccari, complained that rest was impossible at the time when it was most needed:

> Among the things I lack in Rome is sleep. By day it is fairly quiet, but at night all hell is let loose. Amidst the freedom and lack of penalties that is the norm here, and in the absence of proper policing, the shouting, shooting, throwing of jumping jacks and lighting of other fireworks go on in every street all night long until daybreak. [...] If I want to sleep I have to practically drink myself into a stupor, but in the unbearable heat that is not the best solution.[20]

Yet Angelica went on working energetically, revived by the spring light and the lengthening afternoons, determined to pack as much as she could into every day. In addition to the portraits of Garrick, Winckelmann, Parker, Exeter and Byng, she would do another history painting from Homer. *Penelope at the Loom*, a richly coloured composition in gold and blue, shows a tired and soulful-looking Penelope taking respite from her nightly unravelling of the day's work, presumably thinking, as she rolls her eyes heavenwards, of the absent husband to whom she contrives by these means to remain faithful. Her dog rests his head sympathetically on a symbolic bow, the weapon Odysseus would eventually use for the slaying of Penelope's suitors.

This particular heroine had not been much depicted by artists before Angelica, but it is easy to see why Penelope's patient virtue would appeal above all to a female painter. Even though Angelica makes Penelope look depressed rather than exalted, the virtuous woman's patiently waiting spirit is movingly conveyed: she seems to sense the possibilities beyond her fatigue, believing that her under-cover female activities will be rewarded. Angelica paints her as someone fearing exposure as much as Chryseis does, but for a different reason: the intimacy in whose name she works is necessarily a private matter.

Angelica might justifiably have looked and felt as fatigued as Penelope if she had continued to overwork as relentlessly as Dr Morgan supposed. When she consulted him, he later wrote to Henry Pelham,

She had been labouring for some time under an indisposition for which she was pleased to take my advice. The seat of her disorder was in her stomach and proceeded from indigestion. I believe it arose from her sedentary life and close application to painting.[21]

It seems a little paradoxical that Angelica should have set about doing even more work in order to repay Morgan for his attention, but such was her way. The portrait she painted of him is a lush performance, a grand Grand Tour memento that boldly experiments with brilliant lavenders and yellows and – presumably involuntarily – conveys something of the self-satisfied arrogance for which Morgan was unfortunately known. His promotion of his career during five years' travelling in Britain and on the continent was tiresome and unceasing,[22] regularly antagonising those who had dealings with him.

While conventional in its references to antiquity, the portrait is specific and modern in its pointed allusions to Morgan's profession. The paper under his left hand, with its partly legible writing, may be an invitation to a meeting he would attend on 4 October that year, some months after he sat to Angelica, at the Paris Académie royale de chirurgie; but there, rather humiliatingly, he was granted 'corresponding' membership rather than the full affiliation he had hoped for. The book open on the table against which he negligently lounges is Giovanni Battista Morgagni's *Adversaria anatomica omnia*. Morgagni was still alive and teaching in Padua when Morgan met him in July that year: he showed his near-namesake his museum of anatomy and pathology, and in return Morgan graciously gave him his Edinburgh University thesis on pus.

Angelica tries to paint Morgan as he wished to be seen, a polite and learned physician and a dignified member of the European community of medical scholars. Her Winckelmann picture shows how well she understood the conventions of 'scholar' portraits and the iconography of learning, which are also apparent in this work. The gorgeously coloured banyan Morgan wears is a further mark of his profession, for men of science were often depicted in such robes. (Johnson's dictionary defines the banyan as a man's morning gown, a loose garment with kimono-like sleeves worn before its owner was formally dressed, or when he wanted to read or think privately.) The banyan is generally used in eighteenth-century portraiture to show the body at

69

ease, and it was often a studio prop rather than part of the sitter's real wardrobe. In this connection the medical lecturer Benjamin Rush wrote in the 1790s, with unconscious sexism, that

Loose dresses contribute to the easy and vigorous exercise of the faculties of the mind. This remark is so obvious, and so generally known, that we find studious men are always painted in gowns when they are seated in their libraries. Sometimes an open collar, and loose shoes and stockings, form a part of their picture. It is from the habits of mental ease and vigour which this careless form of dress creates that learned men have often become contemptible for their slovenly appearance, when they mix in the world.[23]

We may be reminded of the story Diderot tells in the *Regrets sur ma vieille robe de chambre* about an officious woman acquaintance who replaced his old dressing-gown, which he used for blotting ink and dusting his books, with a new garment that made him look like a perfumed coquette. The portrait of Morgan does not go that far, which is perhaps a pity; instead it makes the doctor seem artificially spruce and poised, almost frozen in self-regard, certain of his status and worth. Ironically, as he grew older he became increasingly embittered by the failure of others to value his gifts and potential, and a portrait of him painted by Thomas Spencer Suché in about 1787 shows him as a depressed, slumped, sardonic figure. He would die prematurely aged in 1789, impoverished and destitute. But none of this is foretold in Angelica's portrait, except in its inevitable intimation that here too pride may take a fall: Morgan is simply and debonairly pleased with himself.

As well as painting Morgan's portrait, whose colourful exuberance seems like a bid to prove her recovery, Angelica did a picture of herself as a gift of friendship to the doctor. (She had originally offered to copy an Old Master painting for him instead, a proposal that Morgan declined.) It bears a remarkable resemblance to one Nathaniel Dance painted of her in the same year. In both pictures she is wearing her hair in plaits, with a lace bonnet on her head and a demure expression on her face. Only Dance has her holding a pencil as a mark of her profession, something that Angelica perhaps omits because Morgan

70

had encouraged her to work less hard. Pelham thought that her painting displayed 'a want of merit', but it is competent enough for what seems to be an unoriginal effort. Another portrait she is presumed to have painted at about this time, the badly damaged Saltram picture showing her holding a guitar, suggests that she was still finding relaxation in another way of which medical science would approve – making music.

A sketchbook of Angelica's now in the Victoria and Albert Museum, the so-called Vallardi sketchbook, contains drawings of many of the friends and acquaintances she had made during her stay in Rome. One of them was Gavin Hamilton, the history painter who in later life would turn almost exclusively to dealing and antiquarianism, and who was rumoured to have died of anxiety when the plundering French republican army entered Rome in 1798. Another head appears to be Piranesi, who may have given Angelica lessons in drawing and perspective. Others are Boswell and Dance, two men linked by a story.

On 16 February 1765 Boswell arrived in Rome on his own Grand Tour, and the following day Dance breakfasted with him. On 18 February Boswell wrote:

Yesterday awaked vastly bad. Indulged hypochondria. Lay till eleven. Then up, dressed and walked. Dance dined. Good conversation. Then Mlle Kauffmann: paintress, singer, modest, amiable. Quite in love . . .[24]

The syntax, or lack of it, is provoking. Is Boswell besotted with Angelica, or are her own affections engaged? We can only guess. What the grammar does not seem to allow for is the unquestioned fact that Dance himself was in love with her.

Farington noted in his diary on 8 December 1797 that Angelica 'was courted at Rome by N. Dance – by Hickey – and by Hamilton &c – was a coquet, giving encouragement to a certain degree to all'.[25] Dance in particular, however, was obsessed with her. Smith's *Life of Nollekens* presents Angelica as unfeeling in her treatment of the young painter:

Angelica was universally considered as a coquette [. . .]. When [she] was at Rome, previously to her marriage, she was

71

ridiculously fond of displaying her person and being admired; for which purpose she one evening took her station in one of the most conspicuous boxes of the theatre, accompanied by Nathaniel Dance and another artist, both of whom, as well as many others, were desperately enamoured of her.[26]

Angelica, he continues, might have remembered Mrs Peachum's remonstrances to Polly in *The Beggar's Opera*, when she says to her daughter, 'Oh Polly! You might have toyed and kissed:/By keeping men off, you keep them on'. Angelica was allegedly a mistress of such prevarication:

[W]hile she was standing between her two beaux, and finding an arm of each most lovingly embracing her waist, she contrived, whilst her arms were folded before her on the front of the box over which she was leaning, to squeeze the hand of both, so that each lover concluded himself beyond all doubt the man of her choice.

Because Hayward's list states that Dance left Rome in 1765, his departure for England is often linked with Angelica's leaving Rome in late June that year.[27] But there is some evidence that he was still in the city in 1766; and the fact that in October 1765, in Venice, Angelica did an etching after Dance's portrait of Morgagni may indicate that they were there at the same time. At least it shows that she admired her admirer's work. Farington's remark in February 1797 that Angelica 'came to England with Lady Wentworth [. . .] with the expectation of marrying Nathaniel Dance'[28] is probably as trustworthy as recollections of thirty-year-old gossip habitually are. No doubt we should be even more sceptical about Farington's memories in 1811. Once in England, he says then, the previously fond Angelica shut her door to Dance, to his utter grief, and set her cap at Reynolds instead:

Her intercourse with Sir Joshua being noticed by him, he [Dance] remonstrated with her in such a manner that she complained of his temper and assigned that as a reason for now refusing to marry him. His passion for her was extreme, and he engaged *his father* to write to her, but all would not do, her

resolution remained unaltered. Dance said she never was beautiful, but there was something amiable and feminine in her appearance that engaged people to her.[29]

It seems fairly clear, at least, that Dance was not blinded by love. His picture of Angelica with her hair in braids is less prettified than hers: he gives her a large nose and a rather long oval face, while she endows herself with a round, sweet, almost childish visage. On another occasion he would sketch a plain but fetching Angelica and her presumed beau Reynolds apparently conversing with each other with all the appearance of infatuation (the sketch is now at Harewood House); and he also did an unflattering drawing, either mildly scabrous or faintly cynical, which shows her clutching a rather poor sketch of a sculpted male torso that she has obviously just finished. Pasquin linked Angelica with the subject-matter of Dance's painting *Timon of Athens*, which was exhibited at the Society of Artists in 1767;[30] some thought that the image of the ironic philosopher hurling gold coins at two mistresses was a version of his frustrating relationship with Angelica, although it seems more likely that the picture simply refers to a revival of Shakespeare's play by Dance's brother James Love a few months later.

That he was kept literally and figuratively at arm's length is suggested by Johann Joseph's continued protectiveness towards his daughter, a theme of long standing that had probably provoked the resentment of other would-be suitors. When Dance went to Frascati for five days with Angelica in September 1764, he also did so in the company of her father, James Martin and Morison; on the Sunday the party was further enlarged, and much of the time was spent at Gavin Hamilton's villa. If this was typical, and if Angelica showed even a fraction of the indifference towards Dance that gossip imputed to her, he would have been right to despair.

Some took the view that Angelica's otherwise inexplicable marriage to Horn occurred on the rebound from Sir Joshua, about whose intentions she had been so painfully wrong. Other flirtations too were ascribed to her – a *tendresse* for Fuseli, for example, leading to an alleged proposal of marriage – but with little concern for anchoring them in verifiable fact. She and Fuseli did not meet until both were in London, although he left the capital in 1766 and did not return until

late in 1779. There is no need to read *Schadenfreude* into the attack he subsequently launched on Angelica in some fragments of poetry that lampoon her style, and in an anonymous assault printed in the *Analytical Review* of June 1788, although they hardly seem loverlike. All they unequivocally suggest is that not every man she knew felt duty bound to defend her reputation and artistic bona fides. Did Mary Moser, who (along with Mary Wollstonecraft) also loved Fuseli, fall out with Angelica over the alleged affair? We cannot know, and perhaps should not wonder. Nor is there any more certainty that, as was rumoured, Angelica later married Antonio Zucchi simply because she had entered into a dangerous liaison with the engraver William Ryland and then discovered him to be married. Such imaginings have long fed into the romantic myth of Angelica's life, and have generated a considerable body of fiction in German, French and English, but it is wise not to take them very seriously. She seemed too busy for non-artistic relationships, however casual.

We know relatively little about Angelica's sexuality, and are unlikely ever to be better informed. Mrs Peachum's admonishment to Polly is an appropriate warning for a coquette, but there is no persuasive evidence that Angelica was one. Her alleged behaviour certainly looks like the classic conduct of a flirt who offers only to deny, yet nothing apart from gossip supports the claim that this was what she habitually did. A letter Abbé Grant wrote to John Morgan on 31 August 1765, again referring to her relationship with Dance, seems to confirm that she was much more preoccupied with painting than with men:

> Mr Dance if you remember him made strong love to her the whole of last winter, and was really so far gone in his tender passion that he was truly to be pitied, but all his address was not able to make the slightest impression upon her heart, her whole raptures not having any other object than that of excelling in her profession.[31]

If Dance was outraged at what Farington calls Angelica's withdrawal, and others were as ready to imagine her Fuseli's or Reynolds's lover, they had not got the measure of her. But still the rumours persisted. On 3 November 1767, when Angelica was settled in England, Isaac

Jamineau wrote to John Morgan about the threat that marriage would have posed to her burgeoning career, adding:

It was lately on the brink of being marred by some engagement *leading to her slavery in marriage* with one Dance, a painter, which she prudently withdrew from before it was too late.[32]

(Ironically, by then Angelica had already married Horn in a Catholic ceremony, which would be followed later in November by a Protestant one.) Given the tone of these confidences, Jamineau might have been surprised to learn that Morgan himself had been suspected of a romantic involvement with Angelica. When he was arranging shipment of his pictures from Rome to London, he tried to have the self-portrait she had given him exempted from scrutiny by the customs on the grounds that it had been 'entrusted' to him and he was not its owner. Since he manifestly was, it has been suggested that he wanted to conceal this gift of friendship because he was known to be attached to another woman, Mary Hopkinson of Philadephia. Perhaps he did, but that need not mean that his relations with Angelica were anything other than innocent.[33]

Angelica's ambitions were for London, not for any of the men she had met in Italy. She still had work to do in the country, but it was more routine than before. When she was elected a member of the Roman Accademia di San Luca on 5 May 1765, she was required to present it with a reception-piece, for which she chose an image of Hope (*La Speranza*) bent over an anchor. Precisely what kind of hope she meant to evoke is unclear. Despite the rather melancholic aspect of the painting she herself must have felt relatively optimistic at this time, though the physiognomist Johann Kaspar Lavater later took issue with the way she had treated the subject:

We beg the admirable Angelica's pardon, but neither the attitude nor the execution of the bust can pretend to characterise hope. These eyes full of repose and sweetness, this head resting on the arms, convey resignation. – Hope, on the contrary, holds itself upright, one foot firmly planted on the ground, arms stretched outwards and gaze directed into the distance. Yet despite the

softness and the lost look we detect in this physiognomy, we are happy to do justice to its expression of goodness and sensibility.[34]

The letter Grant wrote to John Morgan at the end of August reports Angelica's eventual departure from Rome, a parting that disappointed many of those in Italy who had come to regard her as their own. The 'generous willingness to be ever happy in acknowledging foreign excellence' and the 'delight in bringing forward the eminent qualities of every other nation' that Mrs Piozzi thought characteristic of the Italians[35] may have left the natives feeling an almost proprietorial concern for her, but Angelica's mind was made up.

> Our friend the divine Angelica [. . .] left us at the end of June [actually on 1 July] and is now at Bologna from whence, however, we have still hopes left us that she may return again before the winter, for unless she goes to London no city in Europe can be more proper for her than this where she has from our British travellers constant employment afforded her since you saw her, besides supporting herself and father, she cleared quod 500 libs sterling before she left us and although she is very clever in her profession, yet she is hardly able to cope, or weigh either with a Reynolds or a West, your young American Raphael.[36]

While she was in Bologna, Angelica did an etching of a woman plaiting her hair, but has otherwise left no record of her activities. Her next destination was Venice, where again only some etchings mark her stay. She may have made contact with the famous engraver Giuseppe Wagner, who had a workshop on the Campo di Guerra (where she would lodge on her return to the city in 1781),[37] and she certainly had other acquaintances there.

Eighteenth-century Venice lacked the brilliance of Rome and Florence. Its territories and trade had dwindled; it was no longer Queen of the Adriatic; its industries were stagnating and its people poor. The government was widely regarded as corrupt, while the nobility seemed both idle and frivolous. The works of Canaletto and the Guardis were intended to make the city look more splendid to visitors – particularly British visitors – than it actually was, and to cash

in on its undeniable, stricken beauty. Winckelmann had a disappointing time there: 'Venice is a place which at first sight transports you but where you lose your initial admiration [. . .]; at least, that is what I have found'. And again: 'Venice is a place which failed to please me'.[38] The agronomist and traveller Arthur Young saw how its artistic transformation exalted it, but there is nothing fulsome about his praise:

> The city, in general, has some beautiful features, but does not equal the idea I had formed of it from the pictures of Canaletti [sic]. [. . .] There is not that species of magnificence which results from uniformity, nor from the uninterrupted succession of considerable edifices.[39]

Mrs Piozzi, happily, found it the reverse of melancholy:

> These dear Venetians have no notion of sleep being necessary to their existence, I believe, as some or other of them seem constantly in motion; and there is really no hour of the four and twenty in which the town seems perfectly still and quiet.[40]

The status of the artist in Venice was far below what Angelica had grown used to elsewhere. The Guardi brothers were seen as mere artisans, mostly painting altar-pieces and designing gondolas or trade-signs, and the humble position of painters who today are regarded as masters of the rococo, with a wit and gaiety perfectly attuned to their times, contrasted sharply with that enjoyed by craftsmen such as etchers and engravers, whose skills were much more highly valued.

The British Resident in Venice was John Murray, whom Lady Mary Wortley Montagu called 'a scandalous fellow, in every sense of that word, he is not to be trusted to change a sequin – despised by his government for his smuggling, which was his original profession, and always surrounded with pimps and brokers, who are his privy councillors'.[41] Robert Adam, who was in the city in 1757, reported that he valued Murray's friendship along with that of the other Scottish Resident there, General William Graeme; but Casanova de Seingalt was unflattering about Murray, whom he described as 'prodigiously fond of the fair sex, of Bacchus and of good cheer [. . .] hopping from one to the other he always had the prettiest girls in Venice'.[42] His girth

may have curbed such athleticism – Murray himself said that he was 'a man upon the point of fifty, and of enormous size'[43] – but it seems clear that his wife endured a trying marriage.

He was her second husband. The first had been Sir Butler Cavendish Wentworth, and even after her 'deuxièmes noces' she insisted on styling herself Lady Wentworth, as though to advertise the half-hearted nature of her relationship with Murray. She cultivated the arts and held a salon, which made it inevitable that Angelica should be drawn into her circle. When Murray was appointed Ambassador to Constantinople in 1766, after serving for twelve years in Venice, she decided to pursue an independent life and move back to London. She also offered to take Angelica with her.

Rossi says that Angelica believed the friends who told her that her fortune would always be modest in Italy, because the natives so rarely commissioned the work on which her reputation rested, and therefore had little hesitation in accepting Lady Wentworth's offer.[44] It is much more likely, though, that she had already decided on pursuing her career in England because of the clientele she had built up and her hunger for new experiences. It was, all the same, a bold move for her to make. Although the patronage that English travellers showered on artists they met in Italy led the latter to conclude that they would prosper equally in England, they were often wrong: Canaletto, for instance, enjoyed far less favour from English patrons in their homeland than he had done in Venice. So Angelica was lucky to find her work as greatly appreciated in London as it had been in Rome and Naples, however much her reputation may have depended on admiration for her person rather than enthusiasm for her art. The prospect of leaving her father still worried her, but he was apparently content to entrust Angelica to Lady Wentworth, with the assurance that he would soon join her in London. In the meantime he proposed to return to Morbegno and stay with his sister.

This may be true. Equally, it may be a politic rewriting of the past. Angelica's recollections date from the end of her life, when she possibly wished to forget how hard she had tried to dissuade Johann Joseph from immediately coming to England once she was settled there. Perhaps he had already become socially irksome, as Fiorillo's comments ('Her father [. . .] not well regarded in Rome') suggest. For

whatever reason, there was initially no question of Johann Joseph leaving for England at the same time as she did.

Her first prolonged stay in Italy had made Angelica a rounded artist, however qualified the praise of observers like Abbé Grant. She had already become financially successful, and in England would continue as the sole breadwinner for her small household. She was crossing the Channel into a world that seemed made for her in its obsession with portraiture and its fondness for elegant decorative work, and where she would, to general satisfaction, disprove idle claims about her artistic insufficiency. Grant's notion that she was 'barely able to cope' had seemed unjust in Italy; in England it would appear monstrous.

On the contrary, she weighed so heavily in the balance with Reynolds and West that she was in constant demand, and except at the very outset of her new career had no money worries. The vein of caution she had always possessed, and which alone should have made the rumours about her sexual virtue seem ill founded, remained intact, but excitement inspired her too. Lady Wentworth and others had convinced her that her prospects as a woman artist in England were bright, and Angelica was keenly aware of her own energy and power. She was moving to a country where many faces were already known to her, and she felt a communion with them. (The fact that the ruling dynasty was German may also have been an attraction.) Given that she needed to expand beyond the realms of the familiar, London looked to be her promised land.

Chapter Five

Celebrity and Scandal

Angelica arrived in England on 22 June 1766, and was well looked after. At first she lodged with Lady Wentworth in Charles Street, off Berkeley Square, in a select part of London where patrons such as Lord Exeter also had their town houses. Although Rossi claims that she was initially sad, mainly because she was missing her father, a letter to him of 11 or 12 July sounds contented enough:

> People have told me hundreds of times that when the English come back to their homes they forget their acquaintances and the promises of friendship they made abroad. But I find precisely the opposite. The ladies in particular are very kind, of great decency and politeness, and in general very pleasant.[1]

The gentlemen, too, were apparently kind, sincere and mostly sensible. She added in a postscript that she had visited a number of painters, which for her counted as much as forming more general acquaintances did. Visiting artists' workplaces was an established convention in London, and Angelica may simply have meant that she called at studios rather than that she independently made the acquaintance of painters. In any case, she found a welcome.

The profession of portrait-painting was one of the most reliable routes to social advancement at the time,[2] as Reynolds's career demonstrated: humble beginnings did not prevent one from enjoying the patronage of the great, being ennobled and winning election to the highest artistic office in the land. Angelica had already enjoyed worldly favour in continental Europe, and there was no reason – particularly with a titled lady (however ambiguously titled) protecting her – why she should not prosper in the smart West End. It was all very well for Dr Johnson to say, apparently with reference to Angelica, that portrait-painting was an improper employment for women because 'public

practice of any art, and staring in men's faces, is very indelicate in a female';[3] Angelica's cachet, along with her modestly winning personality, seemed to guarantee her an enthusiastic clientele.

In fact her Grand Tour reputation, together with the celebrity her Garrick portrait had earned her, meant that she was already busy, and soon made her Charles Street quarters feel uncomfortably cramped. The Berkeley Square address served its purpose for the preliminary rendezvous she needed to secure some commissions and meet prospective clients, but it soon became essential to acquire some proper studio space of her own, even in a less select part of town.

A slightly defensive letter Angelica sent to her father on 10 October shows that she had indeed moved on. She gives her new address as Suffolk Street, Charing Cross, at a house owned by a surgeon called Hume and in an area which, according to Horace Walpole, was well known for its foreign residents. Happily settled as she appeared to be, she seemed in no hurry to encourage Johann Joseph to leave Morbegno in the company of his niece Rosa and join her:

I see you are determined to continue on your journey without awaiting an answer from me, so it is uncertain whether this letter will reach you. But I cannot refrain from telling you exactly what the situation in this country is, so that you can be guided by it and consider for yourself which is better, to continue the journey now or postpone it until next spring; rest assured, I do want to see you, but – please do not take this amiss – I and some good friends do not think it advisable for you to come here this winter. If you reflect on the reasons yourself, you will find that it is not to our *avantagio*.

Prices in London are extraordinarily high, she continues, and although the family she lodges with treat her as another daughter, she feels cramped even with the four rooms at her disposal, one for painting and another for displaying her paintings, the third her small bedroom and the fourth barely more than a closet for storing linen. 'At present everything is set up neatly – and at the same time as cramped as can be; changing it around would not improve anything . . . ' Then there is the English winter, with its dank days, coal smoke and fog, and 'you are not used to the air and climate here'.

Most critically of all, she has learnt that in London she has to preserve appearances, particularly difficult in winter when everything is more expensive, and 'work does not bring in much, as you well know':

> We would have to have a servant and a maid – *decorum* demands it – I am now known by everyone here, and in the public eye. It is not only my work that has to preserve my *character*, everything else has to accord with it – with a certain *propriety*, which is highly necessary today if one wants to *distinguish* oneself, the most refined ladies come to the house to sit – to visit me – or to see my work; I could not receive people of such rank in an ill-appointed house [...] As long as I am alone I have hopes (apart from the costs I have to bear) of saving something over the winter – then making another arrangement in the summer – houses are easier to find, and everything else is less expensive.

She adds a revealing postscript:

> I have finished some portraits which are *snapped up* by everyone, Mr Reynolds is excessively pleased with them. I have painted his portrait, which has turned out very well and does me much honour, it will soon be engraved. Lady Spencer paid for it – 100 zecchini [slightly less than 100 guineas]. Lord Exeter is in the country. This morning I had a visit from Mrs Garrick. Milady Spencer was here two days ago. Lord Baltimore also visits me occasionally. The Queen was delivered of a child only two days ago, as soon as she is better I shall be presented to her, the Duchess of Ancaster visited me and saw my work two days ago, she is one of the principal ladies-in-waiting at court, I often see my old acquaintances. They are all well. I shall write soonest to Morbegno.[4]

(Why Lady Spencer should have paid for a portrait that would later belong to John Parker is unclear, unless the reference is to a replica; and since he began keeping account books only in December 1770 there is no means of checking when he himself paid for the picture.)[5] Evidently, the fact of being known by everyone – that is, by London's

bon ton – meant incurring some serious expense. Even so, it is hard to reconcile the proud remark that her pictures are selling like hot cakes with the cautious claim that 'work does not bring in much'. To be fair, Angelica would always be extremely careful about money: even when established in glorious quarters in Rome after her return from England, and surrounded by masterpieces, she anxiously noted the price of everything. Perhaps her situation as the family's breadwinner instilled a permanent sense of thrift in her, or perhaps the institutionally disadvantaged situation of women artists inevitably led to fearfulness and undue worry about the cost of living. It was undeniable that she could save money by living on her own until the following spring, though when Johann Joseph finally arrived with Rosa Florini she discovered that her cousin was prepared to be her housekeeper and save her money in that way. At any rate, her letter seems to have served its purpose.

Her concerns about the English climate, and particularly London's fogs, are probably genuine enough too: after all, when she eventually left London for Italy in 1781 it was in part because of worries about her father's health. Foreigners were politely or aggressively incredulous at the 'impure and thick mist' caused not just by fog, but also by the burning of coal in grates, and wheezed their horror at the smuts that dirtied buildings and even horses. The Frenchman Pierre-Jean Grosley remarked with alarm that the smoke formed a cloud 'which envelops London like a mantle; a cloud that [. . .] suffers the sun to break through only now and then, which casual appearance procures for Londoners a few of what they call *glorious days*'.[6] What Lady Mary Wortley Montagu called 'this sinful sea-coal town' appalled Georg Christoph Lichtenberg when he discovered that he had to write by candlelight at half-past ten in the morning,[7] and Angelica too was dismayed at the shortness of the working days. The prevailing damp was also a bugbear for painters. Reynolds was driven to distraction by the impossibility of drying canvases naturally, and according to Louise Vigée Le Brun he resorted to the desperate measure of mixing wax and bitumen with his pigment to overcome the problem. Unfortunately the bitumen itself never dried completely – although it gave a rich, glowing effect when first applied – and eventually produced traction-cracks on the surface of the canvas.

Angelica's observations on the need for society painters in England

to live stylishly are certainly correct. Artists with an elevated clientele had to live where the *bon ton* was prepared to visit, and choosing an expensive area simply reflected their entrepreneurial spirit and business acumen. Portraiture was a buyer's market, which meant that patrons could afford to be high-handed: as Angelica's letter to Johann Joseph emphasises, she was herself treated with great consideration, but it was always as well to maintain one's importance with sitters by receiving them elegantly. No artist could afford to eschew the promotional techniques that would guarantee him or her a place in the public eye. Other witnesses, such as Jean-André Rouquet in the *Etat des arts en Angleterre* of 1755, confirm that a separate studio and showroom were essential to the painter of ambition:

> Every portrait-painter in England has a room to show his pictures separate from that in which he works. People who have nothing to do make it one of their morning amusements to go and see these collections. They are introduced by a footman without disturbing the master, who does not stir out of his closet unless he is particularly wanted. [. . .] Women especially must have their pictures exposed for some time in the house of that painter who is the most in fashion.[8]

Angelica's letter makes clear that she has begun the job of establishing a fortune whose size Farington incredulously estimated in 1793: 'Angelica Kauffman, the paintress, made about £14,000 when she resided in England. [Later on it would emerge that she gave half her earnings to her father to invest as he chose.] Her application was very constant. [Antonio] Zucchi made about £8,000 while he was in England.'[9] Farington is disbelieving for the simple reason that women were not supposed to be worth so much. In this spirit Mme Ancelot, whom one might have expected to be supportive of her sex, would later remark that all Louise Vigée Le Brun's portraits were 'magnifiquement payés',[10] and when Louise was accused by John Hoppner of running a *shop* where she sold expensive *trash*,[11] she was mortally offended by the intimation that her art was less sacred than she liked to think and that she was thoroughly mercenary. To overshoot the mark in pricing portraits was just acceptable in a Reynolds, who in fact could charge more or less what he liked: in 1759 he had raised his fee for a full-

length portrait from 60 to 100 guineas, and in 1764 to 150 guineas; in 1782 the figure would be 200 guineas.[12] But for a comparatively unknown female artist the case was different, and the assumption was that she would be more modest.

Reynolds himself, whom Angelica had made such haste to visit on arrival in London, set her fees for her, and not everyone thought that she was worth what he advised her to charge. On 31 March 1767 Henry de Salis wrote from Knightsbridge to his brother Peter in Chiavenna: 'Mademoiselle Angelica from Coire is painting here with great reputation, and has twenty guineas for a head. Reynolds, who showed her great attention upon her arrival, set her prices for her, and I should think much too high.'[13] A woman – even one whose surname was Kauffman – was meant to be expert at such things as running a household thriftily, not at lining her own pockets at the expense of the (predominantly male) paying public. And yet Angelica was aware that she had settled in a capital city ruled by commerce, in which excessive niceness about the practical business of earning a living as remuneratively as possible was plain naivety. Foreigners generally thought that in England artists painted not out of inborn passion but as a speculative endeavour. For Napoleon's 'nation of shopkeepers', covering canvas with pigment was a commercial undertaking like any other. In any case, as the poet Friedrich Gottlieb Klopstock saw, the high prices Angelica successfully charged might be seen as proof of her capacities. In a letter of 2 September 1769 he remarked that she could earn fifty guineas for a portrait, implying that the fact spoke for itself[14] – that it signified not greed, but an acknowledged competence.

The price Reynolds had told her to charge for portraits meant, given standardised rates, that her half-lengths would cost forty guineas and her full-length, life-size figures sixty. Gainsborough too charged twenty guineas for a portrait head in the early 1760s, though by the 1770s his prices would have doubled. Romney's price for a full-length between 1768 and 1773, when he was emerging as Reynolds's main rival in the capital (Gainsborough was still in Bath), was forty guineas, for a half-length twenty, and for a head and shoulders ten. His success rested partly on the public's perception that he offered *better value* for comparable work than his famous contemporaries, and by the end of the 1770s he was the most fashionable portrait painter in London.[15] Less important painters asked less than he did, and struggled:

Northcote, for instance, was being paid only sixteen guineas for a portrait with two figures in 1784.[16] Angelica would also develop a portrait type for which she charged an intermediate sum of thirty guineas, the full-length on a small canvas, such as the 1775 picture of the glamorous Duchess of Richmond.

If she let herself be guided by Reynolds, it must partly have been because she sensed that she needed to impress the public as an artist who was powerfully protected and thus *serious*, someone who deserved to earn a good living. For one thing, the cost of everything was far higher than she had been used to in Italy (a haven of cheapness for impecunious expatriates, as her later sitters Lady Knight and her daughter Cornelia would confirm). But, equally, top artists were far better paid in London than anywhere on the continent, even if some members of the public grumbled at the fact. In this spirit the anglophile J. W. von Archenholz observed in his *Picture of England* of 1789 that there were two things necessary to the foreigner proposing to live in England: the first that he should understand English, and the second that he should have plenty of money 'to enable him to live in a country where everything is dear'.[17] The practical reasons behind Angelica's cautioning Johann Joseph to postpone his coming become clearer. For all that, she had chosen the moment of her own arrival well. Even if the natives were still inclined to regard continental Old Masters as safer bets, it was the first time in English history that contemporary painters began to be seen as worthy objects of capital investment.

Giuseppe Zucchi claims that Johann Joseph Kauffman came over to England while Angelica was still living with Lady Wentworth, and that he occupied a comfortable and well-furnished flat near the court.[18] The truth appears to be that he and Rosa Florini arrived in the foggy spring or early summer of 1767, by which time Angelica had found a home big enough for all of them to live in together.

She took a sub-tenancy on a house, said to be one of the larger ones with tall windows, at the south side of Golden Square in Soho. It was situated between Lower John Street and Lower James Street, and then was number 16; the numbering today is different, and in any case almost all the original houses have been demolished.[19] The square had been built in slow stages between 1676 and 1705 as part of the first

major westward expansion of London after the Great Fire of 1666, and was initially very fashionable. It began to decline in about 1740, mostly because the western view had long gone and because it had none of the rural amenities that other London squares retained. The glorious new mansions of Hanover Square and Grosvenor Square drew wealthy Londoners in their direction, and after the Bavarian embassy (one of three embassies in Golden Square in the eighteenth century) was closed in 1788, the only titled resident was Lady Read.

A century later it had become virtually deserted, and the streets leading into it correspondingly mean; the clerks employed at writing and counting in the dingy parlours of business houses there had a desolate outlook onto an empty space with a few forlorn, dusty trees. But in Angelica's day Golden Square was still bustling and colourful, and she was close to friends and admirers of hers. Mrs Delany, one of the few natives who actually liked her history paintings better than her portraits, lived in the adjacent Hog's Lane in Soho during her first marriage to the rich Mr Pendarves, which suggests that the area was prosperous; but the fact that Golden Square had lost some of its cachet meant that houses were more readily available and cheaper than elsewhere, though it was still quite grand enough for the clientele Angelica hoped to attract. (It has been suggested that she probably paid at least £100 per annum for her house.)[20] Even in the 1760s the environs were known as much for their artistic inhabitants as for their aristocratic ones, a situation that suited Angelica well. Artists had slowly been moving west along with, but behind, the *bon ton* in the eighteenth century, and Soho was beginning to replace Leicester Square, where Sir Joshua Reynolds lived and worked, as their preferred quarter.

From Golden Square Angelica had easy access to the nearby framers and canvas merchants, which meant that her work could be quickly prepared – probably by her father – and packaged. There was a large French immigrant population, and as late as 1844 Soho was still being called a 'sort of petty France'.[21] The fact that the area was in certain respects *not English* was attractive to many of the foreign artists who clustered there. It was also known for its courtesans. Mrs Cornelys created a great stir in the 1760s and 1770s with her weekly assemblies at Carlisle House in Soho Square, not least, perhaps, because it was also a leading musical venue. Fanny Burney said that 'the magnificence

of the rooms, splendour of the illuminations and embellishments, and the brilliant appearance of the company exceeded anything I ever before saw'. The music went on, but Mrs Cornelys retired from her business and started selling ass's milk in Knightsbridge.[22] It is unthinkable, of course, that Angelica would have sought or even recognized such company, and unlikely that she would have needed Soho's air of foreignness to reassure her. She knew that she had settled well, and did not move from Golden Square until she left London for good.

Her ploy of sending the portrait of Garrick to London ahead of her and having it exhibited in 'Mr Moreing's Great Room' in Maiden Lane at the 1765 Free Society of Artists exhibition seemed to have worked.[23] Not that everyone regarded the piece as an unqualified success. A critic signing himself 'No Connoisseur' remarked of the so-called *Portrait of a Gentleman* by 'Mrs A. Kaffman, at Rome' that 'This gentleman is Mr Garrick, of whom this portrait would be a very good likeness, if it was not larger than the life'. Yet whatever people's precise opinion of the picture, Angelica had made an impressive enough transition from being an Italian (or German) paintress to being an English portraitist. Crucially, too, she had attracted serious public attention. The excited boast in her letter to Johann Joseph about buyers 'snapping up' her first London efforts confirms the fact, even though the identity of the pictures that earned Reynolds's 'excessive' approval is unclear.

The only painting she is known to have completed in 1766 is her portrait of the future sculptress Anne Conway Damer, though there is also a reference to a portrait by her of 'Lady [Hester] Stanhope'. The *Public Advertiser* published a hymn in praise of Angelica and these two works on 20 January 1767, and also alluded to her Saltram *Reynolds*:

> While fair Angelica, with matchless grace,
> Paints Conway's lovely form and Stanhope's face,
> Our hearts to beauty willing homage pay,
> We praise, admire and gaze our souls away;
> But when the likeness she has done of thee,
> O Reynolds! with astonishment we see;
> Forced to submit, with all our pride we own
> Such strength, such harmony excelled by none,
> And thou art rivalled by thyself alone!

The Conway portrait was an early sensation in a career that contained many. It made the sitter appear appropriately monumental, heavily posed and larger than life, and prompted from Lady Mary Coke, a cousin of Anne Damer's mother Lady Ailesbury, this reference to a painter

> who is newly arrived from Italy, and was brought over by Lady Wentworth, the same who drew a picture of Mr Garrick which was shown I am told at the exhibition. I went with them and saw the picture she was painting of Miss Conway (now eighteen). It was like, and appeared to be well done, but too large, as you would take it for a very big woman.[24]

As a young woman, Anne Conway became a friend of the philosopher David Hume, who was her father's secretary between 1767 and 1769. During a walk with him one day she met a boy wax modeller, whose efforts she initially scorned but then thought better of. This was allegedly the spur to her becoming a sculptress. Her instruction in chiselling was got from John Bacon, RA, in anatomy from the surgeon William Cruikshank, and in sculpture generally from the sculptor Giuseppe Ceracchi. After her marriage to John Damer, Ceracchi carved a statue of Anne Conway as *Mrs Damer Representing the Muse of Sculpture*, which was once to be seen in the entrance hall of the Royal Academy in London.

Anne Conway was the favourite niece of Horace Walpole, who bequeathed his Gothic mansion Strawberry Hill to her and who lauded her talents far more enthusiastically than David Hume. (She did a portrait bust of Hume about which the philosopher was markedly cool.) When she prepared to visit Italy in 1781, Walpole wrote grandly to Horace Mann, 'In Italy she will be a prodigy; she models like Bernini'.[25] As well as this she 'has excelled moderns in the similitudes of her busts', besides writing Latin 'like Pliny'. Like Hume, however, Fanny Burney was less of an admirer.

Anne Conway was the half-sister of the beautiful Duchess of Richmond, and she married the heir to a large fortune a year after Angelica's portrait was completed. The newlyweds lived extravagantly from the first, but had relatively little to do with one another. John Damer, 'the man of the hundred waistcoats',[26] had been one of those

Grand Tourists who regarded the tour as penance rather than pleasure, and when he visited the Uffizi he chose to lay bets with his companion as to who could hop to the end of the gallery first, rather than look at the great works of art it contained.[27] The couple separated in 1775, and in June the following year John Damer blew his brains out after paying a bevy of beautiful women in a *bagnio* to pamper and amuse him. Archenholz's *England und Italien* remarks that

> Suicide is not a true character-trait of the British. This is a most unfounded prejudice, generally prevalent in Europe. It is true that cases of this kind are very common in England, and are usually attributed by foreigners to the climate and the foggy atmosphere.[28]

But taking one's life, he contended, was just as common in the healthier environment of Paris. In any case, Damer's futile life of dissipation is much more likely to have been responsible for his death than climatic factors.

The exuberant postscript to Angelica's letter of 10 October 1766 to her father gives a clear idea of what she felt she could hope from royal patronage in her adoptive country. She was indeed presented to Queen Charlotte, and painted her portrait soon after, but another royal commission came first. The predilection of the Hanoverian royal family for anything German was well known, and Angelica would certainly not have seemed less 'deutsch' to them than she did to Winckelmann, Crespin and others. There was every reason for them to favour a young artist who had already captivated society.

According to Rossi, George III's sister Augusta, Duchess of Brunswick, particularly wanted to be painted by the new star. The portrait was done during the Duchess's visit to England to be delivered of her child Karl Georg August, who was born on 8 February 1767. Rossi records Angelica declaring to her father that such an honour had never been done to a painter before, that the applause for her work was constantly increasing, that the newspapers

> spoke of it with praise, and that verses were written in its honour. Truly Angelica's words to her father show a person filled with

90

tranquillity and joy, at the peak of prosperity and happiness. [. . .] She told him too of a proposal for an advantageous marriage she had received, but also informed him of her refusal.[29]

Perhaps, as we shall see, she was being less than frank in this respect.

For all its public success, the composition of the painting is actually rather stiff; but static depictions were the norm in royal portraits. The pose is based on an ancient Greek statue of Peace holding the infant child Wellbeing, which helps to explain its monumental aspect. In its formality the picture also upholds the un-Rousseauist tradition according to which well-born mothers barely knew their children, for the Duchess's distance from Karl Georg August is far more apparent than any close maternal bond with him. There is an allegorical figure of Fame in relief on an urn in the right foreground, while a Cupid picks roses from Britannia's lap – not, contrary to appearances, an image of fancy intended to lighten the sterility of the whole, but instead an allusion to the military prowess of Augusta's husband and its fruitful alliance with love.[30] The reference, however, may have been more flattering than true. According to the transvestite Chevalier d'Eon, the Brunswicks' union was far from harmonious. The Duchess was allegedly jealous of her husband, while he had conceived a distaste for her on account of a cautery he had discovered on her leg. Besides, d'Eon claims, in 1766 the couple's two children were already afflicted with the 'cold humours' that had killed George III's brother.[31] If true, this would of course have cast a further shadow over an already blighted marriage.

If the Brunswick commission was an impressive enough début in courtly circles, securing the patronage of Queen Charlotte was an even greater coup. According to Rossi, she was particularly fond of Angelica and enjoyed spending time with her. The Queen actively supported female artists (Catherine Read and Angelica's Swiss compatriot Mary Moser were both protégées of hers), and she later successfully lobbied for the admission of Angelica and Mary Moser as founding members of the Royal Academy.

This supportiveness, and probably the hope that it would be continued in the future, gave Angelica the idea of showing the Queen together with another allegory, a sleeping child representing the Fine Arts, whom she gently touches and awakens. This adds to the

remoteness of the work, though its intention seems to have been sincere at the same time as calculated. The fact is that the dumpy Charlotte was a far more active patron than her reputation as an unstylish, dim, forbidding and faintly disagreeable consort to the King suggests, which makes it surprising that no one seems to have wondered whether her son, the Regent and future George IV, did not get his taste for the arts and for elegance generally from her. It was probably her role as wife to a famously uxorious monarch and mother of fifteen children that made her seem so dull, so completely imprisoned inside a reputation for strait-laced virtue and good works, and so justifiably known to the public for a thriftiness verging on avarice, a passion for jewellery and an equally intense fondness of snuff (which according to Lady Northumberland, made her husband 'sneeze prodigiously').[32] After her painful and protracted death, a year or two before that of her demented husband, one of her daughters remarked that hers had been 'a long life of trials'.[33]

She suffered, of course, from her acknowledged plainness, which the many artists who painted her more or less successfully disguised. George had chosen her as his bride without seeing her, and was said to have been rather taken aback when he finally did. Horace Walpole offered a relatively generous appraisal of her appearance as a young woman, plucked from a provincial German court and spirited away to the comparatively sophisticated English one:

> She is not tall nor a beauty, pale and very thin; but looks sensible and genteel. Her hair is darkish and fine. Her forehead low, her nose very well except the nostrils spreading too wide. The mouth has the same fault, but her teeth very good. She talks a great deal, and French tolerably.[34]

He might have added that she was rather swarthy, and that initially her English was non-existent. (Others claimed that she spoke French only 'midling [sic] well'.) She herself was under no illusions about her charms, declaring to the small daughter of one of her ladies of the bedchamber: 'The English people did not like me much, because I was not pretty'. She added, however, that she had broken her nose in a carriage accident when George III was driving her, and 'I think I was not so ugly after dat'. Mrs Papendiek's *Court and Private Life in the*

Time of Queen Charlotte notes that her want of personal charms became less noticeable with the passage of years, and reports Chamberlain's comment then that 'the *bloom* of her ugliness [was] going off.[35] Animation as well as increasing age could make the beholder forget her physical disadvantages. The same Fanny Burney who, on meeting her in Bath a year before the Queen's death, wrote that she was somehow triumphing over the handicaps of age, infirmity, sickness, diminutive stature 'and ugliness!'[36] also declared that

> her power of charming [. . .] rarely has been equalled. Her face had a variety of expressions that made her features [. . .] seem agreeable; [. . .] her manner [. . .] was so engaging and encouraging that it was not possible to be the object of her attention without being both struck with her uncommon abilities and fascinated by their exertion.[37]

Countess Harcourt, her lady of the bedchamber from 1784, noted that 'There was a sweetness in her manner and an animation of countenance which caused many who had thought her plain before they conversed with her to admire her afterwards'.[38] A little surprisingly, Mrs Papendiek thought her temper 'quick and rather warm', but added that it was 'softened by an excellent heart and a benevolent and kind disposition'. Yet although the Queen was 'charitable without bounds, and her charities were directed in a way to convey the good she intended for individuals, of whatever rank they might be, totally disregarding any trouble it was necessary to take to achieve the desired end',[39] other contemporaries admitted that her popularity had sharply declined before her death.[40] For all Fanny Burney's regrets at the passing of 'my dear and venerable Royal Mistress, for so many years the brightest as well as highest example of solid and efficient virtue to all her subjects',[41] letters of the time described how in some quarters Charlotte was so intensely disliked that hardly anyone went into mourning.

The Queen, who was painted a surprising number of times during George III's reign (and inspired two masterpieces in the full-length portraits by Gainsborough and Lawrence), shared her liking for the arts with her husband, a far more supportive patron than his comparatively philistine ancestors had been. Yet Angelica's picture

puts the emphasis firmly on his consort's cultural sensibilities, the rather awkward allegory evoking geometry, music, history (or poetry) and theory, and so pointing back to a baroque pictorial tradition of showing painting as the agent of virtue.[42] A portrait of the future George IV is half-concealed behind the sleeping cupid. The overall design is to celebrate the Queen as the sole initiator of England's artistic revival – adept flattery, but not precisely unmerited praise.

Charlotte had decided opinions about work she liked, or rather about artists she was happy to sit to, which provoked a degree of fear in many of them. She did not treat the young and inexperienced Lawrence at all well, but was gracious towards the greatly inferior William Beechey (who talked to her constantly 'in his odd way'). Although she and her husband took a positive interest in the founding of the Royal Academy, neither of them liked Reynolds – whose prices the King thought much too high – despite his invariable politeness. Perhaps unexpectedly, Charlotte seemed not to mind much whether she was grandly celebrated or underplayed. Allan Ramsay's official portrait of her as the newly married and newly crowned Queen Consort lingers over the textures of the ermine and velvet she wears, the details of the lace and embroidery adorning her costume, the whole sea of opulent materials surrounding her, while the much more informal Gainsborough – whom the King and Queen found decidedly sympathetic, both humanly and artistically – captures her in a public-private moment, conveyed by the loose brushstrokes and the under-stated costume.

In Angelica's portrait Charlotte looks dowdy but amiable, full-lipped (not even she, any more than Ramsay, much disguises the faults of the royal mouth), essentially unregal despite the inevitable imposed grandeur. The Queen's face has a cowlike expression of mild benevolence, perhaps reflecting the rooted goodness that her admirers discerned in her, but possibly conveying the ease she felt in the female painter's company. The likeness of the picture, to judge by other testimonies, was not very convincing, but the rapport between sitter and artist seems evident. Angelica was trying to grasp character as well as convey resemblance, to reconcile the wishes of her subject with the demands of art. Was she also responding, consciously or otherwise, to the climate of placid but rigid ordinance pervading Charlotte's court, its abhorrence of most concepts of stylishness, its deprecation of gaiety

as mere frivolity? Because it was a staid milieu in which bright and adventurous spirits wilted, she had to avoid committing any breach of etiquette. This was not a place for daring or experiment.

A related, yet sharply different, royal commission yielded a portrait that was lighter and more winning than either the Brunswick picture or that of the Queen, but whose insubstantiality carried a specific kind of moral charge. In 1768 King Christian VII of Denmark called at Angelica's studio, perhaps because he had seen her history paintings at the Society of Artists exhibition, and an important commission was placed. He was married (unsatisfactorily) to George III's sister Princess Matilda, and it may have been on the royal family's recommendation that he came. On the other hand, they had as little to do with him during his stay as they politely could, while he apparently valued his contact with the common people far more.[43] Horace Walpole remarked superciliously, 'The mob adore him, though he has neither done nor said anything worth repeating, [. . .] for he flings money to them out of his windows', but so lacking in regal stature was he that Walpole also described Christian as looking as though he had just come out of a nutshell in a fairy tale.[44] William Hickey, too, was unimpressed by his appearance when he saw Christian at the masquerade the King gave at the Opera House in the Haymarket on 10 October:

He had nothing dignified or majestic in his figure, but seemed affable and good-humoured. The crowd being very great, it became difficult to move. His Majesty however bustled about getting on by dint of elbowing. I had during the night more than once the superlative honour of being jostled and having my toes trod upon by a crowned head.

Angelica painted this crowned head's portrait tactfully, but with an essential truth. Other witnesses agreed that Christian looked as winning in real life as she depicts him on canvas: according to one witness who saw him at Eton, for instance, he was 'very fair [with] an aquiline nose, a slim boyish figure, and on each side of his face one large curl'. This feature is omitted from Angelica's picture, but she conveys his slightness and his uneasy, almost birdlike alertness; indeed, perhaps she improved the original here, as the King was in fact said to

be slow-witted. As Walpole suggests, he appears neither grand nor impressive, despite being decked out in all the regalia of ceremonial dress – shimmering sash, richly embroidered tunic, patterned waistcoat, huge decoration pinned to his breast and sword in hand. But ceremony does not seem to have appealed to him greatly.

The years of his reign were increasingly stained with madness, and his wife turned from him and duty to the royal physician, with whom she had an affair and probably a child. Mary Wollstonecraft's *Short Residence in Sweden, Norway and Denmark* of 1796 recalls witnessing Christian's incapacity:

> I cannot describe to you the effect it had on me to see this puppet of a monarch moved by the strings which Count Bernsdorff holds fast; sit, with vacant eye, erect, receiving the homage of courtiers, who mock him with a show of respect. He is, in fact, merely a machine of state, to subscribe the name of king to the acts of a government, which, to avoid danger, have no value unless countersigned by the Prince Royal; for he is allowed to be absolutely an idiot, excepting that now and then an observation, or trick, escapes him, which looks more like madness than imbecility.[45]

Anxious, perhaps, lest she should appear to have underplayed his status in her portrait, Angelica places his free hand on the Danish crown, which not even alleged mental debility would wrest from him. However tentative and uncertain he looks, he would claim afterwards that his English trip had been an entirely pleasurable experience. George III, who despite giving a masquerade for his brother-in-law detested such things, may have treated him with ill grace – he spent the whole evening at the Opera House 'in a private box, apparently shut but with peepholes in the shutters', and refusing to mix with the assembled company – but Christian revelled in the world of London society. On an earlier visit to Paris, he declared, he had enjoyed himself much less, although the French had done everything in their power to keep him amused.[46]

Although Angelica's letter to Johann Joseph of 10 October 1766 describes the portrait of Sir Joshua Reynolds as finished, she is usually

thought to have completed it in 1767. On 30 June the previous year 'Miss Angelica' appears in Reynolds's pocket-book, but there is no indication of whether or not this refers to a sitting; her name occurs again on 1 October with the added word 'fiori', flowers – an insertion that has inevitably fuelled speculation about Reynolds's feelings for Angelica – but with no more precise information: is she sitting to him or he to her? A further note of his on 17 October records 'Miss Angel', also a suggestive annotation,[47] but once more tantalisingly incomplete. It is supposed that Reynolds painted a portrait of Angelica at more or less the same time as he sat to her, though no such picture has been securely identified.

Angelica paints Sir Joshua in Van Dyck costume, as she would later do other, more dashing and younger male sitters. He looks older than his forty-three years: his hair is thinning, and the right hand cupped to his ear suggests deafness as much as attentiveness to what the inclined head of Michelangelo, in the bust by Daniele da Volterra behind his right shoulder, is whispering to him. Angelica captures her subject in a sympathetic and strongly felt image, very different from the mood of Reynolds's own self-portraits, but corresponding to what Fanny Burney would perceive in him: her diaries refer to Sir Joshua's 'expressive soft and sensible countenance' and his 'gentle unassuming and engaging manners'.[48] Part of the warm intimacy of the work also lies in the sense of close rapport between sitter and painter it conveys. There is no trace of Angelica's Venetian or otherwise Italian colouring, but a pervasive Rembrandt-like sombreness and a dominance of Old Master browns.[49] The costume may be playful and the treatment fond, but Angelica has successfully focused – as in the Winckelmann portrait – on the serious presentation of a scholar in his study.

The accessories underline the appropriateness of the chosen image, whose emphasis might seem surprising only to those who were unaware of Reynolds's conviction that the great artist must be learned. The books piled on his table are the enlightened productions of the time – The Traveller by his friend Goldsmith, and Johnson's Rambler and Idler, to the second of which Reynolds himself contributed. A copy of Burke's Philosophical Enquiry into the Origins of Our Ideas on the Sublime and Beautiful suggests the theoretical origins of Reynolds's own art, while the fact that Angelica leaves the background unpainted is an allusion to his belief that by far the greatest part of artistic genius

lay in intellectual preparation rather than execution. The blank canvas on the easel to Reynolds's right conveys the same message.

If imitation indicates approval, it seems that Reynolds liked the portrait. His 1776 picture of Warren Hastings reproduces the giltwood console or pier table at which Angelica shows him sitting, though this is obviously a possession of his rather than a studio prop of hers. He might have found fault with some parts of the composition, particularly the enormous left hand, the ineptly foreshortened arm and the slablike left shin; but although the portrait had fallen into disfavour by the twentieth century (both Manners and Williamson and Adeline Hartcup, the author of a 1954 book on Angelica, are disparaging about it), it richly deserves the admiration it now excites.

It was no doubt inevitable that Angelica's friendship with Reynolds should also provoke comment and excite graphic interest. There is the drawing by Dance, probably done in 1766 or 1767, showing Angelica in profile trying earnestly to converse with the apparently deaf Sir Joshua and continuing to paint his portrait while placing one hand on her heart, all unheeded by the woman with a guitar standing by and looking like a deliberately inattentive chaperone[50] – unless her posture, with her back to the engrossed couple, is simply meant to indicate that music is now low among Angelica's priorities. Perhaps this is mild enough, particularly given Dance's own bruised feelings of rejection, but there was a much more scabrous image to come.

In 1775 the Irish artist Nathaniel Hone painted a picture that seemed designed to ridicule both Angelica and Sir Joshua, and in so doing caused a furore. The painting, called *The Conjuror*, was at first accepted for exhibition by the Royal Academy, but then objected to: Angelica lodged a formal complaint against it, ostensibly on the grounds that a nude figure in the top left-hand corner was intended to represent her. A little girl leaning against the conjuror's knees may also satirise her, seeming like a travesty of the portrait *La Speranza*, which she had presented to the Accademia di San Luca in 1765. After her letter of protest to the Academy had been received, Hone's painting was withdrawn. The artist protested that he had never intended to defame Angelica, but the charge stuck.[51]

Joseph Nollekens was convinced that the picture was an attack on protector as well as protégée:

You're always running your rigs against Sir Joshua [he told Hone]; and you may say what you please, but I have never had any opinion of you since you painted that picture of the Conjuror, as you called it. I don't wonder they turned it out of the Academy. And what business had you to bring Angelica into it? You know it was your intention to ridicule her, whatever you and your printed paper affidavits may say; however, you may depend upon it, *she* won't forget it, if Sir Joshua does.

Hone, in Smith's words, knew that the eclectic Sir Joshua had borrowed some attitudes in his portraits from Van Dyck and others, and in order to expose him he had painted a picture of a conjuror commanding to rise out of the flames (or be consumed by them) the very engravings Reynolds had allegedly used. 'There was at first some indelicacy, which he had introduced in the centre of the picture, but which he afterwards painted out, respecting a slanderous report which had been whispered as to Sir Joshua and Angelica Kauffman.' The members of the Royal Academy also considered the picture a malicious satire on the President. After it had hung for several days at the exhibition, Sir William Chambers and another member of the Academy council came to see Hone about the rumour that he had done an indecent caricature of 'an eminent female artist'. Hone, says Smith, was

greatly surprised at the accusation, and assured the gentlemen that he had always had the highest esteem for the lady alluded to, both on account of her reputation as an artist as well as for her other accomplishments, and that he would willingly alter any figure they chose. He claimed not to have intended to represent any female figure in the picture except that of the child leaning on the conjuror's knee.

Chambers and others reported that Angelica's uneasiness remained very great. As well as painting out the nude figures in the background, Hone wrote her a letter of apology on 19 April 1775, having called at her house the previous day but been refused admittance. Angelica replied on the 20th:

99

I should have answered yours immediately, but I was engaged in business. I cannot conceive why several gentlemen, who never deceived me, should conspire to do it at this time, and if they themselves were deceived, you cannot wonder that others were deceived also, and take for satire that which you say was not intended. I was actuated, not only by my particular feelings, but by a respect for the arts and artists, and persuade myself you cannot think it too great a sacrifice to remove a picture that had even raised suspicion of disrespect to any person who never wished to offend you.[52]

After a ballot, the Academicians told Hone to remove the picture from exhibition. Peeved, the artist took a room at 70 St Martin's Lane and exhibited the work there, advertising the fact that he had painted out all the naked figures.

Angelica's reaction may have been disproportionate, but she was wounded both by a slur on her professional reputation and by unfounded insinuations against her virtue. Yet if Farington, for one, did not consider that Reynolds had ever been serious in his attentions to her, others were less certain. At the time of Angelica's second marriage the *Morning Advertiser* noted:

She has long refused many advantageous offers of various suitors, and among them one from Sir Joshua Reynolds, who at the same time he admired her style of painting thought Angelica a divine subject to adorn the hymeneal temple.[53]

However, the *Morning Advertiser* and its editor Blake Dudley were usually antagonistic towards Reynolds, and may simply have wanted to embarrass him. Oliver Goldsmith wrote some dismissive lines on the *Advertiser*'s eulogy:

But 'tis Reynolds' way
From wisdom to stray;
And Angelica's whim
To frolic like him.
But alas, your good worships,
How could they be wiser?

100

When both have been spoiled
In today's *Advertiser*.[54]

Angelica had already proved her ability to paint histories as well as portraits, and she would later work with great success in the decorative modes practised by such artists as Antonio Zucchi and Biagio Rebecca. Her fame seemed assured. But the acclaim she would receive for her epoch-making historical works of the late 1760s, proudly exhibited at the Royal Academy as a practical manifestation of Reynolds's programme for artistic regeneration, might have been gravely compromised by public knowledge of her involvement in some extraordinary events at about this time. Even more seriously, her position of favour at court might have been jeopardised by such rumours, since public scandal automatically led to exclusion. But the events were such that no one seems ever to have known their precise nature or their full implications.

A lost letter from Angelica to her father, probably written early in 1767, matter-of-factly describes the advantageous marriage proposal she has received and rejected. This offer may have been from John Cavendish, the younger son of the Duke of Devonshire: more than one report mentions that a member of an ancient and noble family fell in love with her and wanted to marry her, and some gossip identified Cavendish as the man. Equally, it may have been from someone whom, as we shall see, she was in no hurry to name to her father.[55] In any case, her public reputation meant that there was nothing surprising in her declining the offer, for when she was not being romantically linked with leading artists she was popularly seen as married to her work. Or was she? Events would soon suggest otherwise.

Rossi gives a sensational account of what allegedly happened to Angelica that year.[56] She had apparently met at the house of Dr Charles Burney a man of fine appearance, much talent, reasonable culture and noble manners, who had recently arrived in London. He called himself Count Frederick de Horn, a Swedish nobleman, and was staying in some style at Claridge's Hotel; when he left it to visit the *haut monde* he was driven in a splendid carriage and followed by footmen dressed magnificently in green. In fact, Rossi says, he was merely a servant pretending to be his master; but his manners were so suave and his liberality so convincing that no one suspected the

imposture. The best houses made him welcome, and Angelica was taken in along with everyone else, credulous enough to believe what he said about his noble birth, military honours, vast wealth, ancestral castles and glorious picture collections. She felt compassion for the young man, too, on account of the persecution he claimed to be suffering in Sweden, and became increasingly drawn to him as he visited her studio day after day. Eventually she fell in love with him. Horn offered marriage and said that he would share his fortune – some of which he claimed would shortly be reaching London – with Angelica and with her father, to whom he promised to be a devoted and tender son. He cautioned, however, that the marriage would have to be kept secret from his family because it might displease them. Recklessly and uncharacteristically, Angelica consented to his conditions, was briefly happy, but felt wretched at having agreed to marry without Johann Joseph's consent.

One day, the story continues, the *soi-disant* Horn arrived pale and trembling at 16 Golden Square, telling her that he had been slanderously accused by his enemies of conspiracy against the King of Sweden, and that the Swedish government was about to seek his extradition. He was to be clapped in irons by the Swedish Ambassador to London, branded with dishonour and sent back to his country to perish. His only hope was for her to marry him and so ensure his protection by the English Crown. Despite being filled with doubts, she agreed to marry Horn in a Catholic ceremony, which took place secretly on 13 February 1767 at the San Jacopo chapel of the Austrian imperial embassy – secretly, because in England penal laws against Roman Catholics were in full force. It was unlawful for a priest to marry a couple belonging to the faith, an illegality punishable with his death and the couple's imprisonment, and a fact which casts considerable doubt on Horn's alleged desire to marry Angelica for the sake of his safety. For this or other reasons, there was a belated Protestant wedding ceremony on 20 November 1767, at St James's Piccadilly: the curate George Baddeley officiated, and two unknown witnesses were present, Robert and Anne Home. (Or Hume: were they in fact Angelica's former landlords from Suffolk Street?)

For as long as the secret of their union had to be preserved, the young couple had apparently agreed not to share a bed or even a house with one another. Angelica divulged her secret only to Queen

Charlotte, Rossi writes; although the Queen encouraged her to make it known and even invited Horn to a court presentation, he protested that he would be presented only by a Swedish friend whose arrival in England was awaited, and added that he could not afford the appropriate costume anyway. He tried to persuade Angelica to go abroad with him to avoid embarrassment, but she refused because of pressure of work.

Some weeks passed, during which Horn obtained certain sums of money from Angelica. Eventually he decided that the marriage must be revealed to Johann Joseph so that he, Horn, could establish his legal claim on Angelica's fortune (a claim which, Rossi insists, had been his sole motive in pursuing and marrying her). Johann Joseph immediately concluded that he was an adventurer, and bitterly mourned his daughter's plight. With a naivety her father could only pity, Angelica reassured him that if Horn was not truly the count he had professed to be, their marriage would be null and void, because she had agreed to marry him on that understanding alone. But this suggests more than naivety: it implies that Angelica had married primarily out of social ambition, which – given the elevated circles she now moved in – is perhaps unsurprising.

In the meantime, news of the wedding leaked out. People could find out nothing about Horn, and they too began to suspect him of being a trickster. He started to abuse Johann Joseph and refuse Angelica's acquaintances access to the house, where he had by then seemingly settled. Finally he announced that he was leaving the country, and ordered Angelica to follow. Despite feeling that she owed him obedience, Angelica refused. Gradually she too became convinced of his duplicity, and asked for a separation. At this point Horn grew violent, seized some money and left the house brandishing his stick and uttering imprecations.

Four days later a lawyer appeared and announced to Angelica that Horn demanded either her presence and possessions or a formal separation along with the sum of £500. Angelica, well cured of her passion, decided on the latter course, but tried to challenge the amount of money her husband demanded. While this issue was before court, Rossi writes, Horn made an attempt to kidnap her, having assembled a band of cut-throats, hired a boat and got a carriage and horses ready for the flight to the coast; but providence, in some unspecified form,

preserved his wife. Not that she felt safe or otherwise reassured, for she had learnt to fear the actions of a man who, as she had discovered during their few months together, always carried a phial of strong poison with him. Told of the attempted kidnapping, the court ordered that Horn either be imprisoned or furnish some proof of his alleged noble identity.

Providence then apparently took a further hand in the affair. At precisely this time letters started to arrive describing the various names Horn had assumed in different countries and cities, the menial positions he had occupied, the false decorations he had assumed and the marriage he had already contracted in Hildesheim when allegedly a lieutenant in the army of Frederick the Great. Horn, frightened, thought about reducing his demands. Although the judge and other parties encouraged Angelica to continue her suit, she softened: her husband was now asking for only £300, was making no other demands, and in addition promised not to molest her or try to re-establish their union. She decided to pay him off, hoping that her marriage could be swiftly dissolved, and on 10 February 1768 a divorce *on the grounds of bigamy* was granted – or so the story goes. A year after their union, less than three months after their Protestant wedding and a matter of weeks after Horn had left her house, the sad story seemed to be over; and by 'one of those strange chances,' Rossi writes, 'which, although they appear improbable, really come to pass in the world', on that very day a person of authority revealed more about Horn's German wife, whom he had apparently abandoned in misery.

Even Angelica, whose surprising unworldliness is thrown into cruel relief by the whole affair, seems to have known that bigamy was punishable by death except in the case of real aristocrats – the infamous Duchess of Kingston is the eighteenth century's most famous example of this noble privilege – and, according to one version of the story, charitably declined to pursue Horn any further. He left London with his booty, doing nothing to clear up the mystery that still surrounded his person. Nonetheless, some facts emerged: that he had taken to calling himself Horn after serving a nobleman of the same name in Italy and Germany; that he had been known as Burckle or Buckle in one place, Studerat in another, and Rosenkranz in a third, but was possibly really called Brandt. A footnote in Rossi's text further alleges that he had suffered a wound that made him incapable of

consummating the marriage he had plotted so hard to bring about. Many acquaintances confirmed that he had claimed to want it only for the financial gain it seemed to promise.

It is an astonishing story, and one that raises more questions than it answers. Rossi's account is largely based on a memorandum left by Johann Joseph, who had suffered anguish over the whole affair; but a loving, zealous, over-protective father is a tendentious source, and it seems wise to be sceptical about his allegations. The fact is that no evidence exists of a court case against the impostor Horn, nor any record of the real Count de Horn having visited London in 1767 (as Rossi claims) to reveal the imposture. It also seems unlikely that Queen Charlotte was really involved: if she had been, would it not have been realised sooner that the February (Catholic) wedding was legally invalid, since it had not been conducted according to the sacred rites of the faith whose official protector was her husband the King? Was the urgency of this wedding in some way connected with the imminent arrival of the father Angelica had been so anxious to keep away from the country, and to whom she had described rejecting an advantageous proposal of marriage?

That something had happened is indisputable; what is in doubt is how much, why, when and under what circumstances. Should we simply assume that Angelica had fallen in love unsuitably and desired to keep the fact a secret? It would have been entirely understandable for her to want to assert her independence: she had been living apart from her father for more than six months, the first separation of her life, and it had changed her fundamentally. Within the limits of propriety, too, she was able to be her own mistress at last, although marriage, ironically enough, would immediately make her a husband's chattel. Johann Joseph was a jealous father, jealous of his daughter's talent, which he had nurtured so carefully, and probably jealous in other ways too. When Angelica remarried in 1781 it would be to a friend of his, a solid and reliable older man who would look after her when Johann Joseph was dead and be as much a guide as a companion to her. (Only the disaffected, however, immediately identified him as belonging to the type of the risible elderly spouse or guardian of the *commedia dell'arte*.) If, as appears to be the case, Johann Joseph proposed Antonio Zucchi to his daughter rather than Zucchi proposing himself, the point of the morality tale becomes clearer. Any marriage

not sanctioned by the father was bound to be a dangerous and irregular affair, and the whole alleged business of 1767 was a terrifying cautionary tale.

The footnote about Horn's impotence conveys precisely the kind of information that to a man like Johann Joseph might seem most vital, though it is (deliberately?) given the appearance of an afterthought – evidence that Horn had not succeeded in damaging his daughter where it really mattered. Given that marriage to Zucchi would hardly appear an erotic union either, the virginal Angelica might stay just that: an icon worshipped and exalted by many, but in the end her father's girl.

As a storyteller, however, Rossi could be accused of over-egging the pudding, or allowing his source to do so. The number of reasons adduced to demonstrate the unsuitability – indeed, illegality – of the marriage to Horn makes Angelica look at best horribly unlucky, at worst feckless and credulous beyond belief. For any woman to have married a mendacious, penniless, impotent bigamist does seem excessively careless. It is, of course, entirely credible that the power of passionate love might have blinded her to all these imperfections (which, to be fair, were invisible to the naked eye), though no man had ever excited Angelica's passions before. And this was an age of swindlers and adventurers – Cagliostro is one of the most famous examples – when handsome, plausible, agreeable, well-mannered men infiltrated the courts of Europe and acted their insinuating parts there. We may well imagine Angelica's susceptibility to one of them, particularly if he seemed to offer her social status comparable to that of her clients (but not, surely, if she had just turned down an offer from a blue-blooded Englishman).

If Horn truly was incapable of consummating their marriage, it is also understandable that she would not have wanted the union to be publicly dissolved on that account: it would have amounted to a gross and insensitive statement about her private life, a shocking intrusion into her decorous world. Invoking bigamy might look less damaging, but would be acceptable to her only if Horn took care (as he seemingly did) to put himself beyond the reach of English law. Yet there is no trace of the letters that apparently alerted concerned parties to a previous and undissolved marriage, and no direct evidence that on 20 March 1778 Angelica would eventually declare herself in favour of

annulling the Catholic marriage (but on which grounds?), despite this being a move that she had earlier resisted.[57] Luckily, Horn's timely – alleged – death before the process was completed meant that she could regard herself as a single woman again with a completely clear conscience.

However, perhaps Horn was neither already a husband nor incapable, but simply a young man in love. If he had not been, he would surely have chosen a richer partner. Perhaps he simply married and then quite rapidly tired of his wife. Or perhaps, as some contemporaries speculated, the whole episode had been engineered by a jealous spurned lover of Angelica's, such as the man whose proposal she proudly told her father she had rejected. Others muttered that it had all been a plot of Reynolds's, though no one explained what interest he could possibly have had in hatching it. In a memoir published some years after Angelica's death, Laetitia Hawkins wrote of the Horn affair:

> I have heard it said that she was addressed by a painter of the first eminence – I do not like to name him, it was not Sir Joshua – she refused him and in cruel revenge he dressed up a smart fellow of a low description but of some talent. This man he introduced to her as a person of distinction, and teaching him to profess a passion for her, his specious recommendations deceived her and she married him. They parted immediately – I hope the story may not be true.[58]

A further possibility is that Horn became as irritated by Johann Joseph's proprietorial presence in his daughter's life as he grew tired of her devotion to her work, and left the household for that reason.

It seems unlikely that we shall ever know what really happened; but although Angelica must have been emotionally damaged by this episode, she may have derived certain advantages from it in the long term. Possibly it suited her, for example, to be removed from the marriage market, however flirtatious she may have been earlier on and however questionable her marital status actually was. Her exclusive preoccupation with painting remained legitimate, as it had seemed before, but she was now freed from unwanted and intrusive male attentions. Equally suitably, she would remain unencumbered by

children. Her father was there to discourage anyone rash or bold enough to attempt inveigling his daughter again, and could still make himself useful to her in 'male' ways – preparing her canvases for her and dealing with suppliers, for example. Other woman artists might be trapped by marriage in a life of domesticity that prevented them from realising their full potential as painters, though the strong-willed could resist such pressures: Louise Vigée Le Brun abandoned her picture-dealer husband Jean Baptiste Pierre Le Brun at the start of the Revolution, but kept her adored daughter, with whom she lived and travelled across Europe until Julie's own unsuitable marriage. But Angelica remained freer still, childless and unhampered.

Work remained her true marriage. The record of paintings she completed in 1767 (the Reynolds portrait, displayed in public just before the Catholic wedding, the two royal commissions, a portrait of Lady Elizabeth Berkeley and probably the self-portrait today displayed at Saltram) hardly shows her to have been slowing down. On the contrary, everything indicates that she was revelling in furious painterly activity. She was a friend of the Queen, though perhaps not quite such a close friend as Johann Joseph/Rossi suggest when they report Charlotte's advice to Angelica to advertise her marriage and bring Horn to a court presentation; and a queen's patronage, if managed carefully, guaranteed future success. Furthermore, the fact that in the same year as her separation Angelica became a founder member of the Royal Academy indicates that she had retained the full support of the establishment.

Antonio Zucchi would later accept all the consequences of Angelica's devotion to work with equanimity. He was, after all, a painter himself; but he was an ageing painter with a shaking wrist, and the prospect of becoming the manager and faithful servant of a rich, successful artist wife would no doubt be tempting for a man in his position. For Horn it was different. Society's shock, then, may simply have stemmed from the fact that an attractive and apparently delightful young woman, much in the public eye, had been deserted by a husband who had quickly grown bored with her and her life. There is nothing to indicate that society ever heard the allegation of bigamy: the gossips of the age – Walpole, Boswell – have not a word to say about the 'scandal', and since Johann Joseph never divulged the identity of the person of authority who revealed the secret of Horn's previous

marriage, we cannot know whether or not he or the first wife really existed. (And might not Johann Joseph have felt a prick of guilt as he remembered how he too had deserted a first wife and quickly remarried?) As for the alleged imposture, the real Count de Horn took no legal action against its perpetrator, possibly because – as has sometimes been suggested – the false Horn was his natural son by a servant. If this is true, it might also explain how Horn escaped the usual penalty for bigamy, if indeed he was a bigamist: society simply closed ranks with the aristocratic father, effectively protecting his natural son by exiling him from England.

The coincidences littering Johann Joseph's/Rossi's story are too blatant to carry conviction, suggesting an elaborate hoax or at least a cover-up. 'At this very moment letters started to arrive . . . ', when Horn is allegedly asked to prove his identity; 'By an extraordinary coincidence' a crucial witness turns up on the day the decree of separation is granted. Yet the letters cannot be found – perhaps unsurprisingly, given that Angelica was a notorious destroyer of letters in later life – and the authority cannot be traced or named. All we have, in fact, is a document signed on 20 November 1767 at St James's Piccadilly in the firm hand of Angelica and the shaky one of someone calling himself Horn (not de Horn), a story and a scandal attached to it.

Nowadays, sceptics that we are, we might be tempted to accuse the pure woman at its centre of publicity-seeking, leg-pulling or emotional inadequacy. But conniving at the concoction of an elaborate hoax seems no truer to Angelica's character than severely arrested emotional development does, and self-advertisement was an art she practised only within carefully defined professional limits. Is it not best simply to conclude that she made a mistake, tried to repair it, and (possibly) helped to fabricate a story that made her humiliation seem less complete? Though the details supplied to Rossi seem far-fetched, Rossi reports that he published them in his 'life' of Angelica simply because she herself had had no taste for contradicting the fables that surrounded the affair. Certainly she gained nothing from the episode but sympathy and an enhanced reputation for virginity, both of which, of course, fed into her highly bankable personal myth.

When contemporaries referred to the circumstances surrounding the failure of Angelica's first marriage, it was primarily in terms of the sadness that blighted her life as a result. Herder, at a much later date,

reported that she had tried to tell him the story of her disastrous union, but had been unable to do so because she found the memory of it too painful. Sturz mentions her 'unhappiness', the 'visible melancholy' resulting from a 'misplaced love that ended with an unhappy marriage'.[59] Others were equally unspecific. So instead of wondering why the scandal never really damaged Angelica's reputation in society or halted her artistic progress in England – *pace* John Morgan, who wrote that Angelica 'was in a fair way to rising to fame, to honour and fortune, but an unlucky marriage was a great clog to her'[60] – perhaps we should conclude that there may never have been a scandal at all, just a bad marriage that was subsequently turned into a good story.

Chapter Six

Stepping into History

The fact that Angelica became one of the founder members of the Royal Academy is a token of Reynolds's high regard for her *as a painter*, whatever truth there was in the stories about the President's attraction to her, and whatever part the King and Queen may have played in determining the membership. The institution was established in 1768 in order to raise the status of the arts in Britain by giving academic dignity to the professions of painting and sculpture and by promoting the 'grand manner' that had flourished in other countries with a long-standing academic tradition. The nationalistic purpose behind these initiatives emerges clearly from Reynolds's ninth *Discourse*:

> It will be no small addition to the glory which this nation has already acquired from having given birth to eminent men in every part of science, if it should be enabled to produce, in consequence of this institution, a school of English artists. The estimation in which we stand in respect to our neighbours will be in proportion to the degree in which we excel or are inferior to them in the acquisition of intellectual excellence . . .[1]

The foundation of the Academy, then, would be a mark of cultural confidence that gave the lie to the familiar (foreign) accusations of British philistinism, complementing and refining the commercial strengths that had made native entrepreneurs wealthy and given them a desire for cultivation. Patriotism, in other words, dictated that Britain should produce artists worthy of itself.[2]

True, there was already much that foreigners admired in eighteenth-century Britain: visitors like Montesquieu and Voltaire, for example, had enthusiastically praised British tolerance, freedom and political moderation. But in other ways the country appeared insignificant, even

backward. The German critic August von Sternberg's hostility towards Angelica is matched by his contempt for British *Spiessbürgertum*. Angelica's fame was particularly bruited in Britain, he writes, because 'in matters of art this island has never passed any meaningful judgements'. Britain is 'by its very nature not artistically endowed', and 'collects only in order to possess, not to transmit beauty to the world and fire itself and others to equal creative force at the altar of sublimity'.[3] The accusation that the British patronised the arts more out of ostentation and self-regard than genuine love and expertise was one heard from other foreign observers too.

In fact, the blanket accusation of philistinism is hard to sustain. As buyers (and occasionally pilferers) of great art, the landed British then made a far better showing than the landed British do now. The problem lay elsewhere. It was not that the aristocracy did not collect, but that they did not *display* for the edification of others. Archenholz complains:

> The present fashion for adorning the capital through the magnificence and luxury of their mansions every day increases among the great, and perhaps in the end will at last destroy a custom of which the lovers of painting have so long complained; that of embellishing their country houses with all the wonders of art, and which, thus entombed in the heart of a remote province, are for ever lost to the world.[4]

It was, indeed, probably this tradition of seclusion that accounted for the charge of philistinism in the first place. When Gustav Waagen, the Director of the Berlin picture gallery, travelled round English country houses to inspect their contents in 1835, he found that the natives were in fact unrivalled collectors of art, and that the number of outstanding works in their possession was probably exceeded only by Italian private collections.[5]

The absence of public galleries was a particularly sore point. Some attributed the fact to Britain's status as a constitutional monarchy, claiming that a show of artistic magnificence was inherent only in absolutist regimes. Outstanding examples of painting and sculpture, according to this logic, had to be actively sought out. Louise Vigée Le Brun would later comment fairly:

It is not that one cannot find a wealth of precious objects in England, but most are owned by wealthy private citizens who adorn their estates in the country and in the provinces with them. At the time of which I am writing [the early 1800s] London had no museum of painting; the one which exists at present [the National Gallery] is the product of legacies and gifts made to the nation only over the past few years.[6]

As early as the 1760s, it is true, galleries were proliferating in London, and people in their thousands could and did examine a huge variety of works by contemporary painters and sculptors, both there and at temporary exhibitions. The name of one institution established in 1754, the Society for the Encouragement of the Arts (abbreviated to the Society of Arts), is telling. Although it awarded premiums to men and women whose work and discoveries were likely to benefit Britain's economy – techniques for preparing dyes, growing trees for ship timber more successfully, and so on – its preoccupations were not purely mercantile. It also gave prizes to promising child artists, and in 1761 it held the biggest public show of domestic art ever mounted in the country. Perhaps the motives of the organisers were less disinterested than they superficially appeared, for their hope was still to show that Britain could compete as successfully with its artistic rivals as with its commercial ones.[7] (The dividing line between the consumption of culture and the consumption of *things* often proves to be a narrow one.) But with this exhibition an aesthetic as well as a territorial principle had been established.

Even so, individual and collective patronage could never be sufficient to bring about a comprehensive improvement of the arts; formal instruction too was urgently required. Historically, the foundation of academies had to do with teaching. When Sir Martin Shee, a future president of the Royal Academy, was asked whether he thought the establishment of an Academy of Art would be useful, he replied: 'An Academy is a school, and I think a school is a good thing'.[8] This seemed indisputable. It is true that the great painters of the eighteenth century – Hogarth, Reynolds, Gainsborough – had flourished without formal training, but the first and last had learnt to draw at the art school in St Martin's Lane, an institution established earlier in the eighteenth century specifically because there was no academy of art for

113

instruction in drawing and painting. Reynolds regretted that he had had no such training, and with reason: detailed anatomical knowledge of the human figure such as Hogarth and Gainsborough had acquired at St Martin's Lane by studying from the living model[9] was the only branch of knowledge useful to the painter that he did not possess.

Whatever innovations might be afoot, the convention remained unchallenged – as in the Italian academies at which Angelica had studied – that such instruction could not be administered to (or by) women. Admittedly, as Academy members both she and Mary Moser had other privileges and responsibilities, such as being allowed a vote in the adjudication of gold medals and travelling scholarships, and participating in elections. But although nothing in the Academy's statutes explicitly excluded them from attendance at life classes, it would have been regarded as a serious breach of protocol had they been present. (And lest it be thought that their founding membership of the academy indicates a laudable lack of sexism in the institution, it should be noted both that neither woman figured on the original list that Reynolds presented to George III, and that no full female member would be elected again until Dame Laura Knight at the beginning of the twentieth century.) J. T. Smith recalls that as Keeper of Prints and Drawings at the British Museum he had seen a splendid lively study of a male model, recumbent and *half draped*, that Angelica had done in 1771, which seemed to suggest that she had somehow managed to be present at a life class;[10] but probably it was merely a copy of someone else's original, like the rear view of a male nude (in the Vallardi sketchbook) that she did in Naples between 1763 and 1765.

As a teaching institution, the Royal Academy made membership dependent on skill in instruction as well as expertise in practice: artistic excellence could never be sufficient, because the intention was to educate a nation deprived by habit and geography of such contact with European history and tradition as had generally been available only to the privileged minority who made a Grand Tour. This is why the members included many whose backgrounds were less narrow than those of the pupils they were to instruct, and explains the welcome extended to foreigners.[11] Of the thirty-four founding members, nine were from abroad. Reynolds would later describe foreign artists as contributing the 'manure' that was needed to speed up growth,[12] and in this spirit the Academy's early statutes provided that membership was

to be open to all suitably qualified artists irrespective of nationality, provided they were of 'fair moral character' and were resident in Britain.[13]

Practice, of course, did not necessarily reflect intention. The election of Giuseppe Bonomi as Professor of Perspective was blocked by Academicians such as Sir William Chambers, prompting Reynolds's temporary resignation of the presidency: 'I cannot persuade myself any longer to rank with such beings, and have therefore this morning ordered my name to be erased from the list of Academicians'.[14] With amazing tenacity, Bonomi then stood for every Academy post available in the 1790s, but rarely obtained more than one vote, that of his compatriot Bartolozzi. This was merely the most visible example of the Academy's effective closure to foreign talent at the end of the eighteenth century and its tacit determination to constitute itself as an exclusively 'English' body, give or take a few foreign stars. This resolution was barely shaken by the arrival of a new wave of immigrants from revolutionary France in the following decade, despite the clear intentions of the Academy's beginnings.[15] By that time, of course, Angelica would have returned to Italy.

The prevailing, and slightly xenophobic, view seems to have been that there was no harm in importing the foreign stars – Angelica, Bartolozzi, Cipriani, Zuccarelli – if they really helped to develop the talents of native British ones. The attitude of the foreigners themselves, of course, might be less visionary, if equally pragmatic. The original Italian members had come to England mainly to capitalise on its commercial advantages, not to enhance England's artistic standing *per se*. Cipriani and the associate members Antonio Zucchi and Biagio Rebecca were essentially decorative artists who would be much in demand to do wall and ceiling paintings in country-house interiors and the magnificent aristocratic mansions of the West End. Francesco Bartolozzi had originally been a painter too, but went on to become the most famous engraver in Europe. His membership remained unchallenged despite the fact that the 'mechanical' art of engraving was deprecated by an Academy bent on elevating the status of the arts, which really meant promoting the 'noble' genres of painting; so commercial interests, typically for eighteenth-century Britain, managed to coexist relatively peacefully with 'pure' artistic ones. Nor was the case of allegedly mechanical arts an isolated one in this respect:

115

British academicians too were tied down by a public demand for portraiture that conflicted with the more or less sincerely felt urge to practise the grand manner. Commercial constraints meant that they had to cater to a market where money called the tune.

The first Royal Academy exhibition was held in 1769, the year after Angelica's election as a founder member. However, she had already shown at a different venue three of the paintings that would later be admired there, and probably impressed a woman who was destined to become both a patron and an important client.

In a letter to her brother Fritz of 24 August 1775, John Parker's second wife Theresa mentions some history paintings by Angelica that were bought for Saltram:

> You next ask what subjects Angelica has painted for us. The prettiest, and I think the best she ever did, is the painting of Hector and Andromache. We have also got Ulysses discovering Achilles disguised in woman's clothes by his handling the sword, Venus conducting Aeneas in the character of a huntress – Penelope hanging up Ulysses' armour and two subjects out of the English history which you may remember was part of a commission given to her and West (for which purpose he painted the Death of Wolfe and his other English subjects), I forget by whose order, but the pictures were left upon the painter's hands, and the two that we have of Angelica's are the feast given upon the landing of the Saxons where Rowena presents the cup to Vortigern, and Elfrida receiving King Edgar.[16]

In 1768 Theresa Parker was still Theresa Robinson; she would not marry the future Lord Boringdon until the following year. The paintings done 'for us' were presumably done for her husband, unless Theresa's reference is intended more loosely. John Parker's account book for 16 May 1771 shows a payment to 'Miss Angelica for a picture' of £40, and for 30 June 1772 the same amount again. These may be for some of the classical histories, but the first could equally be for *Vortigern and Rowena*, which she completed in 1770, and the second for *Elfrida and Edgar*, finished in 1771. Three of the four pictures based on episodes from the Trojan War had been shown at the small

116

private exhibition held in 1768 at the Society of Artists in honour of Christian VII of Denmark's state visit to England: *Hector and Andromache, Penelope Taking Down the Bow of Ulysses* and *Venus Showing Aeneas and Achates the Way to Troy*. The following year Angelica would show them again at the first Royal Academy exhibition, along with *Achilles Discovered by Ulysses amongst the Attendants of Deidamia*.

Theresa Parker, whose godmother was Empress Maria Theresa of Austria, came from an artistic family, and there can be no doubt that she was influential in shaping the appearance of Saltram during its golden years – the years when John Parker commissioned Robert Adam to 'improve' the house in the latest style and artists such as Antonio Zucchi, who had worked with the Adam brothers in Italy in the 1750s, were employed to decorate its great rooms. When Theresa died shortly after the birth of her second child, at the tragically early age of 31, Reynolds wrote that she had been a woman of 'skill and exact judgement in the fine arts [who] seemed to possess by a kind of intuition that propriety of taste and right thinking which others but imperfectly acquire by hard labour'.[17] Only four months after arriving at Saltram, for example, she was asking Fritz to 'call at Zucchi's and let us have your opinion on the paintings he has finished for the library',[18] which suggests a real personal involvement in the work of modernisation.

It is possible that she was instrumental in obtaining the three Society of Artists pictures for Saltram, and that she had seen them on show at the exhibition. Angelica may, it is true, have done the classical subjects speculatively, or in order to mark her election to an Academy whose President set such store by the regenerative possibilities of cultivating the grand style. Equally, they may have been commissions from Parker himself: since he had become acquainted with Angelica in Italy, he knew that her kind of work would fit in with the decorative scheme envisaged for Saltram. (Certainly, the *Memorandum of Paintings*, a record of Angelica's work started in 1781 by Zucchi, claims that they were 'painted by Angelica Kauffman on Mr Parker's order'.) On the other hand, she would have had to paint extremely fast to be able to show commissioned pictures at the 1768 Society of Artists exhibition, given that John Parker inherited Saltram only that year, and it is most

117

unlikely that he would have started ordering paintings for its rooms during his father's lifetime.

Angelica was, it is true, known as a very quick worker. In her Golden Square studio she painted busily for as long as the 'murky' light was tolerable, often for three or four sessions a day; she was used to pushing herself, and needed no lessons in industry from anyone. If she had, the example of her mentor Reynolds might have been a spur. Reynolds did not think speed detrimental in itself to the task in hand, and in the case of portraiture it seemed particularly desirable because it meant more clients and hence more money for the artist. (He famously observed that if necessary a face could be begun and finished in a single day, and the rest completed without troubling the sitter further.)[19] In 1793 Angelica would paint a bust of the Russian Count Chernichev, in Antonio Zucchi's words, 'very daringly in one single sitting of four hours: the likeness is remarkable'.[20] The premium on speed was greater for this kind of work than for subject pictures, but some of the same principles applied to both genres.

Whether they had asked Angelica to paint some of the histories or not, the Parkers provided her with one of the vital professional breaks that would serve her career at crucial moments. John Parker had ambitions formed both by his father's collection and by his experiences on the Grand Tour, and he wanted to decorate his home in a striking and modern manner. His second wife possessed an exceptionally discerning eye that made their marriage a true artistic partnership, and when Parker inherited Saltram he acquired the money to set about making it a showcase. For John Parker the elder left his son well off: after his death more than £32,000 was found hidden about the house, 'cash in bags placed in the mahogany bookcase £3,713; ditto placed in the wainscot toilet £3,928'[21] – a tidy sum to spend on beautifying the house according to the most advanced notions. The precise origins of the Parkers' patronage do not really matter; it was the fact of their enlightened liberality that counted. Had it not been forthcoming, Angelica might never have continued doing the kind of work she had first begun in Italy for John Byng and instead remained simply a portraitist.

Royal portrait commissions apart, it was history paintings that in theory won artists the greatest prestige. If these works sold – a big proviso –

they also earned their creators serious money. As the Parkers' purchasing of the two pictures from British history 'left upon [Angelica's] hands' suggests, this could by no means be guaranteed. The decorative artist Mary Delany might well remark in February 1771 after a visit to Benjamin West's and Angelica's studios, 'My partiality leans to my sister painter; she has certainly a great deal of merit, but I like her history still better than her portraits';[22] her taste was not that of the British public at large. Hogarth had remarked that

> Portrait-painting ever has [*sic*], and ever will, succeed better in this country than in any other. The demand will be as constant as new faces arise; and with this we must be contented, for it will be in vain to attempt to force what can never be accomplished, at least by such institutions as royal academies. [...] [A]mong other causes that militate against either painting or sculpture succeeding in this nation, we must place our religion, which, inculcating unadorned simplicity, doth not require – nay, absolutely forbids – images for worship, or pictures to excite enthusiasm. Paintings are considered as pieces of furniture [...]. Can it excite wonder that the arts have not taken such deep root in this soil as in places where the people cultivate them from a kind of religious necessity [...]?[23]

When one thinks of the great names in British painting of the second half of the eighteenth century, it is portraitists and landscape artists who suggest themselves. In Italy, France, Spain and the Low Countries the case is different; there, subject-pictures (historical, mythological, religious) are the rule, not the exception.[24] Portraiture, by contrast, had occupied a lowly position in the academic hierarchy of genres since the Renaissance, lacking the 'ideal essence' that was thought to inhere in histories, and degraded by its association with mere imitation.[25]

It is true, however, that British portraits sometimes emphasised heroism and grand deeds in a way that brought them closer to works in the higher mode.[26] Jonathan Richardson remarked that by successfully depicting a 'great man' the portrait painter could convey to the observer an idea of grandeur that transcended the specificity of his subject.[27] *The Spectator* of 6 December 1712 had argued in the same spirit that portraiture might be for the English what history painting

was for the Italians: the lower type could be seen as an alternative to the higher if it confined itself to representing those who had been elevated by their physical and moral magnitude – their 'virtue', in both the ancient and the modern senses of the word – to the pantheon of great subjects.

Reynolds's objective was to make painting a liberal art rather than a craft, a profession rather than a trade, and popularising the genre of history painting was an integral part of his programme. Although public demand forced him to continue painting portraits, he pragmatically decided that he too would try to make them heroic, reconciling national taste with 'le grand goût'. But he obviously felt uneasy at admitting to this apparent inconsistency, expressing unequivocal hostility towards Richardson's notion and declaring, 'An historical painter paints man in general; a portrait painter, a particular man, and consequently a defective model'. Yet Northcote would counter: 'portrait often runs into history, and history into portrait, without our knowing it'. Fuseli's notice in the *Analytical Review* of June 1788 praises Reynolds's portrait of Lord Heathfield for roughly the same reasons:

> Besides every excellence claimed by portrait painting, these characters, these attitudes, these scenes impart almost every emotion commonly claimed by history and landscape painting. [...] In the blaze of excellence we are lost, and merely content ourselves with observing that if of the many instances in the present exhibition any one should more eminently challenge the contemplation of the physiognomist and the raptures of the poet, it is the portrait of the hoary warrior who launched his thunder from the rock of Gibraltar.

Gainsborough was simply expressing the conventional market wisdom when he remarked to William Hoare apropos of Reynolds's fifth *Discourse*:

> betwixt friends Sir Joshua either forgets or does not choose to see that his instruction is all adapted to form the history painter, which he must know there is no call for in this country.[28]

Perhaps he did know really. After all, he could hardly ignore the evidence of the immediate past and of his own day. Benjamin Haydon would observe in his diary for 1812:

> All the historical attempts for the country have been for nothing; Hogarth and the rest adorned the Foundling [Hospital] for nothing, Barry painted the Adelphi for nothing, Reynolds and West &c offered to grace St Paul's without remuneration, and latterly Fuseli [. . .] made a gigantic effort in his Theatre [i.e. Milton] Gallery without support, without patronage. Had he not sold a few he would have been ruined.[29]

It is undeniable that James Barry's series of paintings for the Great Room of the Society of Arts's new building in the Adelphi, designed by Robert Adam, was done for nearly nothing; indeed, he had originally offered to make no charge at all for the work. (In the end, after a labour of seven years, he was given the proceeds of two exhibitions held in 1783 and 1784, that is £500, along with £250 ex gratia and a gold medal.) William Blake grieved that he should have been allowed to starve 'on bread and apples' for his pains, and in the end Barry was awarded a pension by the Royal Academy – but only a month before his death. Before that his quarrelsome nature had led to his being completely excluded from the institution, where he had been professor of painting for seventeen years.

Barry himself explained his motives as having been to create 'some great work of historical painting' rather than mechanical portraiture, which had made England a 'scoff and byword amongst nations'.[30] Correspondingly, one observer called his efforts at the Adelphi 'a painted epic', and Dr Johnson said that he saw in it 'a grasp of mind which he could find nowhere else'. Barry's Inquiry into the Real and Imagined Obstructions to the Acquisition of the Arts in England of 1775 reasoned that

> History painting and sculpture should be the main views of any people desirous of gaining honour by the arts. These are the tests by which the national character will be tried in after ages, and by which it has been, and is now, tried by the natives of other countries [. . .]. As to the notion that the portrait-painter can

also, when called upon, paint history, and that he can, merely from his acquaintance with the map of the face, travel with security over the other regions of the body, every part of which has a peculiar and difficult geography of its own; this would be too palpably absurd to need any refutation.[31]

The fifth of Barry's idealised 'history' paintings for the Society of Arts was of the distribution of prizes there, and shows the bluestocking Mrs Montagu, the best known of the pioneering women members, and Dr Johnson between the Duchess of Devonshire and the Duchess of Richmond.

The reality for most artists who tried to paint in the grand manner was dire. Sir William Chambers remarked that it would soon be necessary to create a 'hospital' to care for young painters whose hopes had been raised by the founding of the Royal Academy and Reynolds's presentation of his regenerative programme, but who could not find employment in the higher reaches of art.[32] Reynolds, too, had conceded in a letter to Lord Grantham about the abortive project that 'It will certainly be in vain to make historical painters if there is no means found for employing them'. Between 1759 and 1777, it is true, the Society of Arts sponsored an annual competition for the best two pictures on a subject from English (later changed to British and Irish) history, and in 1763 Romney was awarded a special prize for his *Death of General Wolfe*, the talk of the town.[33] West, who arrived in England that year and would later exhibit his own celebrated painting of Wolfe at the Royal Academy, must have been influenced in his choice of subject by the stir Romney's picture created.

West himself would enjoy the patronage of George III, which helped him to earn more than £34,000 for history painting alone between 1769 and 1801. He remarked rather unfeelingly, as well as inaccurately, of his success:

[By choosing history painting] I have removed that long-received opinion that that was a department in the art that never would be encouraged in the kingdom. But I can say that I have been so far successful in it that I find my pictures sell for a price that no living artist ever received before. I hope this is a circumstance that will induce others to do the same; for the great necessity a man is

122

under to have money in his pocket often directs the study of youth contrary to their genius. It is to this I impute their timidity in not having ever produced a painter in that department of art and not that want of genius which the ill-natured voice of critics have [*sic*] alleged.[34]

But other painters were less fortunate with their patrons and had to produce what the general public was prepared to buy. It was, of course, Angelica rather than the President who exhibited histories in the 1769 Academy exhibition. Reynolds showed only portraits, as did Dance, and with the exception of West's two paintings – *The Departure of Regulus* and *Venus Mourning the Death of Adonis* – the rest of the exhibition was devoted to landscapes and views.

Angelica was lucky to have Parker, who knew how well her work would fit into the remodelled interior of Saltram. But she also enjoyed the enviable patronage of George Bowles.

Bowles would eventually hold the single biggest collection of her work owned by any individual – more than fifty paintings, of which he had personally commissioned the vast majority.[35] He belonged to a wealthy family whose money had come from glass manufacture, particularly looking glasses and plate glass (previously a Venetian monopoly).[36] His sister Rebecca, married to the future Sir John Rushout, had been known in her girlhood as 'the beauty of Essex', and would be painted by Angelica with her daughter Anne in 1773. She often acted as hostess for her bachelor brother at his country house Wanstead Grove, a now demolished seventeenth-century property in sixty acres of parkland on the edge of Epping Forest. Bowles's general collection, which he bequeathed to his niece, had been partly inherited, but he himself made unique additions, particularly of Angelica's works.

Theresa Parker's description of the Hector and Andromache painting as 'the prettiest, and I think the best she ever did' is generous, yet in a way appropriate. It is a statuesquely simple but not austere composition, constructed with great economy and with a purity of line that is still sinuous enough to give it considerable emotional power. The two main characters stand at the gates of Troy: with one step more, Hector will be outside, committed to do battle. His wife, half-fainting, leans

her head on his shoulder, one arm flung round his neck, the other dangling down, and as he clasps her hand we see that he has still not made up his mind to go. Indeed, looking as boneless as his wife, he appears alarmingly feminine for a man about to go to war, and the plumed helmet on his head is utterly at odds with his obvious reluctance to leave. Nonetheless, we know that he will end up opting for the 'Herculean' path of greater difficulty and follow it to its grim conclusion. The picture shows the end of private happiness, and the reserved gestures of the figures, the heavy, massive architecture and the muted colours emphasise the tragic doom that Hector's departure foretells.[37]

In the 1772 Academy exhibition Angelica would confirm this outcome by showing *Andromache and Hecuba Weeping Over the Ashes of Hector*, where Andromache leans listlessly on the funeral urn as her son Astyanax tries to comfort Hector's mother Hecuba. Although other artists – Gavin Hamilton, for instance – would happily show the scene of masculine sacrifice that preceded and provoked this one, Angelica characteristically chooses to focus on feminine grief and mourning. This was not particularly original at the time; in the period following the Seven Years War there were many images in English and French art of grieving widows. But she carried on favouring the theme throughout her career, not simply because she possessed feminist sympathies, but also because of her general aversion to depicting brutality, horror and bloodshed.

The pendant picture of *Achilles Discovered by Ulysses* shows the embodiment of Hector's tragic fate, as the educated eighteenth-century spectator would have been aware, since Achilles will be roused from his inactivity to kill him in battle. Yet it too is sentimental. Achilles appears dressed as a maiden because his mother wants to cheat his prophesied early death in the Trojan War, but he reveals his manhood by automatically choosing the sword hidden among the womanly gifts of clothes and jewels he is offered. So he realises his true way; but Angelica catches him at the moment of discovery, before he has definitively asserted his masculine self. Although he may appear womanlike, however, Achilles is not *effeminate*. In this respect the painting contrasts with the 1786 engraving by Georg Siegmund Facius after George Bowles's version of the picture, where the hero minces girlishly and even his sword has a womanly look.[38] The first Achilles

was far more suitable as warrior material for Ulysses' campaign against Troy.

This and the two other two pictures among the quartet bought for Saltram all focus on more or less dramatic moments of meeting and parting, male and female roles, passion and judgement. The *exemplum virtutis* they embody may seem a rather severe theme for house decoration, but John Parker wanted Saltram to make a grand and serious statement as well as a captivatingly domestic one. Today the paintings are displayed in a space both open and closed – the great staircase – which is intermediate enough for them to be either minutely examined or almost ignored, but in Parker's day they were meant to be hung as overdoors in the Grand Saloon, and thus put more emphatically on show. Even so, the fact that they would have mingled there with Zucchi's lighthearted decorations perhaps tempered the impression they made.

At present they are joined on the staircase by one of the scenes from ancient British history that the Parkers bought from Angelica, *Elfrida and Edgar*, and are overlooked from the landing by *Vortigern and Rowena*. To compose these works Angelica had needed the help, not of the Comte de Caylus's selections from Homer and Virgil, but of the histories of England by David Hume and Père René Rapin, and her efforts were genuinely innovative. Other artists adopted the mode as the century wore on – Robert Pine and Francis Wheatley, for example – but Angelica started it. Roy Strong has called the style they developed the 'Gothic-picturesque' and dated it from the 1760s to the early 1800s, when the closure of Bowyer's Historic Gallery in Pall Mall ended a major source of patronage through the commissioning of paintings to illustrate the new folio edition of Hume's *History of England*. The trend was at its height in the 1770s and 1780s.[39]

This new emphasis was of a piece with Reynolds's desire to create a national school of painting, not merely one based on historical works. As he saw it, a consciousness of national identity could be fostered and affirmed by forms of art that underlined the British difference from the hostile or alien Other.[40] Yet one wonders whether paintings of this kind really provided a spur for the ambitions of native artists. Just as Rapin wrote about England in French, from Germany and Holland, and Hume's was a history of England by a Scot, so among the groundbreaking pictures on national historical subjects were the Swiss-English

Fuseli's *Vortigern and Rowena* of 1769, the Swiss-Austrian (and honorary English) Angelica's painting on the same theme a year later and the American West's *Death of General Wolfe*, also of 1770.

A general patriotic interest in origins does, however, seem to have been stirred in the second half of the eighteenth century, and it was underlined by various works, literary as well as artistic, of more or less convincing antiquarianism. Britain was far from being the only nation engaged in discovering and asserting itself; but it felt more proudly than others the surge of commercial expansion and economic success, and a consequent desire to explore and dignify the national traits that had brought them into being. It was still buzzing, too, with the great naval and military victories it had won over the French in the Seven Years War. The disastrous War of American Independence would dent that confidence, but would lead via a different route to the glorification of Britain's past: the new heroes of painting would be the good kings during whose reign the country had prospered, contrasted with the bumbling and inept George III of the present.[41]

This is not to say that Angelica committed herself exclusively to the nationalistic mode. Her 1770 paintings include one of *Cleopatra Adorning the Grave of Mark Anthony* and another subject from Homer, *Hector Accusing Paris of Effeminacy*, as well as *Vortigern and Rowena*. The 'British' painting, however, is in some respects linked to the Homeric one. Just as Paris would prefer loving to fighting (though his passion for Helen is actually the cause of the Trojan War), so the lecherous British prince Vortigern will be encouraged into an affair with the Saxon princess Rowena by her uncle, the general Hengist, who believes that Vortigern will then be unable to withstand a Saxon military takeover of Britain. Vortigern duly divorces his wife and marries Rowena, ceding Kent to Hengist. So begins his downward slide, ending with banishment and an afterlife of bitter solitude.

This is not very uplifting, which makes it a curious subject for Angelica to have chosen. (It was an even odder one for stage performance, but the 1795 theatrical version of the story by Henry Ireland, who tried to present his play as an undiscovered work by Shakespeare, was booed off at Drury Lane after just one performance.)[42] Yet the episode would have strongly appealed to her moral sense, and it is at least a characteristic choice in its emphasis on the substitution of love, however negatively perceived, for war. Angelica

remained resistant to showing bloodshed, and even the alternative of cowardly or traitorous withdrawal seemed preferable to her – not morally superior, but pictorially and psychologically better. Her selection of such an unedifying scene from British history may also have been prompted by the fact that, like the Paris and Hector picture, it showed the disastrous consequences of illicit love, as well as focusing on a character who was the last ruler of the Britons. In any case, others seem to have thought that she had chosen cleverly. John Mortimer would paint the same subject in 1779, William Hamilton in the early 1790s, and Robert Smirke around the turn of the century.

The second Saltram picture from British history, *Edgar and Elfrida*, was engraved only fifteen years after it was shown at the Academy. Angelica's popularity meant that prints were usually circulated much more quickly, but in this case publication had been delayed for a poignant reason. William Wynne Ryland had probably begun work on the line engraving much earlier: the exhibition of a drawing after *Elfrida and Edgar* a few months after the original display of the canvas was a conventional signal that he intended to engrave prints from it. But in July 1783, having been overtaken by financial difficulties usually thought to be connected with over-expansion and the cost of running two families (one illegitimate), he was tried and hanged for the forgery of some India bills. At his trial he argued that he had no need to resort to counterfeiting because he had shares worth £7,000, a royal pension of £200 a year, and 'my stock in trade is worth £10,000, and the net produce of my business falls little short of £2,000 a year'; but he was declared bankrupt before his execution in August.[43] The unfinished plate was bought by a group of well-wishers and completed by William Sharp for Ryland's widow, who had set herself up as a printseller.[44]

What should we make of Angelica's historical works as a contribution to Reynolds's Academic campaign, at least in terms of their public reception? The fate of the Bowles collection suggests an answer, and is indicative of the British taste referred to in Gainsborough's letter to Hoare: histories might be admired, but they could not be loved. At the Northwick sale of 1859 (John Rushout had become Lord Northwick) most of the unwanted history paintings bequeathed by George Bowles to his niece went for about £60 each, while the portraits averaged about £150. Similarly, in 1918 Angelica's replica for Bowles of the

original Saltram *Vortigern and Rowena* sold for less than £90, whereas a portrait fetched £315. In 2001 a self-portrait of Angelica's was auctioned at £421,500, against a pair of smaller histories at £56,500. It was, and is, all highly symptomatic, and demonstrates clearly enough that the long-term as well as short-term goals of Reynolds's grand scheme had failed.

Then there is the fact that the 'British' works are distinctly disappointing as a record of national achievement and identity intended to inspire. It is presumably because Angelica rarely tries to exalt specific civic values, or address the public as a body conscious of its nationhood, that two such paintings so strongly appealed to foreigners such as Tsarevitch Paul, who insisted on buying, over the head of the English collector who had actually commissioned them, the canvases of Queen Eleanor and her husband Edward I at the siege of Acca. The great issues of the distant and more recent past – civil war, internecine strife, political rivalries, national threat – are evaded. Instead Angelica concentrates on the kind of moral images that could edify but not excite to patriotic duty, that could promote gracious conduct but not awaken active national pride. In terms of the historical task Sir Joshua set his academicians, it was an opportunity lost.

But perhaps the fault was partly his. The President's vision seemed to take little account of the eighteenth-century tradition of decorum,[45] whose influence is everywhere in Angelica's work. Her insistence on being restrained and proper would later affect her response to Klopstock's poetry, but it is evident in her histories too. Not being a Burkean, she had little use for sublime emotions and vast ungovernable reactions. The ethos of grandeur and immensity whose theory is traced in Burke's *Philosophical Enquiry into the Origin of Our Ideas on the Sublime and Beautiful* was alien to her conception of art, and the *strangeness* and *otherness* of the past is correspondingly absent from her histories. The well-born women who admired her work on the walls of the Academy or in the decorative interiors of great country houses could do so because there was nothing shockingly foreign about them: their salon quality is precisely what made them acceptable and guaranteed their popularity. In contemplating the Kauffman Rowenas, Andromaches and Eleanors, society ladies were really contemplating heroines singularly like themselves, decorous, graceful, *comme il faut*.

True, Angelica's work is also devoid of the flashy rhetoric that often went with the grand style, because she felt that propriety forebade it; but it is questionable whether the muted substitutes for heroic statement she provides are aesthetically as well as morally any more satisfying. Appearances notwithstanding, she was nothing if not a realist, and she knew that she had to please the public in order to survive. Reynolds's discourses and principles might be stirring and, on their own terms, convincing, but not even he managed to find consistent employment as a history painter. Pragmatically, Angelica would stick to what she was good at, but also turn her trademark prettiness to account. Making history painting less virile and dramatic, closer to the boudoir or the drawing-room than the battlefield, was one way to ensure its acceptability among the moneyed aristocracy and bourgeoisie. If Barry's work fitted into the Burkean mould (the two men were friends), Angelica's was more attuned to the tastes of polite society. She painted for a market, and that is why she succeeded materially where Barry failed. Many, too, applauded her achievements. Northcote's remark on the popular draw of her *Hector and Andromache* and *Venus Showing Aeneas and Achates* at the Royal Academy makes this clear, and a review in *Lloyd's Evening Post* of the same exhibition noted in its commentary on her works that 'Mrs Angelica' was 'an Italian young lady of uncommon genius and merit'.[46]

Once she had fulfilled expectations in this field – Saltram provided for and other commissions completed – she found it easy to leave ancient history behind. The pull of a more contemporary world and its literature was beginning to make itself felt.

Her portrait of Reynolds had hinted at the interrelationship of literature and painting in its focus on the books amongst which Sir Joshua lived, and pointed back to the self-portrait Hogarth painted in 1745, which shows the artist so closely surrounded by volumes of English authors that they almost seem to be tools of his trade. The cultured eighteenth-century observer might be reminded in this connection of the line from Horace's *Ars poetica*, 'ut pictura poesis' ('as painting, so poetry'), because the links between them were endlessly discussed at the time. Angelica, a widely read and reflective woman, was supremely fitted to contribute to the debate about the interrelationship of the arts. At the same time she could not ignore the tensions

129

that arose from the disparities between different mediums. Her abortive collaboration with the poet Klopstock would epitomise the dilemma she faced as she tried to reconcile literature and painting, text and image.

Klopstock, born the son of a court official, had received a classical education which gave him the conviction that it was his mission to be a poet. As such he was supported by a princely pension, but he refused to write mere sycophantic verse in honour of his patron. His belief in the inherent greatness of the poet's subject-matter enhanced his sense of his own worth (he was an astonishingly conceited man, who called his lover a 'female Klopstock' and believed that he was a divine gift to the public), and he regarded himself, rather inconsistently, as the first among a breed of independent men of letters. The project of writing *Der Messias*, conceived in his adolescence, appeared to him a holy duty, and he carried it out religiously between 1748 and 1773. Contemporaries called him 'our more than Milton, our Milton and Shakespeare combined', but they also gossiped about his morals, particularly when, in his sixties, this pillar of righteousness married the niece in whose house he had long been living.

Intended as a liturgical celebration, like Bach's *St Matthew Passion*, *Der Messias* may indeed be something best heard in church rather than in an assembly room or salon. It was without doubt the most important and controversial work of mid-eighteenth-century German literature, an attempt to write a Miltonic epic in German hexameters, an exemplar of the new sacred poetry that Klopstock believed himself called upon to create. But although he told Winckelmann that his theme was 'sacred history and the history of my fatherland', not all who read *Der Messias* (or heard it) could *feel* for it, whatever degree of reverence and patriotism they tried to bring to the experience. Nor was the secular emphasis always as apparent as Klopstock had intended it to be: the principal actors are angels who spend a great deal of their time in the sun or other parts of heaven, and earth receives comparatively little attention. If humans figure at all, indeed, it is as 'souls' to whom the visible, physical world is of far less importance than the supernatural one. The playwright Friedrich Hebbel observed that 'Klopstock's *Messias* stands in our day like an imposing Gothic cathedral. It is glorious enough, and everyone feels respect for it, but no one ventures inside'.[47] It is as long as the *Iliad* and *Odyssey*

combined, but somehow fails to be half as thrilling. Erich Schmidt remarked of it:

Nowadays everyone knows about the poem, but not a soul reads it unless driven by historical zeal. It has long since ceased to be a fount of poetic edification. Once watched over with enthusiasm, it now awakens only an undeniable feeling of pious shuddering.[48]

But Angelica was a passionate admirer, and she did what Klopstock – a man known to be hostile towards the visual arts[49] – called an 'outstanding'[50] painting of a scene from the poem for exhibition at the Royal Academy in 1770, before giving him the picture as a gift. It was sometime after this that the relationship between painter and poet began to break down, for highly symptomatic reasons.

Angelica's lost canvas is loosely based on the section from *Der Messias* that describes how Samma, a man possessed by the Devil, hurls his beloved younger son Benoni against some rocks in a maddened fit.[51] Typically she attenuates the scene, showing Samma cradling an urn containing Benoni's ashes rather than frenziedly smashing his body. (There is no specific mention of an urn in Klopstock, merely a reference to Benoni's mouldering bones.) She reinterprets because she thinks – as many theorists of the time did – that painting and poetry, as different mediums, have to record experience differently, and because she has an instinctive tendency to make horror muted. Other pictures of hers reflect the same belief, that visual imagery is often too direct to convey what is palliated in literature by the inherently distancing effect of language, particularly where issues of decorum are involved. As Diderot put it, licentiousness is so much *more* licentious when it is embodied, when it appears as a concrete object rather than being conveyed by non-graphic means. The written word suggests and analyses, but avoids representation both because language is bad at it and, making a virtue of necessity, because it finds merit in appealing to the imagination. Visual art is (too) good at representation, and may be correspondingly bad at mere implication, although devices such as symbolism and ambiguity can give it a kind of indirectness. Angelica's *Cleopatra Adorning the Grave of Mark Anthony* (1770) and *Andromache and Hecuba* (1772), like her *Samma*, show how visual images may be attenuated in this way, featuring as

131

they do the desiccated remains of lost heroes instead of their corpses.[52] Avoiding graphic starkness in the interests of decorum is the very essence of Angelica's art. Spectators may feel there is also a psychological gain in such transpositions, because what is imagined adds depth to a depiction. You cannot both see and imagine.

In the *Messias* picture, Samma's grief puts him in a state of comparative repose that contrasts with his previous possession. In portraying the body (Samma's) in anguish rather than the body (Benoni's) in suffering, Angelica deliberately presents not the brutal act but its aftermath, elegy rather than tragedy. This may suggest to us that she knew the playwright and theorist Gotthold Ephraïm Lessing's influential treatise *Laokoon* (1766), which discusses the relationship between painting and literature in similar terms. In visual art, Lessing argues, the cry should be converted into the sigh, because crying distorts, contracts the face and disturbs the body's harmony unduly.[53] He attacks the premise of Winckelmann's argument that the sculptor or sculptors of the Laocoon group in the Vatican had intended to show decorous endurance and 'a great and settled soul' – that is, moral qualities – in the priest's restrained expression,[54] maintaining instead that Laocoon's face is calm because the artist wanted to depict beautiful bodies, not assert ethical ideals. Of course, Angelica may not have intended to promote aesthetic arguments rather than moral ones in this way; but in avoiding the spectacle of slaughter, her *Samma*, in common with *Cleopatra Adorning the Grave of Mark Anthony* and *Andromache and Hecuba*, clearly sets beauty above high expressiveness. A sense of decency prevents her from fixing and hardening on canvas the fleeting moments of shock that in literature are made bearable by suggestion and deferment.

Uneasy about the expectations she had aroused, she kept on putting Klopstock off, hard though he pressed her and difficult as it was to plead overwork after she had left England and settled in Italy. Although Klopstock may have seemed sympathetic – he imagines her at one point saying, 'But I cannot draw very frightening things' – in fact he was obdurate: 'there is nothing for it, dearest, you *must*'.[55] Eventually he realised that she was unpersuadable, and turned to the Austrian artist Heinrich Friedrich Füger, whom he called 'unfortunately' superior to her.[56] His rueful conclusion that she was incapable of depicting terrible subjects – the 'neo-classic Horrific', as it has since

been called[57] – is correct, but for more complex reasons than he supposed. She tempers Winckelmann's ultimate sublimity of repose rather than adopt Klopstock's *terribilità* because she believes what Winckelmann himself had in fact conceded, that visual art is constrained by the imperative of beauty and has to show horror in a seemly way.

Despite their disagreement she remained a passionate enthusiast for Klopstock's work, which she reportedly listened to with rapture at a reading in 1795,[58] and when she was given a free choice by Emperor Joseph of Austria for a subject picture he wished her to do for him, she elected to paint a scene from Klopstock's patriotic play *Hermanns Schlacht*.[59] It shows the conquering hero Hermann as a characteristic Kauffman male, all nubile curves and bashful grace, returning from battle to be crowned by his wife Thusnelda. Klopstock's drama, evidently, was more pictorial than his poetry.

Rightly or wrongly, Angelica felt England to be a more literary culture than she had ever known before. Although her immediate circle in London did not include many writers – the poet George Keate was the best-known author of her acquaintance – she remained bookishly aware of past and current literary trends. Karl Philipp Moritz thought that the English in general were singularly well read, and his *Reise eines Deutschen in England im Jahre 1782* found this confirmed in their familiarity with native classics:

> My landlady, who is only a tailor's widow, reads her Milton, and tells me that her late husband fell in love with her because of her fine declamation as she read him. This single case would prove nothing, but I have already spoken to many people of the lower classes who all knew their national authors, and had in part read them. [...] In Germany no poet's name since Gellert has really been on the people's lips.[60]

Angelica would never paint a Miltonic subject, but in 1779 she drew a feminised figure based on his *Allegro*, the joyful one, sitting on a rock in a sylvan landscape and playing a triangle. The engraving made of it was published the same year, to be followed eight years later by one of

its pendant *Il Penseroso*, translated into the womanly equivalent *La Penserosa*, the thoughtful one.

Both are characteristic Kauffman productions. The charm of her style is often captured in the figures of light-hearted dancing maidens, whose model is probably to be found in the ancient frieze paintings she had seen with Winckelmann in Herculaneum and Pompeii. But the pensive woman is equally typical of her, and is implicitly contrasted with the enduring, stoic, male hero of mainstream neo-classical painting. Melancholy heroines like *La Penserosa* are in some respects a prototype of sentimental literature, and Angelica's sensationally successful version of Poor Maria from Sterne's *Sentimental Journey* exemplifies them.

The hopelessness that marks her suffering females precludes heroism. Bereft and beyond help, they endure a grief that, unlike the deaths they mourn, has no ennobling or exalting end. They provide empty images, leaving the gap between depicted state and unexpressed feeling so wide that only a real effort of interpretation can bridge it. The women seem to sit – they usually sit – as icons of abandonment, betraying little about their condition or its cause. Occasionally, as in the early *Bacchus and Ariadne*, their pose of desolation will be converted into one of incipient *allégresse*, but more commonly they are doomed to unrequited immobility.

Figures like this seem almost to anticipate the virtual hieroglyphs of Flaxman's neo-classical style, representative outlines for the observer to fill in. Perhaps this is one way in which visual art can appear to resemble literature. In such a reduced form it presents an understated and infinitely thought-provoking image in which the traditional clarity of the represented object gives way to something that, in common with the conventionalised medium of language, requires more penetrating interpretation. Angelica's paintings and drawings, like Watteau's, are often most evocative when they hint at something beyond what they have seen fit to present. They provoke the onlooker into projecting, and so discovering, hidden layers of meaning.

The melancholic, enigmatic picture of Poor Maria would become one of Angelica's most popular and widespread images, a multi-media hit that seemed to be at home everywhere. 'In the elegant manufactories of London and Birmingham it was transferred to an incalculable variety of articles of all sorts and sizes from a watch-case to a tea-

waiter,' reports J. Moser in his *Memoir of the Late Angelica Kauffman.*[61] Poor Maria, first mentioned in *Tristram Shandy* and then reintroduced in *A Sentimental Journey*, had once been the joy of the French village of Moulines where she lived: a villager recalled that 'the sun did not shine on so fair, so quick-witted and amiable a mind'. But after her marriage banns had been forbidden by an intriguing parish curate, once her lover had left her and her father died, she became inconsolable with grief: her mind altered, she took to wandering the countryside playing mournful tunes on a pipe. In *Tristram Shandy* the hero encounters her as she sits on a river bank with her tame goat, and *A Sentimental Journey* resumes her story. Yorick, whom Tristram has told about Poor Maria, makes a detour on his journey through France in order to see her, and finds her under a poplar by a narrow brook with her head resting on her hand and her hair loose. Her goat has deserted her, and she now has a little dog instead.

Angelica and Joseph Wright of Derby painted precisely this scene at exactly the same time (Wright's version is much starker) and unleashed a stream of Maria images. Between 1777 and 1819 twenty paintings of her were shown at the Royal Academy or translated into engravings. Angelica's is faithful to Sterne down to Maria's green sash, from which her pipe dangles; but her pose has obviously been borrowed from Dürer's *Melancholia*. Ryland's stipple engraving increased the picture's already enormous popularity, underlining Angelica's ability to size up the market and make a commercial killing.

Her *Maria* echoes not merely a sentimental literary motif, but also a mood with wider reverberations. As he looks at her, Yorick becomes conscious of the danger of sinking so far into feeling as to lose one's reason. This is a kind of excess that would be more and more closely associated with sensibility as the age wore on, and which is given classic expression in Ann Radcliffe's *Mysteries of Udolpho* or, in the following century, Jane Austen's *Sense and Sensibility*. The peril was widely discussed in medical tracts of the time, and it is significant that artists who were known depressives – Romney and Wright of Derby, for instance – were precisely those to be drawn to the theme. Angelica's own melancholic tendencies would become marked towards the end of her life, but a preoccupation with the subject of abandoned and suffering women was a constant throughout her career.

✷

James Macpherson's pseudo-Celtic *Ossian* was not calculated to lessen any reader's proneness to gloom, as the hero of Goethe's *Die Leiden des jungen Werther* discovers. In the blackness of frustrated love, Werther finds Ossian displacing Homer in his heart and mind, clarity disappearing, order and outline giving way to formlessness and fog. As Ossian's bardic poetry celebrates death and the departed, so Werther, in the grip of Ossianic intoxication, finds the ultimate promise of sublimity in suicide. Passion has destroyed the harmony of his mind, and self-destruction, the night of northern darkness, inevitably follows.

The Ossian cult to which Angelica briefly subscribed was a prime example of the muddled enthusiasm that could be generated by a poeticised past. It was embraced by Germans as an emblem of emerging Teutonic nationhood, and by British devotees as symbolic of their own mystic roots. Nowadays Macpherson's collection of bardic poems is routinely discussed, though not dismissed, as a fraud, but in the eighteenth century it was praised as the embodiment of primeval energy and pre-Romantic passion. Thomas Sheridan said, according to Boswell, 'that he preferred [Ossian] to all the poets in the world, and thought that he excelled Homer in the sublime and Virgil in the pathetic'.[62] Boswell added that

> Mrs Sheridan and he had fixed it as the standard of feeling, made it like a thermometer by which they could judge of the warmth of everybody's heart; and that they calculated beforehand in what degrees all their acquaintances would feel them, which answered exactly. 'To be sure', said he, 'except people have genuine feelings of poetry, they cannot resist these poems.'

In the same spirit Hazlitt remarked in his essay 'On Poetry in General' (1818): 'I shall conclude this general account with some remarks on four of the principal works of poetry in the world, at different periods of history – Homer, the Bible, Dante, and let me add, Ossian'.[63]

Even political figures lauded the work. Napoleon was said to carry a copy of Ossian with him on all his military campaigns, and commissioned paintings with Ossianic motifs from Ingres and Girodet, while Jefferson declared Macpherson's 'rude bard of the north' to be 'the greatest poet that has ever existed'. Mme de Staël called Ossian 'the Homer of the north', Mendelssohn composed *Fingal's Cave* after

Macpherson's *Fingal, together with Several Other Poems of Ossian* (1762), and Erskine wrote to Boswell:

> It is quite impossible to express my admiration for his poems; at particular passages I felt my whole frame trembling with ecstasy; but if I was to describe all my thoughts, you would think me absolutely mad. The beautiful wildness of his fancy is inexpressibly agreeable to the imagination.[64]

Needless to say, this is not how Angelica pictures the world Macpherson created, nor do her images at all correspond to *Ossian's* mood. When Klopstock rated Macpherson above some Greeks 'of the best period',[65] he was unwittingly giving voice to the unexpressed reservation Angelica had about antiquity – that its clarity was somehow too hard and definite to be authentically 'feeling'. But her artistic response to the storm and stress of *Ossian* was disappointingly tame. Although Macpherson's work is elemental, her *Trenmore and Imbaca* of 1773 is effete, more a dressing-up game played by androgynous teenagers than a pagan evocation of the Celtic past. All the swirling Romantic force of the original has been suppressed. Her enthusiasm for Ossian runs counter to her devotion to a light-filled decorative world evoking the spirit of a different antiquity, the sentimental classicism that inspires her domestic interior designs[66] as well as many of her paintings and engravings. The Ossianic kind of literary subject brought out the worst in her, and whatever weight Macpherson's sonorous forgery possesses is dissipated in the Boucher-like fairytale she chooses as its translation.

If any explanation is needed for the way this intelligent, sensitive and well-read woman so spectacularly failed to understand Ossian's world, perhaps her sense of decorum (again) provides one. In *Fingal*, the sixth book of Macpherson's work, the maiden Imbaca appears disguised as a man before Trenmore, whom she loves, and orders him to lay down his weapon. He does so with alacrity, though the cause may be involuntary: has the lance slipped from his nerveless grip simply because Imbaca has just displayed her bare breasts to him ('He trembled at sight of her snow-white bosom, and love overcame his soul')? Imbaca's gesture is equally hard to interpret. It is unclear whether she is using her female charms as a lure, coquettishly ensuring

that she gets what she wants with the least trouble, or whether her blouse has simply slipped revealingly as she casts her weapon down. Angelica's botched attempt at fusing Nordic sublimity with muted rococo eroticism makes it equally hard to care.

Although she cannot have missed the point of *Ossian* completely, there is further evidence that she was quite unable to illustrate from it sensibly. A portrait of Henrietta Fordyce shows the subject adorning the tomb of Fingal, an aggressively non-Christian Celt.[67] The monument is massive and rough-hewn, complementing the Stonehenge-like shape that can be vaguely discerned in the background. But what possessed Angelica to catch Mrs Fordyce, who was comfortably and dutifully married to a Presbyterian minister, in the act of paying her respects to a pagan hero?

Closer scrutiny would be unkind as well as unprofitable, and in any case Angelica's exploration of the fabled Celtic past was mercifully brief. The picture of Henrietta Fordyce does not necessarily illustrate what was bound to happen when she combined 'straight' portraiture with the vague mythologising that rather mystifyingly counted as historical in academic painterly terms, for many of Angelica's society portraits, especially of women, use the anacreontic imagery of minor deities in a playfully appealing way. The simple fact is that Ossian's brand of gloom did not suit her. Her best English portraits were subtler and more thoughtful affairs.

Chapter Seven

Pretty Women

'I have finished some portraits which are *snapped up* by everyone.' The twenty-five-year-old Angelica's excited exclamation to her father poses some difficult questions. Her picture of Anne Conway Damer was one of the works she refers to, and she explicitly mentions the Saltram Reynolds; but none of the society figures she describes as flocking to her studio – Mrs Garrick, Lord Baltimore, Queen Charlotte's lady-in-waiting the Duchess of Ancaster – seems to have sat to her then. The 'old acquaintances' she says she is seeing are unspecified, but may have included members of the Swiss de Salis family based in London, Benjamin West, the Duke and Duchess of Gordon, Lady Spencer, John Parker and Lord Palmerston. Nathaniel Dance is, for obvious reasons, unlikely to have visited her studio. Not one of these friends, in any case, is recorded as having sat for his or her portrait at this time.

Angelica's later practice of quickly capturing a facial likeness and then painting the rest of the portrait more slowly, without needing the model's presence, may already have been adopted, but since she refers to the pictures as finished she can hardly be alluding to works merely begun in 1766. One of the portraits she did start that year and completed the following one was the picture of Lady Elizabeth Berkeley, later Lady Craven and later still the Margravine of Anspach, an agreeable society figure whose name was noble enough to bring other fashionable sitters in her train.

In later life, Louise Vigée Le Brun would be terrified of painting the Margravine because of her endless chatter, which made the artist impose very strict terms for the duration of the commission:

As I had been told that the Margravine was a very odd woman, who would have me woken every morning at five o'clock, and a thousand other equally unbearable things, I only accepted her invitation after setting my conditions with her. First I asked for a

139

bedroom where I would hear no noise, as I wanted to sleep fairly late. Then I warned her that if we went on a drive together I would never speak in the carriage, and that, besides, I liked walking alone. The excellent woman agreed to everything and kept her word religiously, so that if by chance I met her in her park where she was often to be found digging, just like a labourer, she pretended not to see me and let me pass without saying a single word.[1]

Angelica painted her at a much younger age. It is a fresh-looking and, in view of the subject's subsequent reputation, rather severe portrait showing her as Hebe. Hebe, the cup-bearer and handmaiden to the gods, was a figure beloved of late eighteenth-century British portraitists and their clients: Angelica herself copied Gavin Hamilton's *Hebe* for the Marquess of Exeter, and the Saltram collection includes her version of Reynolds's portrait of the young Mary Heyer in the same guise. Louise Vigée Le Brun, too, fell in with the native enthusiasm for this minor deity when, during her stay in Rome, she painted the daughter of Lord Camelford, Miss Pitt, as Hebe feeding an eagle. Cardinal de Bernis lent her a huge bird for the purpose, and although it was reputedly tame, she was far more frightened of being bitten by it than her vacant, pretty sitter seems to have been. 'The accursed beast, which was used to being always in the open air, chained up in a courtyard, was so furious at being in my room that it tried to attack me.'[2]

Other painters seem to have found the future Margravine difficult to paint, though not necessarily as a creature from mythology. She sat to Reynolds five times – more than was usual with him – without the picture being finished to his liking. When Dr Johnson asked what was hindering him, Sir Joshua replied, laughing, 'There is something so comical in the lady's face that all my art cannot describe it'. He repeated the word 'comical' ten times in different tones, finishing with one of anger. He then gave Johnson such a scolding that he was, according to the sitter, much more embarrassed than before, or than the Margravine was to be the cause of it.[3]

Her portrait as the unmarried Lady Elizabeth Berkeley does not seem to have been so troublesome for Angelica, but not everyone liked it. The Margravine remembers the circumstances matter-of-factly:

Angelica Kauffman painted [a portrait] for me a fortnight before I was married to Mr Craven. It is a Hebe. I sat for it, and made a present of it to Colonel Colleton's widow, who had given me the £500 to deck me out in wedding clothes. She was godmother to my second daughter, the present Countess of Sefton, and left her that picture by will when Maria was only two years old; and that which delighted her father, hung up in his dressing-room for years: she never has asked for it, and I dare say never will.[4]

There is a very similar picture at Tissington Hall in Derbyshire of Selina Fitzherbert as Hebe, which Angelica probably painted three years later in 1770.

To judge by the portraits of women she was doing at about this time, she enjoyed working in this lightly mythologising mode as much as her sitters liked being depicted in it. One sat to Angelica, after all, in order to be fashionable, and 'l'aimable antiquité' was all the rage. She had a fashion-conscious, predominantly female clientele in England; in Italy it had been mainly male, because men rather than women went on the Grand Tour. Women were not thought to need a broadly humanist or seriously artistic education, and mostly stayed at home. If they did the tour, it was usually because they were on honeymoon (as with John Parker's first wife, who died abroad) or because they were of independent means or an indomitably curious spirit.[5]

Sometimes, correspondingly, women of a certain ambition wanted to be represented in a more emphatic and scholarly way than the standard anacreontic or loosely classical images permitted. Angelica's portrait of Frances Anne Hoare with a bust of Clio was painted at about this time, and shows a determined effort to make a woman look genuinely interested in a book – Clio is, after all, the muse of history, and Frances Hoare liked to think of herself as seriously studious. Another picture of her sacrificing to Vortigern in front of a cult stone reinforces the impression, recalling as it does Angelica's pictures of the early 1770s from ancient British history.

But most of her female portraits are less weighty, depicting either playful maidens or more matronly women. Two other mythologising pictures link their subjects with Pandora and Diana respectively, and their attributes may have a slightly different resonance for the modern observer from the one Angelica intended. The girl dressed as Pandora

is Henrietta Williams-Wynn, whom Angelica painted in 1769. This Pandora – the name means 'all-gifted' in Greek – was the daughter of the fabulously rich Welsh landowner and magnate Sir Watkin, whose country mansion Wynnstay was crammed with Old Masters and other artistic treasures, and whose town house at 20 St James's Square was adorned with ornamental painting by Antonio Zucchi (it represented the *ne plus ultra* of interior decoration in England at the time). Angelica's decision – if it was her own – to depict his daughter as one who was endowed with all imaginable blessings is unlikely to have been an ironic comment on the vast material possibilities that her father's wealth made available to her, however. She was not known for her sense of irony.

If she had been, the portrait of Jane Maxwell, the Duchess of Gordon, as Diana, the goddess of hunting, might have caused the knowing spectator to smile. The Duchess was indeed a huntress, but her vicarious quarry was a set of husbands – partners for her five daughters, each of whom, she boasted, she would marry off to a titled suitor. Since the girls were well below marriageable age in 1772, however, Angelica would have had to be prescient as well as dangerously playful for the Duchess's incarnation to be meant mockingly.

Instead she seems to have used the mythological peg randomly as a hook on which to hang an imaginative depiction of costume. The bow and quiver at the Duchess's side seem almost an afterthought, and her dress is far from suitable for vigorous physical exercise or a speedy pursuit. Her mantle is embroidered in gold, and a gold girdle encircles her waist; jewelled brooches clasp her billowing muslin sleeves, which are pushed up her arms as a gesture at practicality. The whole concoction breathes fantasy and reckless, gorgeous irresponsibility, yet the filmy shimmer of Jane Maxwell's costume contrasts with the aristocratically sneering expression of its wearer. For all her hauteur, which challenges derision of her affected playfulness, there is an energy to the portrait that relates it superficially to its supposed subject: the duchess, dressed up as a huntress, wants it to be known that she is no slouch. In comparison, many of Reynolds's female subjects seem paralysed in their vaguely antique gowns, frozen by their status and the artist's vision of their exaltedness.

Later on the Duchess of Gordon would become as ruthless and

predatory as Diana in other than matchmaking ways. Lady Mary Coke tartly observed that she would stop at nothing to gain her own ends, and the view was widespread. She was regarded as a Tory rival to her Whig counterpart the Duchess of Devonshire in the garnering of votes in elections, and allegedly kidnapped the rival to Captain Elphinstone, a friend of hers and candidate for the Argyll constituency, during the 1780 election campaign.[6] She was rich as well as resourceful, and more handsome than Angelica's portrait makes her appear. A fiercely ambitious woman, she planned and plotted to be the most powerful hostess in London as well as the mother with the most impressively married daughters. Because she was calculating and pitiless, her opponents called her violent; where it mattered, she could effectively silence them.

The balls she gave in the service of her ambitions were dazzling affairs that quite outshone the more modest parties thrown for Whig supporters and possible converts to the Whig cause by Georgiana, Duchess of Devonshire, who features as a young woman in one of Angelica's most charming group portraits. This family picture was painted in 1774, after the Spencer children had been travelling round Europe with their parents, and Georgiana in particular been admired for her perfect blend of poised confidence and sense of fun. She had greatly struck the twenty-four-year-old Duke of Devonshire at Spa, where on 7 June 1773 she had celebrated her seventeenth birthday.

Lord and Lady Spencer had met Angelica in Italy on an earlier trip to the continent, which they had undertaken in 1763–4 for the sake of Lord Spencer's health. Batoni had painted his wife then surrounded by books and music, with the ruins of ancient Rome in the background. She had fallen in love with John Spencer ten years before, afterwards confiding to a friend: 'I will own it and never deny it that I do love Spencer above all men upon earth'.[7] Georgiana would inherit her height and russet hair from him, and was her mother's darling: 'I will own I feel so partial to my Dear little Gee, that I think I shall never love another so well'.[8] As an exceptionally well-educated woman herself, she insisted that Georgiana be taught as thoroughly as she needed to become polished, and to that end the orientalist William Jones taught her writing, Sheridan's future father-in-law gave her singing lessons, and the royal drawing master instructed her in drawing. She also learnt French, Latin, Italian, dancing and horse-

riding. Lady Spencer, who had been brought up as a courtier, insisted that she also attend at all times to etiquette and public appearance, an injunction that Georgiana did not always find it convenient to remember.

Her mother had had no intention of allowing her to marry before her time, but the Duke seemed already to have made up his mind. Discussions began before the family returned to England, and were concluded in the spring of 1774. Lady Spencer worried, all the same, about pitchforking Georgiana into marriage when she was still unformed and vulnerable: 'She is amiable, innocent and benevolent, but she is giddy, idle and fond of dissipation.' Others feared that, given the Duke's dullness, she would 'not be well matched'.[9] But the wedding took place on her eighteenth birthday, 7 June 1774, shortly after Angelica had painted Georgiana with her sister and brother.

In the picture Georgiana and Harriet, the future mother of Lady Caroline Lamb, sit in a pose expressive of sisterly love, hand in hand and arms round each other's shoulder,[10] while their brother Lord Althorp, dressed in a *fête galante* costume, stands elegantly plunged in thought, and Harriet looks up at him with either worried or loving concern. His cross-legged stance is the standard one in portraits of country gentlemen at that time,[11] and Georgiana's pose too illustrates Angelica's habit of recycling attitudes from one picture to the next. Her 1771 portrait of Anne Loudoun, Lady Henderson of Fordall, is identical in arrangement. Only the faces differ: Georgiana's more slender and youthful, Anne Loudoun's more settled and wise.

The brilliance of Georgiana's character perhaps explains why, in the stipple engraving that Dickinson did after Angelica's picture in 1782, the figure of Viscount Althorp (the future patron and commander of Nelson) should be omitted altogether, as it also is in a pencil drawing now kept in the Vienna Academy of Arts. The attitude of the two sisters further underlines what would become more and more apparent in the course of their turbulent lives, their unconditional devotion to each other. The pose that betokens their sisterly affection also recalls the attitude traditional in married couple portraits,[12] the closeness of their relationship emblematically represented by the blue ribbons they both wear in their hair as signs of friendship and by the urn that stands on a pedestal beside them as a symbol of eternal fidelity.

Harriet, the younger sister, was generally compared unfavourably

with Georgiana in terms of beauty, though she had as much individuality. When she was born in 1761 her mother called her a 'little ugly girl' with 'no beauty to brag of, but an abundance of fine brown hair'.[13] Fanny Burney thought that she improved with age and illness: 'Sickness has softened her features and her expression into something so interesting and so unusually lovely that I should by no means have known her for the same lady I had so little admired in her early days'.[14] Angelica's picture simply makes Harriet appear less assertive than her sister, who looks directly at the beholder. Both girls have been idealised, but Georgiana has clearly mesmerised Angelica as she did many others.

Archenholz quotes Angelica's opinion that Georgiana 'looked so like one of the Graces as to realise in her own person all the ideas of the most fervid imagination'.[15] In truth, like the twentieth-century Spencer icon Diana, she possessed less than perfect looks. Her mother remarked that she would 'never be pretty', and Louise Vigée Le Brun would later comment:

Her features were very regular; but I was not struck by her beauty. Her complexion was too high, and unfortunately she had a blind eye. As women then [at the beginning of the nineteenth century] wore their hair over their brows, she hid this eye under a mass of curls, which did not at all succeed in hiding such a grave defect. The Duchess of Devonshire was fairly tall, with a plumpness which, at her age, suited her very well, and her easy manners were extremely gracious.[16]

Nowadays she would probably be called a *jolie laide*, whose attractions, as Fanny Burney saw, were dependent on animation. According to Burney, Georgiana's countenance had an ingenuousness and openness so singular that at expressive moments not even her sternest critic could deny the justice of her fame.[17] She herself was well aware of her facial shortcomings – 'a snub nose, a wide mouth and a pair of grey eyes'[18] – but her age thought them well compensated for by her general appeal. Walpole and others agreed that her good nature and liveliness (what one newspaper called her hoydenish affability)[19] made good any deficiencies of aspect, which included the sightless eye. She became the centre of the fashionable world, and in 1784 was the first

woman to wear a chemise gown in public, attending a concert in a muslin shift with trimmings of fine lace given to her by Marie-Antoinette. (She enjoyed easy access to the French queen's circle in the 1780s.) As well as abundant energy and animal spirits, she possessed a recklessness that brought her and those who were close to her a fair measure of grief. Even when illness had robbed her of an eye, the power of her personality convinced people that she was as captivating as she had ever been. She retained quite as much beauty as her fame and public notoriety seemed to demand.

She was as well known for her uncompromising canvassing techniques as for the sexual favours they sometimes seemed to promise. Known as 'Fox's duchess' (after her support for the Whig Charles James Fox, Lord Holland's uncle), she gained celebrity for the way she 'beat the bounds' in the same election hustings for which the Duchess of Gordon had Captain Elphinstone's rival kidnapped, and has been called the first woman to conduct a modern electoral campaign. Her direct method, as Archenholz remarked, involved 'bestowing her gold and her kisses'[20] on the impressionable floating voter and more often than not winning him over.

Most foreigners visiting London were at a loss to understand how aristocrats such as Georgiana could favour the liberal policies of the Whigs, which seemed a calculated threat to the status they enjoyed as leaders of society and fashion. Germaine de Staël, for example, would profess amazement at the political convictions of the Holland House set when she stayed in the capital in 1813, just as Louise Vigée Le Brun had earlier been taken aback by Georgiana's antipathy towards Toryism: how could a *grande dame* knowingly support a party hostile to the political establishment that safeguarded her privileges? But Georgiana continued to throw her parties for the opposition (as well as London's *beaux esprits*) at Devonshire House in Piccadilly, the splendid and now demolished urban equivalent of Chatsworth that had been designed by William Kent and built around 1737 at a cost of more than £20,000. In some respects she resembled Angelica in her ability to exploit the resources of modern technology – in Georgiana's case the rapidly expanding newspaper trade – for the purposes of publicity, in the process turning herself into a national celebrity. By nature, however, she was infinitely less cautious.

The other causes of her fame were her reckless gambling (a disease

she blamed herself for having passed on to her sister, but which she may in fact have contracted from her mother), her affairs and her *ménage à trois* with the Duke and Lady Elizabeth Foster, another beauty whom Angelica would paint during her Neapolitan exile in 1786. Georgiana would more than once be sent abroad too, or take refuge there to conceal her illegitimate pregnancies.

Her extravagance was prodigious, intermittently supported by 'the good Duke' for the sake of appearances, but otherwise exasperating him beyond endurance. The extent of her debts humiliated and chastened her, and she could rarely bear to be frank with her husband about them. She and most of the Devonshire House set relied on the Scottish banker Thomas Coutts to save them when creditors grew impatient,[21] though Georgiana also called on the generosity of the émigré former Finance Minister of France, Charles Alexandre de Calonne. Coutts, whose three daughters Angelica would paint in Italy, liked fawning on the aristocracy, because he was anxious to be seen to have moved up in the world. (The daughters all married into the nobility, which suggests that he succeeded: one became Countess of Guilford, another the Marchioness of Bute, and the third Lady Burdett.) He therefore agreed to become Georgiana's banker and to advance her money without her husband's knowledge, though he would have been less flattered by her custom had he known that the Parisian banker Jean-Frédéric Perrégaux, along with Calonne, shored her up as well.

Angelica's engagements with worldly women in the 1770s produced a series of portraits showing them dressed according to the latest modes. Not that she systematically eschewed Reynolds's recommendation of aiming at generalised and timeless (if vaguely neo-classical) elegance, but the vagaries of fashion attracted her as much as they irritated him. One particular craze prompted her to paint some remarkable portraits. This was the vogue for 'turqueries', which themselves had a kind of timeless appeal as well as a contemporary flavour in the 1770s.

The picture known either as *Morning Amusement* or *The Embroideress* (1773), a work so popular that even Queen Charlotte owned a print of it, has become the representative model for a type of loosely Turkish chic whose most famous real-life manifestation until then had been Lady Mary Wortley Montagu in Osman costume. Lady Mary, the

wife of the English Ambassador to the Porte, had travelled through Turkey between 1716 and 1718, and the posthumous publication of her *Letters from the Orient* in 1763 marked the beginning of a cult. Jean-Etienne Liotard's pastel portraits of European travellers in Turkish costume, too, made this mode internationally famous in the 1750s.

Some of Angelica's Turkish pictures reproduce the Westernised version of the fashion very exactly; others offer a more stylised image, vaguely oriental and closer to masquerade costume than anything else. The eighteenth-century practice, in literature as in visual art, was either to interpret the strangeness of the East in Western terms or to use the apparent strangeness of the East to show how much odder the West actually was. Angelica's pictures naturalise the unfamiliarity of oriental modes by demonstrating how easily they could be adapted to European types and styles. Her images do not emphasise the other, more threatening potential that exotic women possessed – that of mastering the powers of masculine sexuality to which they were in theory subjected – but characteristically show 'Turkish' women alone in self-communion, or busy with some absorbing task that requires no one else's presence. They are muted representations that still appear alluringly foreign. The allurements are rarely candidly sexual, though a picture Angelica painted in 1773 of a woman in Turkish dress fingering her hair while looking at a miniature picture of her lover may be interpreted as erotic rather than melancholic.[22] Possibly, too, it hints at the harem background inasmuch as it underlines (temporary) male absence, and may thus imply either sexual repression or sexual satisfaction.

Morning Amusement alludes to nothing so physical, unless its title – not of Angelica's devising – is intended to make the spectator think ahead to a very different sort of *evening* amusement. The embroideress's loose garments are of the kind recently made fashionable at Christian VII's great masked ball, but here simplified, domesticated and adapted to the free movement required by her task. Angelica's love of classical antiquity leads her to blend 'turquerie' with the flowing lines of Greek statuary costume, though the trousers the woman wears have nothing ancient about them. Their otherness may have provoked a frisson of impropriety when they were worn by society women, but here they seem wholly fitting, a natural extension of the kaftan-like

white silk robe embroidered in gold that the embroideress wears over her muslin *shalwar*.[23]

Her pose underlines the fact that what she is engaged in is no more than an amusement, however great her apparent absorption in the activity. The legs loosely crossed with feet barely resting on the floor, the serpentine line of the body, the tambour frame that seems to be propped up on thin air – these are not functional arrangements, but decorative ones,[24] for the pastime is designed as much to be looked at as to be productive. Knowing that she is being observed, the seemingly rapt young woman offers the spectator an image that manages to appear both innocently alluring and consciously seductive.

In eighteenth-century England as in the culture it mimicked, embroidery was the occupation of those who did not have to do real household tasks. The women Angelica painted with their needles, hoops and silks were following what in Constantinople was a vogue, not fulfilling a need, although serving the cause of ornament and beauty was so much a part of Ottoman domestic culture that fashion and necessity became inseparable. In the seventeenth century the French visitor Jean Thévenot alleged of leisured women there: 'Their only occupation at home is crochet and embroidery. All the housework is done by female slaves'.[25] Embroidery was applied to every available surface, but covering clothes with it appealed most to those whose main concern was with personal allurement. It became synonymous with the whole exotic civilisation of the Turkish capital, even when the city had embraced Western style in almost every other respect. To Western eyes it remained a fad and a pastime as well as a cultural signal, and thus contrived to blend the agreeable and the useful in a pleasantly relaxed way.

No other 'turquerie' of Angelica's possesses quite the charm of *Morning Amusement*, but the circulation of engravings helped to increase the general popularity of all her works in this style. The *Lady in a Turkish Dress* was published in a stipple engraving by Ryland in 1775 as a pair with the *Duchess of Richmond* painted the same year. (Engravings always sold better in pairs, adding to the already strong appeal of muted stipple, as opposed to clear-cut line engraving, for decorative purposes.) The feminine attraction of Angelica's 'turqueries' meant that her designs were often bought by fashionable women such

as Theresa Parker, who were beginning to take a more active part in designing their own domestic environment.

Like *The Embroideress* and *Theresa Parker*, a portrait of her patron that Angelica had painted in 1773, *Mary Duchess of Richmond* shows its sitter in baggy gauze trousers and loose kaftan (inauthentically loose: the real tight-fitting Turkish kaftan was too constricting for eighteenth-century European tastes).[26] The changes Angelica rings on this ensemble are minor. The Duchess of Richmond wears a sleeveless lilac velvet robe lined with un-Turkish ermine, Theresa Parker a more richly embroidered white silk robe lined in pink. The print made of the Duchess's portrait provides other details about her dress: 'She is in the costume of a Persian sultana worn by her at a masque given at Richmond House for the birthday of George III', it proclaims. At Christian VII's masquerade, according to a contemporary report, she appeared as 'the Fatima described in Lady Mary Wortley Montagu's letters'.[27]

Lady Mary's description of her visit to this woman, the wife of the Kyhaia (the representative of the Grand Vizir), in her letter from Constantinople of 18 April 1717 marks the high point of her enthusiasm for Turkish feminine beauty:

> She was dressed in a kaftan of gold brocade flowered with silver, very well fitted to her shape and showing to advantage the beauty of her bosom, only shaded by the thin gauze of her shift. Her drawers were pale pink, green and silver; her slippers white, fine embroidered; her lovely arms adorned with bracelets of diamonds; upon her head a real Turkish handkerchief of pink and silver, her own fine black hair hanging a great length in various tresses, and on one side of her head some bodkins of jewels. [...] For me, I am not ashamed to own, I took more pleasure in looking on the beauteous Fatima than the finest piece of sculpture could have given me.[28]

But attempting to emulate this repose and seductiveness in eighteenth-century London was a tiring affair, as a letter of Mary Delany's makes clear:

> We hear nothing but the King of Denmark's feasting etc., and the

preparations for his masked ball [...]. I suppose all the friseurs of Paris and London will hardly be sufficient for the demand there will be as everybody will try to outvie their brother beau and sister belle in fancy on the occasion.[29]

A piece of doggerel written to mark the occasion of the masquerade underlines the degree of artifice and effort required to match the mingled splendour and simplicity of the original:

> A masque, a masque ran eager through the streets,
> And every lady tells the friend she meets,
> 'O! what a charming scene! – 'twill be so grand!
> Do step with me, I'm going to the Strand,
> To look at buckles, and to buy some hair,
> Jeffreys', no further – but shall you be there?'
>
> Tailors and mercers, mantuamakers all,
> From shop to shop, run busy for the ball.
> Weavers in Spitalfields no more complain,
> Sorrow is turned to joy, and want to gain;
> Fashion scrapes up old remnants for the show,
> And slighted pieces once, become the beaux.[30]

Not, of course, that everyone present adopted the Turkish mode; but its vogue was pervasive and Angelica's promotion of the style highly influential. She was both a follower of fashion and a populariser of it – never self-congratulatory enough to assert that she had created a particular mode (as the much less modest Louise Vigée Le Brun unconvincingly claimed in connection with the introduction of neo-classical female dress to Russia),[31] but obviously aware of how greatly the proliferation of her images would help to disseminate it.

In her masque costume Mary Duchess of Richmond attempts nothing so obvious as a conscious statement, of fashion-mindedness or the desire to seduce; Angelica has painted her too tactfully for that. She is less aware of her charms than the embroideress, less curvilinear and more erect; her gaze is frank, and directed straight at the observer rather than coquettishly lowered onto her work in an affectation of concentration. She is relaxed but firm, not embedded like an iridescent

151

jewel in her surroundings, but dominating them with the unassertive authority of her position. Instead of playing with her fancy dress, she almost appears to have put it on in order to emphasise the sovereignty of her own race, declaring a kind of cultural transcendence by so easily appropriating the costume of another country. What for Fatima is the norm of a doubtless agreeable but still imposed estate is for the Duchess the freely chosen adornment of leisure.

Significantly, Angelica reserves the depiction of Turkish costume for her single female portraits. When she paints women with their children she shows them less exotically, as though to suggest (probably misleadingly) that eighteenth-century maternity was a serious affair even for the aristocracy, and not necessarily best suited to the fashion-conscious.

Mothers feature as prominently in her work as one would expect among a range of paintings so concerned with women, but there is one striking exception: a group portrait done when she had left London for six months to paint in Ireland. This work, executed in 1771 or 1772, shows the Marquess of Townshend, the Lord Lieutenant or Viceroy of Ireland, with his children, and is remarkable precisely because no mother is present. The Marquess's first wife, Lady Charlotte Compton, had died in 1770, and he did not remarry until 1773. He and Anne Montgomery would then produce six more children to add to the five pictured in the painting.

It is a work that mixes warmth with dramatic chiaroscuro effects – the dark of the mourning clothes, the white of the younger children's smocks and the half-light that plays over them. The overriding impression, though, is of intimacy. One of the two eldest sons, John, is holding his young brother Charles almost maternally as he attempts to teach him and his twin brother Frederick the alphabet. The eldest son, George, allows his serious study of a book to be interrupted by both little boys, who are clearly uninterested in being taught anything. But the most striking image is that of the father holding his small daughter Elizabeth up against a mirror, which reflects his loving face and tender clasping of the girl's hand as she looks at herself with seemingly rapt attention.

This time the scene is a thoroughly Rousseauesque one. The

152

alphabet lesson is undisciplined almost by intention, and the playful-
ness of the tableau reflects the tenets of Enlightenment pedagogy. The
twins' unbookish curiosity is being encouraged and indulged as a
matter of principle, and the remarkable closeness between all family
members reflects its enlightened times. The Marquess's obvious
delight in his young daughter's presence is the most moving aspect of
all. Pointedly and emphatically, Angelica shows motherlessness as a
potentially positive state for the child, rather than one of deprivation. It
can encourage the development of the kind of close bond between
father and child that she herself had experienced, though in her case at
some remove from childhood.

Again in accordance with the (misogynistic) beliefs of Rousseau, the
picture offers an extremely direct and slightly disconcerting image of a
specifically female upbringing. The father's game with his young
daughter seems calculated to arouse her narcissistic tendencies and
develop her nature in stereotypically womanish ways: while little boys
play with books, little girls look in mirrors. Angelica had probably never
read *Emile*, but the group portrait seems to carry an unmistakable echo
of its fifth book, the section that so enraged Mary Wollstonecraft:

Women [...] constantly cry that we raise them to be vain and
coquettish, that we endlessly amuse them with trifles in order to
remain masters more easily; they attack us for the faults we
reproach in them. What madness! And since when has it been
men who concern themselves with the education of girls? What
stops mothers bringing them up as they please? They have no
colleges: what a misfortune! Please God there were none for
boys, they would be more sensibly and decently raised! Are your
daughters forced to spend their time on foolishness? Are they
made to spend half their lives sitting despite themselves at their
toilet, following your example? Are you prevented from instruct-
ing them and having them instructed according to your desires?
Is it our fault if they please us when they are beautiful; if their
flirtatiousness seduces us, if the art they learn from you attracts
and flatters us, if we like seeing them dressed tastefully ... ?[32]

But in Angelica's picture it is the father, not the mother, who connives
at this travesty.

153

In a letter of 5 June 1772 Angelica wrote to a collector and connoisseur of her acquaintance, Giuseppe Beltramelli of Bergamo: 'I spent last summer in Ireland. I was invited there by some friends. I passed the time very pleasantly and profitably staying in their country houses'. The Irish court was much gayer than the English one, and the viceroys were often jovial men who permitted and even encouraged an atmosphere of saturnalia, a kind of free indulgence of the senses. When kept within limits, that, along with its Georgian elegance, made Dublin the most pleasant capital of the three kingdoms. Angelica was based there for a good part of the time she spent in Ireland, staying with the wife of the Bishop of Clogher, Mrs Clayton, a friend of Swift. She had gone at the invitation of Townshend, a great admirer of hers, but whose Lord Lieutenancy came to an abrupt end in 1772; for whatever the paternal sweetness of the image presented in the family group portrait, the Marquess was widely disliked for his intemperate, sarcastic nature and lack of political finesse. Horace Walpole called him 'proud, insolent, ill-tempered, ill-natured, stooping to the lowest buffoonery, and debasing the government he represented, while he drove the opposition to resistance by his absurd and profligate conduct'.[33] Although he was a gallant soldier, frank and convivial, he also abounded in a coarse humour that was frequently at odds with his office. Clearly he was different with his children.

Some of Angelica's artistic acquaintances had also been active in Ireland. Cipriani, for example, did decorative paintings at Lord Charlemont's mansion, beginning work in 1761. At that time Ireland was particularly noted for its *stuccadores*, whose ceilings were even more famous than French and German ones, and they were extensively employed decorating the great houses that dotted the countryside and the smart town dwellings of Dublin. Irish grandees did the Grand Tour as enthusiastically as the English, and Angelica had met many of them in Italy. One, the notorious Bishop of Derry (Elizabeth Foster's father), would become a patron of hers.

Conversation-pieces such as the Townshend picture were Angelica's preferred solution to the commissions she repeatedly received in Ireland. She managed to lay the groundwork for several during her stay by making preparatory studies of individual heads and leaving the painting of bodies and backgrounds for her return to London. Such work suited her temperament and would prove a valuable preparation

for the great group portrait she later painted of the King and Queen of Naples with their children.

She renewed contact with the Damer family, who had been important clients of hers in her early London years, and for whom she did several copies of family pictures for their Irish country seat at Emo Park. Anne Damer's mother-in-law Lady Caroline Damer commissioned her own portrait, and in return Angelica presented her with two of herself, one in oil and the other a pencil drawing.

Of the Irish work Angelica did, only the conversation-piece of the Townshend family depicts young children. The fact that it does so in an engaging way is surprising only because at other times she painted some rather conventionalised semi-allegorical child images. Occasionally she seems to be following a recipe perfected by French artists such as François-Hubert Drouais and later continued in the work of Louise Vigée Le Brun: the slightly sickly picture of Elizabeth Temple at Buscot Park is a case in point, though the way the girl's costume slips revealingly off her shoulder betrays a surprisingly eroticised conception of childhood – surprising for Angelica, that is. She would never be as suggestive in such works as Reynolds.

But she can capture individuality more successfully than in the Buscot picture, and does so in a portrait painted in 1777 of the eleven-year-old Laura Pulteney, the daughter of the Earl of Bath. William Pulteney commissioned Robert Adam to design Pulteney Bridge in the city, and it was conceivably through her acquaintance with Adam that Angelica came into contact with him. His daughter, later described as an indefatigable dancer, appears in a dramatic contrast of light and dark that seems to hint at a future of dash and unconventionality. In fact she would subsequently be called 'censurably neglectful in dress, and in conversation lacking in the embellishments expected in ladies of rank', though none of this seems to be foretold in the very feminine and pretty Bath portrait. Indeed, it is as hard to detect any hint of serious youthful abandon in the image of Miss Pulteney moving through the wooded landscape with a basket of flowers in her left hand as it is to see profligacy and wantonness in the tendril of hanging ivy she holds in her right.

The social ornament Angelica became in England was more adept at

depicting other women as well as herself in a decorative way than almost any other female painter of the time. The graces she had learnt during her exposure to aristocratic life in Italy and then in the court of George III meant that she was regarded as either a near-equal or an agreeable companion by many of the well-born women she painted, and her special ability to make them appear *le dernier cri* was generally acknowledged even when she adopted the kind of timeless costumes Reynolds recommended. The fact, too, that she publicised her work so effectively, both in its original form and as widely circulated engravings, made her art seem almost universal, or as universal as the *bon ton* of London wanted it to be. She endowed both ephemeral fashions and permanent qualities with a grace that simply made people covet her services and her finished work. The same would be true with other types of production she attempted, for the whole world's Angelicamadness extended beyond the bounds of conventional painting and its associated sub-genres. People wanted to possess her in every form.

Chapter Eight
The Sweetness of Life

Angelica did far less original decorative painting than traditional accounts of her activity imply. The cult of personality she inspired (not necessarily through her own doing) was enormous, so intense as to efface the potentially negative effects of standardised images which mechanical processes of reproduction inevitably create. An aura of individuality clung to her works despite everything: she seemed personally identifiable to her admirers even though much of the work attributed to her was simply done after her designs rather than directly executed by her. She was, for example, much too busy to have had time to contribute to the many projects, Adamesque or other, she was once associated with, and far from her having been responsible for the ornamental interiors of countless West End houses and country mansions – Chandos House, Sir Watkin Williams-Wynn's house in St James's Square, Kenwood, Osterley Park – only two such projects can be firmly authenticated as hers: the painting of four roundels now in the entrance hall of the Royal Academy in Burlington House and the ornamentation of two overdoors originally for Derby House in Grosvenor Square.[1] Some of the decorative work she was once credited with is in fact by Antonio Zucchi, whose style had many affinities with her own.

If lack of time prevented her from doing such work, the financial motive may also have been decisive. For her ceiling panels at the Royal Academy she was paid a total of £100, which was the standard price for this sort of production. (Zucchi received the same sum for four large pieces of decorative painting at Nostell Priory in Yorkshire.) Given her rates for portraiture, it was obviously much more lucrative for her to paint faces than ceilings and walls. The disparity between her earnings in England and Zucchi's may be due as much to this as to anything else.

Still, money cannot have been the attraction with one particular

project, the scheme to decorate the interior of St Paul's Cathedral with a series of paintings by British (or honorary British) Royal Academicians – Reynolds, West, Angelica, Barry, Cipriani and Dance. It seems to have grown out of a more modest proposal to adorn the chapel of Old Somerset House, then the home of the Academy after its move from Pall Mall and before its establishment in Burlington House. When this came to nothing Reynolds, according to Northcote, said that the artists in question should 'fly at once at a higher game'.[2] Barry described the great plan in a letter:

> One day, Sir Joshua and Mr West were dining with Newton [the Dean of St Paul's] at his house, and, in the course of conversation, one of them observed how great an ornament it would be to that cathedral if it were to be furnished with appropriate paintings to fill up those large vacant compartments and panels, and which the architect, Sir Christopher Wren himself, purposed to have added to finish the building [. . .]. The bishop [Newton was the late Bishop of Bristol] was enraptured with the plan; and he, being Dean of St Paul's, concluded that his influence was fully sufficient to produce a completion of the business.

Reynolds himself wrote to Thomas, second Baron Grantham, that 'five of us' (actually six),

> and I fear there are not more qualified for this purpose, have agreed each to give a large picture, they are so poor that we must give the pictures, for they have but the interest of £30,000 to keep that great building in repair, which is not near sufficient for the purpose [. . .]. We think this will be a means of introducing a general fashion for churches to have altar pictures, and that St Paul's will head the fashion in pictures, as St James's does for dress.[3]

But his optimism, as well as Newton's, was sadly misplaced.

Initial progress was encouraging. Newton obtained the King's consent, along with that of the Archbishop of Canterbury and the Lord Mayor of London, and the Chapter, with Newton at its head, of course

agreed. But the Bishop of London, Terrick, had unluckily been consulted last. His was the most powerful voice at St Paul's, and he vigorously opposed the proposal. 'Whether,' Northcote continues, 'he took it amiss that the proposal was not first made to him [...] or whether he was really afraid, as he said, that it would occasion great noise and clamour against it, as an artful introduction of popery', he declared:

> as the sole power at last remained with myself, I therefore inform your lordship that whilst I live and have the power, I will never suffer the doors of the metropolitan church to be opened for the introduction of popery into it.[4]

Yet the general opinion, Northcote goes on, plainly appeared to favour the scheme:

> and whatever might have been the case in the days of our first reformers, there was surely no danger now of pictures seducing our people into popery and idolatry – they would only make scripture history better known and remembered. Many other churches and chapels have adopted and are adopting this measure, as Rochester, Winchester, Salisbury, St Stephens Walbrook, and several colleges in the University [...]. Bishop Terrick himself approved, if not contributed to, the setting-up of a picture of the Annunciation by Cipriani in the chapel of his own college at Clare Hall at Cambridge.[5]

Reynolds's own views on the principle of the matter were uncompromising. According to Northcote, he was certain that

> the art of painting, notwithstanding the present encouragement given to it in England, would never grow up to maturity and perfection unless it could be introduced into churches as in foreign countries: individuals being, for the most part, fonder of their own portraits or those of their families than of any historical piece.[6]

Yet the moment was not propitious. The wave of anti-Catholic

159

sentiment that would culminate in the Gordon Riots of 1780, just after the Royal Academy exhibition, helped to ensure that the prospect of religious painting such as Reynolds envisaged would continue to be viewed with suspicion.[7]

Deprived of this showcase for their talents, the artists hit upon the project of doing allegorical ceiling paintings representing the theoretical basis of the fine arts for Old Somerset House. Angelica's task was to depict the four parts of painting, Invention, Composition, Design and Colour. In Somerset House her pictures were affixed to the ceiling of the Council Chamber around paintings by West of Nature, the Graces and the Elements, and portraits by Rebecca of the great artists of antiquity. Later they were moved to their present home in the entrance hall of Burlington House.

With or without the desire to flatter the Academy's first President, she used her allegorical personifications to illustrate the theory of art developed in Reynolds's *Discourses*, which had first been delivered in the Council Chamber. Invention, the initial stage, is depicted as a woman looking to heaven for inspiration, the wings on her head symbolising her lofty intellectual endowments. Composition reclines by a classical column bearing a chessboard, and rather tiredly holds a pair of compasses to indicate the care and reason she must bring to her task. (Her pose, like that of Angelica's *La Speranza*, is borrowed from the traditional representation of Melancholia. The artist's urge to create, in other words, is explained in terms of her depressive disposition.) Design is another female artist sitting in a classical landscape, sketching from the Belvedere Torso, and Colour is given the form of a girl with a chameleon by her side, reaching up to the sky to put the tints of the rainbow on her palette.[8]

The fact that Angelica depicts Design and Colour in an even-handed way – Colour may be prettier, but Design is obviously more serious – suggests the distance at which she stands from the polemical debate between the supporters of line and colour in seventeenth- and eighteenth-century France, the Poussinists and the Rubenists respectively. The intensity of this continental debate was never matched in England, although for many observers and critics it remained a live issue (as the recurrent, rather dismissive contemporary references to Angelica's mastery of colour on the one hand and weakness at draughtmanship on the other imply). A balanced treatment meant,

importantly, that she offended neither such supporters of colour as Reynolds and Gainsborough nor proponents of line like Fuseli and, later, Flaxman. She was tactful as well as talented.

Whereas the abortive St Paul's project might have seemed a doubtful enterprise for Angelica to support, given that she was both a Catholic and a foreigner, the Royal Academy commission was made for her. It called for serious, learned decorative art that was visually attractive at the same time, and was intended for display in an institution that upheld the glories of the profession she lived for. Besides, her commission would prove that she was not mercenary. Other decorative work – her production of drawings for transfer to a different medium, for example – may have been undertaken in a more pragmatic spirit, as a way of usefully occupying herself and filling occasional fallow periods, much as a present-day artist might do theatre sets. It was never her *raison d'être*. But the Royal Academy decorations were another matter.

For all her successes in other fields, she is probably as well known today for her decorative work as for anything else, particularly in Britain. Even if she did not belong to the 'regiment of artificers' – Elizabeth Montagu's phrase[9] – that travelled from mansion to mansion adorning them with roundels and other pieces of ornamental art, her influence on interior decoration was still immense, partly because of the wide dissemination of her work through the medium of engraving. Her style was perfectly attuned to the Adamesque ideal, and is discernible on interior elevations and chimneypieces as well as furniture and porcelain, needlework pictures and other accessories of Georgian life. In that age of good taste Angelica became its personification.

It is all the more regrettable, then, that her work has not always lasted well, often because of the soft woods used for painted furniture and the fragility of their decoration. Motifs were applied in various ways, some more durable than others – painted on wood, copper, canvas or paper, or executed in marquetry (obviously the longest-lasting). Certain items of furniture, too, seem to have stood up better than others to the passage of time. For some reason commodes ornamented with Angelica's designs have proved remarkably resilient: the boardroom of Coutts' Bank in the Strand, for example, has one very fine and well-preserved example adorned with *Telemachus at the*

Court of Sparta (whose original she had exhibited at the Royal Academy in 1773) and *Poor Maria*.[10] Given his fondness for Angelica's work, it seems likely that Thomas Coutts himself was instrumental in procuring it.

The huge popularity of the *Poor Maria* picture is evident from the number of different mediums to which it was transferred. Josiah Wedgwood made it into a cameo, possibly the one that is reproduced in Louise Vigée Le Brun's portrait of the Duchesse d'Orléans, and had it mounted on a cut-steel frame by the Birmingham entrepreneur Matthew Boulton. Rather surprisingly, however, Wedgwood only occasionally used Angelica's work. Bartolozzi's 1783 engraving of her *Veillez amans si l'amour dort*, commissioned by the fan-maker Anthony Poggi, appears on one piece by him, and the British Museum has a white terracotta stoneware plaque decorated with a painting *en grisaille* of *Cleopatra before Augustus*, after Thomas Burke's engraving.[11] A tea and coffee pot in basaltware of the 1790s use the images of Poor Maria and Andromache grieving over Hector's ashes, while jasperware vases of the same period feature relief modelling of some dancing nymphs after her designs and figures from the picture of Lady Elizabeth Grey begging Edward IV for the property of her late husband.[12] Otherwise, Wedgwood manufacture seems to have been only indirectly influenced by her style. The Wedgwood Museum, for instance, has a cut-steel fob chain set with two oval blue and white jasper cameos that is simply 'in her manner', and its pendant steel watch case is set with ivory miniatures in Angelica's style. All in all, it is a rather meagre tally.

But the proliferation of engravings after her work, along with their sheer quality, assured her fame. English copperplate engraving was more highly regarded than that of any other nation, even France, where prints of paintings by such artists as Boucher, Greuze and Fragonard were made by leading engravers and circulated all over Europe. Herder, who in middle age would develop an intense, obsessional *amitié amoureuse* for Angelica, owned a Kauffman engraving even as a young man living in Riga; later he would so multiply his stock of such works that the walls of his house in Weimar were lined with them.

Since her pictures were both fashionable and highly accessible in the form of engravings, it is obvious why they should also have been seized

upon by manufacturers of china and other materials used in articles of domestic consumption.[13] Her work formed the subject of enamel paintings on some of the finest specimens of Worcester, Derby and Swansea porcelain, and scenes from Kauffman were constantly reproduced in the kilns of foreign potteries. But while many high-quality pieces were made for display and ornament, others were mass-produced for everyday use. Angelica was fully involved in the entrepreneurial boom that accompanied the early industrial revolution, and which meant that by the end of the eighteenth century ceramic products were available to far more people than ever before.[14] This commercial energy combined, somewhat surprisingly, with the aspirations towards politeness of a newly empowered bourgeoisie that craved wares previously available only to the privileged few. The tasteful modishness of Angelica's designs was perfectly suited to satisfying this new class appetite.

If it is often difficult to determine the precise social status of those who adopted and adapted the polite practices of their social superiors, including their conspicuous consumption as collectors and users, there can be no doubt that a new drive for ownership, together with the means to satisfy it, resulted in a retail surge from which Angelica profited handsomely.[15] Whereas on the continent the development of quality porcelain was largely dependent on the patronage of the ruling elites and aristocratic entrepreneurs, in Britain the making of fine ceramics was mainly in the hands of middle-class manufacturers such as Wedgwood, who were known to adapt the styles preferred by cultivated tastes for the general improvement of their products. Wedgwood produced affordable vases and pots which were within middle-class means but expensive enough to convince their buyers that what they were purchasing matched their aspiration for social regard.

Transfer printing, which had apparently been invented by John Brooks of Birmingham in 1753, also changed the face of ceramic decoration and brought it within the reach of a clientele that had previously regarded it as unattainable. When in 1774 Wedgwood charged Catherine II of Russia £3,000 for a 952-piece dinner service, each creamware item cost only $5\frac{1}{2}$d; the expense was in the decoration, which averaged more than £2 a piece. Nine years later the price for transfer-printing Garrick's dinner service was 6d per item, roughly what each bit of china cost.[16]

This kind of commercial development was paralleled by the expansion of engraving techniques and the education of the public in consumer terms, a public that could be persuaded, for example, to like Angelica's brand of neo-classicism despite its learned associations. It was all a matter of levelling the hills and valleys of national taste and evening out the economic conditions that partly determined it. To accuse Angelica of vulgarising in this regard would be unfair. She softened and made palatable (as she did the potential austerity of antiquity), as much out of personal inclination as because her versions were more marketable. If she was a populariser, it was within intellectually, morally and socially respectable limits. Her procedure, in any case, was in tune with the convictions of some of the age's foremost industrialists and businessmen. Money mattered to them, but so too did spreading the enlightenment of culture to the masses.

If the British aristocracy from whose patronage Angelica had profited did not support the making of fine china on the scale of their continental counterparts and the *haute bourgeoisie* of France, Germany and Austria, they did put money into new china manufactories such as those of Worcester (which favoured and propagated Angelica's designs). Wedgwood tried to win the approval of the high-born by introducing an element of flattering collaboration into production, though it often simply amounted to copying items from their private collections. To an extent this worked; Wedgwood's classically inspired wares bear witness to a highly refined sensibility, both complimentary to elevated tastes and calculated to 'improve' that of the multitude. Yet it seems that chances were also missed. Sir William Hamilton's enthusiasm for Angelica's work, for example, was well known, but Wedgwood, who happily copied vases for his own factory from Sir William's collection, typically ignored her influential designs based on these prototypes. The German artist Wilhelm Tischbein did an engraving from a Hamilton vase that showed Penelope finishing her toilet and about to resume work, and in so doing stimulated what might have been a best-selling production. In Hamilton's words:

The simplicity and beauty of this composition struck so forcibly the amiable and justly celebrated Angelica Kauffman, that with little variation she painted a most pleasing picture from it which she presented to the author of this work. It is to be hoped that

164

this publication [drawings by various artists under Tischbein's supervision] may furnish painters and artists with many pleasing ideas.[17]

But Wedgwood seems to have been curiously loath to follow Hamilton's and Angelica's example.

The Derby porcelain manufacturers were readier to take advantage of her work.[18] Engravings that Bartolozzi, Burke and others had done of her original neo-classical and anacreontic pictures were enthusiastically transferred to figurines and three-dimensional groups: Dickinson's version of her Andromache, Bartolozzi's of *Two Virgins Adorning Cupid*, Burke's of *Cupid Disarmed by Euphrosyne* and many more. The fact that these are today to be found in the Victoria and Albert Museum indicates the quality of the ceramic modelling done after Angelica's compositions. Her influence spread principally because engravings from her work were available to most porcelain manufacturers of the day,[19] and her popularity guaranteed the makers a return on their money.

The designs she did inspired foreign as well as British manufacturers, with the factories at Sèvres, St Petersburg, Meissen and elsewhere adapting her work in its engraved form to their own purposes.[20] Whole services of Meissen, for example, as well as individual items such as cups, were painted with motifs from her most popular pictures – *Ariadne Deserted by Theseus*, *Cleopatra Adorning the Tomb of Mark Anthony* and (particularly in the first third of the nineteenth century) her illustrations to *A Sentimental Journey*. But these ceramic creations were as often in the *spirit* of Angelica Kauffman as closely imitative of her work. Towards the end of the eighteenth century the Vienna manufactory began to use paintings by her simply as the basis for their designs. Pictures with Cupids were especially popular, but Sappho, the Graces, Orpheus and Eurydice (after Burke's engravings) and various nymphs often featured too.[21] Vienna never chose to use her more serious compositions, preferring her picturesque inventions or sentimental adaptations.

The fact that some alleged Vienna ware carries forged signatures has given rise to a myth as potent as that of her personal involvement in the decoration of Adam interiors.[22] Angelica never actually painted designs on Vienna porcelain, and generations of painters would have

been needed to execute all the work signed with her name.[23] The fact is that authentic Vienna ware never bore her signature; it was the fake productions of Bohemia, Germany and Austria that did.[24] These fabrications flooded the market towards the end of the nineteenth century, underlining the enormous residual popularity of her style: if her histories and mythologies on canvas had lost their appeal and commercial value, her rococo and neo-classical work had not. Real Vienna ware retained the genuine links with Angelica that it had had since the eighteenth century, a connection deriving partly from her patronage by the Austrian imperial family.[25] Maria Theresa and Joseph, like Joseph's sister Maria Carolina, had been her enthusiastic supporters, and the special relationship continued.

Further kinds of social and domestic use were found for Angelica's work. The list of engravings after her designs reveals a number published by Anthony Poggi (*Shakespeare's Tomb*, *Veillez amans si l'amour dort*, *The Three Fine Arts*, *The Setting of the Sun* and *Servius Tullius*), at least some of which were intended for use on fans. Fanny Burney's diary records her spending 23 March 1781 at Reynolds's London house with his niece Miss Palmer, who took her to see some beautiful leather fans by Poggi with designs by Reynolds, Angelica, West and Cipriani. 'They are, indeed, more delightful than can well be imagined; one was bespoke by the Duchess of Devonshire, for a present to some woman of rank in France, that was to cost £30.'[26] Reynolds encouraged leading artists to design such 'toys' for daily use, invoking the example of Cellini, who engraved fashionable ornaments. 'Such persons will infuse into these lower departments a style and elegance that will raise them far above their natural rank.'[27] Angelica did specific designs for Poggi as well: Lord Exeter, for instance, owned her sepia and ink drawing for *The Three Fine Arts*, which Bartolozzi would later engrave. Like the designs for other fans of Poggi's, the illustration was deliberately chosen to complement the neo-classical interior in which (it was hoped, at least) the fan would be used. A record of drawings for fan designs owned by Poggi and auctioned at Christie's near the end of the eighteenth century mentions other original designs by Angelica – a bust of Alexander Pope crowned by the Graces, and Venus leading Caestus to Juno.[28]

One fan formerly belonging to Lady Bristol, decorated with the

Angelica-inspired subject of *Telemachus and Calypso*, has a richly carved ivory stick with medallions of a hunting Diana, amorini, terms and fauns, all in imitation of Wedgwood blue and black jasperware. The mount is silk, with border and ornaments spangled in gold and silver, along with more painted Wedgwood medallions.[29] If Wedgwood's direct patronage of Angelica was disappointing, at least others were able to see the natural affinities between them. However, such 'toys' were as often in the style of Cipriani or Zucchi as of Angelica herself, and their loose pseudo-classicism frequently makes precise attribution impossible. Although Angelica cannot have hoped to make much money from her own work as a fan designer, at its peak the fashion for such objects could be a very lucrative business. Nollekens reports that when his wife was a girl the watercolourist and draughtsman William Goupy was thought to be the most eminent fan painter in the country, and the family of the future architect James 'Athenian' Stuart placed him as a pupil with Goupy in the belief that his fortune would thereby be made.[30]

In 1784 a central European review would bemoan the present age, in which 'no-one is interested in anything except prints after Angelica Kauffman and calendars'.[31] They were primarily products of a land becoming industrialised, whose focal points after London were the cities of the midlands and north, and where industries grew up on the strength of new reproductive mediums. Here too Angelica's art was bound to flourish, enriching businessmen as well as contributing to her own steadily increasing fortune.

Toys, buttons, buckles and trinkets made Birmingham a byword for the miracles of modern manufacturing in the eighteenth century: it was a place that simply had to be visited.[32] According to Lichtenberg, who had just been to Oxford, Birmingham and Bath, 'Whoever has not seen these last two places can scarcely say that he has been in England'.

I will only mention that I saw Mr Boulton's famous manufactory, or rather complete system of manufactories, at Soho in Staffordshire, near Birmingham, where seventy persons are daily engaged in making buttons, watch-chains, steel buckles, sword-hilts, cases, all manner of silver work, watches, every imaginable kind of

ornament in silver, and in pinchbeck and other compositions, and snuff-boxes, and so forth.[33]

Birmingham, wrote Lichtenberg, was a very large and densely populated town where almost everyone was busy hammering, pounding, rubbing and chiselling. Soho became a city in miniature after the establishing of Boulton's factory in 1762, and was reckoned one of the sights of the land.[34]

Angelica had settled in the first country to experience an industrial revolution in which machines were doing the work once done by humans, and where technology was replacing craft. The concept of time itself would be revolutionised when processes that had once taken days or hours were performed in minutes or seconds, and where mechanical reproduction transformed the very nature and availability of the visual image. A year before Angelica's arrival James Watt invented the internal combustion engine, the 'new kind of fire- or steam-engine' that Lichtenberg mentions having seen in Birmingham. (Significantly, Boulton later tried to enlist Watt's help in promoting another mechanical manufacturing enterprise.) In 1769 Richard Arkwright would build the spinning jenny, and in 1776 Adam Smith published *The Wealth of Nations*, a work that invented the concept of capitalism and founded the science of economics.

All such processes create a nostalgia for the past at the same time as tending towards abolishing it. The consequence for eighteenth-century England was to make the country a land of contradictions, both Satanic and Arcadian, business-driven yet sentimental. Paradoxically but also logically, Angelica's often whimsical art reconciled the warring currents of history (or myth) and modernity, brilliantly harnessing the creative imagination to a new and unpoetic world of mass replication. Loss and longing, she discovered, could be lucratively marketed through the very mediums that had helped to bring them about; and although perceptions of value and beauty might alter radically with the advent of cheap mass-produced objects, the Kauffman signature still conferred on them a kind of redemptive grace.

One of the new reproductive techniques particularly associated with her is that of 'mechanical painting', a unique and unpatented process invented by Boulton and his craftsmen at the Soho works. Mechanical paintings were aquatints after existing paintings, touched up by hand

once the engraving (probably done by the Eginton family) had been completed, and then varnished to make them look like oils. This last was a skilled process, usually undertaken for Boulton by Joseph Barney of Wolverhampton, who had connections with Angelica.[35] The resulting works were not used merely for wall decorations; they also adorned furniture and coach panels, underlining the ubiquity and adaptability that had brought Angelica her fame in England. The technique was so successful on its own terms that the paintings were barely distinguishable from oils; indeed, some of the 'original' works attributed to Angelica in older biographies were actually products of Boulton's factory. Puzzlingly, though, the enterprise was not a financial success. The main trade, such as it was, consisted in export, and although Boulton attracted some well-known clients, he never achieved the commercial breakthrough that engraving had made in England. Yet his product appealed to many members of fashionable society, and the partnership most closely associated with the use of mechanical paintings in domestic interiors was that between James Wyatt and James 'Athenian' Stuart, architects to the great and grand. One of their most famous enterprises was Mrs Montagu's house, which Horace Walpole called 'a noble simple edifice', without 'vagaries':

> Magnificent, yet no gilding. It is grand, not tawdry, not larded and embroidered and pomponned with shreds and remnants, and clinquant like all the harlequinades of Adam, which never let the eye repose an instant.[36]

Mrs Montagu herself derived great satisfaction from it, and at sixty-one finally felt that she could settle. 'A good house is a great comfort in old age,' she said, and this one was

> so ample for the devoirs of society, so calculated for assemblies that it will suit all one's humours . . . I congratulate myself every hour on having taken the trouble to build for myself.[37]

It is pleasant to think of Angelica indirectly 'helping' to decorate it, though the house was not finished until the year of her departure for Italy.

Elizabeth Montagu wrote that she had 'no opinion of any room of

beauty or state without embellishments by Mr Boulton'. (He was a distant cousin of hers by marriage, and no doubt it was this connection that inspired a writer in *The Observer* to remark that in her salon Mrs Montagu could make 'a Birmingham hardware man stamp rhymes as fast as buttons'.)[38] Accordingly, she ordered mechanical paintings for the ceiling and overdoors of her Great Room in Portman Square, where from the 1780s onward she presided over regular assemblies and a glittering salon. In her earlier Hill Street (Mayfair) days she had confined herself to learned breakfast gatherings – she told Garrick that 'I never invite idiots to my house' – but in Portman Square she added evening 'conversation parties' rather like those that Mme du Deffand held in the rue Saint-Honoré. (For this reason she was called the Mme du Deffand of London.) Guests simply discussed literary topics, and card-playing was strictly forbidden.

Garrick was a frequent visitor, as were Reynolds, Burke, Walpole and Dr Johnson. Dr Johnson seems to have felt ambivalent about Elizabeth Montagu. He encouraged Fanny Burney to attack 'the Queen of the Wits' in her play *The Witlings*, saying: 'Down with her, Burney! – down with her! – spare her not! – attack her, fight her, and down with her at once!'[39] But he also remarked to Mrs Thrale that 'She diffuses more knowledge than any woman I know, or, indeed, almost any man', and Mrs Thrale openly tried to outshine her in conversation whenever they met. William Pulteney, reportedly in love with her, claimed that no more perfect creature had ever existed; Reynolds repeated his words to Burke, who agreed.

For nearly fifty years she reigned supreme as the hostess of intellectual society in London, and her more exotic guests helped to set the tone for fashionable women. Lady Crewe claimed that they took to wearing blue stockings in imitation of the chic but brainless and far-from-bluestocking French visitor Mme de Polignac, Marie-Antoinette's bosom friend; but in fact the word, coined by Mrs Montagu in 1756, was first used of a particular male acquaintance who wore blue rather than black stockings at her soirées.[40] An indifferent painting of 1779 by Richard Samuel, of which there will be more to say, has Mrs Montagu as well as the Swiss-Austrian Angelica among 'The Nine Living Muses of Great Britain' who form its subject.

It is unlikely that Angelica, the friend of Reynolds and Garrick and the highly cultivated star of the London art scene, would not have been

acquainted with Elizabeth Montagu, though whether she painted any original works for her is less certain. No doubt the wealthy hostess could have commissioned or bought some Kauffmans, but without a fortune matching George Bowles's she was scarcely in a position to decorate entire rooms with them. Besides, the originals that Boulton used as models for his mechanical paintings seem mostly to have belonged to him, although occasionally owners lent him their own Kauffmans.

He often favoured literary or historical subjects, such as *Telemachus at the Court of Sparta*, *Penelope with the Bow of Ulysses*, *Imbaca and Trenmore* or *Rinaldo Preventing Armina from Stabbing Herself*. The majority, however, were vaguely anacreontic: *Nymphs Awakening Cupid*, *Cupid Bound by the Graces*, *The Graces Dancing*, *The Graces Dancing to the Music of Love*, and so on. Compared with original Kauffmans they were strikingly cheap, which further underlines their usefulness as decoration. The *Rinaldo and Armina* was priced at £12 12s unframed, *Imbaca and Trenmore* £8 18s 6d, *Penelope with the Bow of Ulysses* £2 2s. Frames cost a fraction of these amounts in addition.

Whatever her personal cultivation, Angelica's own salon never achieved the reputation of Mrs Montagu's, and it is unlikely that she would have wanted it to. She did not seek to shine, and quiet pleasures suited her best.[41] Although she promoted brilliance and enjoyed its manifestations in others, she herself possessed a natural reticence. Polite understatement belonged with the social status she had acquired and wanted to live by, expressing a moral state of being. The prestige she had won demanded decorous conduct, just as the refinement of the social goods she produced presupposed it. The modernity she espoused in her working techniques and (occasionally) in her subjects did not, she thought, preclude old-fashioned niceties. Indeed, in the industrial world to which she was adapting her own artistic practices they were required as a foil to depersonalised production and the general thrust of commercialism. Although she was the force that launched a thousand images, she was a muted presence in society.

There is a great sense of intimacy in the portraits of men and women she did in England – Sir Joshua Reynolds, Theresa Parker, Mary Duchess of Richmond – and in self-portraits such as the gorgeous

171

brown and gold image of the 1770s, now in the National Portrait Gallery. It was furthered by the kind of social relations she preferred. The deep reflection that, according to the Danish diplomat Gottlob Friedrich Ernst Schönborn, preceded her putting pen to paper or brush to canvas[42] was the mark of a woman who had always set inwardness above the external. She was so overwhelmed with work, he adds, that she rarely ventured outside, and her soirées were devoted to artistic company. Antonio Zucchi was in daily attendance.

There are fuller reports of her salon activity when she returned to Italy, perhaps because the Italians are a more exuberantly social race, or because she simply felt that she had more time in middle age to promote friendship and conviviality. Even so, her London days were culturally busy. Music was always to be heard, both in her drawing-room and in the outside world that she from time to time frequented. Johann Christian Bach, whom she had probably encountered in Milan when he was Kapellmeister at the Palazzo Litta, organised public concerts in the capital at this time, and high society flocked to them. In this climate Angelica's own musical talents were warmly appreciated. As early as 1768 the Austrian envoy Count Zinzendorf noted in his diary: 'The paintress was prettily dressed [later her dress sense would be adversely contrasted with Louise Vigée Le Brun's], she sang an Italian air, and played the harmonica, the glass harpsichord'.[43] This was the same Angelica of whom Winckelmann had once remarked that 'She sings with our best virtuosi'.

Her unobtrusive kindness as a hostess, too, was legendary. When the brother of the painter Philipp Hackert, Johann, came to London in 1772 she invited him into her circle, and after he became seriously ill she helped as far as she was able to make his life easy.[44] Goethe's biographical sketch of Philipp Hackert relates how Johann, who had initially met with success in England, went to Bath to seek restoration from the waters as his condition worsened. But he died there before his twenty-ninth birthday, and Angelica, in Goethe's words, had the goodness to have his possessions and unfinished work sent to his brother.[45]

Another young addition to her London circle was Maria Hadfield, who had been a girl when Angelica was studying in Florence. Northcote wrote of her then, 'She plays very finely on the harpsichord, and sings and composes music very finely and will be another

Angelica'.[46] There is no direct mention of the accomplishment for which she would become best known and acknowledged as Angelica's rival, her skill at painting. It was apparently Angelica herself who, in Florence, had inspired the eight-year-old Maria with the desire to be a great artist rather than a musician.[47] Her early teachers were Zoffany and Wright of Derby, who spent some time in Florence during her formative years.[48] But Northcote writes waspishly that

> She had some small knowledge of painting, the same of music, and about the same of five or six languages, but very imperfect in all these [. . .]. She came over to England filled with the highest expectations of being the wonder of the nation, like another Angelica Kauffman. But, alas! These expectations failed [. . . and] in the end, having refused better offers in her better days, she from necessity married Cosway, the miniature painter, who at that time adored her, though she always despised him.[49]

He called Maria 'not unhandsome [. . .] and with a form extremely delicate and a pleasing manner of the utmost simplicity. But she was withal active, ambitious, proud and restless'.[50] At the age of eighteen she had been elected to membership of the Accademia del Disegno in Florence as a 'pittrice inglese'; from there she moved on to Naples and Rome, where she met Batoni, Mengs, Maron and Fuseli (whose 'extraordinary visions struck my fancy').[51] Her mother recalled her and they set off for London, probably because the widowed Mrs Hadfield was tired of innkeeping. ('Carlo' had died in 1776.) They arrived in late 1779, and Maria would later remember being confident of her entry into London society because she had letters of introduction to Reynolds, Cipriani, Bartolozzi and Angelica.

Between 1781 and 1789 she exhibited more than thirty historical paintings at the Royal Academy, though few of them have survived. Those that have seem to show the influence of Reynolds, Angelica and Fuseli, but most critics disliked the Fuseli-inspired works. Like Angelica, she attempted to illustrate Ossian, painting a picture of *Athan* for the 1783 Academy exhibition, but seemed as little inspired to excellence by Macpherson as Angelica had been.

Angelica took Maria and her mother under her wing. They temporarily lodged with her in Golden Square before moving to rooms

in Berkeley Square and then Hanover Square.[52] Angelica also introduced Maria to useful members of society, taking her to Charles Townley's treasure-filled house in Park Street – now Queen Anne's Gate – where she met Reynolds, Giuseppe Baretti, the composer Parsons, the orator Henry Erskine, Thomas Jefferson (with whom she would later fall in love) and Richard Cosway. Her marriage to Cosway – at which Angelica was a witness – surprised society, though her former lover Prince Hoare (then a painter but later a writer of musical farces) was untroubled by it; he said that he, at least, had recovered his senses.

In some respects Maria did follow in Angelica's footsteps after her mentor had returned to Italy. She held brilliant soirées attended by the *bon ton* and members of the Prince of Wales's set,[53] but she liked moving in worldly circles more than Angelica did. Still their relations remained cordial, and after a difficult confinement Maria named her daughter Louisa Paolina Angelica in recognition of the help Angelica had given her and her family at a trying time.[54] She very quickly deserted husband and infant for a stay of more than four years abroad, seemingly prompted by post-natal depression, but at the age of six Louisa suddenly died. For a long time the grieving parents kept her embalmed body in a marble sarcophagus in their palatial drawing-room at Schomberg House, Pall Mall, the very place where Angelica's later Naples acquaintance Emma Hamilton first tried her talents at adopting 'attitudes'.

Angelica's huge celebrity could scarcely have occurred anywhere but in Britain. The excellence of English engraving ensured her appeal both to connoisseurs and to the public at large, while the nature of the print market guaranteed her worldwide fame: engravings after her work may, for example, even have reached China, which in a bid to rival Western production started exporting to Europe much less expensive articles than those produced by Meissen, Sèvres and the like. The cheapness of less exalted printed matter similarly diffused her designs more widely than she can ever have anticipated; ephemera such as invitations to concerts and galas, engraved with Kauffman motifs by the likes of Bartolozzi, underlined her ubiquity without cheapening her name. Her association with novels such as Sterne's *Sentimental Journey* and Burney's *Evelina* opened another market to her: she

eagerly adapted her art to illustrating best-sellers of the day – Pope's *Eloisa to Abelard* and Macpherson's *Ossian* were two others – and enjoyed the kind of cult status that later ages have reserved for popular singers and actors (but never, since Angelica, female artists), finding new enthusiasts in Russia, the Far East and the New World. In addition to all this, she continued in her acknowledged and lucrative forte of portraiture, which no country other than Britain could have rewarded so handsomely. Her boldness in coming to London in 1766 had more than paid off: while she spent the greater part of her life in other countries, this had indeed been her promised land.

Why, then, did she decide to leave England, where she had enjoyed unheard-of artistic and social success – royal favour, aristocratic patronage, academic honour, establishment approval and popular acclaim so enormous that she was regarded as an honorary English-woman, a source of national pride? Probably for a number of reasons, although the hostility she had occasionally encountered is unlikely to have been among them. Perhaps she still yearned to paint histories for a public that would appreciate them; but she was also worried about her father's frailty and concerned by his anxiety over the imminence of war (which, unbeknownst to them, would not be avoided by their leaving for Italy). Although Johann Joseph had written to Schwarzen-berg on 23 February 1779, 'thank God, we can't complain', he had added: 'None the less we are trying to leave the country as soon as possible', mentioning unrest in England and a rebellion in Scotland between Calvinists and Catholics. The previous year he had noted, 'Because of the American War one doesn't know if one is coming or going.'[55] Angelica had been unsettled too by the Gordon Riots, as Schönborn informed Klopstock:

> The good lady has had a great fright at the recent uprising, because she is Catholic, and has had to keep all her things packed away. All this has greatly affected her health, which is anyway very precarious . . .[56]

Although she must have felt that her situation was genuinely unstable, she was also allowing her underlying depressiveness to assert itself. Nor, as Schönborn notes, was the state of her own health reassuring, for when she and her father had finally readied themselves to leave

London she fell ill and was forced to take to her bed. 'This week she suffered an attack which alarmed me, she had a sore throat and the first signs of a putrefying fever.' A psychosomatic explanation for this might also be ventured, that Angelica was both eager to leave England and alarmed at the possible consequences of doing so.

From a professional point of view it seems unlikely that she was dissatisfied with her adoptive country, whether or not she felt regretful about the relatively few historical paintings she had been commissioned to do there. True, the initial flurry of excitement in the press at her arrival had given way to comparative silence, and there are (as her biographer quickly realises) comparatively few allusions to her in contemporary letters and journals. She often visited Dr Burney's house,[57] but his daughter Fanny mentions her only once in her diary. Mrs Delany's references are confined to a single letter, and Horace Walpole simply gives her a curt acknowledgement in some catalogue notes. Farington is fuller, but never intimate.

Sturz, who spent his working life in the service of the Danish Crown, devoted one of the five letters on England he wrote in 1768 to Angelica. (The others describe a visit to Dr Johnson, Garrick, Garrick's writings and the English constitution.) His remarks on Angelica are balanced rather than rhapsodic. He emphasises her uninsistent charm – 'one is never fleetingly aware of her, but she holds the observer's gaze; there are even moments when she makes a deeper impression' – while dissecting her art coolly. Its familiar faults are unforgivingly rehearsed, despite Angelica's youth:

> As a painter she is lacking in important elements of the art: she does not draw altogether correctly, and so has to avoid dense, busy compositions; even in her individual figures she dare not venture difficult poses or any foreshortening; she is uncertain and fearful in her anatomies, even if the general relations are right: so her outlines, especially hands and feet, are not always correct. People find her colour cold and alien, her shading monotonous, and there is a violet mist wafting over her flesh tones, and yet the colours of her costumes are too dazzling, and do not blend with the tone of the whole. She also has little notion of aerial perspective, and none at all of accessories, landscape, and especially backgrounds . . .

176

But there is, happily, much to compensate:

> She makes up for all these failings with touches of beauty. Her works are profound, *sensu tincta*: she very wisely selects a simple, easily comprehensible action, the moment before a decision is made, when our interest is heightened by anticipation and our imagination has a deliciously free rein; her forms are full of grace, quite according to the Greek sense of quiet dignity; and in her female figures there is a very personal, inimitable womanliness, an inwardness, a yearning, such a moving giving of themselves, such a consciousness of sexual dependency, which captivates all male connoisseurs.

He then makes the familiar remark about Angelica's men looking like women in disguise, as far from the heroic or criminal as it is possible to imagine.[58]

The fact is that Angelica's inadequacies were generally forgiven her on account of her strengths and seductions. Truth might demand that her faulty technique be relentlessly brought to the public's awareness, but fashion and fondness dictated otherwise. So her favour continued: she did not flourish as a result of the premise that woman's art is essentially inferior, but she did prosper by virtue of being a female artist of whom certain things would not be expected and in whom certain things would be more or less easily tolerated. On the other hand, she had undoubtedly had to work for the success she enjoyed. During her journey through British society possible failure had presented itself in a variety of forms – the native indifference to history painting, the hum of scandal, the academic weakness of technique – yet she had managed to surmount them all with greater or lesser éclat. She had not been thwarted by adventitious circumstances, but had disarmed hostility with a mixture of professional skill and almost superhuman purity of character. The realms of imagination that she inhabited in her art exalted her, while the practicalities of commercial life anchored her firmly in the workaday world. It seemed an enviably secure compromise.

But it could not last. Although, as Schönborn would claim to Klopstock on 19 October 1781, her 'fragile old father' had held her up in England for two years longer than she had intended ('she is a model

of filial tenderness'), she was determined to go once she had cleared the backlog of commissions that had accumulated during her own ill health. Family loyalty was more likely than public duty to dictate her movements, but she still felt concern about the clients as well as friends she would be leaving behind.

One other thing remained to be accomplished before she left. Antonio Zucchi must become her husband.

Chapter Nine

'Roma mi è sempre in pensiero'

This marriage was a less bizarre arrangement than many have taken it to be. Zucchi had lived in England for as long as Angelica, and was as ready to leave; he was the practical sort of man whose support a celebrity artist uprooting herself from a familiar culture and burdened with a querulous old father might welcome; he understood her professional needs and routine, being a good and successful painter himself (if not so outstanding that playing second fiddle to Angelica would be demeaning); and he had apparently become very used to her company.

In October 1779 Schönborn had written to Klopstock from London:

A daily visitor [to Golden Square] is a certain painter called Zucchi, who has been here in England for over fifteen years and is a very good artist as well as a good man, to whom she is promised and whom she is to marry in Italy...[1]

This does nothing to clarify the matter of Angelica's feelings about taking such a step, an issue Rossi would evade with the flat affirmation that Zucchi had never thought of her as a prospective wife.[2] Johann Joseph, he suggests, wanted the match, and when friends also impressed its desirability upon Zucchi the latter agreed to it. But perhaps we should be sceptical about what Rossi says. His informant in this respect seems to have been Johann Joseph himself, and no doubt it pleased a still possessive father to make an adored daughter's relationships appear unthreatening affairs of common sense, particularly as she herself had been traumatised by the circumstances of her first marriage. (Princess Bariatinsky later remarked that Angelica had remained fearful of contracting any close ties after this disastrous union.) Propagating the view that the intended marriage was one of

179

convenience rather than passion probably suited Angelica and her father equally well.

Zucchi himself did little to dispel the notion that practical considerations had dictated the engagement. He announced his plans to his patron Sir Roland Wynn, the owner of Nostell Priory, in terms that sound measured rather than enraptured:

> The report you heard of the intention I have to enter into the conjugal state is not without foundation, and I hope it will contribute much to my felicity, as the person who is to be my companion is in every respect agreeable to my wishes, and her merit as an artist is sufficiently known to the world by the greatest [sic] number of prints published after her works.[3]

Perhaps the emphasis on 'my felicity' is a little surprising, and the choice of the phrase 'agreeable to my wishes' slightly disconcerting. One almost wonders who is conferring a benefit upon whom – the fifteen years older and less successful man upon the celebrity woman, or the frail woman in need of a new manager upon the worldly-wise man? But it is no doubt misguided to see Zucchi as intent on securing his own satisfaction at the price of his future wife's; he seems to mean no more than that he and Angelica have the same aspirations and values. And 'companion' does not really suggest a lack of love. Zucchi is, after all, writing to a grand patron in a language foreign to him, and trying to sound as weighty and dignified as the occasion demands.

He had become a man of some substance during his years in England. Apart from a large house in Soho which he shared with his brother Giuseppe (an excellent copperplate engraver) he owned the freehold on a house in John Street, Adelphi, which he let out for £90 per annum,[4] and he was in regular employment. If, as some implied, he saw personal advantage in marrying Angelica, it was probably not of a financial kind. Rossi remarks that his health was precarious (though presumably it was far more robust than Johann Joseph's), his hand had become tired and shaking, and he had decided that a return to Italy would be beneficial.[5] On the other hand, he was far from being the Harpagon of popular myth. Although Farington makes him sound a man in his dotage compared to his wife-to-be – nearly seventy to her

forty-eight – in fact Zucchi was fifty-five when he married the thirty-nine-year-old Angelica.

The habit of denigrating him dies hard, but it could scarcely be less justified. It is bad enough that he should be criticised (by people who, like Herder, had no personal knowledge of the matter) for not being a 'full' – that is, presumably, sexually active – husband to Angelica, but for him to be called a third-rate painter as well is monstrous. Pasquin may have considered Zucchi to have 'no sufficiency in the art',[6] but Pasquin's judgements are notorously untrustworthy. A more reliable indication of his merit is the fact that his decorative works have sometimes been attributed to Angelica herself. Kenwood, with its remodelled Adam interior, has or had a number of works by Zucchi – the central ceiling roundel of the entrance hall, for example, and some lost ceiling paintings (which, according to the Royal Academy records, were by 'Antonio Zucchi, a Venetian painter *of great eminence*)[7] of Diana with nymphs and dogs.

It is generally considered a charming style, though some commentators disagreed. Sir William Chambers expressed a strong dislike for this form of decoration, exemplified (according to him) by the 'trifling gaudy ceilings now in fashion, which, composed as they are of little rounds, squares, hexagons and ovals, excite no other idea than that of a dessert upon the plates of which are dished out bad copies of indifferent antiques'. Another contemporary saw Robert Adam as 'a certain compounder of ceilings' decorated with 'cheesecakes and raspberry tarts'.[8] But favour for Adam ran stronger than distaste, and Zucchi was one of his right-hand men.

There is no evidence whatsoever to support the romantic story that Angelica and Zucchi met and fell in love while working at Kenwood, where Zucchi was certainly employed in 1769.[9] On the other hand, there is reason to believe that Angelica may actually have been inspired by some of Zucchi's decorations in her own historical and mythological works. In 1767 he did a *Hector and Andromache* for Robert Child's Etruscan Room at Osterley Park, one year before Angelica painted them in the Saltram picture.[10] The central roundel in the entrance hall at Kenwood is of Hercules caught between glory and the passions, and the wall frieze in the library depicts the same heroic choice, one that Angelica would later translate into a celebrated self-portrait. Finally, Zucchi decorated Sir Watkin Williams-Wynn's London house between

1772 and 1776 with pictures of the Judgement of Paris and Bacchus and Ariadne, again anticipating later mythological treatments by Angelica (who would return to the theme of Bacchus and Ariadne that she had first broached in 1764 thirty years later).[11] For these he was paid £332, a large part of what Farington estimates as his total earnings in England.

Zucchi's own decorative work at 20 Portman Square, Home House, was attributed to his future wife, and it is certainly true that some of his themes, if not actual designs – *Virgil Reading the Aeneid, Hector Challenging Paris to Enter Battle, Telemachus Returning to Penelope, Paris and Helen* – are too close to Angelica's later history paintings for the likeness to be accidental. On the other hand, many such Homeric or Virgilian subjects were common property after Caylus's publication of suggested themes from the two authors. On balance, it seems more likely that Angelica was influenced by Zucchi than the other way round.

True, her portrait of him makes Zucchi look too sober a man to have devised and executed such charmingly playful decoration as he did for houses like Saltram, with their ceiling paintings, medallion heads, landscapes, ruin capriccios and assorted overdoors, but appearances are clearly deceptive here. Is it significant that his thin-faced seriousness closely resembles that of Angelica's beloved father, at least to judge by the portraits she did of them? Zucchi was clearly cultured, learned and experienced, and there is no good reason to doubt the companionship he gave Angelica, and which he refers to in his letter to Sir Roland Wynn. Schönborn, whose *tendresse* for Angelica possibly made him a jealous witness, reported against Rossi that Zucchi had

long sought to win Angelica's inclination, he is, as far as I know him, a thoroughly decent man of good sense. May the devil take him if he should show himself differently with her as her husband from when he was a respectful and imploring suitor.[12]

His circle of friends was wide and cosmopolitan. One of its more remarkable members was Jean-Paul Marat, whom Zucchi is said to have met at Slaughter's Coffee House in St Martin's Lane, a favourite gathering place for foreigners.[13] According to Farington, the Frenchman came to Zucchi's house 'in the most familiar manner'[14] and had a

knife and fork laid for him there every day, though he rented his own lodgings in St Martin's Lane. Zucchi had the highest opinion of his abilities, again in Farington's words, and Marat, '[being] a man of extensive classical reading, [. . .] continually proposed subjects which he had selected for Zucchi to design'.[15]

As a physician, Marat was seemingly accomplished too, curing Giuseppe Bonomi of unspecified but serious complaints on two or three occasions.[16] He had, says Farington, an original way of thinking in his professional capacity, as was noticed by the apothecary who made up his medicine, and he acted against accepted rules. However, there was a negative side to Marat's contempt for norms and conventions. The Frenchman borrowed about £500 from Zucchi at different times, and could not repay it.

On balance, the picture Farington paints of him is a mistrustful one. He was

a little man, about the size of Cosway, the painter, slender but well made. Of a yellow aspect, and had a quick eye. He had a great deal of motion, seldom keeping his body or limbs still. He was thin, discontented, and abused the establishment which existed. This was about eighteen years ago, when Marat appeared about forty years of age. Zucchi at that time courted Angelica Kauffman, the artist, and frequently took Marat with him in the evenings when he went to visit her.[17]

Later Marat would boast to his fellow revolutionary Jacques Brissot de Warville that he had seduced Angelica, but it seems the height of unlikelihood. He is, however, known to have dedicated his *Découvertes sur le feu, l'électricité et la lumière* to her.

Rossi reports that Horn opportunely died in the middle of Angelica's efforts to have her first marriage annulled.[18] In fact she had obtained a papal annulment in 1778, before her husband's death in 1780, but the latter event alone seemed to this devout woman to represent true dissolution. It meant that she was free to marry Zucchi in the eyes of the Catholic Church. The marriage contract, a typically businesslike document, is remarkable for its single-minded determination to guard Angelica's interests, and hers alone. It reads as follows:

Deed of Trust and Marriage Settlement, executed on July 10th 1781, 21st year of George III's reign, between Antonio Zucchi, parish of St Ann, Soho, painter, 1st part; Angelica Kauffman, of Golden Square, Bloomsbury, spinster, 2nd part; and George Keate Esq., H. Peter Kuliff, merchant, and Daniel Braithwaite of the General Post Office, 3rd part –

To put in their hands as trustees the sum of 3,350 l., 3% consolidated annuities, 1650 l. 3% consolidated reduced bank annuities –

For the use and benefit of said Angelica Kauffman, whether sole or convertible. And to enable her to enjoy the dividends thereof exclusive of the said Antonio Zucchi, her intended husband, who is not to intermeddle therewith; nor is any part thereof to be subject to his debts; and is also to give her power to leave the said sums by will as she shall appoint.[19]

The tenor of this cannot have been particularly pleasant to Zucchi, however common such celebrity contracts have since become. Given that he was likely to die before Angelica, the clause concerning her right to dispose of her estate as she wished is unlikely to have irked him. The express prohibition on his 'intermeddling' with her capital must have seemed insulting, however, even if Angelica's sad experience with Horn appeared to excuse it. The law gave husbands power to dispose of their wives' fortunes, but since the end of the seventeenth century legal provision had existed whereby trusts might be set up for the purpose of giving wives sole and separate use of their capital. This is precisely what Angelica wanted to arrange.

If Zucchi was indeed aggrieved at the tone of the contract, his neglecting to provide for Angelica in his own will might seem an explicable act of retribution; but nothing of the sort seems to have been intended. Angelica was a wealthy woman, if one who would worry increasingly about her financial position in old age amidst the upheavals of war-torn Europe, and the half-interest in some short-term annuities that her husband did leave her was a token rather than a financial necessity. Zucchi's family would inherit the bulk of his estate. In any case, he had means of his own – the house in John Street, the annuities and various sums of money lent out to different friends on which they were supposedly paying interest (though Marat was

evidently a defaulter). And, to settle the matter, Angelica herself expressly sanctioned Zucchi's action in cutting her out of his will for the purpose of attending to the needs of his own family, writing to the Kuliffs: 'I have a high regard for what he has done in favour of them'.[20]

That being the case, it would be unwise to read any more into this document. Angelica did not know Zucchi's family well, and felt that her material loyalties lay elsewhere. If the tone of the contract suggests to modern readers that she mistrusted her husband and was aggressively determined to set her welfare above his, the truth is more likely to have been that she did not want to suffer again as she had suffered once before from failing to exercise caution over a marriage, and (possibly) that she resented the automatic powers that eighteenth-century husbands had over their wives' property. We have to remind ourselves that Angelica was as much the unsentimental businesswoman as the unworldly, ethereal artist of public myth, and that she kept art and business separate as often as she combined them. While she was working she needed to feel unclutteredly creative, and Zucchi answered perfectly to her desire for a practical and undemanding organiser.

In other words, she made a match that left her as free as possible to concentrate on her work, thus demonstrating again her absolute control of her existence both as an artist and as a woman. Her personal life was simply an extension of her professional one, and perhaps always had been. Zucchi was exactly the right man for her in this respect. Rossi says that he adored Angelica not as a wife but as an artist; in effect, he 'nursed' her possessively (though Angelica never really allowed anyone to possess her) as he might have done a precious work of art or a commercial speculation. The breadwinner had to be kept in good health, as did the genius; the fact that they were one and the same person simply meant redoubling the care and attention she received. While Zucchi lived, his wife felt entirely secure in his guardianship, and sometime before his death she took on another male, her relative Johann Kauffman, to play the same vital role. Zucchi was her major-domo, and more than that; for there is little doubt that Angelica became deeply fond of him, whether or not she had felt that fondness from early on. But if she had agreed to marry him, he had to accept her on her own terms. The marriage contract makes that perfectly clear.

There were those who believed with Goethe that Zucchi later forced Angelica to work more than she wanted or needed to, simply because he had become used to enjoying the fruits of her labours. That does not square with the many reports of the couple's harmonious relationship, the loving care that Zucchi took of his wife and the plentiful evidence of artistic insecurity that made other female painters overwork in much the same way as Angelica. If the dynamics of the couple's relationship were unclear to some outsiders, they were apparently obvious to Angelica and Zucchi themselves. There is nothing to suggest friction between them and, despite the rarity of contemporary documents relating to Angelica's life in general, remarkable unanimity on their fondness for each other. It would be wise to leave the matter of their precise affections there.

Rossi emphasizes the qualities that endeared Zucchi to Angelica: his energetic eloquence, his brilliant pictorial perceptiveness and his ability to make his listener see and understand what he described.[21] The portrait Angelica painted of him sometime after 1782, which shows him pointing confidingly or magisterially towards a building he is sketching, underlines his attentive, possibly slightly donnish nature. They made a good team.

Schönborn, who reported that Angelica was hoping for spiritual nourishment as well as cheer from her return to Italy, was unwilling to admit to any signs of artistic exhaustion in her. 'She is unbelievably productive. What a quantity of paintings here in England alone. Everything she does is snapped up.'[22] We have heard this phrase before, both in her excited early letter home to her father and in the engraver's assessment of the world's Angelicamadness. England, on this evidence, was decidedly reluctant to let her go.

The party finally left on 19 July 1781. In a letter of 19 April 1805 to her young Scottish friend Captain Robert Dalrymple Angelica recalled the first part of their journey:

> Your letter is dated from Chatham, which place I have seen when I left England [sic] on my way to Margate where I embarked for Ostend. At Chatham I was recommended to a gentleman by whose means I saw a Man of War then in that port. A most beautiful sight indeed, and what surprised me was to find at the same gentleman's house a small but chosen collection of pictures

kept with the greatest elegance. I saw also the cathedral at Rochester, a most beautiful Gothic building.[23]

The Zucchis and Johann Joseph were accompanied by Angelica's cousin Rosa and Giuseppe Bonomi. According to Rossi, Rosa had been distressed at the thought of leaving England after so many years, and Angelica had thoughtfully provided her with a husband to cheer her up.[24] If this suggests that the spirit of marriage-making was contagious, the truth seems to be that Rossi is confused. The couple's son was at that time four or five years old, and the marriage dated from 1775. There is no need to suppose that it was a match of pragmatism rather than inclination: Bonomi might have been regarded as quite a catch for the little cousin, now surely in her late twenties or thirties. He had been born in 1739, and earlier in his career had spent about fourteen years working for the Adam brothers, who had originally persuaded him to come to England. He was employed by them mainly to do interior decorations, though when he set up on his own he became known as an architectural draughtsman of impeccable taste. He contributed designs for the house that Wyatt and 'Athenian' Stuart built for Mrs Montagu, and despite the rebuffs he kept receiving from the Royal Academy was valued enough as a professional to be elected an associate member. His friend Reynolds's regard for him is known, but others too rated him highly. He would return to England with Rosa after the death of their small son within a year of their arrival in Italy and pursue a successful independent career.[25]

The party sailed to Ostend and made their way slowly towards Austria. Once in the country they headed for Schwarzenberg, and seem to have spent about a month with Kauffman relatives.[26] Reports speak of the charity which the now wealthy Angelica showed towards the poor villagers, seeming to them like an angel bestowing rich gifts. Her generosity was even greater than it appeared, and dated from far back. For although Johann Joseph had invested a sum of money in Austria and given much of the interest it earnt to the needy of the parish, the original capital had been made over to him by his daughter. 'I gave almost half of what I earned during the time I was in England to my blessed father, and he has invested it for his own use.'[27]

During their stay Angelica painted another portrait of herself in the

Bregenz Woods regional costume, and for once depicts herself as a rather tired-looking artist, no longer bent on impressing the observer with her eternal youth. (One she did three years later for Count Firmian makes her look younger.) It was clearly an image that she wanted to be truthful as well as loyal to her supposed roots.[28] Yet there is still a touch of coquetry – her broad-brimmed hat is tilted alluringly to one side – in the presentation of a 'native' who wears her hair in plaits, wound around her head and left to fall onto her shoulders according to Bregenz Woods custom.

Despite doing some more painting en route, Angelica was bent on reaching her new goal. Their journey took them via Verona and Padua to Venice, where they arrived on 3 October 1781. Venice was Zucchi's home city, and his many relatives greeted the party.

Angelica's name was already well known there, but Rossi makes the sequel to her reception sound extremely dramatic. *La toute Venise*, he claims, swarmed to see her after an unexpected and highly gratifying visit from the travelling Tsarevitch Paul and his wife Maria Feodorovna, a significant visit because it ushered in patronage from other Eastern European clients over the following years. This was, on the face of it, entirely beneficial to Angelica, since the move from England meant that she needed to identify other lucrative markets, yet it hardly gave her the new freedom that Schönborn had assured Klopstock she would find and turn to good account in Italy. The floodgates may not have opened quite as wide as Rossi implies, but Catherine II's artistic agent in Italy, Angelica's old friend Reiffenstein, alerted the Tsarina to her collectability and began to place orders with her.

The Tsarevitch too wanted some of her work. Almost as soon as she had settled in a house on the Campo di Guerra by the church of San Giuliano, north of St Mark's Square, the imperial couple arrived and appropriated the picture of *Leonardo da Vinci Expiring in the Arms of François I* on which she was then working, even though another client had commissioned it, as well as the two canvases of King Edward I and Queen Eleanor. They also asked Angelica to paint their portraits later on in Rome, although this commission fell through when they were obliged to leave Italy sooner than expected. However sincerely Angelica might have hoped to be less busy in Italy, she would normally still have rejoiced at her apparent breakthrough. But circumstances had suddenly changed. Two weeks before the visit of the so-called

Comte and Comtesse du Nord (the imperial couple's incognito), she had sustained a devastating loss.

Johann Joseph had died on 11 January 1782 of influenza and bladder trouble,[29] leaving his daughter to suffer agonies of grief that made work and ordinary human intercourse seem both futile and barely endurable. She must somehow have preserved appearances in the presence of Paul and Maria Feodorovna, but her letters after her father's death make one wonder how. To Anton Metzler, a prosperous wool-merchant from Schwarzenberg, she simply wrote: 'My sorrow is indescribable'.[30] All the old irritations associated with Johann Joseph's possessiveness and interference melted away. What remained was the consciousness of her father's care and protective love for her, his moulding of his daughter's career and his charity.

She did what she could to honour him, burying him with appropriate ceremony and having masses said for him. But months after his funeral she still felt the pain of loss acutely. By then her grief was no longer simply for her father, for Johann Joseph's sister, who had come to Venice from Morbegno to look after him during his illness, died herself on 6 February, less than a month after her brother. 'She loved me like a mother. In return I gave her all my childish love, honoured her in life and in death. God give the beloved souls eternal rest, and grant me the grace to submit to His divine will.'[31]

With heroic endurance Angelica carried on painting, if almost mechanically and without the new insights she had told Schönborn she hoped to find in Italy. But nothing diminished her suffering. 'The sorrow in my soul from the loss of such a beloved father and beloved aunt has barely lessened, if at all. It is a wound in my heart which will never heal as long as I live.'[32] Her election to the Venice Accademia on 8 April 1782, an honour that at other times would have raised her spirits, now seemed empty of significance.

She needed to move on from a city that she, like others at the end of the eighteenth century, was beginning to find sinister and threatening despite its overwhelming beauty, and whose mournful associations she could not put out of her mind. The lure of Rome was still strong, and the depleted party set off in its direction in mid-April, travelling via Ferrara and Loreto. On arrival, however, they seem to have thought it best to move straight on to Naples. Naples had a better spring and summer climate, and Angelica wanted the house she had settled on in

the capital, Mengs's former home at Via Sistina 72, to be fitted out in appropriate style.

Yet however sensible it seemed to travel further south, Angelica knew that the capital had more to offer her professionally. Still grieving, she could not begin to explore such possibilities immediately, though her dormant appetite may have been whetted by the implications of Tsarevitch Paul's interest in her work. She cannot have been unaware that in returning to Rome she had stepped into a near-vacuum that she was particularly well placed to fill. Virtually all the artists who had been in the city during her first stay there, or whose influence was still to be strongly felt – Parrocel, Natoire, Mengs – had died. Vien, the promoter of a rather perfumed neo-classicism that in some respects resembled Angelica's own, returned from Rome to France in 1782, the year of her arrival. Of the older generation of painters her only potential competitors were an ageing Batoni, Mengs's son-in-law Anton von Maron, and Gavin Hamilton, who was by then far more interested in dealing and exploiting the excavations at Herculaneum and Pompeii. The young Turks who would usher in a newer style – David and his contemporaries, and Flaxman – were not yet settled there. She had chosen a good time to return. But her old acquaintances Winckelmann and Cardinal Albani were dead, and she found Rome a different city from the one she had known nearly twenty years before. So she left her steward Gioachino Prosperi with instructions about the fitting-out of Via Sistina 72 and departed.

Once, it seems, she had intended to settle in Naples for good, and had even had her harpsichord transported there. But a letter she wrote in June remarks that although 'The area is exceptionally beautiful, [...] Rome is the seat of the fine arts'.[33] In other words, her brief reacquaintance with the capital had convinced her of its absolute centrality to the life she now hoped to lead. Her plan was to combine residence in the two places, starting commissions in Naples where possible and completing them in Rome. The success of this scheme would depend to a great extent on the nature and understanding of her patrons and clients; but here, as always, she seemed either to have calculated well or to have struck lucky.

Thomas Jones records an October visit to 'Madama Angelica, lately arrived at the Albergo Reale [in Naples] from Rome with her husband

Il Signore Zucchi',[34] and lists the names of people he found at her levée: the scholarly Dr Cirillo, the Italian painter Giovanni Passeri (whom Sir William Hamilton employed as a restorer of vases), the French volcano-painter Pierre-Jacques Volaire and two Polish artists. In due course Queen Maria Carolina would attempt to lure Angelica away from her rented apartment to the luxury of a suite of rooms in the royal palace, but Angelica fought hard to preserve her personal and artistic freedom. Not that she spurned flattering royal commissions, for writing to Metzler after this trip was over, probably in November, she reports:

> In the meantime I have the honour of painting the entire royal family, that is, Their Majesties the King and Queen, three princes and four princesses. All in one picture which I have permission to complete in Rome, after promising that I will return to Naples to hand over the picture in person to Their Majesties.[35]

The Neapolitan stop-off, it had become clear, was not to be one of the *villeggiaturas* Angelica mentions in her letter to Metzler apropos of the revised plan to live in the capital and occasionally leave it for refreshment elsewhere. ('It may be that we shall base ourselves in Rome and every now and again go on little pleasure-trips.')[36] The main reason was the insistent enthusiasm of the Queen, though it seems likely that Sir William Hamilton was also responsible for helping to find Angelica other clients in the city and so keep her busy. Maria Carolina had assembled a huge collection of prints after Angelica's work and wanted to stake a further regal claim. She largely controlled patronage at the Naples court, as she controlled her boorish husband and a great deal else, and she was particularly fond of artists of Austrian, German or Swiss origin – Füger, Angelica, Mengs, Tischbein and the Hackert brothers. In Angelica, as, equally bizarrely, later on in the case of Emma Hamilton, she believed she had found a kindred spirit. Angelica was too polite and diplomatic ever to disabuse her, but she unquestionably found the Queen both demanding and difficult.

In this she was far from alone. Maria Carolina was a fearsome woman, though she inevitably inspired sycophantic praise in many of those who had dealings with her. (A very ugly portrait of the Queen sometimes attributed to Angelica, at present in the Neapolitan Museo

Civico Gaetano Filangieri, perhaps gives the measure of the artist's true feelings about her, since it is about as far from the heavily idealised image of the group portrait Angelica painted as it is possible to imagine.) A mother who had borne her loutish husband seventeen children, and had more or less successfully endured him since her early marriage at the age of sixteen, she was manifestly not a person to be trifled with. Napoleon loathed her, and she returned the compliment: if for him she was an Athaliah and a Fredegunda, a Fury and a Messalina, for her he was the scourge of Europe, Attila, a wild beast and 'archlump', a hydra, a devil, a Corsican bastard, a dog and a monstrous, despotic parvenu majesty.[37] But Emma Hamilton professed to adore this terrifying woman, and Emma's lover Nelson declared that he would choose Maria Carolina as the monarch of the entire universe if he had the power. Catherine Wilmot, less reverentially, noted in the journal she kept during her travels in Italy with Lord and Lady Mount Cashel that the Queen was 'a wicked politician'.[38]

Clearly she was not someone who could be ignored. Angelica fought off some of her demands, it is true:

> I was received very graciously by the court, particularly by Her Majesty the Queen. I was offered pensions and every imaginable token of regard to persuade me to stay. But, thank the Lord, my circumstances permit me to preserve my freedom.[39]

Yet the request to paint a group portrait of the royal family was as flattering as the picture itself proved to be. It was also, she must have suspected, likely to be an extremely lucrative commission. The group portraits she had painted in Ireland had given her a taste for composing relatively informal conversation-pieces, and she was keen to adapt the formula for the depiction of a royal family. In fact the picture is closely modelled on Mengs's *Parnassus* (1761) in the Albani collection, which Angelica knew well from her first trip to Rome, and it confirmed her tendency to depict the socially elevated rather stiffly. The preparatory sketches are much bolder in this respect, full of the life and character that was leached out of the finished article as Angelica began to worry about breaking the mould of deference and conventionality that courtier artists had to preserve. But when she delivered her work in 1784, Ferdinand and Maria Carolina were

delighted. As two ill-favoured but outrageously 'improved' sitters, they had every reason to be.

Ferdinand, in particular, has been transformed, and his Bourbon features are virtually unrecognisable. Angelica has adroitly disguised the huge nose of the monarch known as 'il re nasone', and covered over the general coarseness to which the Margravine of Anspach refers in her memoirs. Catherine Wilmot's judgement was unsparing:

> The King looks like an overgrown ass, though in his demeanour he is exceedingly civil; however, his face surpasses any abridgement of imbecility I ever saw in all my life, and the vulgar debauchee reigns triumphant throughout his majestic exterior.[40]

Surprisingly enough, the Margravine of Anspach still thought the expression of Ferdinand's countenance 'rather intelligent, perhaps even agreeable', and commented that the King reminded her of a rustic elevated by accident to the throne.[41] Ferdinand's childish rumbustiousness, she added, was to be blamed on his father, who had been so alarmed at the imbecility of his eldest son that he had instructed Ferdinand's tutors to spare him all profound study. This gave Maria Carolina her way in. Her husband, whose greatest pleasure lay in slaughtering wild animals in the company of the hapless envoy Sir William Hamilton, thought her far too bookish, but she took advantage of his impatience with the minute details of government to run the kingdom. Not for nothing, after all, was she her mother's daughter. She made the best of a discouraging dynastic marriage to wield influence wherever she could.

Notwithstanding his widely known appetite for tomfoolery, Ferdinand is endowed in the portrait with a gravitas he was far from possessing. In 1780 William Beckford had noted that he was not a weak monarch, but one who had 'the boldness to prolong his childhood and be happy, in spite of years and conviction'. He was, Beckford thought, living in a state of prelapsarian purity:

> Give him a boar to stab and a pigeon to shoot at, a battledore or an angling-rod, and he is better contented than Solomon in all his glory, and will never discover that all is vanity and vexation of spirit.[42]

The Queen, too, must have rejoiced at her own transformation in the portrait. According to Catherine Wilmot, in real life she was

> a sturdy looking dame by no means elegant in her deportment [who] trotted about in her black and blue robes, much more as if she was crying tooky, tooky, tooky after her poultry, like a housewife, than a Queen doing the dignities of her drawing-room.[43]

The ever-flattering Louise Vigée Le Brun (whom an unkind wag called 'entichée de noblesse', besotted with nobility) was far kinder in words, as she would be kind in paint:

> The Queen of Naples, without being as pretty as her youngest sister the Queen of France, reminded me greatly of her; her face was tired [this was in 1790], but you could see that she had been beautiful; and her hands and arms were perfection, both in shape and in colour.[44]

Whatever her reservations about the Queen, Catherine Wilmot did find some of her daughters 'prettyish', though Angelica's preparatory sketch of Maria Teresa suggests that she will inherit her father's long nose, and the one of Maria Luisa gives her an incipient Habsburg haughtiness. When Louise Vigée Le Brun came to do the princesses' portraits ten years later, it was in order to 'sell' them in paint, and she did not find it a particularly easy task. Maria Carolina, who at the time was away trying to arrange suitable dynastic marriages for them, said of the two eldest that they were neither beautiful nor agreeable, but that she hoped they would make good wives. Maria Luisa was acknowledged to be ugly and grimacing, but the Vigée Le Brun touch makes her look unobjectionable, with an alert, slightly gamine charm. She did her best by Maria Teresa and Maria Cristina too.[45]

Angelica's group portrait, which John Ramsay thought 'very well composed' when he saw it on 29 September 1783,[46] is filled with children, but none of their faces has much character. She shows Maria Teresa on the left of the huge picture playing the harp, while Maria Luisa holds her little sister Maria Amalia on her knee: a charming and domestic image, and one that helps to give the whole something of the

informality that the Irish group-portrait of the Townshend family possesses. Inevitably, though, there is a poignancy to the picture's recording of a happy-seeming family whose number would later be depleted. Prince Joseph was dying even as Angelica worked at the portrait; in the modello his small form is covered with a veil, and the final canvas would leave him out altogether. By the time Louise Vigée Le Brun arrived in Naples, Prince Januarius – who in Angelica's version sits on the right in front of a pram – would also be dead. The other prince, Francesco, survived and became King in his turn, though if Catherine Wilmot is to be believed, he possessed no more grace or regality than his father:

> The hereditary prince delights in dancing, which he does like a cow cantering. Vulgar is no expression to apply to his appearance, for vulgarity becomes genteel within his presence.[47]

Mortality, particularly infant mortality, was a painful hazard of group portraiture, demanding of the artist as great a willingness to adapt as the rapid changes in female fashion did (always supposing that the artist disdained a Reynolds-like timelessness in clothing). Louise Vigée Le Brun would be furious with the future Queen of Naples, Caroline Murat, for changing clothes and hairstyles so rapidly, and so necessitating constant alteration, when she painted her in 1806. Death, of course, was more than an annoyance, though to a woman as fertile as Maria Carolina that of a child was unlikely to rate as a tragedy. For the artist, however, it still meant troublesome painting-out and correcting.

What gives the Neapolitan portrait charm is the setting. Angelica has chosen to place the royal group in parkland, with spreading autumnal trees and gently undulating hills behind and a pair of hunting dogs, one standing and the other lying, in the foreground. Prince Francesco fondles a greyhound as he stands between his father and eldest sister, helping to give the whole composition an effect which is part that of an English family portrait by Gainsborough or Reynolds and part that of a *fête galante* by Watteau or Fragonard. Remarkably enough, Angelica rarely painted backgrounds of this kind in her conversation-pieces or single portraits. For an artist so close to Reynolds, and who had been

imbued with the spirit of English art for so many years, it is a surprising kind of frugality.

She did her best to prevent the Naples court, and its Queen in particular, from taking her over. When she wrote to Metzler, 'Thank the Lord that my circumstances permit me to preserve my freedom', she was ostensibly referring to her financial situation. But an underlying message is that she commanded enough respect to ensure her independence. Apart from her art, the only duty she owed was to Zucchi, who himself represented part of the 'arrangement' that guaranteed her liberty. She would never willingly have offended regal or aristocratic patrons, but they had to yield before artistic imperatives.

It was not immodesty that dictated this attitude – she was as free from it as it is possible to be – but the gentler ruthlessness of commitment. There was always a fixed determination about Angelica that the floating prettiness of some self-portraits may apparently gainsay, but which cannot really be denied. Hence the purely symbolic significance of the 1792 *Self-Portrait Hesitating between Painting and Music* (where there is actually little hesitation, only regret), and her persistence in depicting herself with the tools of her trade. They, and she, might look decorative, but they are actually weapons of deadly earnest.

There was another reason for withdrawing from the insidious, lavish pressures of Naples. She explained it in a letter of 28 December 1782 to Dr William Fordyce, who had been her family physician in London: 'Mr Zucchi has been troubled with fevers last summer, and the air at Naples did not so well agree with him, he is much better since we returned to Rome'.[48] Perhaps this is only partly true; Angelica had, after all, desperately wanted an excuse to escape from Maria Carolina. But according to another acquaintance, she herself improved in health when she was in the capital:

> I have heard Angelica say that the water of Rome revived her powers, and gave her ideas. This amiable woman is the idol of her invidious profession, the only artist beloved by all the rest.[49]

Living at last in what visitors would later call her jewel of a house by Trinità dei Monti must have exalted her spirits too. During her absence in Naples, Prosperi had fitted out the first and second floors of Via

Sistina 72 (owned by a Signor Stefanoni) as a worthy residence for an artist of international renown whose visitors would largely be the *bon ton*. Manuscript copies of the bills paid in November and December 1782 and January and February 1783 refer to the supply of lampstands, crystal chandeliers, marble chimneypieces, chairs, settees, china, mirrors, silk hangings and silverware.[50] The Zucchis, it seems, had brought little from London apart from the harpsichord and Angelica's fine English grandfather clock.

They lived comfortably but not ostentatiously, employing an Italian and a German manservant and two maids.[51] However, one expensive luxury shows that Angelica still intended to live as a *grande dame*: the largest single surviving bill is for a coach and four in the latest English style[52] supplied through the offices of Thomas Jenkins. This is the vehicle that would later transport her and Goethe through the heat of Rome to the sumptuous art collections of the city, or into the cooler air of the countryside for refreshment and relaxation.

As Via Sistina 72 had been Mengs's home, and Mengs's hospitality had been legendary, the house was spacious and well appointed – fifteen rooms, stables and storerooms, and a small garden. (The Bonomis lived with the household until their return to London.) A long hall lined with plaster casts of classical statues[53] led into the drawing-room, where according to the German writer Kotzebue Angelica's own collection of Old Master paintings was kept behind silk curtains. 'There is a St Jerome, which she claims to be by Leonardo da Vinci, behind one of them; I confess that everything I have seen by this master has a completely different tone . . .' Apart from this, there were Angelica's copies of portrait heads by Van Dyck and Rembrandt, her own portrait by Reynolds ('not like'), and a range of works that she herself had painted.[54]

Gerning, who always rhapsodises about Angelica, called her house 'a temple to the Muses', which seemed to open of its own accord to welcome the visitor, offering innumerable treasures to his gaze.[55] The studio, at the other end of the house – and which she would rebuild in 1787 – was by contrast a cluttered and workaday space filled with easels, palettes, brushes, stones for grinding pigment, jars of oil, special mannequins that she had had supplied from Paris, lamps and pocket lenses.

In this palatial home Angelica felt she was her own mistress, though

the London practice of receiving visitors who wanted to see her pictures as if they were on display in an open gallery continued. A self-portrait she painted in 1782 on her return to Rome shows her aspiration to the kind of peace and reconciliation her recent life had been lacking, and is described in the *Memorandum of Paintings* in these terms:

> For Mr Bowles of London a circular picture [. . .] of two figures representing Poetry embracing Painting who is listening eagerly to the suggestions of Poetry, given by the artist to the above-named, because the figure representing Painting is the portrait of herself Angelica Kauffman.

In fact, Painting should more accurately be called Drawing or Design, given that Angelica depicts herself holding a pencil and block of paper (perhaps because Drawing is, mythologically speaking and otherwise, the mother of all the arts). So she appears not merely as an artist, but as the *Ur*-artist, like the daughter of Dibutades (or Butades) shown in Wright of Derby's 1783–4 picture in the act of inventing drawing as she traces the shadow of her lover's profile on the wall. The two figures – Poetry with winged temples, wearing a laurel wreath and holding a lyre, and the white-robed Painting – are in perfect harmony: as they clasp each other fondly they reveal that they are indeed sister arts.

Significantly, Painting welcomes Poetry's embrace as she does not that of Music in the later self-portrait: concord and harmony prevail rather than exclusion and regret. (Until the late eighteenth century this type of 'friendship' portrait was mostly of married couples.) The two women's pose is almost identical to that of the Spencer sisters in the portrait Angelica had painted eight years before, except that Poetry looks to her right at Painting, while Lady Harriet Spencer looks to her left and upwards at her brother. Painting and Poetry, too, clutch drawing-block and lyre respectively rather than each other's hands.

Angelica was naturally affectionate as well as reserved, and portraits such as this one (now at Kenwood) reinforce the reputation that she cultivated or allowed to grow in her London and Roman salons – that of the quintessential eighteenth-century 'beautiful soul' infused with an ideal womanly essence, beneficent, loving and sympathetic. To be the mother of the arts, as she depicts herself here, is to be creative in every

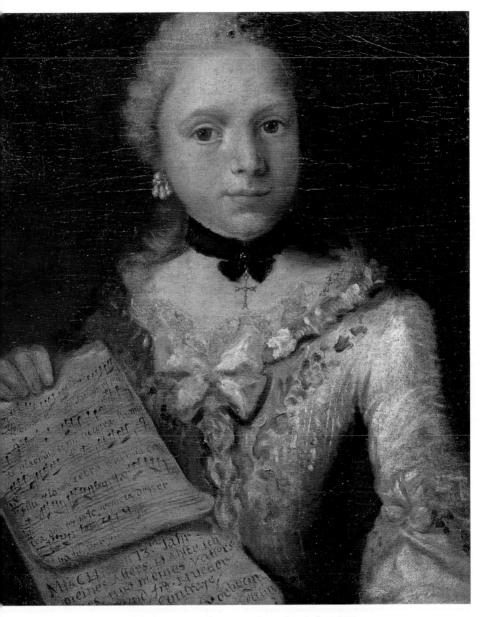

1. *Self-Portrait at the Age of Twelve* (oil, 1753).
This early painting, done 'in my thirteenth year', is the first illustration of the
pairing of painting and music that recurs over the length of Kauffman's career.

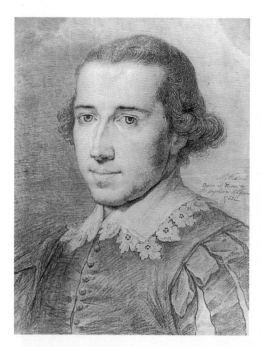

2. *Benjamin West* (drawing, 1763). This picture of the future President of the Royal Academy of Arts shows the young West in the Van Dyck costume Kauffman favoured.

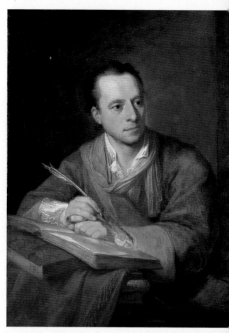

3. *Johann Joachim Winckelmann* (oil, 176~ The antiquarian and founder of art histor whom Kauffman met in Rome, influence her conception of neo-classical art.

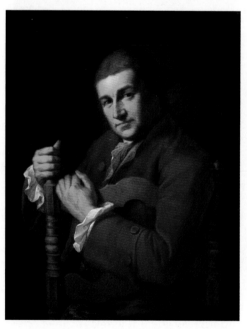

4. *David Garrick* (oil, 1764). Kauffman painted the actor's portrait in Naples, and sent it to London as an entrée into the English society she went on to conquer.

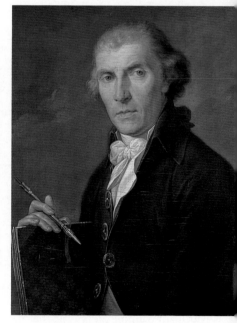

5. *Johann Joseph Kauffman* (oil, after 176] This sensitive portrait of her father is an impressive early example of Kauffman's psychological penetration as a painter.

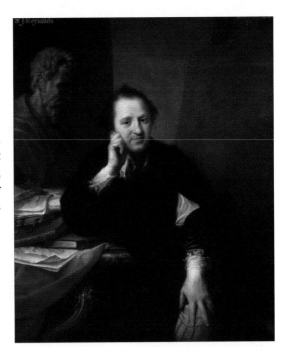

6. *Sir Joshua Reynolds* (oil, 1767). Reynolds, the first president of the Royal Academy, became Kauffman's mentor and friend in London.

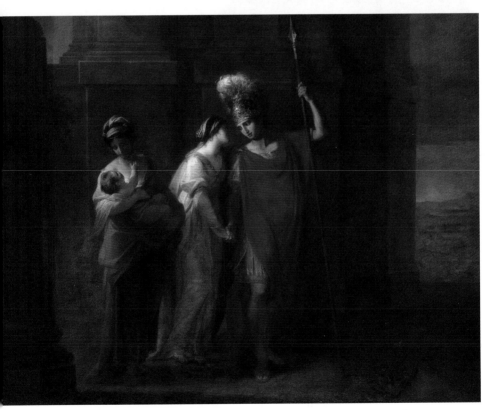

7. *Hector and Andromache* (oil, 1768).
This striking composition, along with others bought by her patrons John and Theresa Parker, marked Kauffman's early ambition to be recognized as a history painter.

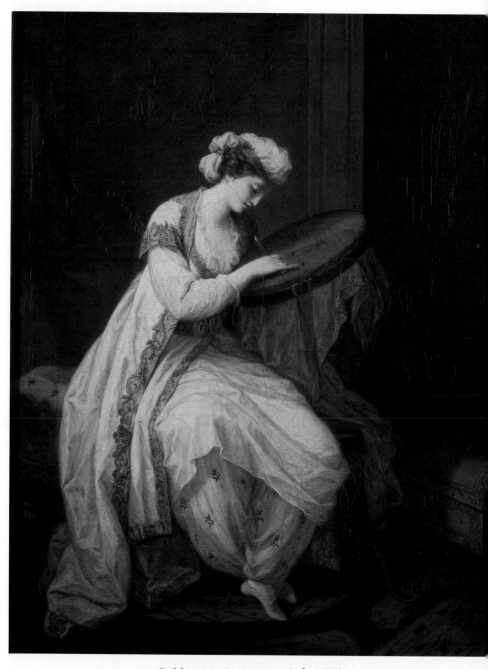

8. *Morning Amusement* (oil, 1773).
One of Kauffman's most admired works, this delicate study is an example
of her success in the fashionable 'Turkish' or 'Oriental' mode.

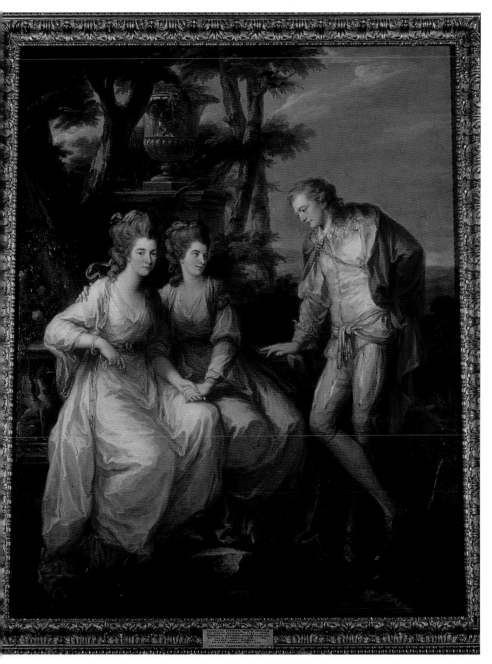

9. *Viscount Althorp with His Sisters* (oil, 1774).
The future second Lord Spencer stands contemplatively by the future
Duchess of Devonshire (on the left of the picture) and Lady Duncannon,
shortly before Georgiana's marriage to the fifth Duke of Devonshire.

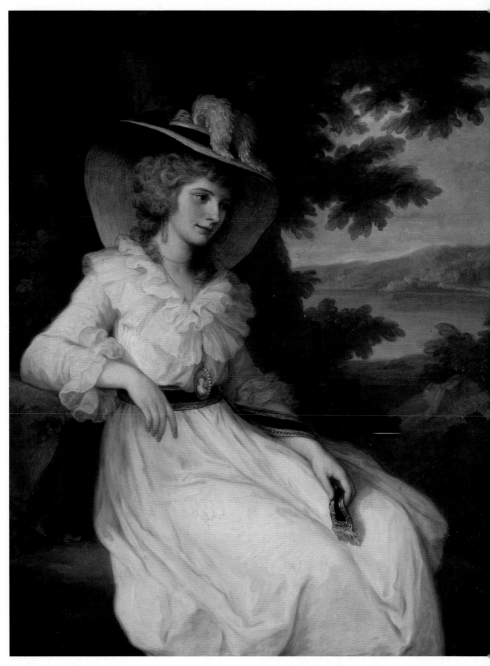

10. *Lady Elizabeth Foster* (oil, 1785).
The famous beauty (and later Duchess of Devonshire) sits pensively in
an Italian landscape, wearing a cameo of her beloved friend Georgiana.

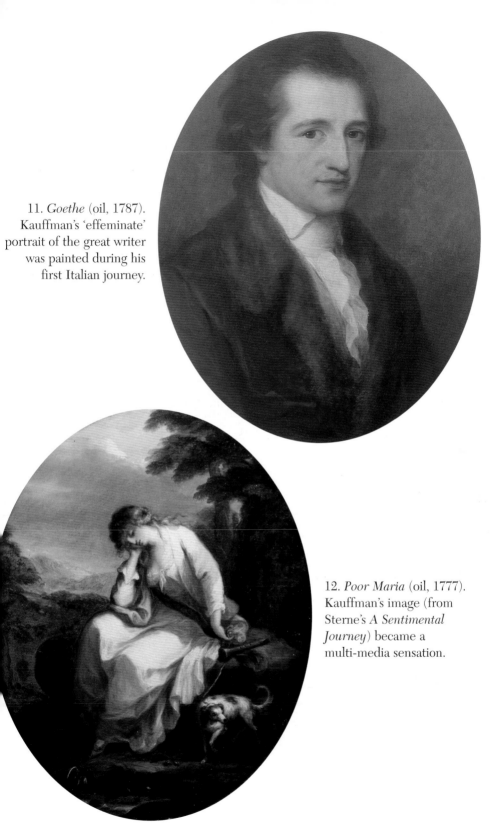

11. *Goethe* (oil, 1787). Kauffman's 'effeminate' portrait of the great writer was painted during his first Italian journey.

12. *Poor Maria* (oil, 1777). Kauffman's image (from Sterne's *A Sentimental Journey*) became a multi-media sensation.

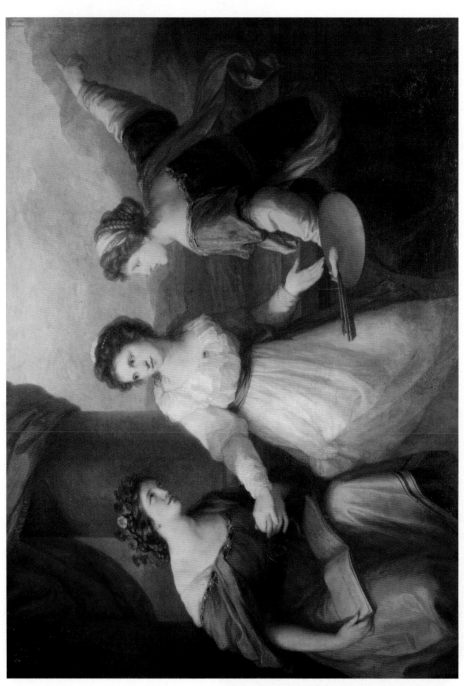

13. *Self-Portrait Hesitating between Painting and Music* (oil, 1792). This celebrated picture

sense of the word, producing life as a mother does, fostering (the arts), nurturing and dispensing fellow-feeling. Her charity gave practical expression to her enlightened sympathy, and her paintings were the fruits of her inspiration. The fact that they would never be fruits of her loins was immaterial. Angelica presented herself as an almost godlike source, one that others could draw nourishment and inspiration from. Consciously or not, she presided over her own myth of fertility.

Her love of literature in general, and perhaps poetry in particular, had emerged in the correspondence surrounding her Samma picture and the project of illustrating Klopstock's collected works, and the pictures she did after Sterne, Tasso and Macpherson confirmed it. This affinity would be brought into even sharper focus by her friendship with Goethe and the later commission from John Boydell to paint scenes for his Shakespeare Gallery. But her portraits show the links between writing and picture-making in other ways. Writing and picture-making, or drawing, were skills that women in Angelica's society were allowed to practise: like playing a musical instrument, they were polite social talents. Women artists might show themselves at their easels or with their drawing-paper and pencils, but they could also depict other women writing or reading – writing letters (that quintessential female pastime), as Louisa Hammond does in Angelica's Fitzwilliam Museum illustration to Samuel Pratt's *Emma Corbett*,[56] or reading books, like Anne Loudoun in the 1771 portrait that shows her sitting in an exquisite country landscape. This picture also makes clear that withdrawing into nature is far from meaning that one abandons the accompaniments to civilisation; it merely signifies fitting them into a different environment.

Angelica had always been good at painting men as well as women, despite her abiding reputation for making them look less than manly. Her Winckelmann portrait had been a brilliant distillation of passionate scholarship, and her picture of Reynolds a moving depiction of a great man in a moment of relaxation. But she had been so much in demand as a Grand Tour and society portraitist of gilded youth from the 1760s onward that there had been relatively little time to paint men who *made* society. In Italy that would begin to change.

In Naples, borrowing pose and attitude from the earlier portrait of her father, she had painted an exceptional picture of a great man

destined for a terrible end.[57] Dr Domenico Cirillo, whom Thomas Jones reported seeing at Angelica's levée at the Albergo Reale, was a celebrated scholar, a lawyer by profession who had written books on botany and medicine, and Angelica seems to have painted his portrait in exchange for some medical advice. He knew many of the leading figures of the age – Benjamin Franklin was a friend – and had a deep political and social conscience. After Angelica moved away from Naples he became more and more deeply involved in pro-revolutionary and anti-monarchical activity, and would ultimately pay for it with his life.

Eminent enough to have been made a Fellow of the Royal Society and named official physician to the Neapolitan court, he was Sir William and Lady (Emma) Hamilton's doctor, a man of immense cultivation with whom Sir William could relax from coping with the King and his courtiers. During the Neapolitan republican rebellion of the 1790s, however, Cirillo had reluctantly accepted an appointment as head of the legislative council, and had signed anti-monarchist documents. This was his downfall. Despite the fact that he had, on the republic's behalf but for the general good, carried out vital reforms in the organisation of hospitals and medical care for the poor, and had attended the wounded irrespective of political sympathy during the uprising, he was found guilty of treason and jailed.

He sent Emma Hamilton a petition appealing for help in the name of their friendship, but it went unanswered. Catherine Wilmot's view of her behaviour was damning:

> The conduct of Lady Hamilton is universally considered, not only as a slur upon her sex and country, but upon humanity; to her influence over the weak mind of Lord Nelson, the breach of treaties, as well as individual persecution, is attributable, and during the execution of Caracciolo and his own physician Cirillo, and others of the revolution on board his ship, which tinged the bay with blood, Lady Hamilton sat contemplating on deck the detailed miseries of the wretched sufferers, reclining upon a chair and affecting the theatrical display of grief by a white pocket handkerchief which she had waving in the air, and changing into the most graceful attitudes.[58]

200

Perhaps Sir William could have intervened with the man who had already become his wife's lover, but he seems to have accepted the loss of old friends turned Jacobins with comparative equanimity. Nelson, who had sailed into the Bay of Naples to enforce order, and who authorised the public execution of rebels in the city square, was determined to exercise a rough justice. So Cirillo was slaughtered on 19 September 1798 because war, in Nelson's eyes, did not admit of exceptions to the 'correct' rules of conduct.

Although Angelica's portrait would later have done her no credit with the Neapolitan royal family, the times had been less dangerous when she painted it. However much she disliked being subject to imperious royal desires, she was too diplomatic to risk courting Ferdinand and Maria Carolina's displeasure. Working artists had to be pragmatic. Her father had trained her to fit a social order in which she must always remain to some degree a subordinate, for this was what the unwritten contract between client and supplier implied. Angelica's personal gifts and endowments, her attractiveness as well as her talent, turned subordination to higher effect, so that neither buyer nor seller was particularly aware of the distance separating them. But if the seller's guard slipped, if she made one false move, the contract of trust and decorum would be broken. Louise Vigée Le Brun appears to have allowed this to happen in the case of Louis XVI and Marie-Antoinette of France, although the circumstances are unclear; the King drew away from her and had words with his wife. But Angelica seems never to have taken a wrong step.

There is little evidence that she was turning deprivation of her more usual clientele – Grand Tourists and travellers – to gain of another kind, at least away from the court of Naples. It was true that the Italian resistance to portraiture held firm, but conversation-pieces of the kind she had begun with Ferdinand's family were rarely commissioned instead. If Angelica had indeed had a more than passing plan to swap portraiture for history painting in Italy, she abandoned it; the difference now was that she often chose sitters rather than sitters (or clients) choosing her. The quality of client she still attracted, and the subjects who still agreed to sit to her, suggest that it had never been her intention to give up working as a portraitist once she had settled in Rome. Just as she would continue to find intriguing women to paint, so

interesting men also kept on presenting themselves and demanding – or so it seemed – her attention.

Dr Samuel Tissot, known as the prince of doctors and the doctor of princes, was one of these, and a European celebrity. His books on professional, social and sexual maladies – one on the health of men of letters, another on the ills of worldliness, and a third on the perils of masturbation – had been translated from their original Latin into French and the major European languages, all becoming best-sellers. To an extent, Tissot was an enlightened man helping to bring education to the ignorant: he contributed to d'Alembert and Diderot's *Encyclopédie*, the archetypal Enlightenment publication, and was at the forefront of the eighteenth-century campaign to take medicine out of the Middle Ages. But his lurid warnings about the dangers of masturbation seemed needlessly killjoy to Diderot and the author of the *Encyclopédie* article 'Manstupration', and his conservatism rather typically Swiss. Tissot was an advocate of temperance in other than merely sexual matters, recommending abstention from meat and 'violent' wine to the worldly creatures who read his diagnoses with mingled horror and relish, and championing the kind of diet which his fellow-Swiss Rousseau preferred: milk, cheese, bread and vegetables. The working man's plain regimen of beans and grains seemed to him healthier than all the refined delicacies of civilised life, and he forced it with pitiless rigour upon the revellers he treated. Somewhat surprisingly, he, along with his compatriot Dr Théodore Tronchin, still suffered from gout.

Tissot was probably in Naples at the invitation of Emperor Joseph II, who wanted him to become head of the Pavia clinic, but he made time to sit to Angelica. She painted him as a direct echo of her *Winckelmann*, so emphasising culture rather than rank. In the portrait Tissot is thinking, as the great men Angelica depicted often do. He is, in fact, quietly engaged in being a genius, sitting with eyes fixed on the middle distance, ignoring the spectator, rapt, wholly given over to inspiration. In this respect he cuts an altogether more impressive figure than the self-satisfied medic John Morgan whom she had painted fifteen years before, a man who seems desperate to impress the spectator with his professional weight. Tissot is unconcerned with such vulgarities, as well he might be. His portrait is today in the cantonal

museum of Lausanne, at whose Academy he held a professorial chair until his death in 1797.

Angelica's intellectual interests were broad, and she knew many scientists as well as public figures from other spheres. The man who discovered dolomite, Déodat de Dolomieu, was another sitter, and she painted his portrait in 1789. His life was sadly marked by conflicts with his order, that of the Knights of Malta, from which he found some consolation in devoting himself to the study of mineralogy. He became professor of the subject at the Paris Museum of Natural History in 1799, but before that had taught at the School of Mines. This accomplished man was both practical (a trained engineer) and intellectual (he was elected to the Institut de France after the Revolution), and he fitted perfectly into Angelica's circle.

A third subject, Père Jacquier, was an equally representative man of the Enlightenment.[59] He was a priest, an astronomer, a mathematician and a contributor to the *Encyclopédie*, and belonged to the same liberal current in society as Cirillo. Voltaire wrote to d'Alembert of Jacquier's benign tolerance towards all those who were not of his opinion.

His life had not always been easy. Once he had had the thankless task of attempting to teach mathematics to Ferdinand of Naples (later on he seems to have had the easier job of teaching John Ramsay French), and it was possibly at the Neapolitan court that Angelica first met him. She painted his portrait, however, in Rome, when he became a professor of mathematics at the Papal University after the dissolution of the Jesuit order in 1773. Jacquier seemed to know everything – ancient literature, music, architecture, painting, theology and philosophy. Living in the Franciscan monastery at Trinità dei Monti, he was Angelica's neighbour. She adored him, and did the 1786 portrait of him for herself.

When she had finished the huge picture of Ferdinand, Maria Carolina and their children, Angelica obediently went back to Naples. On 24 March 1784 she delivered the work personally, as she had promised, at the great country palace of Caserta. The *Memorandum of Paintings* describes how the rolled-up portrait was presented to gratifying applause, and also records that the sum she was paid for it included

certain expenses of transport from Rome to Naples. It was paid for during the first days of November 1784 with 4,317 Neapolitan ducats, and Her Majesty the Queen made the gift of a beautiful jewel with the Queen's initials in diamonds and surrounded by twelve big diamonds beautifully mounted. The value of the jewel is estimated at 700 ducats.

Of course, such presents cost Maria Carolina nothing: they were baubles that were meant to dazzle and overwhelm the recipient. Converting them into hard cash was impossible, and so they remained no more than tokens. Angelica, however, refused to be caught in the Bourbon toils. Not even the Queen's flattering act of installing her in the Palazzo Francavilla, with its breathtaking gardens and ravishing views of the sea, could win her over. She had to agree to teach the princesses the rudiments of drawing (the boys, presumably, could learn to hunt with their father), but she did so with reluctance. At a much later date, in a letter of 21 July 1795 to the great *improvvisatrice* Fortunata Fantastici, she explained why she had to risk giving offence in this way:

I am [. . .] always very busy. And this is the reason why I have not accepted and cannot accept all the requests people make for me to give some instruction in painting. I study it with great difficulty – and time is too short.[60]

Perhaps Fantastici too had asked her to take on a pupil, possibly herself. But in 1784, in Naples, Angelica had simply been too tired, as well as jealous of her independence, to comply. She returned to Rome in November and wrote to Metzler the following month: 'Sometimes I find my energies rather sapped, with so much work and constant application. We have now been back in our comfortable apartment in Rome for three weeks'.[61]

Maria Carolina, having failed to persuade Angelica to become resident court painter, had ordered more paintings, some of which she intended to give her sister Cristina as a gift. One was a version of a painting for George Bowles commissioned in 1785, and it counts among the fatigued Angelica's most important works. However tired, she could never bear to let important patrons down.

Chapter Ten

Command Performances

On her final trip to Naples in 1785, delivering the historical works that Maria Carolina had commissioned, Angelica came under renewed pressure to be the princesses' instructor. Again she resisted, and eventually Philipp Hackert was offered the job along with the lodgings at the Palazzo Francavilla. When the Queen discovered that he was spending his evenings drawing for relaxation with the nieces of her lady of the bedchamber, she simply demanded that he transfer his allegiance to her. Hackert accepted meekly, and seemed so far from resenting the intrusion his teaching duties represented that he even answered summonses to give improving 'lectures' on art at the end of the day. 'The good Lord sent you to us,' Maria Carolina is said to have exclaimed, 'I am enchanted.'

Eventually, however, his patience too wore thin. After three years he was happy to pass the unpaid job on to Tischbein, receiving nothing more than a gold box as a mark of the Queen's regard. Tischbein in turn performed his duties for several months, at the end of which he was rewarded with a gold ring bearing Maria Carolina's cipher, but nothing else.

At least Angelica was handsomely paid for the Queen's subsequent commissions. According to the *Memorandum of Paintings*, the picture for Cristina of Cornelia, the mother of the Gracchi, and her children Tiberius, Caius and Sempronia, with an accompanying one of Pompey's wife Julia fainting at the sight of a blood-stained garment,

> were paid a little more than the usual price of 60 guineas each; in payment for [a] small portrait of Princess Teresa and also for having given a few drawing-lessons to the two princesses, Her Majesty the Queen gave Angelica, when she left, a beautiful cross set in diamonds [and] the use of the court carriage [...]. Therefore for the two historical pictures with their frames, the

expenses of wooden cases and transport from Rome to Naples, a total sum of 1,122 ducats was paid, plus the diamond cross and the other things mentioned above.

Goethe writes in the *Italienische Reise* about the version of the *Cornelia* picture that Angelica was painting in 1787:

Angelica is now painting a picture that will succeed admirably: the mother of the Gracchi displaying her children as her greatest treasures to her friend, who is digging out her jewels. It is a natural and very happy composition.[1]

As an *exemplum virtutis* this picture ranks with David's contemporary *Serment des Horaces*, but its emphasis is subtly different. The striking contrast in the *Serment* between the world of warriors, strong and fierce, and that of their women, bent in exquisite arabesques, overwhelmed with grief at the folly of men,[2] is a more overt and dramatic version of the implied opposition in Angelica's work between two human types (here represented by women), one obsessed with physical show, the other infused with virtuous human principle. Cornelia's type of woman is unable to flaunt martial valour and unwilling to display material concerns, but shows self-denial, modesty, and domestic and familial devotion instead. This is her virtue: a maternal love that equals public, essentially male values. The *Memorandum of Paintings* describes the subject as 'a gentle reproach to vanity' that reveals 'the beautiful nature of a good mother'. Another visitor to Angelica's studio, Alois Hirt, saw in Cornelia an example of the great soul faced with a mean, abased one, betraying not contempt, but simply tender pride.[3] Perhaps Cornelia's upright posture is rather regally self-conscious, as emphatically vertical as the folds of her dress and the stark Doric columns in the background, but it embodies something understated, the 'gentle reproach' to her seated and humbled neighbour.[4] Even her daughter Sempronia, playing with the neighbour's jewels, is an accusation of vanity, revealing the sheer insignificance of what the worldly cherish.

A version of the picture done for Stanislas Poniatowski has as its pendant Angelica's lost picture of Brutus condemning his sons to death for plotting against the Roman republic. The preoccupation with duty

remains, then, but the morality of parents is distinguished in both sexual and social terms. The mother's sphere is that of private life, the father's the world of public action and affairs of state, the male sacrifice of children opposed to the female choice of a moral life devoted to tending offspring and making them good citizens.

The obedience of her own brood releases in Cornelia a voice held within by modesty and decorum: they are her statement of love. She throws open the question of womanly sacrifice and passion that the other Roman picture painted for Maria Carolina also explores.[5] Julia, Pompey's wife, falls in a faint when a bloodied cloth is brought to her, because she believes it to be her husband's and assumes that he is dead, although in reality the garment has been innocently stained with another man's blood and Pompey has simply sent it back to be changed. In the story by Valerius Maximus that is Angelica's source, the shock makes his wife give birth prematurely, and she herself dies. Julia's fate is doubly ironic, for after her death the old rivalries between Caesar and Pompey are reignited and Pompey is eventually defeated. Yet even though she died for nothing, her death is still an exemplary instance of wifely devotion.

In Angelica's world men may show greater stoicism, but not greater depths of suffering or endurance; indeed, their stoicism may indicate the absence of deep feeling. An earlier painting for George Bowles had firmly ascribed these profound internalised values to woman alone, and its tender sentimentality – here sharpened with a touch of irony – is characteristic of the works this patron liked to collect from Angelica.

Alexander Ceding to Apelles His Beloved Campaspe, painted in late 1782 or early 1783, may seem to exalt masculine virtue in its image of the lover forsaking the woman he adores – this, at least, was how the story was presented in antiquity – but in Angelica's interpretation its message is characteristically different. As a painter Apelles was the emblem of gracefulness, the quality for which Angelica herself was repeatedly praised, yet from Pliny's *Natural History* onwards the tale of Apelles, Alexander and Campaspe had been regarded as a moral one contrasting self-control with the passionate and self-indulgent desires of the creative artist. Alexander is ruled by *ethos*, which makes him willingly yield his mistress to the painter who has been overcome by love as he depicts her in her naked glory (although one might conclude, more pragmatically, that the ruler has simply grown tired of

his paramour). Angelica typically muffles the erotic charge of the tale by showing Campaspe clothed – lightly clothed, it is true – but she also hints at something more profound. In placing the helpless woman between the two men, whose attitudes indicate that they are bartering with one another over her, she underlines the impotence of any female caught between male desire and the urgent demands of artistic genius. Apelles may look uncertain of the outcome, but the way Alexander attends to him rather than to his manifestly devoted mistress suggests that her sacrifice has already been decided.

So although Campaspe is in one respect the centre of attention, in another she barely seems to count. To Alexander and Apelles she is no more than an object, even though the gesture she makes with her hand, which she has placed on her heart, proves her to be a subject for love. Ordinarily this might empower her, but here the courtesan's only weapon is a beauty that is not truly hers to manipulate. While Apelles' status as an artist of genius allows him to make demands that decorum should prohibit, the woman (and the woman artist) must retain her sense of propriety: convention forbids her to articulate or depict the objects of desire that might inflame her, whether in the world or in the studio, in life or in art. Angelica's picture, then, is a parable of woman's estate that weaves new meaning into the artist myth of Pliny's *History*. Forsaking and then (part) triumphing, yielding and then attaining, are the best that women can hope for, be they creators like Angelica or creatures like Campaspe, and even this best inevitably entails a loss. Alexander rehearses his proud renunciation, from which he will, justly or otherwise, gain glory; Apelles' fame wil not be diminished by his possessive fury; but what Campaspe can hope to gain from the arrangement the two men are discussing will be limited and precarious. That is woman's lot. So she shows no resistance, indicating the only acceptance that is morally proper, allegiance to the man (Alexander) of comparative virtue.

Unlike Campaspe the courtesan, Angelica was not an instrument, but an instrument-user. Yet she was also the tool of a public that could at whim cease to be Angelicamad, and had to veil resentment when she felt it – at Maria Carolina's autocratic demands, for example – because her reputation and livelihood depended on compliance. Although she could to a degree compel an audience through her art, translating compulsion into a commercially active relationship demanded tact and

self-denial, virtues that dealing with the Queen of Naples had called forth in full measure. If she had to be subordinate like Campaspe, however, she still had the consolation of moral and aesthetic superiority.

History painting was hard work, and the tiredness Angelica complains of in her letters at this time is understandable. Alternating between exhilarating achievement and exhausting effort, needing regular relief, she knew that the art of portraiture could be a sort of salvation, at least if she contrived to invest it with a moral or psychological significance that gave it value. While Grand Tourists had gone to Batoni for swagger-portraits that conferred on them a dash they might lack in real life, people sat to Angelica for more tender, interiorised images. She was adept too, however, at suggesting qualities they might wish to conceal or shadows they might prefer to ignore. Like her early portrait of Dr John Morgan, the later Italian pictures of celebrated men showed how skilful she was at seizing unspoken qualities and giving them form.

She celebrated uncomplicated female beauty too, but handled it best when the beauty had a story to tell. Emma Hamilton, resident in Naples since 1786, was the possessor of looks that inspired many, and Angelica would be drawn as others were to paint her.

Amy or Emily Lyon (who later called herself Emma Hart) was of lowly origins, born in Lancashire of a blacksmith father and a servant mother, but brought up in Wales by her grandmother. She moved to London as an adolescent, and may or may not have slipped into prostitution; but she found that her beauty won her as many admirers as lovers. Louise Vigée Le Brun claims that Emma acquired a taste for novels and the theatre while she was working as a chambermaid in a respectable house, and so got herself dismissed. By then, however, she had begun to study the gestures and poses that would later be introduced into her 'attitudes', which brought her fame and a pleasant notoriety.

First, though, she had to sell herself cheaply. It was when she was posing as the goddess Hygieia for the quack Dr Graham in Schomberg House that artists became interested in her, Romney in particular. They depicted her in various guises – a bacchante, Circe, St Cecilia, Euphrosyne, a sybil, and so on – that all reflected her seemingly

instinctive ability to project different characters convincingly. The main Hamilton residence in Naples, the Palazzo Sessa, would eventually contain dozens of portraits and fancy pictures of her; for once he had adjusted to her utter difference from his cultivated first wife Lady Catherine and had fallen in love with her, Sir William could not have enough of them.

He had met Emma in 1784 during a period of leave spent in England, and she arrived in Naples two years later accompanied by her mother Mrs Cadogan. Sir William immediately set about educating her and instilling in her a taste for the ancient relics of which he was so passionately fond. Lady Webster, the future Lady Holland, reported Emma's reassuring words to Sir William when he saw her reclining against one of his Grecian vases: 'Doun't be afeared, Sir William, I'll not crack your *joug*'. Hamilton, she continued, was 'distractedly in love' with her.

On 22 July 1786, after the unmarried Emma had moved into the Palazzo Sessa, she wrote to Sir William's nephew, her own former lover Charles Greville, who had 'sold' her to his uncle because he himself needed a wife worth £30,000:

> There is two painters now in the house, painting me [. . .]. But as soon as these is finished, there is two more to paint me – and Angelica, if she comes [. . .]. I wish Angelica would come; for Prince Draydrixton [Diedrichstein] from Vienna is here, and dines with us often, and he wants a picture of me. He is my *cavaliere servente* or *cicisbeo*, which[ever] you like. He is much in love with me [. . .]. The Queen likes me much, and desired Prince Draydrixton to walk with me near her, that she may get a sight of me [. . .]. But Greville, the King has eyes, he has a heart, and I have made an impression on it.[6]

Yet the pleasure of being the object of besotted but anxious love outweighed all passing concerns. She was 'distracted' too, like a child who has been given new toys: 'All the artists is come from Rome,' she declared, as though they did so only in the hope of painting her. At the same time she herself drew a picture of Vesuvius, explaining: 'I am so used to drawing now, it is as easy as ABC'. Sir William, desirous of adding to her accomplishments, supplied her with a music master who

so helped develop her soprano voice that she had 'great offers to be the first whoman [sic] in the Italian Opera at Madrid'.[7] The following month Emma told Greville that Prince Diedrichstein thought her 'a dymond of the first watter and the finest creature on the hearth'.[8] There would be other admirers too, before Nelson. But for the moment she belonged to the fastidious aristocrat with a passion for the antique and Vesuvius, which he climbed twenty-two times in four years. Soon after her arrival in Naples Byres remarked that Hamilton had 'lately got a piece of modernity from England which I am afraid will fatigue and exhaust him more than all the volcanoes and antiquities in the Kingdom of Naples'.[9]

Emma's power to transform herself lent her a sophistication that made her seem an acceptable companion to Sir William, at least on slender acquaintance. She never lost her commonness in the eyes of the *bon ton*, it is true: in 1791, the year of her marriage to Sir William, Gouverneur Morris met her in Paris and thought that she still had the air of a kept woman. The Duchess of Devonshire concurred on seeing her in Bath.[10] Lord Hervey's judgement on Emma, she thought, must stand: 'Take her as anything but Mrs Hart and she is a superb being – as herself she is always vulgar'.[11] Not everyone agreed, admittedly. The Grand Tourist John Morritt wrote that 'when not acting her manners and air are noble', and that when she *did* act it was with the greatest delicacy, 'and represents nothing but what the most modest woman may see with pleasure'.[12] He was well aware of the artistic origin of Sir William's love for her, 'namely [. . .] that she only of her sex exhibited the beautiful lines he found on his Etruscan vases'. Nor was this a trifling impulse:

Every man has a reason for marrying, and this is certainly a new one, though perhaps as good a reason as most others. If one may judge from effects, the case is so indeed, for no creature can be more happy or satisfied than he is in showing her off, which he does exactly as I have seen a wax figure exhibited, placing you in the most favourable lights, and pointing out in detail before her all the boasted beauties of his *chère moitié* . . .[13]

Maria Carolina's attraction to Emma caused vulgar rumours to circulate about the nature of their friendship. According to Louise

Vigée Le Brun, the intimacy was politically based: 'Lady Hamilton, being very indiscreet, put her in possession of quantities of little diplomatic secrets, which Her Majesty took advantage of for the running of the kingdom'.[14] Emma herself would always refer to their closeness with disingenuous carelessness:

> The Queen invited me last night herself and we passed four hours in an enchantment. No person can be so charming as the Queen. She is everything one can wish – the best mother, wife and friend in the world. I live constantly with her, and have done so intimately for two years, and I never have in all that time seen anything but goodness and sincerity in her, and if you should ever see a cursed book written by a vile French dog with her character in it, don't believe one word.[15]

Emma may have wanted an early meeting with Angelica, but the evidence suggests that she had to be patient. Apart from anything, Angelica was not prepared to return to Naples after the 1785 trip, and their eventual acquaintance seems to have been made in Rome.

The wait, to judge by the picture Angelica painted in 1791, was not so prolonged that Emma's famous looks had become spoiled, though by 1790 Sir William himself was finding her appearance a touch luscious.[16] In 1786 Goethe had remarked on her perfect shape, but ten years later, according to Sir Gilbert Elliot, her body was 'nothing short of monstrous for its enormity, and is growing every day':

> She tries hard to think size advantageous to her beauty, but is not easy about it. Her face is beautiful; she is all Nature and yet all Art; that is to say, her manners are perfectly unpolished, of course very easy, though not with the ease of good breeding, but that of a barmaid.[17]

Farington observed at about the same time that Emma was 'bold and unguarded in her manner, is grown fat and drinks freely'.[18] A drawing James Gillray did in 1801 conveys her enormous bulk, and carefully notes the flask of maraschino she kept on her dressing-room table. Emma's slide had by then become unstoppable. When Louise Vigée Le Brun re-encountered her in London two years later she found

Emma, who had also developed a taste for porter, a blowsy, mountainous travesty of the beauty she had once seen in Naples, and Farington reported then that 'Lady [Hamilton] is now about forty years of age, very fat'.[19] An obese alcoholic who lived beyond her means, she was eventually disappointed in her hopes of an adequate inheritance from Nelson, found herself imprisoned for insolvency and eventually died destitute in Calais, where in 1995 a monument to her was erected in a public park. But in the 1780s she was in her prime.

People watched entranced as Emma adopted her 'attitudes', which the besotted Sir William encouraged her to multiply. Morritt thought the sight of them 'fairly worth all Naples and Rome put together . . . it is beyond what you can have an idea of':

> Her toilet is merely a white chemise gown, some shawls, and the finest hair in the world, flowing loose over her shoulders. These set off a tall, beautiful figure, and a face that varies forever, and is always lovely. Thus accoutred, with the assistance of one or two Etruscan vases and an urn, she takes almost every attitude of the finest antique figures successively, and varying in a moment the folds of her shawls, the flow of her hair; and her wonderful countenance is at one instant a Sibyl, then a Fury, a Niobe, a Sophonisba drinking poison, a Bacchante drinking wine, dancing and playing the tambourine [. . .]. You will be more astonished when I tell you that the change of attitude and countenance, from one to another, is the work of a moment, and that this wonderful variety is always delicately elegant, and entirely studied from the antique designs of vases and the figures of Herculaneum, or the first pictures of Guido . . . [20]

Mme de Krüdener, whom Angelica herself painted in 1787, declared that it was Emma who first revealed the artistic possibilities of the so-called shawl dance, teasing, dramatic and utterly Pompeian.[21] Louise Vigée Le Brun thought that she lacked style, and noted that she dressed very badly when she was not posing 'à l'antique'. But attitudes transformed her.

The picture Angelica painted of Emma was probably done when she and Sir William were on their way to England to be married, and if the

artist is to be believed it was a commission she had long wanted to fulfil:

> How often have I wished [. . .] to see and be acquainted with Mrs Hart [. . .] and I confess to envy especially all the artists who were so fortunate at least to attempt an imitation of so graceful an object. There are beauties in nature not to be imitated. Yet I should certainly strive to do the utmost in my power to give at least an idea of that grace which even in nature one seldom does find, and the which Mrs Hart possesses in the highest degree.[22]

Although these are the extravagant profusions of the courtier artist and of Angelica's rhapsodic age, Emma regularly inspired such outbursts. The *Memorandum of Paintings*, by contrast, gives a rather dry account of the portrait Angelica actually produced, with Emma

> portrayed as the character of comedy. With one hand she is lifting up a curtain as if just coming out to appear before the public, and the other hand is raised and holding up a mask which she has taken off her face; she is garbed in classical style in thin and light material, her hair is partly hanging loose on her shoulders, and partly tied round the forehead; she is a very expressive and effective figure. 120 zecchini.

No doubt Sir William influenced the pose Emma adopts in the picture. It was common for young women to be depicted as one of the Graces or Muses, especially the bacchante Euphrosyne (the Grace of Mirth) or Thalia (the Comic Muse). Appropriately or otherwise, Emma is shown not as the bacchic Grace, who carried obvious erotic overtones, but as the Muse respectably associated with the arts, especially music, comedy and theatre.[23]

Louise Vigée Le Brun would paint a sultry and lascivious picture of her as an abandoned Ariadne, lounging, like Elinor Glyn, on a tiger skin: this was Nelson's favourite portrait of his mistress, which he bought from Sir William in 1801 and left in his will to Emma herself. Angelica, by contrast, chose a joyful, inviting but unsuggestive image. After all, Sir William had supervised Emma's attitudes and helped to foster her musical talents, and he presumably wished her to remain associated

with the attributes proper to a woman who was now his lawfully wedded wife. In the picture she wears a cameo portrait of Sir William on her belt, which makes the picture's function as a celebration of their marriage obvious, and Raffaello Morghen's print after it bears a Latin inscription that underlines Sir William's role as creator of his own muse. Loosely translated, it reads: 'The beautiful Thalia whom the Greeks painted has been recreated more beautiful in Latium'.

The portrait appears to have been lost en route from Rome to Naples, to judge by a letter Angelica sent Lady Hamilton in December 1793:

> I was glad to hear from Sir William that Your Ladyship's portrait
> at last was found. Had your Ladyship made a longer stay in Rome
> I should have produced a better picture, approaching nearer to a
> model inimitable, and so excellent in mind and person.[24]

But Sir William was evidently satisfied with it, hanging it in the gallery of the Palazzo Sessa next to a Giorgione portrait and Furini's *Sigismunda*, and at a diplomatic distance from the more boisterous and erotic images of Lady Hamilton by Romney and Reynolds.[25]

The almost vernal sweetness of Angelica's Emma is matched by that of another beauty with a better pedigree and a better-deserved reputation for wantonness. Angelica's portrait of Lady Elizabeth (Bess) Foster was completed in 1786 in Rome, but begun the previous year in Naples. Today it hangs at Ickworth, the Suffolk mansion constructed by her eccentric father Frederick Hervey, the Earl of Bristol and Bishop of Derry.

Bess had been to Italy before. In spring 1782, recently separated from her husband and left with only £300 a year to live on, 'the poor little thing' had been despatched at Georgiana Devonshire's suggestion on a continental tour, during which she supposedly acted as chaperone to the Duke's illegitimate daughter Charlotte William. She took her duties lightly, finding her charge a disagreeable burden, but remained in Italy for nearly a year and a half, passing from Turin via Rome to Naples. She was presented to the Pope and had an affair with Count Fersen.

Georgiana, at a distance, worried about Bess's scandalous reputation, at least as far as circumstances permitted. The letters Bess sent

from Naples in 1783 blithely claim that she became a court favourite after Sir William Hamilton introduced her to Ferdinand and Maria Carolina in September.[26] There is no evidence that Angelica met her there, though if what Bess asserted were true one might have expected it. When she moved back to Rome she conquered the impressionable Cardinal de Bernis, at one of whose soirées Louise Vigée Le Brun would encounter Angelica in 1791, but the obviousness of their relationship when they appeared together in public caused a scandal.[27]

By July 1784 Bess was back in England, for a brief but critical period; within four months she was abroad again, now expecting the Duke of Devonshire's baby. From Turin she travelled via Milan, Florence and Rome to Naples, proceeding thence to Ischia, where she meant the child to be born. But her brother George, who was in Naples himself at the time, decided that Ischia was not secluded enough for the purpose, and arranged for her to go to the town of Vietri on the Gulf of Salerno. There she gave birth to a baby girl who was given the name of Caroline St Jules, 'at a house little better than a house of ill fame' (a hostel that doubled as a brothel), and promptly returned to Naples, leaving her child with a wet-nurse. She was soon engaged in another flirtation, this time with the sickly and delicate Russian Ambassador Count Skavronsky.

Her reputation there was far less exalted than her letters imply, though the sweet guilelessness of Angelica's portrait belies it. When her brother and his wife encountered Bess at Christmas that year, they found her situation leaving much to be desired. According to George, she was disliked in the city (where she lodged with the wife of the French Ambassador) and was disapproved of for wearing too much scent.

Later on Fanny Burney would think her odious, as unreliable (if as apparently charming and witty) as her father,[28] but in Angelica's portrait she radiates elegance and poise, as though to belie all the rumours about her Neapolitan fortunes. Her pensive expression and the view of Ischia in the background may hint at her recent ordeal, but the picture effaces it, making her the very image of romantic charm. Under her broad-brimmed Leghorn hat with ostrich plumes, loose curls frame her face and soft tendrils of hair float down over her shoulders. She is dressed simply but in the height of fashion, in a muslin chemise dress with a broad sash, the very plainness of her

outfit somehow making her look blameless as well as relaxed. Round her neck is her 'beloved medallion' of Georgiana, a miniature she had been upset at having to remove when she was giving birth to her illegitimate child.

The two women's friendship survived the evidence of Bess's infidelity with the Duke, and when she returned to Italy in 1792 it would be with the now exiled Georgiana, banished abroad to bear a love-child herself. Georgiana, who had claimed that she was accompanying her sister Harriet abroad, gave birth on 20 February 1792 in Aix, after which she slowly proceeded with Bess, Harriet and Lady Spencer to Italy. In the new year they were in Pisa, where Georgiana took an understandable interest in the foundlings' hospital, and where the general conditions so shook her that she complained to the Tuscan government. 'By Her Grace's representation the abuses were remedied.'[29] By 11 March the party had reached Rome. Bess's last years were spent in the city, where as the Dowager Duchess of Devonshire (she had married the Duke in 1809) she would be remembered for excavating the base of the columns of Phocas in the Forum. But even then her old reputation remained alive.

Angelica would paint her father too. He was a sportive man, called 'lively, odd and half mad', who took his ecclesiastical duties lightly, on one occasion organising a curates' race along the sands at his Irish seat of Downhill to fill the benefices then vacant in his diocese. A famed epicure, he took such care to ensure that he stayed only in the best hotels serving the best food on the continent that, as a mark of their indisputable excellence, they all renamed themselves the hotels Bristol after enjoying his custom. Naples became a favourite stopping place of the Earl-Bishop, who climbed Vesuvius every day with such intrepidness that Mrs Piozzi became alarmed: '[the] Bishop of Derry did very near get his arm broke' from venturing too close to the crater while red-hot stones were being flung into the air, she noted.[30]

This episode occurred when he was staying with Sir William Hamilton in 1765. They had been friends since schooldays, and Hamilton's enthusiasm for vulcanology was contagious. He had a house, the Villa Angelica, that Dr Burney described as being at the very foot of Vesuvius, and it served as a base for their frequent expeditions up the mountain. They were both fanatical collectors too, though much of Sir William's trove of vases and antiquities sank to the

bottom of the ocean when it was being transported to England for delivery to the British Museum, and the Earl of Bristol's assemblage of pictures was confiscated when he was arrested by the French in 1798. He subsequently recovered it, only to see the part that had been kept in Rome seized again by Napoleon's troops. Ironically, he had had the great rotunda of Ickworth built precisely in order to provide the collection with a suitable home; but it was never retrieved,

> that immense, valuable and beautiful property of large mosaic pavement, sumptuous chimney-pieces for my new house [Ickworth], and pictures, statues, busts and marbles without end, first-rate Raphaels, dear Guidos and three old Carracci.[31]

Angelica painted him in March 1790 sitting pensively by a bust of Maecenas. The latter was perhaps a reference to his huge outgoings on art and buildings, for he freely gave commissions to artists and architects as well as collecting Old Masters and antiquities. Not that the commissions were always as lucrative as they had promised to be. Hervey paid £600 to Flaxman for a marble of *The Fury of Athamas*, 'the size of Laocoon', and the artist told Sir William Hamilton, 'for his generosity to me I must be silent, for I have not words to express its value' – but his costs far exceeded the fee he was paid.[32] Although John Deare received commissions worth £270, he expressed a disappointment that was familiar to those who knew Hervey's ways:

> The Earl of Bristol [. . .] had given a great many commissions besides to different artists here [in Rome]; and just as we all expected orders on his banker his Lordship suddenly (as usual) left Rome without giving any orders.

In April 1791, again, Deare was finishing a *Venus and Cupid*

> which he supposes will remain on his hands according to the usual equitable and gentlemanlike manner in which His Lordship thinks proper to treat so many artists.[33]

Flaxman's generous estimate that Hervey's liberality as a patron had

'reanimated the whole fainting body of art' in Rome was obviously a matter for some dispute.

He was seen as a chameleon figure. Wesley may have called him exemplary in all parts of public worship, full of good works, while others claimed that he clothed the naked and fed the hungry, but Lord Charlemont said that he was devoid of firm principle, a bad father and a worse husband, ambitious, sensual and mean.[34] In the same spirit Morritt reported in early 1796 that he was

> the strangest being ever made, and with all the vices and follies of youth, a drunkard and an atheist, though a *Bishop*, constantly talking blasphemy, or indecently, at least, and at the same time very clever, and with infinite wit; in short, a true Hervey. [...] [H]e courts every young and every old woman he knows. [...] He has been nearly dying, and I am sorry to say is better, and likely to recover.[35]

The profanity of his talk was remarked upon by Sir William Hamilton, who on hearing that Hervey had been arrested near Ferrara in April 1798 on his way from Venice to Naples via Rome remarked to Charles Greville: 'We all know that his Lordship's freedom in conversation, particularly after dinner, is such as to make him liable to accidents of this nature'.[36] Catherine Wilmot was unsparing in her verdict on the man:

> He is the patron of all the modern artists, whose wives he not only associates with as his only female company, but has their pictures drawn as Venuses all over the house.[37]

This was the more shocking, perhaps, because on an earlier visit to Italy in 1778 he had commissioned a marble *Venus and Cupid* from the sculptor Thomas Banks, only to reject it later in the year on the grounds that it was 'improper for a Bishop'. This and related acts of betrayal caused much ill will in the artistic colony of Rome. The same month, for instance, Hervey commissioned designs for a new dining-room at Downhill from John Soane, who was dazzled by 'the magnificent promises and splendid delusions of the Bishop of Derry',

yet the designs were never adopted. Joseph Ford, travelling in Italy in 1802 and 1803, was struck by his ambivalent nature, for Hervey

> would sometimes talk divinely on art, and then relapse into affected absurdity. His conversation was obscenity itself, no modest woman could talk with him, or go up his staircase at Rome, where the frescoes were most indecent, neither he, nor his son the first Lord Hervey, could create any esteem here with all their liberality.[38]

He was never constrained by his ecclesiastical duties. During his last visit to Italy, when he was staying in Siena, he allegedly threw a tureen of pasta from the upstairs window of his hotel onto a passing procession of the Host. The architect Charles Tatham remarked that the Earl-Bishop was in a constant state of inebriation.

Louise Vigée Le Brun's 1790 portrait of Hervey shows him glowing with health, a state no doubt helped by his regular ascents of Vesuvius; Angelica's picture of the same man, to judge by a surviving copy, was a flatter affair, and he appears much older. When he died it would be ingloriously, in the outhouse of a peasant's cottage between Albano and Rome, because superstition prevented the inhabitants from letting a heretic bishop inside. Yet in 1790 he still had thirteen years to live, and he seems to have carried on active to the end. Three months before his death he was seen, in Catherine Wilmot's acidulous description,

> riding and driving past our windows and his appearance is so very singular that I must describe it to you. His figure is little, and his face very sharp and wicked; on his head he wore a purple velvet night-cap, with a tassel of gold dangling over his shoulder and a sort of mitre to the front; silk stockings and slippers of the same colour and a short round petticoat, such as Bishops wear, fringed with gold about his knees. A loose dressing-gown of silk was then thrown over his shoulders. In this Merry Andrew trim he rode on horseback to the never-ending amazement of all beholders! The last time I saw him, he was sitting in his carriage between two Italian women dressed in white, bedgown and nightcap like a witch and giving himself the airs of an Adonis.[39]

His obsequies, however, were allegedly attended by 800 artists of all nationalities, and his body was brought back to England in a box identified for security purposes as containing an antique statue.

His daughter's casual Naples fling had been with an aristocrat who would also become a client of Angelica's. Count Skavronsky had been appointed to his post by Catherine II in 1784. He was one of her great-nephews, an immensely rich Livonian grandee known for his passionate, eccentric love of music. His servants were forbidden to talk and allowed to communicate only in recitative, while Skavronsky himself gave all his orders in musical form and made his visitors converse by way of vocal improvisations. The other source of his celebrity was the beauty of his wife, Potemkin's niece and sometime lover Catherine Engelhardt. Angelica's portrait of Skavronsky was painted in 1786, probably after she had done some preliminary work during her trip to Naples the previous year. It highlights his fragility, and perhaps also the yieldingness that made him so ready to tolerate his marriage to an indolent, lethargic but evidently sweet wife. The Tsarina described him as 'a bit silly and clumsy', while Potemkin called Catherine Engelhardt one of the prettiest women in the empire. Comte Roger de Damas declares in his memoirs that Potemkin carried his affection for all his Engelhardt nieces to excess, but Catherine was his favourite.

Although she continued to be her uncle's occasional mistress until he died (uncle-niece incest was not uncommon in Russia), she is said to have only 'tolerated' his embraces. But then she only tolerated most things: husband, court, finery, all the trappings of her elevated position. She took so little interest in the trunks of clothes sent her by Rose Bertin, Marie-Antoinette's *marchande de modes*, that she never bothered to open them, simply asking 'What is the point?'[40] Her idea of true happiness was to lie on a sofa wrapped up in a black pelisse and wearing no corset. Potemkin called her his 'angel incarnate', and the Prince de Nassau-Siegen confirmed the justice of the name. The comte de Ségur thought that Catherine could fittingly serve as a model for Love itself,[41] and many men duly adored her.

Angelica painted this seraphic woman twice, first in Naples in 1785 and then in Rome in 1789. In neither does she look as dreamy and passive as Louise Vigée Le Brun's portraits make her appear, though both are appropriately restful images. The first version of the 1785 portrait, which shows Catherine sitting at the foot of a tree in an

English-looking park, has her with her small child, who hands her a bunch of flowers; the second depicts her without, as though the presence or absence of her offspring was another of the things that left her indifferent. In the 1789 picture, commissioned by Potemkin himself, she is wearing a Grecian garment and crowning with a garland the helmet of her uncle, the Prince of Tauris. The fame of her own beauty, she seems to imply, should be subordinate to the political and philosophical glory of Potemkin, who probably insisted on the insertion of this proprietory detail.

Angelica's Russian clientele was considerable, in large part because of the fame that Catherine II's patronage had won for her. The Empress had probably first become acquainted with her work when Princess Dashkov presented her with an unspecified 'fine Greek figure', which was

> perhaps the first specimen of the talent of this charming artist, of this even more charming woman, which had ever appeared in Russia, and I was happy to learn that the Empress had been charmed by it.[42]

In November 1795 Catherine would write crossly to her confidant and agent Friedrich Melchior Grimm that Louise Vigée Le Brun had just arrived in Russia with the express intention of rivalling Angelica, but that Angelica was effortlessly superior to her:

> She unites elegance with nobility in all her figures; she does more: all her figures possess ideal beauty, [whereas] the rival of Angelica, for her first attempt, begins to paint the grand-duchesses Alexandrina and Elena; the former has a noble, interesting face, the air of a queen; the latter combines perfect beauty with a look as if butter wouldn't melt in her mouth. Mme Le Brun plonks these two figures on a settee, twists the young one's neck, gives them the appearance of two pugs basking in the sun or, if you prefer, two ugly little Savoyard girls looking like Bacchantes with bunches of grapes in their hair, and dresses them in vulgar red and purple tunics . . . [43]

Angelica's superior skill at idealisation would never have permitted her to make such a faux pas. But it had not needed Louise's gaffe to persuade the Tsarina of Angelica's desirability. It was reported in the *Oracle* of 11 July 1789 that she was in the process of illustrating Fanny Burney's novel *Evelina* for the Empress, and in fact Catherine had been commissioning pictures from her for years. Engravings after Angelica's drawings of the Virtues were done for her by Gabriel Skorodomov in 1777, but Reiffenstein had already alerted the Tsarina to the quality of her work.

No more than Maria Carolina was the Empress of all the Russias a woman to be toyed with. When Maria Carolina's brother Joseph, the ruler of the Holy Roman Empire, visited Angelica in 1784 and tried to place two commissions, she told him without compunction that he would have to wait, as she was painting a huge historical piece for Catherine. She probably found such frankness easier in Joseph's case than in that of many other potentates. After all, Joseph had come to Rome affecting simplicity, calling himself Count Falkenstein, living without show and eating in guesthouses around the Piazza di Spagna. Although he went to Angelica's studio incognito, she was well aware of who he was. In a letter to Metzler she could barely contain her joy:

> I had the unexpected honour of seeing His Imperial Majesty in my house. His Majesty stayed for more than an hour in my studio. Inspected my work very closely and expressed the greatest pleasure, spoke to me as kindly and in as benevolent a way about areas of my native land as it is possible to speak. His Majesty honoured me with the commission of two paintings for his esteemed self. You cannot imagine, and I cannot sufficiently describe, how gracious and benevolent this great monarch showed himself towards me. Do give this news to my relatives and friends who ask after me.[44]

The orders, placed three weeks later by Joseph's ambassador Cardinal Hrzan, were for two unspecified paintings, but which the Emperor hoped would have links with the fatherland. Angelica's subject *Hermann and Thusnelda*, if not that of *Pallas Killed by Turnus*, cannot have disappointed him, if it is indeed the case that he left the choice to her.

The picture for Catherine that Angelica had to complete before undertaking these commissions is a monumental and many-figured work showing the child Servius Tullius asleep in the apartments of King Tarquin, a vast, unalluring composition that makes one yearn for her sensitive portraits or light-hearted mythologies. Was she trying too hard, overwhelmed by the grandeur of all things Russian and the majesty of her client? It seems unlikely. She would paint a far more attractive picture a few years later for an equally terrifying Russian patroness, Princess Bariatinsky; but, probably crucially, it was not an attempt at the historical mode.

Although the Princess, née Holstein-Beck, looks calmly regal in Angelica's group portrait, she filled people with such fear that her bailiff apparently died of joy when he heard that she had passed away.[45] The conversation-piece shows her sitting surrounded by her son, daughter and son-in-law, holding a miniature portrait of her husband (who during his time as Ambassador in Paris had been known as 'le beau Russe') and looking every inch the matriarch. The arrangement of the family group, with the children spread out like a frieze to the Princess's left, is a conscious reminiscence of the ancient marble relief *Orpheus and Eurydice with Hermes*, which Winckelmann had discussed in his *Monumenta antichi inediti*, and is an appropriate compliment to a woman who spent a fortune on works of art. During her time in Italy she ordered four paintings from Angelica whose price ranged from sixty to 800 zecchini: the last sum was the fee for the family group portrait, and it shocked Angelica's later acquaintance Mariane Kraus. (Apparently the sculptor Alexander Trippel, whose bust of the Princess's father stands on a pedestal next to his daughter in Angelica's picture, earned no more than this for sculpting half a funeral monument that kept him and his assistants busy for weeks if not months on end.)[46] Princess Bariatinsky also bought the first version of Angelica's *Self-Portrait Hesitating Between Painting and Music*, but in the end her money seemed to run out, and although she commissioned a 1792 scene showing Cupid and Psyche it was eventually bought in 1796 by the Princess of Anhalt-Dessau.

Princess Bariatinsky's diary contains the following entry:

Before I left Rome, I had to see Angelica Kauffman once more and admire her works [. . .]. This woman, despite her great

talent, is extremely modest: there is a tenderness in her character which makes everyone love and esteem her. The whole world confirms her merit as a person, and the Cardinal de Bernis calls her the Tenth Muse. In England, where she spent twenty [*sic*] years, she was extraordinarily esteemed, and she became very famous there, although she had already won recognition in Rome, where she began her studies. At the age of eighteen she did a copy after Rembrandt for herself. She did it with such perfection that she astounded all connoisseurs, who could not understand how it was possible to possess so much knowledge at such a tender age.

This woman conducts herself without any great pretensions, utterly simple in her manner and her way of expressing herself. Far from thinking of boasting or angling for people's praise, she seems on the contrary to shun both, and accepts praise from those who admire her work with the greatest modesty. Such a woman enjoys no favour with the superficial people of today, who think true merit is to be found only in pleasure and outward appearance. Many of the French, and unfortunately many of the Russians, are the same, and as they only judge superficially she seems to them devoid of wit and lacking in knowledge. Yet she is one of those people who deserve to be known, all the more when one thinks of all her merits [. . .]. She was to have married a rich lord with a great name, she was very much in love, but she had bad luck with her first husband, said to be a baron, who was only an adventurer and deceived her; she was afraid of new ties. In the meantime a Venetian called Zucchi, a reasonably good draughts-man . . .[47]

It is the usual mixture of commonplaces, myths and half-truths. However grateful she was to generous patrons, Angelica had reason to wish – as she openly did at about this time – that others would leave reporting the facts of her life to herself.

If she was drawn, financially as well as emotionally, to the depiction of glamorously 'other' races such as the Russians and Poles, Angelica was for obvious reasons particularly at home with German clients and friends. German artists formed what was sneeringly called a coterie in

Rome, and Trippel was particularly scathing about their clannishness. It is no doubt true that German-speaking expatriates stuck together, but so did the denizens of the Caffè inglese. In any case, it is hard to avoid the suspicion that Trippel's general disapproval was partly prompted by his jealous dislike of Angelica and the 'santa famiglia' of compatriots she allegedly gathered around her at Via Sistina 72. The Trinity was formed by the Hackert brothers and Reiffenstein, with Angelica herself the Madonna and Zucchi Joseph. When Maron found it difficult to win commissions because of the prevailing Angelica-fever, Trippel noted sourly:

> Angelica gobbles up everything, and has so much to do that she can hardly dispute the fact, and she is still painting as manneredly as before. People are still so blind, and they refuse to see it.[48]

Angelica seems not to have borne Trippel any corresponding ill will, if her inclusion of his bust in the Bariatinsky conversation-piece is any indication, but others, like Mariane Kraus, shared his objections to her money-making ways. Kraus also expressed shock at the virtuoso airiness with which Angelica won her clients and commissions, though she was equally disapproving of Trippel's tendency to judge other artists (including Angelica) adversely whatever their conduct and artistic capacities.[49]

At all events, if Angelica was guilty of colonising as well as monopolising the market, she was herself only part of a colony that Trippel had helped to constitute. Rome was, after all, a magnet for German-speaking artists. Philipp Hackert had arrived in 1768, Trippel himself in 1776, Rehberg in 1777 and Tischbein in 1779. Füger, Bury, Johann Heinrich Lips and Angelica would come in 1782, Schütz and Meyer in 1784. Many, having arrived, stayed on, Hackert for thirty years and Tischbein for twenty. They congregated in cafés around the Piazza di Spagna and gathered in salons such as Angelica's, where *conversazioni* sometimes lasted until three in the morning.[50]

This was another way of cultivating useful acquaintances, although some visitors found *conversazioni* unbearably dull, if not positively uncomfortable. John Moore thought that one enjoyed no such thing as conversation on these occasions, but simply put up with being squeezed and jostled in the most select and well-dressed company.[51]

But brilliant *salonnières* lived and entertained in late eighteenth-century Italy. One was the cultivated lover of the Egyptologist and museum director Vivant Denon, Isabella Marini (who would later, rather unnervingly, marry the State Inquisitor Count Albrizzi). She held glittering court in Venice, ravished everyone (including Louise Vigée Le Brun, who painted a seductive portrait of her for Denon), received the cream of artistic and literary society – Canova, Staël, Chateaubriand and Stendhal – and tirelessly promoted the claims of culture. In Venice, Louise Vigée Le Brun would be surprised to be 'lent' Denon by la Marini, who was shocked that she lacked a *cicisbeo*. 'Have you no male friend?' she asked her.[52]

Another fabled beauty was merely a visitor to Italy, one of the Polish-Austrian contingent with whom Angelica felt particularly at home. Countess Kinsky had contracted an unsatisfactory marriage which she was able to have dissolved when the Papal Nuncio decreed that a terrifying storm had made her barely conscious during the wedding ceremony, so that she could not be said to have consented to become the Count's wife. The couple had been entirely unacquainted with one another beforehand, according to Louise Vigée Le Brun's *Souvenirs*, and the Count arrived from a town in Germany to meet his bride:

> Immediately after the service he said to his charming young wife: 'Madam, we have obeyed our parents; I leave you with regret; but I cannot disguise from you the fact that for a long time I have been attached to a woman I cannot live without, and I am going back to her'. The post-chaise was at the door; having said his farewell, the count climbed into the coach and went back to his Dulcinea. So Countess Kinska [*sic*] was neither girl, nor wife, nor widow, and this oddity must have surprised anyone who looked at her; for I have never seen anyone so ravishing.[53]

Angelica's portrait of Countess Meerveldt (as she became when she married *en deuxièmes noces* the Austrian Ambassador to London, Count Meerveldt) is in fact slightly flat, and as she looks out at the world from Vienna's Belvedere she appears less beautiful than merely pretty. Whatever idealising tendency Catherine II detected in her, Angelica clearly did not choose to indulge it on every occasion.

She had dealings with a member of another Austrian family figuring in the Vigée Le Brun *Souvenirs*. Graf Joseph Johann Fries belonged to a hugely wealthy banking dynasty, whose founder had been ennobled by Maria Theresa for his economic successes as an army supplier, although his descendant seemed far more interested in spending money on works of art and objects of beauty than in amassing it. In the *Italienische Reise* Goethe writes:

> I dined at Graf Fries's [...]. Graf Fries buys a lot, and has among other things bought a madonna by Andrea del Sarto for 600 zecchini. Last March Angelica offered 450 for it, and would have offered the whole sum if her foolish husband had not raised an objection. Now both regret it. It is an unbelievably beautiful picture, you cannot imagine such a thing without having seen it.[54]

Fries's entire dressing-room was lined with engravings after Angelica's works,[55] but in collecting terms her 1787 portrait of him went one better. He is shown standing on the right of the plaster cast of a marble statue he had recently purchased (possibly on Angelica's advice), Canova's *Theseus and the Minotaur*. In the picture the sculpted Theseus cuts an even more insouciant figure than the Count does, lounging with legs elegantly extended against the Minotaur he has just killed. Fries looks equally slim and almost as dashing, his thin-lipped, sensitive face framed in romantic curls and complemented by the pretty Van Dyck costume he wears. His passion for the Eternal City as well as for art is conveyed by the Roman landscape in which he stands, a vague terrain whose general situation is indicated by the column of an ancient building just visible to his left.

Some of the male Grand Tour pictures Angelica did have less éclat than this, their subjects seeming trapped in the fancy dress which she was one of the last late eighteenth-century portraitists to preserve. The Van Dyck outfits and the romantically pretty curls can enervate the subject, making him into toyboy as well as playboy, and the recycled uniform standardises sitters in the same way as contemporary 'Grecian' costume did women. The result is a series of barely distinguishable recipe paintings, records that their owners were glad enough to keep as mementoes of the past, but wearying or frustrating for beholders in search of psychological truth.

Did Italy attract male peacocks, or was it simply that Angelica was attracted to the idea of painting them? The effeminate grace that contemporary critics complained of in her male images features again in the 1793 portrait of a gorgeously attired Lord Berwick, dressed in what the *Memorandum of Paintings* calls a Spanish costume, with lace collar and cuffs, slashed sleeves, and bows on his knees, breeches and shoes. (In the eighteenth century this kind of dress was a predominantly English affectation, and had been since the 1740s.) It is probably significant that Winckelmann liked men to wear such outfits in art and life, and in the *Geschichte der Kunst des Altertums* called them far more 'advantageous' than constricted contemporary dress. But in what respect advantageous – for the beguiling of the male observer or the contemplation of the rather defensive female? Angelica's picture of Henry Lambton in a similar costume prompted the predictable comment from the Royal Academician William Artaud that 'An attempt at [. . .] giving a certain kind of prettiness even destroys, in my opinion, the energy of her male portraits, and makes them all appear to be emasculated.'.[56]

It was a look that might have seemed calculated to appeal to William Beckford, the aesthete author of *Vathek* and builder of Fonthill, whose homosexual indiscretions had banished him from England but did not stop him enjoying an intense *amitié amoureuse* with his cousin Sir William Hamilton's first wife Catherine. 'Before you,' he wrote to her, 'I can venture expressing all my wayward thoughts, can murmur – can even weep in your company.'[57] His presence in Rome aroused the same kind of hopes in struggling artists as the Earl-Bishop's did:

young Beckford laid out a little money though but a few days in town; and as he returns in Holy Week from Venice it is hoped he will scatter a little of his immense fortune among the artists.[58]

He loved Venice, 'stalking proudly about like an actor in an ancient Greek tragedy', but would have no truck with the likes of Byres and Morison in Rome:

I absolutely will have no antiquary to go prating from fragment to fragment, and tell me that were I to stay five years in Rome I should not see half of what it contained. The thought alone, of so

229

much to look at, is quite distracting, and makes me resolve to view nothing at all in a scientific way; but straggle and wander about, just as the spirit chooses.[59]

Beckford hated the garishness of the city's celebrations and observances, with the Festival of Saints Peter and Paul marked by 'cannon bouncing, trumpets flourishing, Pope gabbling, Cardinals stinking and fish frying in every corner'.[60]

But he adored Angelica, writing to Sir William on 12 October 1782: 'Angelica is my idol; so say everything that can be said in my name, and tell her how I long to see Telemachus's papa and all the noble family'.[61] Beckford, who may have met her in London, probably 'loved' her as he loved other women – that is, for reasons of artistic sympathy and maternal need. If the rigid good sense of Zucchi ever grew irksome to her, she was unlikely to seek solace with a man so different in temperament from herself, whether Beckford or any other of her apparently impassioned admirers. Their type of adoration was as often a pose or an expression of their period's sentimentality as real regard. Angelica certainly inspired deep feeling, but it was reciprocated only when she felt artistic humility before the man professing devotion. Klopstock had been an early case, but in Italy she discovered that she needed to move beyond and away from him.

She needed Goethe, who came to Italy in 1786. With him Angelica would experience all the pleasures of intense artistic allegiance and – or so it appears – all the pain of forsaken emotion. She worshipped him. Precisely what Goethe's feelings were for her is less easy to say; but their relationship, perhaps the most important in Angelica's life, was nothing if not profound. Through her, as through Italian art generally, Goethe would discover ways of seeing as well as ways of doing that he had only imagined before leaving Weimar.

Chapter Eleven

Goethe and the Undulist

Goethe arrived in Rome on 29 October 1786, his sense of having reached a destination immediate and absolute. Writing to Herder two years later, he called it the place 'where for the first time in my life I was completely happy'.[1] Undertaking the Italian journey may have seemed like the response to a calling,[2] but before he could answer it confidently he had to forget his identity as a great writer and a courtier, and start again. Although Tischbein's famous portrait of Goethe in the Campagna glorifies him as a German statesman-genius, reclining in the classical landscape and languidly appropriating it with his gaze, his Roman beginnings were far from proprietorial. He knew that before he did anything 'I must school my eye, accustom myself to seeing'. This was not always easy, because he lacked the necessary training. The result was that 'I run around and tire myself out, think myself dry'.[3]

What he wanted out of Italy was *difference* – the opportunity to experience a world that was ancient and classical, as well as the chance to push his artistic leanings to their limit. Weimar, where he had been since the mid-1770s, had become oppressive. He had been tempted there by the young hereditary duke Karl August, who had been fatherless since boyhood and over whose mind Goethe had gradually gained ascendancy since their first meeting in Frankfurt. In accepting his invitation to join the Weimar administration, Goethe had also taken on the role of poet in the 'Muses' Court', which the former regent Anna Amalia, Karl August's mother, was busy establishing. But he had been wrong in believing both that he could flourish artistically under such conditions and that a political career might fulfil him; the latter, he found, stultified the former, and he gradually became convinced that anyone who in the absence of philosopher-kings allowed his time to be taken up with administration was a philistine, a knave or a fool. Although his main function was to act as companion and mentor to Karl August, and although his official position – he was a Privy

231

Counsellor, and attended regular meetings with the Duke – was not unduly burdensome, he felt put upon and frustrated.

Italy, therefore, had to rekindle his creative enthusiasm, train his eye by introducing him to masterpieces of painting and sculpture, and set him free. Yet the preliminary courtship of the work of art was discouraging, for so much remained beyond his comprehension. Although he tried to adopt a new way of looking at things, truth still seemed beyond his grasp. One difficulty kept recurring: 'it' would not get into his head, he complained, because 'it' would not get into his field of vision. What 'it' was remained mysterious until Angelica and his other artist friends (almost exclusively the German-speaking coterie) had given him an artistic education, and the process was long and humbling.

Goethe had originally meant to spend a bare month in Rome before starting on his return journey to Weimar, but various circumstances intervened in the course of those four weeks to make him change his mind.[4] In mid-November he heard that Vesuvius had begun to erupt, which to the keen natural scientist he had become was an irresistible attraction. His response was to revise his travel plans with a view to setting off immediately for the Kingdom of the Two Sicilies.

His Naples diary, sent at regular intervals to Charlotte von Stein (the wife of a Weimar court official with whom he was platonically in love), was destroyed in 1817, but the *Italienische Reise* gives an account of his stay there that is both meditative and factual. Everyone in Naples was agreeable towards him, he wrote, 'even though they can get nothing out of me'. If Angelica had found the court's insistence on having her personal attention as burdensome as Louise Vigée Le Brun would later do, Goethe was immune to it. For Italians, after all, his was not a name to conjure with, even without the incognito of Philipp Möller that he had adopted in Rome. *Werther* was certainly known in Italy, but nothing else he had written was. Rossi has not a word to say about Angelica's friendship with Goethe, perhaps because in Italian eyes Goethe did not really count. If the great man had been visibly producing something, circumstances might have been different: as Goethe remarks, the busy Tischbein pleased the Neapolitan court and won its undivided attention simply by industriously painting portrait heads of its members in the evenings, 'which make them gesticulate like South Sea islanders at the sight of a man of war'.[5]

But all Goethe's plans – to leave for Naples as soon as he heard about the volcanic activity there, to return to Rome for Easter and then to spend two months in northern Italy on his return journey – were upset by a crisis in his correspondence with Charlotte von Stein. He obtained indefinite leave of absence from the Weimar court, though Duke Karl August eventually set a firm date of Christmas 1787 for his return (and then extended it to Easter 1788).[6] His artistic education, it seemed, could continue unchecked by anything except his self-doubt and the limited personal capacities to which his letters repeatedly refer.

In Rome he had started as he meant to go on by lodging with a painter. On the night of his arrival he scribbled a note to the unsuspecting Tischbein asking him to meet him at the Locanda dell'Orso[7] – an inn known to Dante and Montaigne – and wrote to Charlotte von Stein, 'I am here'. It was all he could think of to say. The following day he moved into a spare room at Tischbein's house, the Casa Moscatelli, a stately corner building opposite the Palazzo Rondanini and a stone's throw from the Piazza del Popolo on the Corso. On 9 December Tischbein wrote excitedly to Lavater:

[Goethe] is certainly one of the most excellent men one could possibly know. Imagine my inexpressible joy a few weeks ago! Goethe came to me unexpectedly, and now he lives in my room beside me (so I enjoy the company of this strange, clever man from morning till night). You can readily imagine what a pleasure that is for me, since you know of Goethe's qualities and my reverence for great men [. . .]. What particularly delights me about him is the simplicity of his life. He wanted only a small room from me, where he could sleep and work without interruption, and very plain food, which I could easily provide him with, because he is satisfied with so little.[8]

He jealously protected his privacy, Tischbein added, spending his time writing, looking at works of art and consorting with a limited group of acquaintances. Only artists were allowed to visit him, and he refused to accept any honours or special attentions.

The Casa Moscatelli housed two other artists, the landscape painter Johann Georg Schütz and the portraitist Friedrich Bury. When

Tischbein went to Naples as court painter to Ferdinand and Maria Carolina they stayed on, but Goethe himself moved into Tischbein's large vacant studio. Here he seemed contented, if to outer eyes restricted. 'Maler' Müller[9] wrote to Heinse on 17 April 1787 that he was the 'state prisoner' of the antiquarian Hirt – 'a merciful prince' – with a bodyguard formed by Schütz, Bury and Tischbein's other painter friends.[10]

Tischbein's protection was crucial for the early stage of Goethe's stay. A letter to Charlotte von Stein declares: 'Tischbein's company is endlessly useful to me, he cheers me up, and it does me such good to be with a man who, with all his great strengths, is on the right path'.[11] With him Goethe could feel that he had sloughed off his old Weimar self: he was nothing but an artistic novice trying to acquire knowledge, not a celebrity writer or a power behind the throne. Tischbein represented the qualities of balance and serenity that his own life in Weimar lacked. His virtues, Lavater wrote to Goethe on 17 April 1782, were gentleness and modesty[12] – precisely the virtues that Goethe would later attribute to Angelica – and his influence could only be beneficial.

The first artists Tischbein introduced Goethe to were Trippel, Reiffenstein and Angelica,[13] who called the Casa Moscatelli household 'the German Academy of the Rondanini'. Goethe was quite unabashed about Tischbein's services to him as an *introduttore*. The artist had first come to Rome in 1779, and it was his sociable nature as much as his artistic expertise that Goethe valued. As Herder would later remark in a letter from Rome to his wife, there was a selfish and even exploitative streak in Goethe's character,[14] which may explain why Tischbein left Rome without reluctance to assume his official duties in Naples, and why the friendship between the two men grew less warm from the spring of 1787 onwards. Tischbein's instinct for self-preservation had asserted itself, though the Neapolitan court was hardly the ideal place for it to flourish.

Angelica's generosity towards the new arrival seemed unbounded. Her rendezvous with Goethe soon became a fixture, and in July 1787 he wrote:

I ate at Angelica's house; it is now settled that I am her Sunday guest. Before the meal we drove to the Palazzo Barberini to see

the glorious Leonardo [*Vanity and Modesty*, now attributed to Luini] and Raphael's portrait of his mistress [the so-called *Fornarina*, certainly conceived by Raphael but probably painted by Giulio Romano]. It is extremely gratifying looking at pictures with Angelica, as her eye is so highly trained and her technical knowledge of art so great. She also has enormous feeling for everything that is beautiful, true and tender . . .[15]

The artist Albert Christoph Dies, a German landscape painter and engraver, coloured Goethe's drawing of an imaginary landscape and so aided his understanding of harmony and tone. 'My greatest pleasure is that my eye is being trained to see forms as they really are, and my feeling for attitude and unity is being restored with it.'[16] His knowledge of perspective and architecture advanced too, along with his skill at landscape drawing. But Angelica's companionship was as priceless as her instruction.

On 29 July, a week after visiting the Palazzo Barberini, they inspected the Palazzo Rondanini. Apropos of this visit Goethe reminded Charlotte von Stein of his earlier reaction to a sculpted head of Medusa, which had then merely struck him forcibly, but which now filled him with real pleasure:

Just to have the notion that such a thing is possible in the world, that such a thing can be made, makes one into twice the person one was. How I should love to say something about it, were anything one could say about such a work not empty bleating. So art is there for one to see, not to talk about, except possibly in its presence. How ashamed I am of all the artistic gossip I once went along with.[17]

Angelica's personal modesty can only have helped him to this realisation. The quiet authority of Zucchi and the learning of Reiffenstein also contributed, as the party braved the ovenlike heat of midday and made their regular Sunday trip to a gallery or collection before returning to a lavish meal at Via Sistina 72.[18] It was highly instructive, according to Goethe, to talk about art in the presence of such masterpieces and to three such people, all educated practically, aesthetically, theoretically and technically. But Angelica, he insisted,

remained his best acquaintance in Rome, an excellent, tender, clever and good woman.

Of course, when he calls her an outstanding artist *for one of her sex* he is judging her by a different yardstick. His regard for her artistic expertise is one thing; his evaluation of her artistic production quite another. True, it did not need Goethe's eye to perceive that her work suffered from her chronic over-production, but even without her excessive zealousness the paintings she did were not calculated to appeal to every taste. If Goethe liked the picture of *Cornelia, Mother of the Gracchi*,[19] he either passed over in silence everything else she did or flatly criticised it. Herder, who may have been jealous, suggested to his wife that Goethe was at bottom uncaring, shamelessly using Angelica as he had used Tischbein to further his own interests and help him achieve his goals. Besides, notwithstanding his claim that Angelica was his best friend in Rome, and despite his praise of her instruction, Goethe states in the *Italienische Reise* that it was the young painter Johann Heinrich Meyer, whom he met there late in 1786, who first opened his eyes to art. 'He never speaks to me without my wanting to write down everything he says [. . .]. His instruction gives me what no [other] person could.'[20]

Given the two men's later collaboration in the writing of *Winckelmann und sein Jahrhundert* (1800) and the tone of Meyer's own art-historical contribution to it, the *Entwurf einer Kunstgeschichte des 18. Jahrhunderts*, this may suggest a latent anti-feminism. The *Entwurf*, which conveys the essence of Goethe and Meyer's conversations, would govern the entire subsequent notion of woman's artistic production in the nineteenth century and beyond. The linchpin of Meyer's argument is that denying women traditional forms of artistic education condemned them to inferiority, and that for as long as they lacked anatomical training their art must remain second-rate. This is uncontroversial enough, and its relation to the standard criticisms of Angelica's painting equally evident. What is more surprising is that even while acknowledging woman's inferiority to be the inevitable consequence of educational deprivation, Goethe and Meyer did not recommend a radical change in the status quo. Instead they simply repeated that the current state of morals did not allow the opposite sex to deal with 'indecent' matters such as nudity (despite their daily familiarity with it as midwives, nurses and mothers). Nor did the

drawing school that Meyer subsequently established in Weimar open up wider horizons to them, for women were still restricted there to engaging in 'seemly' activities – flower painting, botanical drawing and the like.[21] True, such skills were a highly regarded part of training in the polite arts in the eighteenth century, and were also cultivated by men; but men, crucially, were not institutionally confined to them.

It hardly seems fair, then, that the *Entwurf* should criticise not Angelica's capacity to depict the charming and beautiful, but her preferring the charming to the worthy (even if this were true). The worthy or significant, according to Meyer, consists in art that is impregnated with deep understanding and ideal desire, and it produces sublime, poetic images that speak to the soul.[22] Of course, no unprejudiced assessment of Angelica's work could ignore the fact that lightweight charm is absent from much of it: not just her historical paintings, but some of her portraits too, explore dark motives and complex psychologies. But Goethe at least was convinced that women, artistic or otherwise, could do little but softly please.

'It is very odd,' he wrote to Meyer, 'how completely *undulistic* women are in art.' His story *Der Sammler und die Seinigen* describes undulists as people

who love soft and pleasant things lacking in character and significance, from which only an indifferent charm can arise [. . .]. As works of art of this kind can scarcely have substance or any other real content, their merit consists for the most part in the handling, and in a certain seductive appearance. They lack significance and strength, and in consequence they are generally welcomed as nullity is in society.[23]

For Goethe, Angelica's undulistic nature was epitomised in the portrait she painted of him, a sweet and feminine image (oddly similar to her National Portrait Gallery self-portrait) whose charm seemed to him wholly untrue to the original. Goethe's virility was mortally offended by the picture. 'It annoys her greatly that it doesn't and won't resemble me. Still a pretty boy, but no trace of me in it.'[24] If Herder's account is correct, Angelica would have been less impressed with her own failure in depiction than conscious of the sitter's dissatisfaction. She had simply idealised Goethe, Herder wrote, because that was how she saw

him. This 'angel with a brush' had conceived of Goethe's image with more tenderness than he actually possessed, he continued, which is why everyone exclaimed that the portrait was unlike. But Herder took a different view. If there was idealisation, 'the dear soul thought him to be as she painted him'. She could not help it, he concluded: 'she is above all a sweet angel-woman or rather maiden . . . '[25]

It is typical that Tischbein's physically distorted portrait of Goethe reclining in the Campagna provoked far less criticism than was standardly meted out to Angelica whenever her paintings were found anatomically odd. Goethe may not have seen Tischbein's completed picture, but he probably saw enough of it to know that he had been given an excessively long left leg impossibly articulated with his hip, and was apparently leaning against an overturned obelisk that his body did not actually touch. Even if he did not see these things, others certainly did; but it is Angelica's ineptness they habitually note. The only explanation for this is sexism, and it seems to be confirmed by the same passage from the *Italienische Reise* as contains Goethe's criticism of Angelica's portrait: 'My portrait is going well, it looks very like me, everyone remarks on it'. When a male artist paints a portrait, facial resemblance is all that counts; bodily distortion suddenly becomes immaterial. Angelica would have had every reason to feel indignant.

Friedrich von Matthisson would later support Goethe's complaint about her version of him, remarking that the poet's face only feebly recalled the characteristic features of the original. But the various images of Goethe done during his lifetime reveal that he possessed no more objective reality than any other sitter in the history of portraiture. If Angelica makes him look like a pretty boy with a more charming mouth and gentler, wider-set eyes than he apparently possessed, Meyer depicts him as a stern grey-coated thinker, and Tischbein as a languid Apollonian man of leisure.[26] Many of his portraitists, including Angelica, disguised his protuberant eyes or flattered him in other ways, but it seems clear that the great man had a strong nose, a full mouth and an emphatic though well-proportioned profile.[27] If Goethe disliked his open and anxiously expectant expression in Angelica's picture, he was also critical of the bust Trippel sculpted of him at about the same time. Yet Angelica seems to have liked it, and it was certainly hugely successful. A watercolour study she did after a plaster cast of the bust

that their mutual friend Lips engraved was used as a frontispiece to the eighth volume of Goethe's works published between 1788 and 1790.[28]

Angelica's portrait, by contrast, had been intended as a private act of homage. Since she painted the picture for herself, she was entitled to compose and execute it as she pleased. Whether or not Goethe was correct in claiming that the lack of resemblance annoyed her, she was not so dissatisfied with the portrait as to want it out of her sight. On the contrary, like other favourite works of hers it seems to have remained with her in her studio until she died. Goethe's daughter-in-law Ottilie then bought it from her estate, and it now hangs in the Weimar collection.

Yet Angelica had wanted to possess Goethe as an individual, not as an image; that is why she preferred an intimate private portrait to an official one like Tischbein's. Much ink has been spilt over the matter of her precise feelings for Goethe, and his for her. Their age difference (Angelica was forty-six in 1787, Goethe thirty-eight) need not have prevented love between them, but Goethe's unambiguous virility – which Angelica's portrait masks – might not have responded to her slight old-maidishness. His Roman elegies feature the lover Faustina who supplied to his real physical needs in the city. In Weimar he had left behind a love-affair with Charlotte von Stein whose complexities continued unresolved. Angelica was a devout, recently married, timid, sentimental woman who is most unlikely to have wanted passionate love to enter her life. But her adoration of Goethe was real, and her relations with him would not have been more significant if they had boiled with sensuality.

Goethe's feelings certainly contained warmth as well as pragmatism. Angelica, he wrote to Herder in late 1787 from Thomas Jenkins's retreat at Castel Gandolfo, helped him to endure everything.[29] What he was having to endure is little enough, it is true. He describes his situation as enchanting, only occasionally disturbed by the need to socialise after the morning's activities, but always placid and peaceful.[30] Angelica, staying nearby, helped him to focus this *villeggiatura*, encouraging him to believe in his artistic talents. 'It is more flattering than I can say,' he wrote when he was back in Rome, 'the way Angelica gives me hope for my landscapes, under certain conditions. I shall

continue, at least, to get closer to the goal I shall probably never reach.'[31]

Angelica was Goethe's companionable and reassuring teacher, a woman who was always understanding, good, sweet-tempered and accommodating. One could not, he thought, be anything but her friend.[32] That he did not regard her in any other light seems clear enough from his open attraction to a young Milanese woman, Maddalena Riggi, whom he met at Castel Gandolfo and belatedly discovered to be engaged to someone else. His reaction to the discovery was shock followed by philosophical resignation: 'I was old and experienced enough to recollect myself instantly, if painfully. It would have been pretty astonishing, I exclaimed, if a Werther-like fate had pursued you to Rome to spoil such propitious and until now protected conditions'.[33]

When Maddalena was jilted, Angelica looked after her with a mother's care. The *Italienische Reise* details her kindness in taking the young woman (the sister of one of Thomas Jenkins's employees) under her wing and nursing her devotedly through her nervous collapse. At the end of February 1788 Goethe writes of her loving attentions:

> With quiet satisfaction I again took my distance and disappeared into the throng [. . .] with the most tender feeling of gratitude towards Angelica, who had seen the need to take in and comfort the good creature immediately after her 'accident' and, which is rare in Rome, received a previously unknown girl in her noble circle, which moved me all the more as I could flatter myself that my concern for the good child had not been without its effect in all this.[34]

Goethe himself was also present the day Maddalena met her future husband on a walk to a porcelain factory, and described their whirlwind courtship phlegmatically:

> the young Volpato [the son of the engraver Giovanni Volpato], who wanted a wife, had the good fortune to please her; to see her was to love her [. . .]. In the space of a fortnight everything was concluded. Up to now they seem a happy couple; let us hope they will always remain so. They are good.

240

Angelica's role was above all to minister – first to the wounded Goethe, then to the heartbroken Maddalena. She accepted her lot uncomplainingly, perhaps in the same spirit as Zucchi accepted her devotion to Goethe. Indeed, this childless woman seems always to have been happy mothering people, and the fact that she exalts virtuous motherhood in paintings such as *Cornelia, Mother of the Gracchi* is not accidental. Her maternal aura was both powerful and soothing, strong enough to reassure Goethe but also to stimulate him.[35] If the nature of her feelings was disturbing to herself, as her unbounded grief at his eventual departure suggests, there is little evidence that Goethe found their friendship anything but affirmative. 'Angelica is the kindest, best creature, she makes me indebted to her in every way.'[36] This was his composed, if not final, summary of the place she occupied in his life.

Angelica could be more visibly moved than he cared to be or was capable of being in her presence, but it is difficult to decide whether the raptures he provoked in her were due more to his person or to his literary genius. Her acute sensibility led her to respond violently to readings of Goethe's work whether or not the man himself was actually there, yet perhaps she was thinking of Goethe as much as of the sound and meaning of words when she listened to one of his greatest poems years after his departure from Rome. Matthisson reports the occasion in 1795:

One morning she listened very attentively to several lyrical pieces by Schiller, but carried on painting with quiet collectedness. After this came one of the richest and most poetical works, the most impregnated with genius, that are known in our language: Goethe's 'Der Wanderer'. [...] The impression which this revelation of classical antiquity made on Angelica's tender mind was so powerful that she suddenly laid down her brush and, with a wonderfully concentrated expression on her face, asked for a second reading. The whole being of this quiet, Vestal-like, introverted woman was exalted and shaken as though by an electric shock. Her silence was the silence of a muse gripped by enthusiasm. Finally she uttered the words: 'What a glow of feeling! What magical colour! What depth of artistic knowledge – I shall try to paint the scene where the wanderer cradles the child in his arms and the young woman comes back from the stream

with a bowl of water! She stands before me so full of life that there is no need for me to do anything but copy her faithfully'.[37]

Angelica's reaction to Goethe's poem was a loyal as well as typical response. She was predictably moved by the pathos-ridden subject – one calculated to appeal to the combustible sympathies as well as the enthusiasm for antiquity of eighteenth-century readers – and artistically impressed by the technical skill of Goethe's treatment.

'Der Wanderer' had been written years before, in the spring of 1772. It was inspired by the ancient world – Goethe seems to have conceived the poem whilst surrounded by the ruins of Roman baths, bas-reliefs, inscriptions and columns in Niederbrunn, as he travelled from Strasbourg to Saarbrücken – but the spirit of Rousseau, Gessner, Goldsmith and other contemporary writers infuses it too. Herder wrote to his wife in June 1772 that it was 'an excellent piece', its language unadorned and Old German in feel. In it a wayfarer asks a young woman suckling a child for permission to rest beside her; she directs him to the stream by her mountain cottage for refreshment, and as he climbs the hilly path he sees relics of the ancient world all around. Finally he reaches the cottage, which seems to him like a ruined temple pieced together from the remains of antiquity. Almost oblivious to her attentions, he gives way to the enchantment of the past, whose monuments are both mocked and adorned by the invasiveness of nature. The contrast between the world of the living, embodied in the sleeping child, and the ruination of the past is a source both of hope and of elegiac melancholy; but hope, springing forth from the union of past and present that the woman's little world represents, is the stronger. Even so, as she directs him towards Cumae he is left yearning for the sanctity of a vanished universe and the sentimental warmth of living human relations.

The poem was bound to move Angelica to the marrow. The classical grace of Goethe's style recalls the 'edle Einfalt und stille Grösse' ('noble simplicity and quiet grandeur') that Winckelmann saw as definitive of the Grecian ideal, while the trusting tranquillity of the mother and child appealed directly to her latent maternal urges. Above all, she was pierced by Goethe's ability to draw ancient and modern together in an act of lyrical celebration. Her own efforts to exalt and renew the past in her uninsistently neo-classical history paintings were

tokens of the same impulse, but 'Der Wanderer' brought it to a fruition whose quiet authority and movingness seemed to her infinitely superior to anything she was capable of achieving. It was inevitable that Goethe's genius should make her so bitterly aware of her own inadequacies, however different the forms of art they practised; so she admired, envied and regretted. Her relationship with the poet would remain a compound of these half-desolating, half-exalting perceptions for the rest of her life.

Even without such evidence as this, Goethe knew how powerfully attuned she was to his work: it was almost instinctive, a proof of their harmonious human rapport, and something he saw as specific to the spirit of Italy. So he excitedly praised her frontispiece illustration for his tragedy *Egmont*, which Lips engraved for the 1788 edition, with the exclamation that it could not have been drawn or engraved in Germany.[38] In fact he thought less negatively of the capacities of native artists than of the chances Germany offered them, which the fledgling artistic mecca of Weimar was not yet powerful or advanced enough to correct; but enthusiasm for Angelica was part of his determined enthusiasm for the principle of Italian life. If Angelica (like Germaine de Staël's Corinne) had stayed in the north, by implication, her talent would have shrivelled and died. Of course this was not what had actually happened to Angelica in England, but Goethe was obsessed with the idea that a warm classical world gave the artist energy, an energy from which he himself was deriving sustenance and renewal. It was a poetic myth as much as a geographical and cultural argument. Whatever his distaste for the 'undulistic' femininity of Angelica's style, therefore, Goethe valued her meridional perceptions as an interpreter of his work.

In October 1787 he presented her with the first four volumes of the luxury morocco-bound collected edition of his works published by Georg Joachim Göschen. He also gave her and Lips the commission to illustrate subsequent volumes, without consulting the publisher. This was arrogant, but he had every reason to trust her feeling for what he wrote.

Göschen was aware that Angelica's drawings would boost sales, and the knowledge consoled him for Goethe's profligate distribution of free copies ('Goethe is giving his forty copies away, which is at least making our Dutch edition known . . . ').[39] Her enthusiasm for illustrating

Egmont had been instantly ignited by a reading Goethe gave in June and July 1787, though by December that year she had carefully studied the play too.[40] For the fifth volume of the collected works she did black chalk drawings, which Lips subsequently engraved, one showing the intense conversation between the lovers Egmont and Klärchen, the other the final scene in which Klärchen appears to Egmont in a dream.

Although Lips makes heavy and imposing what in Angelica's original is light and intimate, the illustrations still retain some charm. The very purity of Angelica's conception matched Goethe's own view of the play, the writing of which he described to Charlotte von Stein as having been 'an inexpressibly difficult task, which I would never have brought to completion without unlimited freedom to live and think'.[41] Klärchen's moral virginity must have strongly appealed to Angelica. Goethe defended his heroine fiercely to Charlotte von Stein:

> I do not altogether understand what you say about Klärchen [. . .]. I can see that you seem to miss the nuance between a prostitute and a goddess. But given that I have kept her relationship with Egmont so exclusive; that I place her love more in the concept of the perfection of the beloved, her delight more in the enjoyment of the incomprehensible fact that this man belongs to her than in sensuality; that I present her as a heroine; and that she follows her love for her lover with the profoundest feeling of eternity, and is eventually glorified through the transfiguring dream when she appears to his soul: I do not see where I can place the nuance . . . [42]

Egmont's laconic entrusting of Klärchen to his Spanish opponent Ferdinand before his own execution, according to the *Italienische Reise*, is what most shocked Goethe's female friends. Angelica unerringly chose for her frontispiece the scene that Karl Philipp Moritz called the central one of the play, where Klärchen kneels at Egmont's feet and asks who he is, to which he replies that he is simply hers. It is a pathos-filled moment containing the seeds of Egmont's own demise and Klärchen's freely chosen death, and its appeal for Angelica lay in its moral clarity and simple emotivity.

The importance she had assumed in Goethe's eyes is evident from another observation in the *Italienische Reise*. Stung by the criticism of

Egmont's conduct, he had spent two hours sitting in the Borghese Gardens thinking the play through again, and finding nothing in it that he could change. The following Sunday he presented Angelica with the problem. Having reflected deeply, she confirmed his instinctive certainty. Criticisms such as those made by Schiller (who thought the scene melodramatic and operatic) were unfounded, she said. As Goethe wrote to Charlotte von Stein:

> If only you had been there to hear how she explained everything in such a tenderly feminine way [...]. Angelica said that the apparition only represented what was going on in the mind of the sleeping hero; so he could not express more strongly with words how much he loved and cared for her than through this dream, which raised the beloved creature above him, not up to him.[43]

This was balm to Goethe's soul. Angelica was someone whose sensitivity and tact were known to him, but the psychological finesse of her interpretations was unexpectedly reassuring. Whatever the solidity of Lips's engravings, Goethe was confident that she understood the essence of his work as others did not. Rather than choosing the wrong moment, she had, at worst, made the wrong decision about what the moment implied in visual terms.[44] The difficulty of subtly and convincingly embodying the non-incarnate was something she had faced before, but in the case of Klopstock's *Messias* she had shied away from it: although even Klopstock regarded the portrayal of the Divine as blasphemous, he had still wanted Angelica to provide embodiments of spirits and angels in her illustrations. Perhaps the reserve and reluctance she had maintained in the face of his naggings then should have guided her approach to Goethe as well.[45]

Her enthusiasm for another of Goethe's plays, *Iphigenie*, had been awakened several months earlier. Goethe wrote on 22 January 1787 that he had been forced to give an entire reading of the newly versified work (previously a prose drama) to the German colony in Rome, and sounded faintly disgruntled about it.[46] Yet it may have been of this reading that Tischbein wrote to Goethe in later life:

> In the evenings [at Angelica's house] you read to us from your *Iphigenie*. It was the only time that something read aloud has

really penetrated my heart, and I can still often hear it within me, and thoughts well up which I ought to write down.[47]

In his memoirs Tischbein recalls an evening at Via Sistina 72 when a reading – possibly the same one – had profoundly moved him, even though he had heard it many times before with Lavater. Angelica was far from alone in her impressionability to Goethe's lines, but she was still among his most adoring admirers.

After the reading to the German coterie, Angelica, Zucchi and Reiffenstein were the privileged recipients of Goethe's detailed exposition of the play.[48] On reflection, Goethe was able to account for its emphatic success:

the form of the play resembles what the Greek, the Italian and the French have long accustomed us to, and which still speaks most effectively to anyone who remains unspoilt by English audacities.[49]

Before he left for Naples he was forced into a second reading at Angelica's behest, to the same audience. The gentle Angelica's reaction was 'unbelievable' and 'heartfelt', and she promised Goethe a drawing to commemorate the occasion. 'And just now,' Goethe complained, 'when I am getting ready to leave Rome, I find myself tenderly bound to this benevolent person. It is both a pleasant and a painful feeling when I persuade myself that people dislike letting me go.'[50]

It was bound to be an intrusive sensation for a man who wanted to live his Italian life without serious ties or duties to distract him from the process of self-discovery. The difficulty was that Goethe needed people such as Angelica to help him discover himself: his own expertise in the ways of their world was too limited for it to be otherwise. So Angelica, like Tischbein, had to serve his artistic purpose as she aided his groping efforts, while being kept as distant as his more intimate needs required. Perhaps Goethe should not be criticised unduly. The human instinct for self-preservation and self-improvement that guided his behaviour may not have been particularly admirable, but it was scarcely more reprehensible than the habits of Angelica's own intensely dedicated life, which relied first on a father and then on a husband to free her from practical cares.

From Naples, Goethe reported in mid-March 1787 that Angelica had undertaken to do a picture from *Iphigenie*. 'Her idea is very sound, and she will do an excellent job.'[51]

Once more she chose a turning point in the drama, the moment when Orest recovers his mind in the company of Iphigenie and his friend Pylades. Her drawing shows the characters communicating by gesture, but manages to avoid the theatrical body-language that was often thought expressive at the time. Indeed, Goethe commented on the sensitivity of her interpretation, 'how well she manages to make her own what belongs to her subject. And it really is the axis of the play'. '[I] was pleased with how well she "felt" the poetry: she is an excellent, tender, clever, good woman'

The word Goethe uses to describe Angelica's illustration to act III, scene iii of *Iphigenie* is 'gemütlich' – comfortable, appealing: 'Angelica has done a very appealing drawing of the scene "Have you too already descended here?"'.[52] Since Orest, who believes himself to be in Hades, is putting the question to his sister and best friend, 'gemütlich' does not seem precisely the right term, even though it may generally be one of the best all-round words for Angelica's characteristic style. Goethe's approval is the more surprising because Angelica's pretty picture actually blunts the dramatic sharpness of the scene. Yet if the composure of the group hardly reflects the turmoil of Orest's mind, that is perhaps Angelica's (and Goethe's) point: the influence of love will transform his guilty madness into serenity. As priestess of Diana on Aulis, Iphigenie might have asked for divine help to save her brother, but instead she herself manages with Pylades' help to bring Orest to his senses, in true sentimental fashion. The Furies withdraw to Tartarus, and Orest is released.

Goethe certainly knew how lucky he had been to tempt Angelica into doing the illustrations, as he told Göschen. Paying her was out of the question:

> She has so many commissions that you can't buy a penstroke from her with gold dust, if she doesn't do it for love. Recently she surprised me with a drawing [the illustration from *Iphigenie*] which is perhaps one of her happiest compositions. And I mustn't even sound too keen about that.[53]

247

So he asked Göschen to send her a present of contemporary German writing to mark his gratitude – Christoph Martin Wieland's poetry, a selection from Herder, Voss's short poems and *Odyssey* translation and Hölty's works, all luxuriously bound.

> The drawing from *Iphigenie* which the excellent artist did for me is so dear to my heart that I cannot make up my mind to let it out of my sight. If I could manage to bring it as far as Germany, I might not be disinclined to entrust it to a well-known, careful artist.[54]

It may be that Angelica identified herself with the image of pure sisterly love that *Iphigenie* presents, and so undertook the task of illustration with particular enthusiasm. Her type of idealism would not have been above converting urgent personal feelings into safer transposed ones. But there is little need to seek a precise biographical key to her work, a specific personal emotional state requiring representation. She possessed a powerful imagination – allied with considerable artistic composure – as well as a feeling heart.

After Goethe had left Rome there was a further memorable reading from his dramatic work. Angelica's particular affinity with *Tasso* has often been mentioned, particularly the similarity between herself and Tasso's half-distant, half-loving patron the Princess d'Este. On the other hand, the resemblance between the petulant young poet and Goethe, the national and international figure who had dramatised Tasso's life, is slight. The play idealises woman as a figure of reconciliation, humanity and stability, a familiar theme in Goethe, and Angelica always found such transposition sympathetic. The most obvious explanation for the emotion she displayed at the playreading, however, is without reference to any particular link with the Princess. She had simply lost Goethe, and was made wretched and tearful by the fact.

Angelica told Goethe that *Tasso* was 'one of the most beautiful of your beautiful works', and in a letter from Rome of 23 May 1789 describes a recent trip to the Villa d'Este in Tivoli where, in the shade of the great cypress trees, Herder read out the parts of the play that Goethe had sent them. She was seized with the urge to write to him

with her thanks and gratitude, but timidity discouraged her. 'I delayed for fear that you might perhaps say I write too often.'[55]

She felt bereft. At the time she wrote this letter her new friend, Duchess Anna Amalia, Karl August's mother, had left Rome with 'the respectable company' (including Herder) for Naples. 'The pleasure of having such good neighbours seems to me a dream from which I have awakened too early, and now I am living in my solitude again, very sadly.' She needed to communicate to Goethe something long thought-out and important, but lacked the courage as well as the stimulus. 'I wanted to be able to write you something about art or artists or something else of a pleasant kind, it was truly my intention to make up for my long silence with a long letter. But the departure of so many great friends made me very sad.'[56]

The watercolour painting by Schütz of the Tivoli scene – Herder reading from *Tasso*, Anna Amalia with a basket on her knees from which her lady-in-waiting Fräulein von Göchhausen feeds a sheep, Angelica beside the sheep, Reiffenstein standing and Zucchi lounging in the foreground – makes the occasion look like a pastoral idyll, an impression which the antique statue overlooking the group and the other ancient remains paradoxically reinforce. Angelica knew that she was living in a dream. In Goethe's absence she felt as though she was simply biding time, apparently busily but in fact desperately, and as though some answer to her suffering would soon be forthcoming. On 10 May 1788 she was writing to him that his departure 'pierced my heart and soul' and that the day it occurred 'was one of the saddest in my life'. She would nearly have died of distress, she went on, had he not written to her from Florence. But her remaining pleasures had disappeared with him. 'The Sundays I used to look forward to so much have become sad days. And you say the Sundays will never return. I hope that is untrue – the words "never come again" sound too harsh . . .'[57]

But Goethe had moved on. In January 1788 Karl August had requested him to stay in Rome until the arrival of Anna Amalia, who had long been impatient to see Italy and who had been intrigued as well as stimulated, along with the rest of the Weimar court, by the reports Goethe sent back.[58] Probably sensing that attending to the Duke's mother would entrap him in the very same social duties he had

left Weimar to escape, Goethe had managed to persuade her to postpone her arrival until his trip was over. In the meantime he had assured Karl August that he and Angelica could find his mother a suitable lady companion for her Roman stay. Whether or not Karl August sensed a reluctance behind this profession of activity, he subsequently told Goethe that he was not needed to oversee Anna Amalia's visit. He was, on the contrary, to return to Weimar for a new life free of burdensome official duties and with a higher salary.

There is something routine about Goethe's subsequent relations with the pining Angelica. More than a hint of impatience can be heard in his March 1789 letter from Weimar to Herder: 'The eighth volume of my writings has been sent to Rome. As soon as *Tasso* is ready, a copy will be sent to Angelica. That should do duty for a whole bundle of letters'.[59]

Herder appears to have mistrusted Goethe's feelings for Angelica, unless he simply suspected that Goethe was likely to mock his own. 'Speak of nothing but commonplaces to Goethe,' he instructed his wife; 'I don't want him to know what I think of her.' A later comment is more explicit: 'Say nothing particular to Goethe about what I write concerning Angelica; after all, he has hardly opened his mouth about her'.[60]

Goethe evidently had other preoccupations. Angelica had fitted into a time and a life that he had moved beyond. The statesman-poet captured in Tischbein's portrait had added a new dimension to his being as a result of the experiences he had undergone in Italy, but it still had to be measured against the old one. Goethe, who had done more than 500 drawings in Italy, knew that his life's work was writing, and none of his artist friends' flattering remarks about his graphic skills could alter that. So for Angelica to clamour excitedly for a reunion was to miss the essential point. She failed to understand that she had fulfilled the function she had been allotted and should now gracefully withdraw.

He must therefore have been alarmed at her announcement in a letter from Rome of 1 November 1788:

Do you know, my dear friend, I am coming to Weimar – could you have dreamt it . . . Blissful Weimar, which since I have had

the good fortune to know you I have envied so often, where I dwell so often and so happily in my thoughts, should I at last see it and see you there, oh what a lovely dream![61]

Her Highness the Duchess, she told him, had graciously invited her, Zucchi and Reiffenstein either to return with her or to follow her, and they had exchanged promises as far as circumstances allowed. She still, she added, hoped to see him in Rome before then, but may have suspected that the prospect of that was slight. In any case, Goethe's answer has vanished: Angelica probably destroyed it along with nearly all her other letters. It seems likely, however, that he sounded unenthusiastic: his relationship with Charlotte von Stein had come under pressure again, and he had begun his liaison with Christiane Vulpius.

The following years brought renewed promises, this time on Goethe's part. On 13 June 1796 he would write:

My friend [Johann Heinrich] Meyer has conveyed my best wishes to you and assured you of my continuing remembrance [...]. If you are persuaded that gratitude for your goodness and friend-ship remains unchanged in my heart, that reverence for your character and talent has remained within me as lively as it ever was; you will be able to imagine the pleasure I feel at the prospect of seeing you again [...]. May I meet you in health and happiness! [...] How lovely it would be to meet in October, remember the times we spent in the country, and enjoy that blissful happiness again.[62]

It sounds unconvincing, and it was not to be. A few months later Goethe dashed Angelica's hopes at a time when she was becoming increasingly worried about the French republican incursions into Rome:

My hopes of being able to visit you next year, dearest friend, have sadly been thwarted for the moment by the unfortunate war which barred the way to me and afterwards threatened us at such close quarters.[63]

This seems final, and there is no evidence of further written communications between them.

Goethe had done his best to ensure remembrance in other ways, and not simply through distributing copies of his works. When he left Rome he gave Angelica the plaster cast of the Ludovisi Juno that had been in his room during his time in the city. Meyer reported from Naples on 22 July 1788 that the cast had been safely transported to Angelica's house, where she was guarding it with her life. 'She wants to look after it carefully and treat it like a treasure, as something which comes from you.'[64]

It is, however, possible that the present had been less nobly conceived than Angelica imagined. In the *Italienische Reise* Goethe speaks of the sheer difficulty of conveying such goods back to Weimar: 'the formalities, the effort and cost, and a certain helplessness about some things deterred me from immediately reserving the outstanding pieces for Germany. Juno Ludovisi was intended for the noble Angelica . . .'[65] But he still seems to have regarded the piece as a precious gift, saying that it was the most treasured thing in the household and valued all the more because the original was so rarely seen. The *Italienische Reise* describes this work, which Goethe initially saw in January 1787, as his first love in Rome, 'and now I own it. Words give no idea of it'.[66]

In later life Goethe would be given another cast of the head (now believed to be a bust of Claudius's mother Antonia Augusta) by State Councillor Schultz, and it is at present displayed in the Juno Room at the Goethehaus in Frankfurt. But the first version, the first love, stayed in Angelica's possession until she died.

Earlier, both she and Zucchi had tried to put a damper on Goethe's desire to dabble and deal in ancient art, as Jenkins, Nollekens, Gavin Hamilton and others did with such conspicuous success. On the point of leaving Rome, Goethe was tempted to join with Meyer in buying an important bit of classical statuary, but decided to ask Angelica's opinion so that she could advise them on restoration and maintenance. The frugal woman and her thrifty husband counselled against the purchase, and Goethe and Meyer reconsidered. Meyer was sure of the statue's antiquity; Goethe had available credit. They decided to ignore the Zucchis' warnings and go ahead. But at the last minute they were assailed by violent doubts, 'as one is between passionate love and a

marriage contract', and concluded that they dared not proceed without the Zucchis' approval, despite the fact that (as Goethe points out) the couple, though known to spend lavishly on pictures, had never bought any sculpture themselves. Goethe began to invest the whole episode with cosmic significance, as though the opportunity was a ploy dreamt up by the Fates to keep him in Rome. But in the end Angelica's caution prevailed.[67]

All her objections had been perfectly reasonable – almost too sensible, in fact: restoration was difficult, obtaining licences for export tricky, and transport dangerous. Goethe saw all this, but continued to regret. Years later he reported on the present glories of the Museo Pio-Clementino's collection, which now included 'his' statue, silently reproaching his and Meyer's unadventurousness in its dazzling beauty. Certainly there had been good sense in Angelica's remarks on the difficulty of changing oneself from art lover to speculator, and on the taint which the art lover thereby acquired. But the statue had been a symbol of Goethe's residual allegiance to Italy, and possessed great representative force as part of the myth of his development as artist and statesman, cosmopolitan and German.

Goethe's other present to Angelica probably meant even more to her than the cast of the Ludovisi Juno. In an essay on his botanical studies he tells the story of the pine-trees he had planted as a living memory of his time in Rome.[68] Already attentive to the laws of natural growth and transformation that his poem 'Die Metamorphose der Pflanzen' would later explore, he had observed the way in which the kernels of the pine cones strewing the ground broke through their bonnet of skin to lay bare a crown of green needles, which in turn revealed the origins of the tree to come. As though obeying a command from nature, Goethe planted one of these prototypes in Angelica's garden before he left, and it thrived there for years.

Angelica took care to leave the tree where Goethe had planted it, guarding it as an icon. 'You would almost laugh,' she wrote, 'at my concern when there are black clouds in the sky that suggest a storm is brewing – I run down the garden and put the young plant under cover, so it doesn't get damaged. Everything else I leave to its fate.'[69] But the tree met its own fate after Angelica's death. The new inhabitants of Via Sistina 72, according to Goethe, uprooted it mercilessly, thereby

involuntarily associating the loss of one of Goethe's links with Rome – Angelica – with its symbolic expression.

When Herder saw Angelica in Rome, he found her 'all resignation'.[70] In October 1789 she was writing to Goethe that everything she did was sheer foolishness.[71] The names of some studies she did at the time – Vanity, Memory and Meditation – suggest the extent of her hopelessness; but when work refused to provide the usual solace, it was difficult to see what else she could resort to. It was not her marriage to Zucchi that suffered from her devotion to Goethe, but the other, more fruitful marriage, her weddedness to work.

If he had not already guessed, Goethe would soon suspect what losing him had meant to Angelica. A quietly sociable woman, she would continue to greet newcomers to Rome and to entertain her friends, and she still, despite everything, had some good painting to do. Yet the habit she had formed of seeing Goethe, teaching him and seeing how much he needed her help, had become too fixed to be broken without pain. She went on clinging to 'her' interpretation of Goethe, the pretty, considerate, slightly shy boy she had painted, not the famous man single-mindedly pursuing his vocation. But in reality Tischbein's Goethe had already taken over.

Chapter Twelve

The World from the Studio

Before he left Rome Goethe, like Angelica, had been admitted to a mysterious institution.

The members of the Arcadian Academy were celebrated writers, philosophers, artists, nobles, bankers, lawyers, doctors, priests and women living or travelling in Italy. The Academy had been founded in 1692 by a group of fourteen men, including the most famous literati of the time, after they had read and improvised verses in a meadow beyond the Castel Sant' Angelo. They gave themselves Arcadian shepherds' names – no one could be admitted without one – and took as their *raison d'être* the correction, promotion and beautification of native poetry.[1]

By the mid-eighteenth century the Academy's numbers had declined, and the most important business of its 'chief herdsman', according to Samuel Sharp, was to send 'Arcadian patents' to English travellers arriving in Rome.[2] Few members seemed to have a clear idea of what the real purpose of the foundation was. Goethe's description of the induction ceremony in the *Italienische Reise* makes it sound like much ado about rather little, but the underlying intention to honour artistic achievement or celebrate artistic interest was obvious enough. Many of the major artists of the time belonged, with French members predominating, and admission undoubtedly helped the less celebrated to make their names. Louise Vigée Le Brun was inducted into the Academy's mysteries after Angelica, and when Germaine de Staël passed through Rome in 1805 she was invited to one of the sessions, where she recited her French translation of a sonnet by Onofrio Minzoni on the death of Christ and received an ovation.[3]

Herder told his wife on 6 December 1788 that Anna Amalia had also become an Arcadian, under the name of Palmirena Atticense. 'I shall take care not to cross the holy threshhold again.'[4] Goethe, christened

Megalio Melpomeneo by the Academy, probably felt that the institution stood for the kind of time-serving artistic intercourse he had largely managed to avoid on his Italian journey. The more receptive and less preoccupied Anna Amalia von Sachsen-Weimar-Eisenach, however, took it as part of the delightful cultural otherness she had come from Weimar to seek.

She was an intellectually ambitious woman who always wanted to *know* and *experience* things. Endowed with all the energy of her uncle Frederick the Great, she had had plenty of leisure to develop her literary and artistic interests. An arranged marriage had brought her at the age of sixteen from the brilliant Brunswick court where enlightened ideas flourished to the tiny, culturally backward and impoverished duchy of Weimar. Widowed after barely two years, she acted as regent to her baby son Karl August and ruled skilfully for sixteen years. On Karl August's succession in 1775 she was able to devote herself full-time to the cultivation of her Muses' Court, where she established and tended a kind of German Parnassus. She spoke better French than German (despite her ambition so to promote native writing in Weimar that German literature could rank with that of any country), understood English – she translated passages of Ossian – and learnt Italian with the help of her librarian Christian Joseph Jagemann. Christoph Martin Wieland and Jean-Baptiste Villoison taught her Latin and Greek, and Wieland, who was also Karl August's tutor, presided over the *Musenhof*.

Goethe was the greatest luminary of the artistic society she had built up, and whatever could inspire him was calculated to excite her as well. Before she left for Rome she wrote:

> I believe that Italy is for us what the river Lethe was to the ancients, one grows younger as one forgets all the unpleasant things one has experienced in this world and so becomes new-born.[5]

She set out in August 1788 with a chamberlain, Friedrich Hildebrach von Einsiedel, and Luise von Göchhausen in attendance. Before her departure, Goethe and Angelica – 'an angel of understanding and *conduite*' – had tried to find her a suitable Roman female companion,

but had been only partially successful: 'we have probably found two women, but there is a question mark over both of them'.[6]

Anna Amalia had already made Angelica's acquaintance in London, and according to Matthisson she longed to renew it:

Quite against the normal rule, the Princess's first enquiries in the venerable city on the Tiber were not after lifeless objects. The desire to reestablish [. . .] the bond of friendship formed on the banks of the Thames led her immediately to the home of this charming artist before there had been talk of anything else . . .[7]

By November, Anna Amalia was writing to Goethe about the rewards of Angelica's company, as though he himself had experienced none of them: 'I go to see her as often as I can, and she me; she is a very kind woman'.[8] Luise von Göchhausen told Knebel that Reiffenstein, Herder, Herder's patron Hugo von Dalberg and Dalberg's lover Sophie von Seckendorff were regular visitors at Anna Amalia's house, and that the Zucchis joined them at table most evenings.[9]

Before immersing herself in things Roman, Anna Amalia went to Naples; then she settled in Rome in a rented house, the Villa Malta, salubriously situated above Trinità dei Monti. It had extensive grounds that backed onto Angelica's small garden, and it soon became obvious that easy access from one property to the other was vital. A gate was therefore built, permitting the women's friendship to develop unchecked.

'Angelica's beautiful mind and her constant quiet joy in art always increase our pleasure in life,'[10]Anna Amalia wrote to Goethe in April 1789. When she went to Naples again in the summer of that year she found being out of touch with Angelica so unbearable that she wrote begging her to come to the Kingdom of the Two Sicilies. All that was needed, she said, was for her to persuade Zucchi of the artistic benefits they would both enjoy. 'Give him a really enticing account of the glorious drawings he would do and the wonderful new ideas he would have here.'[11]

It seemed like a true union of souls. In her letter of 5 November 1788 to Goethe, Anna Amalia wrote that she was 'blissfully happy', could wish for no other existence and was sated with inexpressible pleasures.[12] This sense of wellbeing was almost entirely due to

Angelica's perpetual companionship. Others confirmed the preternatural harmony she created and exuded. Luise von Göchhausen wrote about her to Goethe at the end of 1788:

> She has a truly beautiful soul, the sort you rarely meet with, and I almost believe that one becomes better oneself through loving her. She is very fond of the duchess; yesterday evening she wept and wept at the thought that the joy of the quiet evenings with us would one day be past for her. We often toy with the idea of all meeting again in Weimar . . . [13]

It was Anna Amalia who invited Angelica to the *Musenhof*, and Angelica who in the end found it impossible to go, whether because of Zucchi's ill health or for some other reason.

Several years later Tischbein recalled the cultural feasts they had enjoyed together:

> There was plenty of joyful intellectual pleasure, all around you people were cracking witty, clever jokes – Herr Herder, Angelica Kauffman, Zucchi; I still remember many conversations [. . .]. I had almost forgotten the lion [Reiffenstein], the patriarch of all antiquarians, who imparted his wisdom in a resounding voice. [14]

Angelica painted a portrait of the Duchess that hung in the original summer seat of Karl August, the Römisches Haus in Weimar, until shortly after the outbreak of the First World War. It was then confiscated from the ducal house and sold, since when it has been lost from view. [15] Opinions about its merits were divided even as Angelica was working on it. On 29 November 1788 Anna Amalia reported to Goethe that she had already sat to Angelica twice:

> It is going to be a fine *tableau* where I shall shine forth resplendent, the last time I sat Herder read your poetry aloud to us; the good Angelica was so enthused that the picture became more and more beautiful. [16]

Privately, though, she considered it as over-idealised as Goethe thought his portrait by Angelica to be. [17]

Matthisson, who later saw the picture at a soirée of the Duchess's attended by scholars, poets and artists, was uncritically impressed, judging it

> incontestably one of the most perfect works on which a dazzling artistic genius has ever based legitimate claims for immortality. The beauty, grace and harmonious colouring of this painting are so enchanting that I would never dare to comment on it even if I had a more acute artistic sense. The life-size figure dressed in Grecian costume sits on a chair in the antique style and holds a book in her hand, which one recognises with pleasure from the title on the cover as Herder's *Ideen zu einer Philosophie der Geschichte der Menschheit*.[18]

But if contemporary descriptions of the real Anna Amalia are to be believed, the portrait shamelessly beautifies its subject. Henriette von Egloffstein, who had come to Weimar in 1787, appraised the Duchess's looks dispassionately. Imagination, she wrote, had depicted Anna Amalia in the most charming colours to her, but the reality was quite different:

> A small unimpressive body on which a far too big head rested, the very image of the late King Frederick of Prussia, advanced with stern and solemn tread, greeting people only with an impercepti- ble nod of the head, into the circle which had formed in reverential silence round about, and after a brief welcome sat down beside the Duchess Luise [Karl August's wife]. This was Amalia! The world-famous patroness of the arts and sciences, the founder of Weimar, the benefactress of the small state on which she had conferred such remarkable fame.

According to Henriette von Egloffstein, she possessed large, penetrat- ing blue eyes, which together with her severe expression inspired dread. But she spoke so gently and pleasantly that her listener was reassured:

> I was astonished to register how greatly the frozen expression that had seemed so off-putting to me had changed. A charmingly

benevolent smile now played around the small mouth, the Junoesque eyes now communicated only goodness and interest, and the graciousness with which they rested on me beautified the strongly marked, masculine features, which I had found so repellent a few moments before.[19]

She concluded that Anna Amalia was a strange woman, but kind and motherly.

Angelica had chosen to place the Duchess in an elegant, classically furnished interior with a view of the Colosseum and dressed her in a light-coloured antique costume, with a floating veil loosely covering her hair. The sheet music by her hints at her musical talents, and the books (by Goethe as well as Herder) at her literary passions. To the right a bust of Minerva, seen in profile, underlines the sitter's cultural identity. No trace of the illness that the Duchess had recently suffered remains: she looks serene yet acute, aesthetically alert and controlled, as determined on self-improvement as Goethe had been during his Italian journey.

Anna Amalia's resemblance to at least one of Angelica's self-portraits is striking, and reminds us too of the similarity between the Goethe portrait and the artist's own National Portrait Gallery one. Is there a secret intention behind these likenesses? Perhaps Angelica is quietly playing the game of psycho-physical harmony that will be an explicit theme in Goethe's novel *Die Wahlverwandtschaften* ('Elective Affinities'), which explores in part-scientific, part-fictional terms the 'feeling' ability of lovers to affect the physical appearance of their partners' newborn children, even though they are biologically unrelated to them. In her pictures of Goethe and Anna Amalia, Angelica seems to actualise soul friendship in the same sort of way, making her two sitters' closeness to her own idealised portrait an implicit demonstration of emotional and temperamental unity.

The surviving copy of the picture of Anna Amalia may be set against another far less flattering image. When the Duchess returned from her second visit to Naples in 1789, Tischbein painted an uncompromising likeness of her that gives her the same severe profile and rigid pose as a famous Pompeian relief in the Naples national museum of a goddess receiving homage.[20] Possibly Tischbein's intentions had been kindlier and less ironic than at present appears – he was, after all, ostensibly

doing no more than echoing the antiquarian enthusiasms that Anna Amalia had just been developing. Even so, the contrast with Angelica's tendency to prettify is startling. Since, to judge by the Duchess's aside on her resplendent appearance in the latter's portrait, she was unconvinced by the improved version of herself, we may wonder whether Angelica was conscious of what she was doing in cases like these. The question is unanswerable. If Herder's verdict on her pretty Goethe – that the artist had her own vision, which might be utterly unlike anyone else's – has unsettling implications for her art of imitation, they are disturbing only inasmuch as ideal interpretations of reality are taken to be inherently and significantly misleading. Later observers may be far more interested in Angelica's way of seeing than in the superficial accuracy of her depiction.

Certain people had always criticised some of her portraits because they seemed untrue to life, but for all their dissatisfaction – Goethe's rejection of his effeminate image, Lady Exeter's objections to her husband's likeness – there is no evidence that Angelica mistrusted her perceptions. Whether or not her subjects wished to be flattered by her, she painted them as she saw them. Her way of seeing was neither 'objective' nor completely unaffected by the expectations of her sitters, but her main preoccupation was with translating an essence that lay behind appearance. Naturally, this often meant availing herself of some poetic licence. If she was to gain acceptance for her interpretations, she had to overcome the unimaginative reactions of realists who were too ready to see simple flattery or straightforward incompetence behind them. As her preference for Angelica over Louise Vigée Le Brun makes clear, Catherine the Great understood this artistic impulse, and sympathised with it. (She wanted her granddaughters to be 'real' as the Vigée Le Brun versions were not, but at the same time expected their faces to shine with ideal beauty.) So did Herder.

The Herder whom Angelica met in Italy was for many a prickly individual, but towards her he was rhapsodic – so rhapsodic, indeed, as often to appear ridiculous. Yet there was far more to the man than romantic susceptibility. He had greatly influenced the young Goethe's literary development, particularly by promoting a national literature for Germany and rejecting borrowed (usually French) models for native writers to imitate. Goethe had read Herder's prize-winning treatise on the origin of language in Strasbourg, and admired his intellect as well

as his colossal learning. (Herder, by contrast, initially though Goethe to be 'sparrow-like'.) His importance for Anna Amalia's project of creating in Weimar a Muses' Court that cultivated home-grown literature and art was obvious. He had been living there since 1776 – securing his presence had been seen as a great coup – acting as the Superintendent-General and Principal Chaplain to the court.

His portrait by Angelica, today in the Frankfurt Goethe Museum, was conceived as a complement to the one of Goethe, and if they were ever hung together the true nature of their rather suspicious relationship might well be clarified. Herder, however, dismissed this possibility bad-temperedly. Although Angelica was a 'poetess with the brush' and had a 'very delicate sensibility', nonetheless she had

> proposed my picture as a pendant to the one of Goethe, whom she has also painted. I hate pendants, and have no idea whether she will find time for it, otherwise it *would* be worth seeing how she sees and thinks of me.[21]

His wife instructed him not to object. 'I certainly hope [. . .] that you will allow yourself to be painted by the tender Angelica; I should like that better than your bust.'[22] The first thing Angelica had shown Herder in Rome was Trippel's bust of Goethe, which had come into her possession. When Karl August ordered a copy of it 'in finest marble', and Herder's bust as a companion piece, he was aghast:

> Oh, wretched pendants! Goethe has let himself be idealised as Apollo; how will a poor fellow like me with his bald head look in comparison? All the better, I shall look naked and poor.[23]

He duly objected to the bust Trippel eventually did of him because his hairlessness had not been spared in it:

> I should like a little more hair on the forehead. In the bust I am virtually bald, which makes me much too philosophical. It seems to me that the contrast between Goethe and me is simply too strong . . . [24]

But given this implicit acceptance of the notion of limited artistic

'improvement', he had little reason to complain about Angelica's portrait, though of course he did. In fact, as well as smoothing and rejuvenating Herder's face, Angelica had, mischievously or otherwise, managed to convey his creamy self-satisfaction, something that apparently always manifested itself when he and his wife Caroline argued. On such occasions they took to living on separate floors of the conjugal home, exchanging endless letters, until Caroline finally went into her husband's room reciting a passage from his writings in wonderment. 'Whoever wrote that must be a god,' she would say, 'and no one could be angry with him.' Herder would then hug her as a sign that the feud was over.[25]

Herder had begun as a student of medicine, but the sensibility that finds such extreme expression in his effusions about Angelica regularly made him faint at dissections and directed him elsewhere. Despite his court position in Weimar he was a rather priggish sensualist, ordained in 1765 and owing his Superintendence and Chaplaincy in large part to Goethe's influence over Karl August (there were some doubts, not altogether unfounded, concerning his orthodoxy). The range of his interests outside religion was vast, and he produced original work in the fields of psychology, history, aesthetics, linguistics and philosophy, notably attacking Kant – who returned his hostility – and arguing for the existence of a discrete cultural identity in all nations, not merely the German. His initially good relationship with Goethe became mistrustful with time, both men manifesting the kind of unforgiving hauteur that periodically marked Herder's union with his wife.

He had been invited by the composer and cleric Dalberg to accompany him on an expenses-paid trip to Italy, and the offer came at an opportune time: the Herders had just lost their youngest son, and their marriage was under strain. Like Goethe, Herder had also suffered professional annoyances and setbacks that he wished to overcome. But his rigid propriety was troubled by the presence of the widowed Sophie von Seckendorff, whose relations with Dalberg, a canon of the Church, were deeply offensive to him. Frau von Seckendorff also represented a dilution of the intellectual and spiritual purity he believed he brought to Dalberg's company, and he often complained about her in his letters to Caroline.

Because he knew Angelica's character, by contrast, to be beyond reproach, he rather inconsistently gave free rein to his own, essentially

adolescent, infatuation with her. Her friendship was never remote, however detached she seemed from certain of life's vulgarities, and he adored her from the start. Mostly his long-suffering wife was the recipient of his besotted confidences, but in December 1788 it was Goethe:

> Angelica is an adorable madonna; but withdrawn into herself, a faded flower on her solitary fragile stem. However honourable as a Prussian Reiffenstein may be towards her, and however good a Venetian her Zucchi, she still stands there alone without any support; so I always leave her company with a heavy heart.[26]

Yet Goethe had done her much good, he added, and he knew that he himself was no substitute.

Herder spent most of his time with Anna Amalia, in whose company he was called the Archbishop.[27] She was, she reported, often congratulated on having such a man in her train: 'he pleases people greatly, even women. But his dear wife has nothing to fear, because he remains as faithful to her as a General Superintendent'. For his part, Herder could reassure Caroline:

> I have already written to you of the virginal continence I live in and probably shall always live in, for the other thing is not worth the trouble, or has too many dangers for body and soul.[28]

But if Goethe's precise feelings for Angelica had been unclear, Herder's were clearly ambiguous. It is true that his effusions about her qualities and person are impregnated with the lush sensibility of their times, which makes it hard for us to evaluate them dispassionately. But his tones (soon imitated by Caroline, who had never met Angelica) seem to leave no doubt about the reality of the emotions she provoked:

> This woman, dearest wife, is a true pearl of friendship and innocence which I have at long last found and shall treasure for ever. She is like purified gold, as tender as a dove huddled back in itself, but who lives in a great and joyful inner world, and is the very essence of morality, piety, virtue, purity and innocence.

According to him, the admiration was mutual. When Angelica read a passage about herself from one of Caroline's letters to her husband, she burst into tears,

> and was so moved that for a long time she could not compose herself. She loves you like an angel, I might almost say a goddess, and recently said to me in her quiet way that she wanted at least to die in our midst, as she could no longer live amongst us. What a shame that she lives in Rome, accursed Rome![29]

'She is an angel of a woman,' Herder informs his wife in another letter,

> who repays everything sevenfold in her goodness, and wipes away all the unpleasant things others of her sex have done to me. But she has absolutely nothing of the *baseness* of her sex about her, any more than you do, as I have told you: she is as active as a man, and has done more than fifty men can do and do do over the years; and she is truly like an unearthly being in the goodness of her heart [...]. Sometimes I have kissed her forehead, and she has unexpectedly taken my hand and wanted to kiss it; that is now our relationship.[30]

Was this, half-chaste and yet preposterous, the innocence that Anna Amalia had identified? To the uninitiated or sceptical reader it scarcely sounds like it.

'Take her letter in good part,' Herder commands Caroline, 'she is not strong in words, but an honest soul in deeds.' We may be reminded that Angelica apparently spoke Italian and English well, but that German was 'a foreign language' to her. Yet whatever her deficiencies in expression, Caroline derived 'indescribable joy and sustenance' from Angelica's letters. She told her husband:

> I am very tenderly moved, and stretch out my arms to her to thank her for her love and her kindly presence where you are concerned [...]. She is my saint, my angel sister – oh, that fate did not allow me to be raised in such a beautiful soul's company.[31]

'Should I but see her once in my life,' Caroline remarked on a later

occasion, 'she would be like a heavenly apparition to me.' Heaven did not allow it, and perhaps it was just as well. Could Angelica possibly have lived up to such expectations? What exactly *would* Caroline have been expecting? Perhaps she was simply shrewdly playing along with her husband's fantasies, realising that since Herder was as intoxicated with Angelica's purity as with her womanliness, and was revolted by Frau von Seckendorff's unchaste behaviour, he was incapable of violating Angelica's trust. This was the price of the divinity he had conferred upon her: 'She is, I must repeat, a true moral beauty, who worships you as a goddess and loves me as a spirit.' But Caroline's manifest and generous maternity marked the vital difference between them. Her status was that of a different kind of goddess altogether.

It is quite possible that there was less frankness on both the Herders' sides than it suited them to admit. Herder harboured some suspicions of Caroline's relations with Goethe during his absence in Italy, and given the insistence with which she reported Goethe's frequent visits to her it is hardly surprising. 'You esteem and love in Angelica the happy and holy things nature has given her; Goethe is in this respect her brother.'[32] On the other hand, when Herder's ecstatic praise of Angelica became too much for his wife, she told him that she felt like Ariadne deserted by Theseus, and summoned him home. There certainly seems something crassly misjudged, if not simply provocative, in his rehearsing of his passion for a female artist in Rome to a wife hundreds of miles away, and saddled with a brood of children.[33] As though to compensate, he occasionally and half-heartedly alludes to Angelica's loss of beauty and rapid advance (in her mid- to late forties) towards old age.

Not that his regard for her was based on essentially physical attraction – far from it. Herder's writings make perfectly clear that he rated her highly as an artist as well as worshipping her as a virgin or a madonna. The seventy-first of his *Briefe zur Beförderung der Humanität* calls Angelica's art the direct descendant of that of the Greeks, and says that she, along with Raphael and Mengs, is the post-classical embodiment of the Greek achievement, capturing humanity in all its purity and truth. 'An angel gave her her name, and the muse of humanity was her sister.'[34]

Angelica's instinctive grasp of colour, and her artistic vision generally, seemed to Herder so obviously reflections of God's creation

266

that he could simply regard her as divinely gifted, and unblasphe-
mously call her by sacred names. If this appears unconvincing, there is
still a certain pietistic force to it. It also allowed him to emphasise the
purity of his feelings for Angelica in ways that implied her transcen-
dence above the basely sensual – 'she does not excite the senses, but
calms them'.[35] In keeping with this sanitised love, he reported, on 2
May 1789 Angelica had given the Herders a small gold chain as a
memento of their wedding anniversary.

Yet the ambivalence of his own praise of her is matched by an
ambivalence in his evaluation of her talent. If he saw Angelica as an
exemplary exponent of art, it was (for all the comparisons with Raphael
and Mengs) a *female* kind of art.[36] She might display the masculine
virtues of industry and understanding, but her complete womanliness
supervened over them. There was and would remain a clear distinction
between the sexes, which indicated different modes of responding and
comprehending, and meant that some kinds of creation were simply
alien to women, as others were to men. This is not very different from
Goethe and Meyer's view. Angelica's works, Herder considered, were
necessarily products of her womanly essence, and nothing illustrated
this so clearly as her softly feminine male portraits. As for his
infatuation with her, it did not survive absence. When he eventually
returned to Weimar the friendship subsided, whether because his wife
insisted on it or because other preoccupations came to absorb him
more.

However great the delight that Angelica's company gave him, and
however much Anna Amalia and her party fêted him, Herder disliked
Rome. He felt put upon, morally offended and intellectually snubbed.
The Duchess may have interpreted his decision to leave Italy in terms
of his family commitments –

> A single thing pains me. Herder is leaving us! When I think how
> little capacity to enjoy himself he has, far from his wife and
> children, I am a little consoled[37]

– but the truth was rather different. Angelica was his 'only consola-
tion'[38] in Rome less because he was passionately in love with her than
because he felt alienated there. In any case, he was tired of being

financially dependent on other people. Naples suited him better, as he wrote to Caroline in January 1789: 'Freed from the pressure of Rome, I feel a completely different man, born again in body and soul'.[39] Dalberg had left, and Herder had joined Anna Amalia's party. But he remained obscurely dissatisfied with Italian life.

Others would keep the German spirit alive after Herder's departure. Wieland, who was a close friend of Anna Amalia (he called her Olympia, the queen of the gods),[40] was encouraged by her assertion that Angelica loved his poetry to approach her about illustrating it for Göschen's planned complete edition of his works. His letter of 6 September 1792 is a compendium of ingratiating flattery and pompous self-regard, but it failed wretchedly in its intention. After assuring her of his admiration for her work, he announced:

> With such feelings nothing could be more natural than the wish to have some part in the friendship of an artist who through the properties of her mind and heart, even more, possibly, than through her rare talents, is one of the most beautiful ornaments of her sex and our century [...]. Among my poetical works *Oberon* is, in my judgement, the least unworthy of immortality: but it would be certain to achieve immortality if Angelica were to find one or two scenes from this poem, excellently suited to painterly depiction, not unworthy of her crayon. I cannot imagine any reward that would be greater or more satisfying to my heart.[41]

When Goethe had previously asked Göschen to send Angelica Wieland's works, he believed that he would be giving her pleasure. Nothing specifically indicates that he was not; but neither Wieland's sanctimonious letter nor the accompanying edition of *Oberon* yielded any visible response.

She was not allowed to forget her bond with other nationalities. Sometimes her dealings with them were acts of friendship rather than commercial undertakings, and the pleasure Angelica derived from bestowing herself upon others in this way – giving them pictures as she had 'given' herself the portraits of Goethe and Herder, or as she gave Caroline Herder silhouettes and small pieces of jewellery – is evidence

of the generosity of spirit from which Goethe and Herder both profited.

A case in point is her portrait of Cornelia Knight. According to Mrs Piozzi, this writer and bluestocking, together with her mother Lady Knight, was regularly laughed at for her eccentric or unstylish dress, her habit of draping her body rather than cladding it in proper clothes in order to avoid dressmaker's bills. But Lady Knight maintained that she and her daughter lived in the best company in their Italian exile, and not inelegantly,

> though with a severe economy in our table and by my daughter's being the milliner and I the mantua-maker, stay-maker and workwoman. We make dress but a small part of our expenses, and we really spend about a tenth part of what our countrypersons do, yet we cannot sometimes help regretting the hard fate we have had.[42]

She was proud of the degree of freedom they had managed to retain despite everything: 'I am sure few persons in the world have preserved independence upon so small a pittance, or are more clear of pecuniary obligations'. She thought Rome the cheapest city in the world, as well as the most beautiful, but she was still mocked by the unsympathetic or unimaginative for the figure she cut. Lady Webster, for instance, reported that she once saw 'an old witch, by Salvator Rosa, which might easily be mistaken for a portrait of Lady Knight'. But Angelica was not among those who jeered at this straitened pair for their pursuit of a cheap but respectable existence on the continent, and particularly Italy, after the death of Rear-Admiral Sir Joseph Knight had left them in financial embarrassment. Nor would she have wanted to add to their distress by charging them for her work.

As Lady Knight explains, Angelica

> often desired us to give her leave to paint my Cornelia, but we declined, my purse not being of a length sufficient to repay her for the time she has not only the power of making such good use of, but the money she gains by it; however, at length it's been consented to. Cornelia is drawn half-length, seated with her pencil in her hand, books beside her, and the beginning of a

drawing of a column of the first naval victory [probably in homage to her father]. She is dressed in white with a purple mantle, and a purple riband on her head [. . .]. Famous as she is in all she does, yet this is said to be the very best portrait she ever painted and pleases everybody. To say truth it gives me great pleasure, for it's very like Cornelia, and seems to express the goodness which she really has. Her goodness and affection, and the constant peace we live in, makes me less repine at the misfortunes and disappointments I have met with.[43]

Angelica also painted Lady Knight, both portraits, as the latter emphasized in a letter to her friend Mrs Drake, being *presents* from the artist.[44]

Angelica's 1793 portrait of Cornelia ignores her comparative poverty to the extent that the sitter is shown in vague neo-classical garb, elegantly imprecise and essentially the same as the costumes her wealthier and more worldly female sitters wear. But perhaps as a reflection of the Knights' situation, the restrained and unflamboyant composition is muted in colour (apart from the purple-blue of Cornelia's shawl) and waxen in its flesh tones. Even so, the subject looks a strong and settled personality, handsome rather than pretty, and uncompromisingly – almost fiercely – thoughtful. In later life the children of Nelson's daughter by Emma Hamilton, Horatia, would much prefer this reassuringly correct lady to their grandmother.[45]

The buckle of the belt that clasps her costume bears a cameo self-portrait of Angelica, further proof of the 'friendship' category to which the picture belongs. According to Lady Knight, the women had always been 'familiar with Madame Angelica',[46] whom they had known in England before the collapse of their fortunes, and it was at her request that the image of Minerva that Angelica had originally intended to depict was changed into one of the artist herself.

Cornelia, who made light of her economic and social difficulties, worked determinedly at being a writer. The fact that she had already acquired a certain literary reputation at the time of her father's death might have made the years of exile with her mother hard to bear, but it was Lady Knight who expressed regret, not her daughter. 'It's a loss to her country,' she remarked, 'that necessity obliges us to be removed from it [. . .]. Her learning is very profound, and at the same time very

general [. . .] but what avail her talents or services?'[47] This pessimism was reinforced by her initially disparaging view of the culture in which she and Cornelia had taken refuge. Early on she was persuaded that the Italians were

> a very worthless sort of people, but very few worth knowing. The ladies dress most horribly, like strolling players, and have as many shining stones around them as the waxworks in Fleet Street.

This was in 1778, the year after their arrival in the country. But fifteen years later her opinion had changed. The Italians were 'a very sensible, agreeable people' who were 'ready to show us esteem and courtesy'.[48]

Cornelia remained well connected in artistic as well as literary circles, and became more famous as an author and poet as the years passed. Fanny Burney praised her first book, *Dinarbas* (1790), which was regarded as a kind of sequel to Johnson's *Rasselas*; Horace Walpole was impressed by her *Marcus Flaminius or The Life of the Romans*, which was dedicated to him. (This is the book on which she is resting her left arm in Angelica's portrait.) She was later appointed a Companion in Queen Charlotte's household, a post she subsequently filled for the Queen's granddaughter Charlotte. But this would be many years after Angelica's meeting with her and her mother in Rome.

Their friendship was reassuring to all parties, filled with all the warmth of old acquaintance and present regard. Angelica always enjoyed rediscovering the civilised company of the British, and the Knights found comfort in a milieu, part salon and part studio, that combined elegant worldliness with peaceful industry.

It may seem a little puzzling that the 1793 portrait should have depicted Cornelia as Design (or Drawing) rather than Poetry, especially as Angelica showed the allegory of poetry in other paintings. Is it, as one writer has suggested, that she simply wanted to show her as the Muse of painters rather than a painter herself?[49] Probably the claim of the *Memorandum of Paintings* that 'she holds a pencil, as she is very fond of drawing', is sufficient explanation. It is an unconventional female portrait for Angelica to have painted, impressively direct, avoiding palliative sweetness and serious in its implied claims. If Cornelia is not a Muse, she seems to suggest, then she may almost be an honorary male; certainly she is less comely than Angelica's Goethe.

271

A very different kind of undertaking was Angelica's 1795 full-length portrait – now lost – of George III's sixth son Prince Frederick Augustus dressed in what the *Memorandum* calls the 'national uniform of the Scotch Military Highlanders', a picture for which she was paid the sum of 250 zecchini. She seems to have laid aside her old habit of painting royalty with a rather stiff deference, perhaps because Augustus was so clearly rebelling against the stuffy confinement of his father's court. Because he suffered from poor health, he repeatedly travelled on the continent in search of warmth between 1791 and 1796. Many observers thought him badly behaved: Lady Knight disapproved of both his morals and his liberal views, and her daughter described a party given by Lady Plymouth to celebrate his twenty-third birthday at which the company was so disreputable that all the Roman ladies and even some young Englishmen stayed away. In 1798 a dour Scot, Mr Livingston, told King George that his son had 'constant dinner parties and suppers with very bad society'.[50] He had married Lady Augusta Murray secretly in 1793, but his father had the marriage annulled and Lady Augusta confined to England. British artists in Rome, however, liked the Prince because he was a generous patron.

If Augustus's portrait struck an emphatically national note, it was fairly unusual in that respect. Angelica continued to prefer painting her subjects, particularly her female subjects, in generalised costume. Her big full-length portrait of Thomas Coutts's daughters in 1790 shows them dressed in plain white chemise gowns as though they were the Muses or Graces, standing near a pedestal bust of Minerva to underline the analogy. The usual semi-classical background is present – there is a glimpse of the Temple of Aesculapius at the Villa Borghese – emphasising the atmosphere of decorous learning that Coutts hoped would surround his girls during their stay in Rome. At the outbreak of the French Revolution in 1789 they had been learning French at a convent in Paris, where the Duchess of Devonshire enlisted the help of her old flame the Duke of Dorset, then living in Parisian exile, and of Marie-Antoinette's favourite Mme de Polignac to welcome them into society. Angelica had none of Georgiana's particular reasons for wanting to cultivate Coutts's goodwill, since she had a perfectly satisfactory banking arrangement with Thomas Jenkins in Rome and with Kuliff and Grellet in London, and was more than solvent. The painting was a straightforward commission, and was handsomely

rewarded. It cost Coutts 300 guineas, which Thomas Jenkins paid to Angelica on 8 April 1791.

Jenkins played a crucial role in introducing new clients to Angelica and handling their payments to her. Their relationship never seems to have been compromised, though since Jenkins was also associated with more dubious dealings it might have become awkward with time. Whereas Angelica had advised Goethe against buying a work of doubtful authenticity, Jenkins had a veritable factory for turning out 'antiques', and his undeniable duplicity (as well as his legitimate business activities) made him the richest figure in the British art colony during Angelica's time in Rome. Nollekens writes about his counterfeiting business:

> Jenkins [. . .] followed the trade of supplying foreign visitors with intaglios and cameos made by his own people, that he kept in a part of the ruins of the Colosseum, fitted up for 'em to work in style by themselves [. . .]. Bless your heart, he sold 'em as fast as he made 'em.[51]

Charles Townley became one of his main clients, and inevitably his 'outstanding' Mayfair collection included a great many Roman fakes.

Jenkins was an urbane operator. The Countess of Bristol told her daughter Lady Bess Foster that he would be a far more agreeable *cicerone* to her than Byres: 'he knows so much, and will communicate his instruction less en routine'.[52] He also possessed great influence. He had been such a favourite of Pope Clement XIV that, in Northcote's words,

> his gate and stairs used to be lined with petitioners as it was in his power to make the Pope do as he pleased [. . .]. The people used to call Mr Jenkins illustrissimus and kiss his hand, and it was even in his power to get the freedom for one condemned to the galleys.[53]

There was no accredited English envoy to the Holy See, but Jenkins acted unofficially as one.[54] Although the Jacobites claimed that he was a Hanoverian spy, he seems actually to have been an agent of the

British government. Not everyone was as easily taken in by his fakes as Townley. Catherine II of Russia, for instance, told Reiffenstein that he was to buy her nothing more from Jenkins because it was 'scandalous' to pass off wretched daubs as authentic masterpieces.

His fine apartment at Castel Gandolfo, formerly inhabited by the General of the Jesuit order, was sometimes described as a trap for young Englishmen gullible and rich enough to be persuaded to spend large sums of money on worthless 'antiquities'. But there was a more respectable side to Jenkins. He arranged major art auctions and was the intermediary through whom important works of art such as those of the Villa d'Este at Tivoli and the Villa Negroni in Rome, which today form the basis of the British Museum's collection of antiquities, found their way to England.

Like Byres, he gave an annual Christmas party for his workmen artists where, according to Thomas Jones,

> it was customary for every one to present a specimen of his abilities to his protector, for which he received in turn an antique ring [...]. These specimens were hung up in their respective rooms of audience for the cavalieri who came.[55]

It was on such occasions that work contracts for the following year were settled.

Angelica trusted him as a financial consultant and agent. From 1786 he was increasingly in her service, and many of her major clients – Catherine II, Lord Berwick, Prince Yusupov, Princess Bariatinsky – paid for their commissions through him. As his income grew, so did the physical space he occupied. In 1782 he took over a further floor of the palace on the Corso in which he had lived since 1765. There he received important clients: Grand Duke Paul and his wife called several times in 1782, and in 1784 King Gustav III of Sweden paid a visit to see Jenkins's own art collection. The French Revolution, which brought republican troops to Rome, seems to have scattered it, in the process ending Jenkins's stay of nearly half a century in the city. He eventually fled to England, where he died in Yarmouth in 1798.

Before this, however, he had sat to Angelica for his own portrait. The draughtsmanship may be rather poor, but the overall effect of the picture is very winning. Jenkins, who remained unmarried, is in the

company of his niece Anna Maria, who would stay with him from 1776 until her own marriage in 1794 to the Italian Giovanni Martinez, whose uncle lived next door. The double portrait shows Jenkins sitting stiffly and slightly apprehensively under the spreading boughs of a tree, holding a broad-brimmed hat in his right hand and fondling a brindled dog with his left. (The colour of the dog's coat almost exactly matches Jenkins's.) Behind him is the Colosseum, prettily set in an Arcadian Campagna – a rare case of Angelica's adopting Batoni's standardised type of landscape.

Elizabeth Gibbs's diary for the year before the portrait was painted calls Anna Maria slim, tall and 'not dressed according to the world's fashion'. In Angelica's picture, however, where she stands to the right of her uncle fingering a trail of convolulus that tumbles down the tree trunk, she looks modish in her white chemise gown and tall-crowned, broad-brimmed hat. Indeed, the 1790 picture is much easier to date on the evidence of costume than many of Angelica's other works.

In return for the picture, which according to the *Memorandum of Paintings* was done out of friendship, Jenkins gave her various antique jewels and a marble head in bas-relief. The *Memorandum* notes that the latter was 'wonderfully preserved', and by 'an excellent and expert artist'. It is to be hoped, but cannot be confidently affirmed, that they were genuinely old.

People who commented on Angelica's own dress sense often did so disparagingly. In real life she seems to have been curiously uninterested in personal adornment, however gorgeous she often made herself appear in her self-portraits. When Mariane Kraus, who was travelling as lady-in-waiting to the Countess of Erbach-Erbach in 1791, met her and Louise Vigée Le Brun at a musical soirée of Countess Solms's, she remarked that 'Mme Le Brun sang, she is a beautiful woman, dresses better than Angelica'.[56] At that time, however, Kraus was a stern critic of Angelica. Once she knew her better she called her 'very pleasant', eventually describing her as the only woman worth respecting in Rome.[57]

The urge to idealise herself in her portraits rarely left Angelica. In this respect she does resemble Louise Vigée Le Brun, and contrasts with other female artists of the eighteenth century such as Rosalba Carriera and Anna Therbusch. What Rosalba attempted in her self-

portraits was to arouse expectations different from the conventional ones, and prompt different responses: her chosen role was that of spinster, not seductress. In keeping with this intention she elected to depict herself in the one allegorical picture she did as Winter, traditionally the least appealing of such representative figures.[58] Anna Therbusch, similarly, seems to have taken positive pleasure in tracing the collapse of her looks in old age, as though it freed her to concentrate on essentials. But Angelica's view of essentialism was different. Although a letter she wrote Goethe on 5 August 1788 remarks that the Uffizi self-portrait she painted in 1787 was generally liked, it cannot have been because it was thought to be a faithful image; indeed, she herself admitted that the picture was better simply termed 'the painting I have done for the Florence gallery' than a self-portrait.[59] The Grand Duke liked it enough to accept it as a gift, and rewarded the donor with a gold medallion, but it is not Angelica's most successful work. Part of the reason is that it mixes different approaches: the formality and grandeur of the setting recall Van Dyck, yet in other respects it is warmly sentimental. The neo-classical touches – furniture legs, belt buckle – appear gratuitous in the context and at odds with the pervasive sensibility, but the dress Angelica wears is a pure white Vestal-like concoction, and so seems designed to confirm and promote the view of her that Herder repeatedly presented to his wife.

Although her own portrait is as unreal as the one she painted of Goethe, there is a far stronger emphasis on worldly success. Angelica here depicts herself as an icon of refinement, a ravishing creature fit to grace a ducal collection, a picture of tastefulness and reserve. She appears to be flirting with the concept of ageless beauty at the same time as announcing herself as a woman rich in experience, whose assurance and self-awareness are the product of years of maturity.

She also stands alone, confident of her settled identity as a painter. In 1792 she will paint herself hesitating between painting and music, buttressed by the allegorical female figures representing the two competing arts as well as seemingly seduced by one of them. This may or may not reflect the 'Herculean' choice she allegedly had to make in her youth, when a young man she met at Montfort Castle, seconded by her father, advised her to devote herself to music, while Firmian's chaplain Trogher persuaded her that painting was a nobler as well as

276

morally safer profession for a young woman to follow. According to Giuseppe Zucchi, who told Rossi the story, Angelica's picture *Orpheus Leading Eurydice out of Hades* makes Orpheus the portrait of the young man who had tried to deflect her from her art. The emphasis in the 1792 self-portrait, however, is on the autonomy of the artist whom the young Angelica would become, and whom by 1792 she had actually become. The women may be Three Graces, but Angelica's white dress – the pivot of the colour spectrum – marks her out as the exception. She is not morally purer than the others (if she has chosen the topos of the Herculean choice as her theme, Music is by no means depicted as vice to Painting's virtue), but radiantly independent, possessed of free will. It is all the more paradoxical that she should shine with such purity when she has just chosen to follow the hard, stony, discouraging path of art. But by 1792, recalling the dilemma she had faced as a young woman in Milan, she knew with certainty that the way would not be an ungrateful one.

The presence of *three* female figures also helps to ensure that there is nothing too coquettishly alluring about the painting. Reynolds's portrait of Garrick torn between comedy and tragedy thirty years before had underlined the openness of the situation facing the actor, but at the same time legitimised the flirtatious response he gave the two temptresses: he could enjoy the one without having to renounce the other. Angelica's choice looks much starker, but its harsh implications are tempered. To head for the temple of glory is a necessity whose absoluteness absolves her of all blame for her 'unfeminine' ambition: the urgency of Painting's entreaty, her severe profile and animated sash, make it evident which way Angelica will go. In the picture she still glances back tenderly at Music as she makes to leave, while Music sorrowfully holds her hand in a final parting gesture. It is clear that Music remains a beloved companion, whose characterisation may remind us that Cesare Ripa's *Iconologia* had designated the Graces as representatives of ideal friendship; but the *Memorandum of Paintings* still observes that the Angelica who resists Music's attempted seduction 'gives herself entirely up to Painting'. By recasting the mythological story with three female protagonists she justifies her rejection of a career that seemed an easier one for eighteenth-century women to embrace, legitimizing her own artistic ambitions in partly social terms.[60]

Even the dyspeptic and disappointed Barry was charmed and impressed by the work:

Some may say [. . .] that this is great, since it was executed by a female; but I say that whoever produced such a picture, in whatever age or whatever country, it is great, it is noble, it is sublime! How I envy plaintive Music the squeeze she now receives; the impression seems deeply imprinted on her hand – all is feeling, energy, and grace!

And Cornelia Knight wrote some enthusiastic, if slightly unfortunate, lines on the picture:

> Next turn and see Fame's lofty temple rise,
> With dazzling glory, 'midst yon azure skies;
> On thee, Angelica, enrapt we gaze,
> Uncertain, wavering, in the dubious maze;
> While Painting's genius to the summit leads,
> Soft Music woos thee, and thy flight impedes.
> Yet see! Thy steps her fading flow'rs forsake,
> And for their guide triumphant Painting take:
> O! happy choice, for ages yet to come!
> O! brightest ornament of modern Rome![61]

Matthisson remarked that the portrait showed the artist, who was about fifty years old at the time, as though she were still in the first bloom of youth.[62] Of course it fooled nobody; unimaginative or hostile commentators, even disingenuous ones like Herder, regularly drew attention to the fact that Angelica had (unsurprisingly) lost all her girlish prettiness, appearing to be what in the language of the times was an old woman. But whereas Louise Vigée Le Brun was receiving compliments on her looks until late in life, what people had always praised in Angelica was less her physical beauty than qualities of (moral) character that found visible expression on her face. Friedrich Johann Lorenz Meyer's *Darstellungen aus Italien*, published in 1792, admitted that she no longer looked young, 'but that character of goodness, which moulds the features and outlives the charms of youth in imperishable beauty, dwells on her face'.[63]

Yet thirteen years later the surly Kotzebue was determined to give her no quarter, in this or in any other respect. When he visited Angelica in 1805, two years before her death, he described her as a very kindly, pleasant old lady whose face expressed no genius but much goodwill.[64] A tired self-portrait of 1800 no doubt showed her more or less as she then was, unglamorous and melancholy. A different image again is that of the posthumous bust sculpted by Peter Johann Kauffman, an artist originally from the Bregenz Woods but probably only distantly related to her, which shows her as a woman of harsher and more masculine appearance than in any of her own portraits.[65] This is the bust originally displayed in the Pantheon, but which today is to be seen in the Protomoteca Capitolina in Rome.

Whatever the facts and fantasies of her own self-depiction, she still liked trying to capture the glamour of other artistic women. If the English Cornelia Knight looked prim and rather proper, the fiery talent of Italian artistes seemed to call for more excited expression. Angelica, however, tempers the fire, for no very evident reason. In the same year as the 'Herculean' self-portrait she painted a picture of Fortunata Fantastici as a Muse in the act of declaiming. It is a paradoxically undramatic work in which the poetess has a *gemütlich* rather than an inspired look, her outstretched arms suggesting that she is holding a skein of wool, not measuring the rhythms of poetry. Can Angelica, in all her artistic and feminine modesty, have wanted to convey genius in other ways than through the fixed (male) intensity of her *Winckelmann* or the remote reflectiveness of her *Dr Tissot*? Or does she still jib at showing her own sex as exceptional?

Fantastici herself wrote a sonnet commemorating her attendance at Angelica's *conversazioni*, and it is shown lying next to her on a table. Rather misleadingly, it refers to Angelica's desire to capture 'with masterly brush' the faces of two women bound together with ties of heartfelt friendship in a moment of enthusiasm, as though a double portrait were being attempted. But however interesting Angelica's effort at showing the physical actuality of female inspiration, its realisation is no more convincing here than it is in Louise Vigée Le Brun's famous portrait of Germaine de Staël declaiming with a lyre like her fictional character Corinne. The act of improvising is not, of course, a state that can be clearly represented on canvas. Conventional-ised images may serve the artist well, as in Vigée Le Brun's brilliant

pictures of the inspired composer Giovanni Paisiello and the 'enthusi-astic' artist Hubert Robert, but they run the risk of trapping the image in routine and stereotyped patterns of body language. Fantastici, in this case, manages to look no more *mania*-filled than the bovine Germaine de Staël 'en Corinne'. Perhaps Angelica and Louise harboured the same doubts about the reality of female genius.

Undeterred, Angelica does her best with other familiar motifs. Fantastici's turbaned head, her loosely Grecian chemise dress and her belt fastened with a clasp bearing the head of Terpsichore, the Muse of song, fit her into a different artistic convention that recalls the inspired sibyls of Reni and Domenichino. The *improvvisatrice*'s reputation at the time Angelica painted her was at its peak. She and Teresa Bandettini had succeeded the celebrated Corilla, of whom Mrs Piozzi remarked:

[she] no longer exhibits the power she once held without a rival, yet to her conversations [i.e. *conversazioni*] everyone still strives for admittance, though she is now ill, and old, and hoarse with repeated colds. She spares, however, [...] no labour or fatigue to obtain and keep that superiority and admiration which one day perhaps gave her equal trouble to receive and to repay. But who can bear to lay their laurels by?[66]

Corilla, the Arcadian name of Maria Maddalena Morelli, was probably Germaine's model for the heroine of *Corinne* (though she denies it in a footnote to the fourteenth book), and as with the Staëlian heroine, 'the Capitol will long recollect her being crowned there'. In fact Corilla's crowning marked the moment when her decline in public regard began: her accusers claimed that she was an inadequate mother, a plagiarist and a sexual opportunist, and *Corinne* builds on such attacks to elaborate its warning about the ephemeral nature of female glory in a patriarchal society.[67] For society could not accept the justice of a woman's receiving the laurels that had been awarded only three times in Italian history, and exclusively to men (Petrarch, Tasso and the improviser Perfetti). Casanova disparaged Corilla for having a merely ornamental poetic talent, as Angelica's own art would frequently be disparaged both in her lifetime and after her death. Worse, she offended the male establishment by breaching the accepted norms of

female decorum, as Angelica had very occasionally done early on in her career.

Although Mrs Piozzi was 'exceedingly entertained by the present *improvvisatrice*, the charming Fantastici',

> whose youth, beauty, erudition and fidelity to her husband give her every claim upon one's heart, and every just pretension to applause, I could not, in the midst of such delight, which classic learning and musical excellence combined to produce, forebear a grateful recollection of the civilities I had received from Corilla, and half-regretting that her rival should be so successful.[68]

Rossi recalled meeting 'the excellent Fantastici' in Angelica's house

> as she spontaneously sang her poetry; perhaps neither of them ever sang better than at this moment, and it does seem that enthusiasm inflamed them and snatched them away to a place that one might, as it were, call the temple of female fame.[69]

Advancing years did not always diminish the effect such stars made. Even at the age of fifty, decades after she had made her choice between painting and music, Angelica could still dazzle with her own vocal performances, if no longer with her looks. 'Though Angelica has given up sound for substance,' the Irish sculptor Hewetson wrote in 1791, 'she still has no trifling claim to merit in singing.'

She naturally loved the lyric art of the female improvisers, and Rossi describes how the two great female improvisers of the day frequented the Kauffman household in Rome – the Florentine Fantastici and the Luccan Bandettini, whose Arcadian name was Amaryllis. In 1794 Angelica painted her too as a Muse in the act of reciting, garlanded with laurel and again in the grip of a rather temperate-looking divine madness.

In her *Souvenirs* Louise Vigée Le Brun accuses Angelica of a similar lack of vitality, and so seems to damn this 'glory of our sex' with faint praise:

> I found her very interesting, quite apart from her admirable

talent, in her intellect and knowledge [. . .]. She talked for a long time with me, very informedly, during the two evenings I spent at her house. Her way of conversing is gentle; she is formidably learned, but has no enthusiasm, which given my own ignorance did not electrify me.[70]

It is nonsense, of course, to claim that Angelica lacked enthusiasm. Her passion was all for her art and those who helped further it, and she was only truly happy when she painted. Perhaps her inborn reticence made her find the younger woman's self-promotion distasteful, or possibly, cultured as she was, she frightened the comparatively uneducated Louise with her reflectiveness. Louise offers no judgement on her work apart from the vague statement that Angelica was the glory of her sex. The practitioner of what Sir George Beaumont called a 'waxwork kind of painting'[71] or Hoppner a smoothly finished 'enamelled' style[72] might well have found Angelica's touch too light and her finish too sketchy. Whereas Louise had adopted her own polished technique well before the time she visited England in the early 1800s, Angelica had still been developing during her London years. She was much more open to outside influence.

It is quite likely too that Louise simply found Angelica too serious. When Goethe remarked that she worked too hard, he also claimed that she never enjoyed relaxations such as going to the theatre ('why, no one knew').[73] But Louise records that she and Angelica did go to the opera together:

Very soon after my arrival I went with Angelica Kauffman to see the opera *Cesare*, where Crescentini was making his debut. His singing and his voice were at this time equally perfect: he was playing a female role, and he was decked out with great panniers of the kind people wore at the court of Versailles, and which made us burst out laughing. It should be added that at that time Crescentini had all the freshness of youth, and acted very expressively. In short, he was the successor to Marchesi, whom all the Roman ladies were mad about . . .[74]

Louise and Angelica undeniably had a certain amount in common. Both were seen as ornaments of society, however reluctant to dissipate

their energies in the *monde*, and in Rome both moved in the best circles. Cardinal de Bernis invited them together to one of his famous dinners in the Palazzo dei Caroli (now the Banco di Roma), along with members of the diplomatic corps and other foreigners. He had refused to take the oath demanded by the new civil constitution of the clergy, which meant that he had effectively ceased to be French Ambassador, but he still did such guests the honours for which he felt himself responsible.[75] His chef was nearly as celebrated as Bernis himself. Lady Anne Miller's *Letters from Italy in the Years 1770 and 1771* remarks of Bernis:

> The cardinal, being subject to the gout, starves at his own table, as he thinks living low the only means of keeping the fit [*sic*] off. He feeds on nothing but herbs boiled and all the juice pressed out; neither gravy, butter, salt, cream, eggs, oil, not any kind of meat, fish or fowl does he ever taste, eats very little bread, and that extremely stale. Though he is himself thus suffering famine, his dishes are of the best kinds . . .[76]

By 1790, according to the Comte d'Espinchal, Bernis was the only foreign plenipotentiary in Rome to serve his guests serious food.[77] If the average *conversazione* was an undernourished affair, something seemingly designed expressly to keep curious visitors away, the ones that Bernis presided over were different. Fragonard's patron Pierre Jacques Bergeret de Grancourt reported in 1773 that they were always generous occasions, with *valets de chambre* pressing refreshments of every kind on guests. Canny Italians, knowing how rare such luck was, would swallow fifteen ices in a single evening,[78] and foreign visitors felt welcomed rather than excluded by the well-known Roman snobbishness.

Whatever Goethe thought about Angelica's liking for seclusion, she did leave the house for certain social pleasures. In March 1791 Mariane Kraus reports being present with her at a theatrical performance given by Emma Hamilton and her husband, and comments revealingly on Angelica's emotion:

> So there sat the wooden Kraus beside an Angelica who gulped so loudly that stones might have been moved [. . .]. Herr

Reiffenstein wept decorously too, one could count the antique tears rolling slowly down his cheeks [. . .]. Angelica was so beside herself that she kissed the beauty's [i.e. Emma's] hand probably twenty times . . .[79]

But Goethe was convinced that she was deprived of theatrical entertainment, and decided to put matters right. With a group of friends he set about arranging an impromptu concert for her one summer's evening, and invited Reiffenstein, Jenkins and Giovanni Volpato besides the Zucchis. Hordes gathered under the windows of his apartment to listen, and immediately the 'decent but quiet' residence opposite the Palazzo Rondanini was rumoured to have become the stopping place of a wealthy English lord. Nothing done for money, Goethe writes in the *Italienische Reise*, could have matched this performance, given for virtually nothing by a band of artistes. Although the household resumed its relatively peaceful life once the gala for Angelica was over, its members could never quite shake off the suspicion of being rich, noble and secretly British thereafter.[80]

Events like this provided a break in what was otherwise a life of regularity. Rossi describes the daily pattern in Via Sistina 72, a routine that would have seemed dull to others, but which to Angelica was essential in its very predictability: drawing or painting from the early morning, having a light midday meal, taking up brush or pencil again in the afternoon and carrying on working for hours (in winter until sunset) before stopping to eat. After this the evenings would be spent in the company of 'the most cultivated men' (and women), especially those with a keen understanding of the arts: Reiffenstein, Volpato, Philipp Hackert, Abbot (later Cardinal) Spina and others.[81]

In addition there were writers, cultivated tourists and other acquaintances who simply wanted to spend some time in her presence. Angelica's company was the more sought out, Rossi says, for her sweetness and unassertiveness: she rarely spoke in discussions, and even when the talk turned to art she seemed to want to learn from others rather than impose herself. And however necessary routine was to her life, late nights seem not to have compromised it.

Needless to say, the cost of such entertaining mounted up. Angelica's household accounts show that she spent heavily on tobacco, chocolate, wine from Albano and Cyprus and barrels of Malaga: as she

had told her father in that early letter from London, living in the style that befitted her status and that of her grand clients and friends could not be done on the cheap, and continuing in this manner in Italy was both necessary and a duty. Even so, her major outgoings were on books and paintings. Goethe approved of her treating herself to the occasional glorious work of art, which her industry and success made affordable, however annoyed he felt about her and Zucchi's 'prudently' cautioning him against buying possible fakes himself. The year after her failure to purchase the wonderful Andrea del Sarto Madonna, he reported:

> Angelica has given herself a treat and bought two pictures, one by Titian, the other by Paris Bordone. Both for a lot of money. As she is so rich that she can't spend her income, and every year adds to it, it is fitting that she should acquire something which gives her pleasure, and something which increases her zeal for art. As soon as she had got the pictures into the house she began to paint in a new way in order to try and find out how she could make certain of these masters' strengths her own. She is tireless, not just about work, but also about studying. It is a great joy to see artistic things with her.[82]

Household bills cast further light on the expense of Angelica's judicious thirst for acquisition – the cost of having two Canalettos cleaned, the purchase in Naples of another painting by him for 143.50 scudi, the buying of an alleged Van Dyck for about 100 scudi, and so on.[83]

But successful, moneyed, childless people notoriously attract spongers. Angelica was understandably annoyed when family members took advantage of her good fortune, which, as she pointedly put it, was actually the product of solid industry rather than serendipity. Of her nephew Joseph Anton Kauffman she wrote to Metzler in 1786:

> He has got it into his head that I have a lot of spare [money] to keep him like a lord. [...] My wealth consists in my daily work, if I have saved anything it has happened through effort and industry, so it is right that I should enjoy it in peace ...

She then rehearsed the familiar truths about the expense of living in the style that her fame and her profession demanded:

The cost of living in a big city with the decorum my status demands without spending anything on non-essentials amounts to a considerable sum every year. In consequence I have to apportion everything carefully. God knows if I do not mean well by my relatives, but their number is great and [. . .] a young man who is healthy and strong and is not afraid of hard work can manage in the world. Joseph Anton has thrown away his good fortune, I have long been patient with him.[84]

To a relatively detached observer like Goethe it may have looked as if she had money to burn, but Angelica saw things differently. Though she never stood on her dignity, she was aware of what she was worth. Frugal by temperament, she expected others to respect the principles by which she had successfully lived. Restraint and measure were her bywords, and they ought to have ensured that she would carry on existing comfortably in her Roman palace, appreciated by all and unassailed by adverse circumstances. There would be plenty of time to retrench and worry obsessively about making ends meet when the old secure world of patronage and aristocratic leisure collapsed. For as long as her investments were secure and her clients kept her busy she would carry on prospering. But could she rely on the continuance of the world she knew?

Chapter Thirteen

'These Happy Times Are Over'

However remote from political events some of Angelica's activities appeared, her success was still dependent on a barely changing social scene. Before 1789 it was possible for her to embrace potentially risky new projects enthusiastically, without needing to concern herself with anything more threatening than whether a new artistic departure would be favourably received or a client pay in full. When the political world was turned upside down, far more agonising possibilities presented themselves.

In this altered environment it was hard for her to continue as she had done before. Just as the Gordon Riots had upset her balance towards the end of her stay in England, so the turmoil of revolutionary war would cause her anxiety out of all proportion to the actual danger she faced in Italy. In October 1795 she wrote to her trustee and solicitor Kuliff in London about goods despatched a year earlier: 'I had the pleasure to learn the other day from Mr Jenkins that the ships upon which my pictures were loaded escaped being taken by France. I hope to have this news soon confirmed'. The letter was accompanied by a querulous one from Antonio Zucchi enquiring about the sale of his house in the Adelphi and about different loans he had made, one of £600, another £80 or £100, to the Italian artist Giovanni Locatelli, a sculptor of indifferent reputation. Yet Angelica would write to a friend soon after Zucchi's death in 1795, 'It is not poverty I fear, but this dreadful solitude' – a statement that suggests the advantages she derived from her practical marriage, as well as the need for company it met. Like many punctilious and well-organised people, besides, she was acutely troubled by the onset of anything that spelt change or disruption. Yet at the same time she was still tempted by proposals that offered her the chance to broaden her artistic horizons.

The revolutionary wars in fact damaged one important client in England far more seriously than they would ever hurt Angelica herself.

On 13 February 1787 Reynolds had written excitedly to the Duke of Rutland:

> the greatest news relating to virtù is Alderman Boydell's scheme for having pictures and prints taken from those pictures of the most interesting scenes from Shakespeare, by which all the painters and engravers find engagements for eight or ten years. [. . .] He wishes me to do eight pictures, but I have engaged only for one. He has insisted on my taking earnest money, and to my great surprise left upon my table £500 – to have as much more as I demand.[1]

Reynolds indeed ended up expecting to be paid much more, a possibility he had warned Boydell of at an early stage. A letter of 15 December 1791, not in Reynolds's hand but certainly drafted by him, observed that he had undertaken a picture from *Macbeth*

> in consequence of the most earnest solicitation on Mr Boydell's part, since after Sir Joshua had twice refused to engage in the business, on the third application Mr Boydell told him that the success of the whole scheme depended on his name being seen amongst the list of artists. He recommended to Mr Boydell's consideration whether it would be worth his while to give so great a price as he must demand, that though his demand would not be in proportion to what he got by portrait painting, yet it would still be more than probably he would think proper. To this he was answered that the price was not an objection to them; that they would gladly give whatever Sir Joshua should demand. [. . .] Sir Joshua advised him that [the price] would be very high, desired him to recollect that his fixed prices for portraits were double that [*sic*] of any other painter . . .[2]

A panel was appointed to determine a fair price after Reynolds's death, 'the question Sir Joshua apprehend[ed being] whether he [could] make it appear that he could have got £2,000 if he had employed the time in portrait painting which was employed in that picture, though Sir Joshua's demand [was] only 1500 guineas'. Eventually the panel settled on £1,000.

Reynolds did three pictures in all for the so-called Shakespeare Gallery. Other artists were paid far less than he was. But whatever the value of their contribution, most must have regretted the fate the Gallery met with, and heartily pitied the begetter of the scheme for the money he lost as a result of the upheavals in Europe.

When he recalled the conception of the Shakespeare Gallery, which may be dated to November 1786, Boydell remembered his determination to do for native art what Reynolds had desired so many years before:

he should like to wipe away the stigma that all foreign critics threw on this nation – that they had no genius for historical painting. He said he was certain from his success in encouraging engraving that Englishmen wanted nothing but proper encouragement and a proper subject to excel in historical painting. The encouragement he would endeavour to find if a proper subject was pointed out. Mr Nichol replied that there was one great national subject concerning which there could be no second opinion, and mentioned Shakespeare. The proposition was received with acclaim by the alderman and the whole company.[3]

Such, he continues, was the origin of 'the greatest undertaking of its kind that was ever carried on in this or any other country, which has cost one private family considerably over £100,000, which formerly had by their talents and encouraging liberality turned the tide of the commerce of England in prints in favour of their own country'.

It is hard to suppress a groan at this revival of a project that even Reynolds must eventually have sensed would never bear fruit in Britain, and particularly at the choice of a *theatrical* source for the hoped-for revolution in subject painting. Not all contemporaries saw matters in a negative light, however – far from it. Burke told Reynolds that he thought it an extraordinary undertaking, to which Reynolds replied:

It is so, I confess. It surprises me. I am sensible that no single school at present in Europe could produce so many good pictures, and if they did they would have a monotonous sameness: they would all be Roman or Venetian, Flemish or French;

289

whereas you may observe here, as an emblem of the freedom of the country, every artist has taken a different road to what he conceives to be excellence, and many have obtained the goal.[4]

It sounds unconvinced and unconvincing, particularly in the light of Reynolds's expressed view that aldermen such as Boydell did not understand history painting: 'they can judge only of likenesses'.[5] One wonders how many of the artists Boydell approached shared his and (professedly) Reynolds's visionary interpretation of the project. Even Boydell himself was suspected by some of having undertaken it for baser motives than he was prepared to admit. Thus Gillray did a satirical cartoon of *Boydell Sacrificing the Works of Shakespeare to the Devil of Money-Bags*.

But there were other and more bitter ironies. Boydell, with the help of outstanding artist-craftsmen, had indeed turned the tide of favour away from continental and towards British engraving, and grown prosperous on the proceeds. The success of his Shakespeare Gallery would depend in large part on the continuing support of those patrons abroad whose liking for superior British prints had helped to ensure his initial prosperity, as well as on the saleability of the new Shakespeare edition that the prints were also intended to illustrate. But in historical terms the gallery was conceived too late. In the climate of war and attrition the support Boydell needed failed to materialise; custom dried up, and none of his acumen (he was a first-rate businessman, if himself a second-rate engraver) could save the scheme. True, there were plenty of visitors to the huge building at 52 Pall Mall where the original paintings were hung,[6] but they could never contribute sufficient to pay for the costs incurred in setting up the enterprise. This meant that selling prints of the paintings was crucial; yet it was impossible to find enough customers, and not merely because of Napoleon's blockade on goods exported from Britain. The quality of the Shakespeare Gallery contributions, as well as the prints done after them, was often seen as comparatively disappointing, and there were rival enterprises. The political crisis was simply the *coup de grâce*.

Angelica had illustrated Shakespeare before: in 1782 she did a picture of *Miranda and Ferdinand* for the publisher James Birchell, along with two oils of *Cordelia* and *Lear*. But between 1788 and 1789 she completed for the alderman a scene from *The Two Gentlemen of*

Verona, about which she wrote to Goethe on 5 August 1788, a distinctly undramatic rendering of the moment when Valentine, Proteus, Sylvia and Julia meet in the wood. This scene had never been taken as a subject for illustration before (though Thomas Stothard and Francis Wheatley would attempt it after Angelica), and one can see why. Another letter to Goethe, of 21 September that year, describes the problem of constructing an effective picture from a moment in Shakespeare when nothing very dramatic happens – in this case, the scene from *Troilus and Cressida* in which Cressida finds herself imprisoned in the camp of the Greeks. 'It is rather difficult,' she wistfully remarks, 'to make something out of a subject which does not contain much material in itself.'[7] In that case, why had she chosen it?

Part of the difficulty was the old problem of Angelica's need to be *decent*, which fatally interfered with the possibility of being dramatically effective. In the coy wording of the *Memorandum of Paintings*, Cressida is 'in amorous conversation' with Diomedes, and her husband Troilus has unfortunately chosen to pay her a visit during an armistice. Given that Angelica could presumably have chosen either a more eventful scene or one that exalted virtue rather than depicting vice, the pallid canvas she produced has to be seen as her own fault. She carefully defuses the shock that the scene ought to carry, and in which a large part of its theatrical effectiveness lies, by electing to show Cressida doing no more than plead with Diomedes to release her from the oath she has sworn to him. Angelica cannot bring herself to depict the duplicitous coquetry of the original heroine, though others were less nice about the matter. Thomas Kirk's Cressida, for instance, is a woman who knows how to seize the chance advantages of war, and Henry Fuseli's licentious female wriggles in Diomedes' embrace while her husband looks on. Angelica's Cressida is too pure and unfeigning, and as a result simply uninteresting.

There were other less than distinguished contributions to the Boydell project, which may further explain the lack of public interest when the whole gallery was auctioned in 1805. Previously to that it had been offered as a single lottery prize, which was won by the modeller William Tassie. Boydell's nephew Josiah offered him £10,000 for the collection, but Tassie wanted £23,000.[8] The auction raised a mere £6,161 18s 6d, however, of which the highest price was that paid for Reynolds's *Death of Cardinal Beaufort*. This too was a strange picture

for the champion of the English historical school to have painted, and once more raises questions about the genuineness of Reynolds's commitment to the cause he appeared to promote. Many observers found the characters undignified, and several were unsure about the propriety of including a small devil behind the Cardinal's pillow.[9] If this had struck Boydell himself as unworthy, the price he paid Reynolds – twice what the picture fetched at auction – does not suggest as much. Luckily, he was not alive to witness that final indignity. He had died a broken and disappointed man on 12 December 1804, five months before the individual lots were offered for sale.

By that time Angelica felt too detached from the problems of the British national school to care very much about such abortive schemes. Different preoccupations were taking over, and perhaps predictably they were Christian ones. She had always been devout, but the pull of religious faith became stronger as she grew older and her depressive worries about the perils of war intensified. If the artistic consequences of her religious enthusiasm were, with some exceptions, rather disappointing, there is no doubt about the fervour she brought to this new kind of work.

In 1796 she met an Englishman, James Forbes (not to be confused with her friend the Edinburgh banker Sir William Forbes, whose daughter would marry Angelica's later subject the fifteenth chief of Glengarry), and he gave her an important commission. Later he wrote about the encounter:

> During my stay in Rome in the year 1796, I enjoyed the greatest pleasure in cultivating the friendship of Angelica Kauffman; I had at all times free access to her studio, where I passed many delightful hours.
> I was with her when she put the finishing touches to her picture 'Suffer the little children to come unto me' [for the Bishop of Münster]. I gladly embraced the opportunity of introducing the sublime description of 'Religion' and her lovely train, which I had copied from a sermon by Dr Horne of Norwich, before I left England, in the hope that I should engage Angelica to paint me a picture upon that exalted theme. She

292

entered deeply into the spirit, and said she had every hope of giving me satisfaction.[10]

The *Memorandum of Paintings* notes for 9 September 1797 'began to paint the picture of Religion', of which she had already completed a small sketch. When the French entered Rome, however, distress and delay ensued. In 1799 Angelica wrote to Forbes:

> When you honoured me with your commands respecting the picture of Religion, you generously offered me half its amount at Rome, which I declined, and told you how much I wished my situation was such that it might only be given and received as a pledge of my esteem and friendship, and that no money might be mentioned; nor do I forget your kind reply: but I could not then bring myself to accept of it, having at that time several commissions for pictures from my friends in Germany; but the unfortunate war in which that country has been also overwhelmed has occasioned a suspension of these orders; and I have therefore given all my time and attention to your picture, and I flatter myself have, by frequent renewed touches, brought it to a greater perfection than I once thought of . . .

And in another letter she writes that 'my whole soul was in it; I was delighted with the subject'.[11] She also mentions the work in a letter of 14 January 1801 to Cornelia Knight:

> I received a letter a few days ago from my good friend Mr Forbes but rather of an old date, he had then not had the pleasure of seeing you since your return to England. I mentioned to you in a previous letter how much I am obliged to him for his attention to me. I shall write to him soon. Several cardinals and prelates since their return to Rome honoured my study to see the picture of religion and expressed their approbation. The French when they were here used to say votre Religion est bien aimable et les vertus qui l'accompagnent sont bien séduisantes. [Your Religion is most amiable and the virtues accompanying her are most seductive.][12]

(Clearly, her relations with the invading republican French could have

been worse.) According to Rossi, Forbes later told her that his house in London was barely able to contain the crowds who flocked there to see the picture. Now it can no longer inspire any devotion, having been destroyed in the Second World War.

She did other pious paintings – a picture of *David and Nathan*, which the hard-to-please Kotzebue praised, or at least regarded as 'unquestionably the best' among the historical paintings displayed in Angelica's studio in the early 1800s, one of *Jesus and the Samaritan Woman*, and a design for a mosaic in the Swiss Chapel at the Santa Casa of Loreto, done at the request of Pope Pius VI. Perhaps this was belated recognition by the Holy See of her artistic standing and piety, for Rossi reports that she had vainly sought an audience with the Pope for years, and that although he regularly visited artists' studios in the autumn, he had missed hers: 'certain common artists who surrounded him were able to deflect him from his intention'.[13] One wonders why they should have wanted to, or why the Pope allowed himself to be influenced by them. Perhaps he harboured a lingering prejudice against women painters (Louise Vigée Le Brun claims rather unpersuasively in her memoirs that she had been invited to paint him in Rome, but had refused because he insisted that she wear a veil), or possibly the memory of her irregular first marriage still lingered. Against this, however, it should be remembered that cardinals, bishops and other clerics were regular visitors at her *conversazioni*.[14]

In the 1790s some observers thought Angelica to be past her prime. The artist Domenico Pellegrini wrote to Canova in 1792 or 1793 to ask how Angelica was, and added that she was no longer 'so much in fashion'.[15] Since she had painted the portraits of the Earl-Bishop and Thomas Jenkins with his niece in 1790, the group portrait of Princess Bariatinsky with her family in 1791, and in 1792 the portrait of herself hesitating between painting and music, along with the picture of Fortunata Fantastici, this may seem an unduly harsh judgement. Given that portraits of Cornelia Knight and Lord Berwick would follow in 1793, too, it seems fairly clear that as a face painter she could still impress. As late as 1795 Johann Heinrich Meyer would write to Goethe:

Angelica is still cheerful. She looks healthier, plumper and

younger than before, and paints just as well as, or better than, in our time [i.e. the late 1780s]. The English Prince Augustus in Scottish dress and a few portraits in the Van Dyck style are indeed successful productions.[16]

Angelica was too alert to artistic change not to have been affected by the new severity of Davidian neo-classicism, though whether her instinctive response was to follow or to react against it is a moot point. She was still developing as an artist, moving with the times because fashion or self-respect demanded it. Although Pellegrini felt that her popularity had waned, it can scarcely have been because she was painfully stuck in the past. Either to satisfy her clients or to please herself, she went on painting up-to-the-minute works, and in the 1790s produced some magnificently strong portraits. If she faltered later on, it was probably for reasons other than artistic nerve.

In 1795 Antonio Zucchi died. His health had been precarious for some time; physical weakness had of course been responsible for his decision to return to Italy, quite apart from his wife's desire to settle her father in a warmer climate. In Rome and Naples he had still been able to work: painting or drawing on the horizontal stopped his hand trembling, and he did a number of pen-and-ink and watercolour sketches. But his true *raison d'être* after their marriage had been to assist Angelica. When Zucchi approved her ideas, Rossi says, she worked with more confidence. It was an arrangement that made her comfortable and gave her a sense of security. He was a less gloomy man than Goethe's disparaging remarks suggest, and even the unforgiving Mariane Kraus was eventually won over by this 'surprisingly old' husband when he showed her some of his drawings and gave her paper to do copies on.[17]

He died after seventeen days' illness, during which his friend Cardinal Spina, who had been acquainted with the couple since the 1780s, stayed constantly by his side. Angelica's grief was intense. To an unknown correspondent in England she wrote: 'I suffered and am still suffering the greatest grief – to see myself deprived of him whose life was dearer to me than my own'.[18] She told her London agents Kuliff and Grellet of 'the misfortune, the irreparable loss which the death of

my worthy husband, friend and best comrade has dealt me, but it was the will of God, to whom we must submit'.[19]

This does not sound like routine regret. However great the temptation may be to see Zucchi as a superannuated comic character, a Pantaloon from the *commedia dell'arte* acting as a gloomy foil to the young sparks around him, the facts do not encourage it. He was a highly cultivated man and a caring partner, whom Angelica missed sorely and grieved to be without. Although before his death she had invited her relative Johann Kauffman to come and live in the household and take over the management of some of her day-to-day affairs, Zucchi was irreplaceable.

Because compiling the *Memorandum of Paintings* had essentially been his task, it is difficult to determine exactly how busy Angelica was over the following years of unrecorded work. There was certainly a tailing-off in comparison with her busiest days in England, but depression, ill health and advancing age were not the only causes. Consumer demand was beginning to decrease, and Angelica's productiveness was anyway affected by her acute worry over the political situation in Europe.

In 1797 she exhibited for the last time at the Royal Academy, showing the so-called *Portrait of a Lady of Quality*. Napoleon's campaign in Italy, which had begun the previous year, brought invading troops to Venice and the start of the plundering of artistic collections through which he intended to furnish French galleries and museums with foreign masterpieces. On 20 January 1798 the French army marched on Rome, where the military command had orders to set up a republic, though the grand entrance was reserved for 11 February. Angelica and Johann both felt threatened. He wrote on 30 September 1798 to a Bregenz Woods relative:

> people are leaving Rome when they have another refuge. We too would certainly not still be in Rome if we knew of another safe place, but everywhere is touched by war [...]. The Pope is still in the monastery near Florence, but in a pitiable state of health. My cousin is well, but constantly made impatient by the wearisome uncertainty of things.[20]

In general the Romans failed to react much to the invasion, greeting

the invaders with a mixture of mild curiosity and gloomy stupor.[21] But Angelica was seriously troubled. High inflation had caused a dramatic fall in the value of her investments and induced in her a state of intense (if needless) anxiety. She felt paralysed at the sight of her familiar world collapsing. Cornelia Knight remarked in a letter that

> The foreigners who were obliged to remain at Rome were naturally anxious to obtain correct accounts of what was passing elsewhere. Of this number was the excellent Angelica Kauffman, who was civilly treated, however, by the French, as they rather paid court to artists, though one of their generals and his aide-de-camp made her paint their portraits gratuitously, and all the pictures they found in her house belonging to Austrians, Russians or English were carried off by them. These were tolerably numerous, as there had been for some time past no means of forwarding them to their respective destinations.[22]

When Cornelia and Angelica corresponded about the revolutionary wars, they did so in a kind of pictorial code: the French were referred to as landscape painters and the English (paradoxically) as historical ones. Nelson's sobriquet was Don Raffaell. But, Cornelia notes,

> I recollect being puzzled how to inform her that our fleet was gone to Malta, until I thought of referring her for the subject of 'the picture' to a chapter of the Acts of the Apostles, well knowing that the book in which that island was mentioned was not likely to be opened by the inspectors of the post.[23]

She had been wrong to state that Angelica was forced to paint one of the French generals, Lespinasse, for nothing. Angelica was grateful to him for having spared her the billeting of soldiers, and willingly gave him the portrait. The same year, also apparently without compulsion, she started on a painting of Achilles for the revolutionary soldier and politician Paul Barras.

But she continued to feel haunted by the loss of her hard-earned money, or the threat to its security. A letter of 12 October 1799 paints a dismal picture of her impending poverty, and in the same month she wrote to tell Forbes that circumstances obliged her to accept his

advance of half the sum agreed for the picture of *Religion* that he had commissioned three years before. Her conviction that war was inimical to the flourishing of the fine arts explains much of her melancholy in the years following Zucchi's death. As early as June 1790 she had written to her old friends and patrons the Salis-Marschlins family:

> people are still living peacefully here, but in Naples very gingerly, in Tuscany a little unsettledly. A brief period of time will decide whether we are going to have war or peace. I pray in the name of all the arts for peace, in whose lap the arts rest, as well as the fates of so many people.[24]

And a year later she told Anton Metzler:

> The French nation is unfortunately creating unrest throughout Europe. God save us from an all-out war, and give all of us what is for the best, for everything is at His disposal, and He is a merciful father.[25]

It is, however, undeniable that when war came she was spared many of its adverse consequences. She certainly suffered delays in payment, partly because communications with London – where many of her investments remained – had broken down, but she was still wealthy enough to survive.

Feeling impotent to change the course of world events, she continued to take refuge in pious platitudes. On 6 January 1798 she wrote to Metzler about occurrences 'which could give our enemies cause to create great misfortune, but with prudent conduct – and especially God's protection – we shall be safe from greater misfortune'.[26] By the following year she was less sanguine. In a letter of 12 October she wrote of the prospects facing her as gloomy beyond description, and claimed to have sustained 'stupendous' losses.[27] At an age when she might have hoped to enjoy a little comfort and ease, she was being forced to work harder than ever; the whole state had been 'plundered of all that is valuable in every branch'. At the end of the letter, however, she recollects herself, remarking that 'a resigned mind is able to endure the distress of this world'.

Quite how resigned she felt is debatable. She resented the

revolution for solid professional reasons, despite painting some of its leading figures with as good grace as she could muster. It was natural that her attitude should resemble that of conservative (women) artists generally, rather than the philosophy of those who stood on the left wing of politics. Louise Vigée Le Brun was a kindred spirit in this respect, though she had long since moved from Italy to Austria and then Russia. The pro-republican painter Adélaïde Labille-Guiard, on the other hand, would have seemed profoundly unsympathetic to her, despite the fact that she too had had royal patrons. (Labille-Guiard contributed her own money to a munitions fund, supported the revolution financially in other ways and did several portraits of representatives at the Assemblée nationale.)[28] Napoleon might never make a beggar of Angelica, but she loathed him for upsetting the decorous order of society in which she flourished. The Grand Tour had died, people were fleeing from Rome, and she was left with little to rejoice over except the fact that she had had the comparative good sense to leave her dowry in London.

The awareness that she was living through momentous times, as likely to stimulate acts of heroism as to cause economic collapse or usher in a new and unwanted ruling class, does not seem to have encouraged her to return with new spirit to history painting; her efforts in this respect remained distinctly unrevolutionary. The works of David and his fellows might celebrate history in the making, but Angelica was prepared to do little more than paint a new version of her 1765 picture of Coriolanus. As well as being beseeched by his mother and wife to stop waging war against his people, her new Coriolanus has to face the tears of his young son.[29] The earlier version had probably excluded the latter, usually included in Coriolanus pictures for emotive reasons, in order to sharpen the appeal to patriotism: Coriolanus is to remember that he is a Roman, not a father. But the older and apparently more sentimental Angelica softens the scene in accordance with her conviction that sentiment should take priority over politics. Kotzebue could not forgive her for doing so, complaining that she was devoid of feeling for the heroic – 'the departure of Coriolanus is a very delicately depicted scene from a French tragedy,'[30] he wrote, as though Corneille had not built a reputation on depicting heroes facing agonising dilemmas, or Racine on presenting the extreme and destructive effects of human passion. Catherine Wilmot, on the other hand, found the

picture extremely beautiful in design as well as execution,[31] and Friederike Brun enthused over it. Both, evidently, were as unabashed as Angelica at betraying a stereotypically female response.

One heroic portrait Angelica did in or around 1800 was of the kilted Colonel Alasdair Ranaldson MacDonell, fifteenth chief of Glengarry, who after graduating from Oxford was visiting Rome with his great friend Lord Montgomery (whom Angelica would also paint). He stands as a proud young man of impressive physique and noble countenance, wearing full Highland dress of Glengarry tartan with an ermine sporran, and managing to look as proprietorial of his Italian surroundings as anyone so visibly foreign could expect to do. He had an intense, volcanic temper that earnt him the name Alexander the Untamed (Alasdair Fiadhaich), and after a duel in 1798 had actually been tried for murder. Sir Walter Scott is said to have used the more favourable features of Glengarry's character for Fergus MacIvor, the hero of *Waverley*, and wrote of him in his diary on 14 February 1826:

This gentleman is a kind of Quixote in our age, having retained to their fullest extent the whole feelings of clanship and chieftainship, elsewhere so long abandoned. He seems to have lived a century too late, and to exist, in a state of complete law and order, like a Glengarry of old, whose will was law to his sept [clan]. Warm-hearted, generous, friendly, he is beloved by those who know him, and his efforts are unceasing to show kindness to those of his clan who are disposed fully to admit his pretensions. To dispute them is to incur his resentment, which has sometimes broken out in acts of violence which have brought him into collision with the law. [...] Strong, active, muscular, he follows the chase of the deer days and nights together, sleeping in his plaid when darkness overtakes him. The number of his exploits would fill a volume ... [32]

He wore Highland dress on every occasion, and continued living as his ancestors had done. When he was visiting friends in the Highlands he would march from Invergarry in all the panoply of chiefship, with eagle's feathers in his bonnet, followed by a retinue of retainers – 'Glengarry's tail' – and a personal bard dressed in full professional regalia to deliver an oration at the end of the journey. Politically he was

not a strong partisan, although he served George III loyally. For this and other reasons he would be derided by the Gaelic poet Sorley MacLean, who called him one of the 'Anglicised land-capitalists with Gaelic names who all but destroyed their blood-kindred in order to fill their own pockets' (partly by introducing the sheep farming that led to the eviction of cottars and smallholders, and hence caused a wave of migration). 'He made a destruction of the clan Donald,' MacLean added; but he was said to have the heart of a prince, and his birthday was always celebrated with Highland games. He lived in such style – a style necessary, he thought, to the upholding of the family's honour – that his estate was left much mortgaged and encumbered at his death, forcing his son to dispose of it and emigrate to Canada with his wife and clan. Glengarry had died suddenly and accidentally, unlike Fergus MacIvor. In Scott's novel this feudal chieftain perishes steadfast to the Jacobite cause, his loyal clansmen by his side; but Glengarry, his enemies said, died sold to the Hanoverians, whose new order of rationality and domestic concern was antithetically opposed to the old feudal way of life in Scotland, with its powerful passions and fierce loyalties.

Encounters such as her meeting with Glengarry stirred Angelica's memories of the life she had led between 1766 and 1781. Her 1801 letter to Cornelia Knight blends the kind of heartfelt regret she felt at the loss of her old personal world with an elegiac lament for her past life in England – flattering to her correspondent, but probably only half-sincere:

> Who more than myself feels the loss of the friend I used to see with so much pleasure – oh! Often do I remember the happy moments I passed in your society. But these happy times are gone, I fear forever – this place is too much altered in these later years – and what other changes we may yet be subject to I really do not know. I assure you, my worthy friend, my desire of seeing dear England again is more than you can imagine, and was I to follow the inclination of my heart I would set out for that dear country rather today than tomorrow; but when I consider the great distance, the difference of the climate, the great expense it requires only to live tolerably comfortable, I find myself in a

perfect bivium. I have in these unfortunate times with many others sustained great losses. I am passionately fond of my profession and flatter myself with continual study and practice to know a little more about the matter than ten or twenty years ago – I occupy myself with the same enthusiasm and real pleasure, but [. . .] one must either possess a good fortune or live in great activity and be sure of great encouragement, which in the present time perhaps may not be expected.[33]

It seems highly unlikely that Angelica was ever tempted to return to England, the 'country which I love as I do my own home', but her discomfiture in early nineteenth-century Rome is clear enough. 'Ah! These happy times are over. At least for the inhabitant of this hill, a certain gloom still covers this once happy sky.'

She may have been depressed, but she was not finished. In early 1790 a rumour spread that she had died, and Johann Kauffman refers to it in a letter of 15 February to Metzler, adding that the story had travelled so quickly from Rome to London, Schaffhausen and Lucerne that 'Monsieur Blanchard must have transported it in his hot air balloon'.[34] Fanny Burney had obviously heard the rumour, since she mentions having learnt that Angelica was doing illustrations to her novel *Evelina* for the Empress of Russia, but that if the artist was dead that was impossible. Though she was not dead, Angelica was certainly not well. In the spring of 1802, according to Rossi, she was suffering from a heavy cold in the chest, and people again feared for her life. She was treated quickly and seemed to recover. Rossi calls her illness a sluggishness of the humours circulating in the lung region, and lymphatic 'blockages' – that is, probably pneumonia.[35] Her recovery, he adds, was not aided by the ongoing political upsets and civil disorder.

It was at about this time that the young Robert Dalrymple also commented on her poor health; but his diary describes them as meeting regularly (he was sitting to her for his portrait) despite her progressive physical weakness:

March 6 1802. I called on Angelica Kauffman with the letter that Lord Northwick had sent me. This lady is a paintress and I fancy one of the first geniuses of Europe in her profession. She seems to be about 65 years of age, is remarkably mild and gentle in her

manner, and speaks English perfectly, having been fifteen years
in our country, where she met with the most flattering encourage-
ment.

March 30. On my return from the Monte Cavallo, I sat an hour to
Angelica Kauffman for my portrait. She thinks my likeness will be
a very strong one. She is a most amiable woman, and the more
one sees of her the more one esteems her. We always converse in
Italian, which I now understand tolerably well. When sitting for
my portrait she wishes me to talk during the whole time, and
upon such subjects as interest me most. By this means the
countenance becomes more animated and of course can be
drawn to much greater advantage. Angelica Kauffman has done a
beautiful likeness of the Princess Labanov. The sight of this was
what in fact induced me to sit for my portrait.[36]

(Matthisson remarks that Angelica's usual practice was to have sitters
read poetry aloud to her as she painted, particularly Klopstock's
works.)[37]

The likeness of Dalrymple's portrait was confirmed by other
observers. On 26 April he wrote:

Spent the evening with Angelica Kauffman. I like this lady more
and more every time I see her. I sat to her for my portrait this
morning for the last time. It is so strong a likeness that everybody
speaks of it. A German addressed me last night at the ball saying
that though he had never seen me before, he was sure he must
have seen my portrait at Angelica Kauffman's.

But the following month brought bad news:

May 6. Called on Angelica Kauffman in the evening. Poor
woman, she was yesterday seized with a fever, and she is worse
today.

By 18 May she was getting better, though Dalrymple did not see her
when he paid a chance visit.

May 29. Called upon Angelica Kauffman; she has had a second

fever and is very thin. She seems much flattered by my attention in calling upon her, and making such frequent enquiries.

June 3. Paid a long visit to Angelica Kauffman. She is getting better, and able to walk about the room.

June 5. In the evening I called and took leave of Angelica Kauffman. She is a most amiable and agreeable woman, and I have been infinitely happy in her acquaintance. We were mutually sorry to part, the sentiment we entertain towards each other being founded on the sincerest friendship and esteem. She is to finish my portrait as soon as she is able, and to forward it to England through Mr Hoare. I paid her 40 sequins for it (£20) and 10 crowns (£2 5s 5d) for the frame.[38]

The intensive work that friends had once counselled as a means of distracting Angelica from unhappiness now appeared dangerous to her precarious health. Doctors advised her to stay away from her easel while she was convalescing, but she hated being idle. She suffered from neglecting her 'beloved art', and was tormented by the thought that she was not working enough – less because she was failing to meet deadlines than because she was not justifying her artistic existence.

When a trip was proposed, on the grounds that she needed a change of air and scenery, her friends worried again. Was this her doctors' way of saying that her condition was beyond hope, that the sick should be distanced from the world and from medical care when recovery was impossible?[39] If so, they were wrong. Angelica left Rome in mid-July 1802 and wrote from Florence, where she paused for a few days' rest, that she was feeling well. She proceeded via Bologna to Milan, and thence to Como, where she was 'enchanted' by the situation and the purity of the air. Feeling instantly recovered, she determined to spend all of August there.

She met many cultivated people in Como, and enjoyed an agreeable social life. Johann Kauffman, who had accompanied her, left to see his relatives in the Bregenz area, promising to return later. During her stay, according to some recollections that Angelica scribbled onto a set of cards, she was 'nearly pierced by love's arrow'. Walking with some companions amongst shady groves, she went up to a 'sleeping Cupid', who recognised her upon awakening despite her grey hair. He followed her at all speed and shot his dart, which narrowly missed. The

revenge, she explains, was for the failure to hit her on her first visit to Como as a girl. The second occasion may be connected with a trip by Robert Dalrymple to the area.[40]

From there she continued her journey to Venice, where she stayed twelve days and visited her Zucchi relatives. Travelling through Padua and Bologna she returned to Florence, and then via Cortona and Perugia to Rome. She arrived on 30 October, after an absence of three and a half months, and was greeted with joy by her friends. A feast was arranged for her in the country to mark her recovery; essays celebrating her life and work were published, and allegorical copper-plates engraved in her honour.

The King and Queen of Sardinia, Victor Emanuel and Clotilde (the sister of Louis XVI), visited her during a brief visit to Rome. They praised her work, and Angelica felt flattered by the regard of this very pious couple. It is highly improbable, however, that they can have wanted to commission their portraits from her or anyone else. About ten years earlier Louise Vigée Le Brun had met them in Turin, instructed by Clotilde's aunts Madame Adélaïde and Madame Victoire that their niece wanted to sit to her, but had been politely brushed off:

She told me that she was sorry to contradict her aunts, but that having renounced the world altogether she could not allow herself to be painted. What I saw of her, indeed, seemed to accord perfectly with her words and her decision; this princess had had her hair cut; on her head she had a little bonnet which, like her whole costume, was as simple as could be. Her thinness struck me all the more as I had seen her at a very young age, before her marriage, when she was so enormously plump that in France she was called the Fat Madam. Whether too austere a religious faith, or the grief which her family's misfortune caused her, had brought about this change, the fact is that she was no longer recognisable. The King joined her in the drawing room where she received me; this prince was so pale, so thin, that both were pitiful to see.[41]

Angelica did not eschew further portrait commissions, but her thoughts were turning to other things. In April Catherine Wilmot was struck by her extreme frailty:

She allows us to sit with her often in the mornings, as her delicate state of health makes confinement necessary; her appearance has so much more of mind than body, that one forgets she is more than half way past into another world, which seems anticipated in her countenance, though viewed through so much fancy that genius counteracts her piety, and in advance she seems a mythologic heaven reflected in her imagination [. . .]. The pale transparency of her complexion, one attributes less to her declining health than to the idea that no other light has ever shone upon her but the silver beams of the moon.[42]

Her influence as an artist, Wilmot said, had been Promethean, and even now sparked others into life. The mood she conjured up in her visitors was elegiac, like that inspired by plaintive music, and all worldliness seemed to have left her. Even her beloved art no longer seemed, at least in company, the focus of her being; or perhaps it was rather that Angelica's old modesty had simply increased with advancing age:

She speaks when you like of her profession, but it is so secondary an object in one's visit to her house that we forgot to ask her for her pictures until the third time we were in her company.

On 17 June 1803, 'sound in mind, sight, hearing, with all her mental capacities, though ill in body and confined to bed', Angelica drafted a first version of her will, which divided her possessions between her relatives, acquaintances and servants. She emphasised that she was entitled to dispose of her fortune as she wished, since

everything I own I have gained through hard work and effort, having devoted myself from my tenderest childhood to the study of painting, it is for me of my own free will to dispose and divide the fruits of my labours and show beneficence towards my relatives.[43]

Later on, on 23 November 1805, she would sum up her position to Anna Amalia, her tone one of resignation rather than bitterness:

306

I have lost many good friends over a few years – and also suffered much with everything that has been going on here, many days full of worry, but these too have passed by, if not without a weakening of my health.[44]

She decided to burn her letters, explaining that she did this because she disliked the thought of 'quiet passages of friendly communication' being published. This may anticipate her objections a year later to the peddling of unreliable accounts of her life. It is very likely that early acquaintance with social scandal had made her unusually sensitive to loose talk.

An anonymous notice in the *Italienische Miscellen* of 1806, probably inserted by a friend of Angelica's at her behest, complains that an article on her (by Sturz) in a volume published in 1797, the *Manuel des curieux*, is riddled with inaccuracies:

It is to be wished that those who write about people who are still alive would apply to them for information, and take care not to show them in a false light by credulously accepting fabulous reports and inventions. Whoever is exposed publicly in this way really has the right to demand truth, if not discretion.[45]

The *Manuel*, it adds, is wrong about the date of Angelica's birth, the place of her marriage and her second husband's first name. Was any of this so-called information worth giving? Angelica preferred to be remembered in public by her public achievements. As for friends and relatives who knew her privately, they could not want to know more about her than she herself had thought it right to tell them.

Although she seems genuinely not to have regarded her posthumous fame as involving anything other than her work, she may have welcomed the proposal of a relative by marriage to write her life. Rossi based his account on the material that Giuseppe Zucchi had assembled and which his nephew Dr Francesco Zucchi was deputed to complete, as well as on Angelica's and her father's surviving papers. He was a close friend whose involvement in the task she could trust. But her stock of letters was hers alone, and destroying it was a final act that she undertook in full *connaissance de cause*.

It was the same desire to be known fittingly by posterity that led her

to stipulate that only her 'good' drawings should be preserved after her death. If she had any inkling of the fanatical interest that all aspects of her production would provoke – the detailed scrutiny of every scribble, every draft, every sketch, in the hope that they might tell her admirers something new about her – Angelica did not betray it. She wrote no self-serving memoirs, as Louise Vigée Le Brun did towards the end of a much longer life, though it may be assumed that she discreetly angled some of the information transmitted to Zucchi and Rossi. On the whole, perhaps paradoxically for such a tireless self-portraitist, she deprecated the discussion of her art in terms of her person. To want to see the woman behind the art, on the other hand, was a different kind of desire, and one that she made little attempt to thwart.

Between 1803 and 1805, according to Rossi, she continued to work hard, though the vigour she had regained from her travels in 1802 began to wane. She carried on with countless portraits from life, of beautiful women in oriental garb, of an English lady suckling her child, of any member of the *beau monde* staying in Rome who wanted to sit to her. She did her lost sketch of the indefatigable Germaine de Staël, exiled from France by Napoleon and enjoying a stay in Italy from December 1804 to June 1805.

Germaine was gathering material for *Corinne* and finding the Eternal City a touch disappointing. She wrote to Duke August of Saxe-Gotha:

> As for Rome, it offers a dreamy melancholy pleasure, and certainly most of those who come here get secretly and nobly bored, for the pleasure is not a vulgar one. Society amounts to virtually nothing [. . .] – an oriental indolence and flexibility of character which diminishes the value of all affection prevents one from becoming closely involved with it.[46]

Angelica, in turn, probably found Germaine rather overwhelming, with her unstoppable talk, emphatic presence and general loudness. For a modest, withdrawn woman, this blazing egocentric (a writing machine, as her more muted fellow-novelist Isabelle de Charrière called her) would have seemed as engulfing as the Vesuvian lava she describes so floridly in a climactic scene of *Corinne*, though in temperate moments

her celebrated kindness and goodness would surely have won Angelica over. She was no less intellectual than Angelica, but she had little or no feeling for the visual arts. Perhaps she intimidated Angelica; probably she foisted herself upon this delicate sensitive creature (as she had thrust herself upon Fanny Burney) like an unwelcome guest; and yet Angelica was always keen to meet interesting and cultivated people. Possibly a sketch was the least she could get away with in Germaine's company, and she attached too little importance to the sitting to bother about preserving what it had yielded. Equally, though, she might have regarded it as worth no more and no less than her earlier quick 'heads' of Roman friends like Piranesi and Reiffenstein. Or could she simply have been too tired to pursue her efforts, her uncertain health weakened by mere proximity to Germaine's torrential eloquence?

Yet in 1805 Angelica did begin a remarkable portrait of Crown Prince Ludwig of Bavaria, which she would finish just before her death in 1807. It was Ludwig of whom Germaine remarked to Juliette Récamier that he possessed wit and feeling trapped inside pathetic organs – presumably a reference to his stammer and deafness.[47] During his sittings the Prince, who was already receiving an artistic education in Rome from Maler Müller, was so fired by his conversations about painting with Angelica that he resolved from then on to assemble outstanding works for the Bavarian collections. After Angelica's death he consulted Müller about buying some paintings from her estate, though he eventually decided against it.[48] Angelica had directed that the money raised from selling the pictures should go to a foundation for the poor of her homeland, but she had initially left them to Johann Kauffman. According to Müller, however, she had intended to give Ludwig replicas of *David and Nathan* and *Christ and the Samaritan Woman*, and death alone had prevented her from delivering them personally.

Ludwig sat to Angelica, as was usual, only long enough for her to capture his face and expression. Since she wanted to depict him in ceremonial garb, she asked Müller to arrange for her to be sent drawings of Ludwig's costume adorned with the Order of St Hubert. When these proved insufficient to her purpose, the Bavarian ambassador to the Vatican, Bishop Kasimir von Häffelin, requested that the original braid used for decorating the tunic be despatched to her. Apart from illustrating the care she often took over particularities of dress,

the episode shows how imbued Angelica remained with the spirit of the *ancien régime*. Ludwig may be painted in an Empire chair, but the courtly-androgynous flavour of the composition breathes pre-revolutionary style to its last detail.

The full-length portrait shows the Crown Prince with hair foppishly curled, mouth slightly pouting, and body resplendent in its black, red and gold uniform. It is a virtuoso performance, with the sitter's attitude expressing *désinvolture* and all the elegant arrogance of majesty. He wears the Order of St Hubert with pride, but also with the intimation that such an honour is no more than his due: his father Elector Maximilian IV Joseph, as Grand Master of the order, had passed statutes establishing the centuries-old institution as the most important one in Bavaria, and Ludwig assumes its badge as his right.

Not unexpectedly, his face has been considerably prettified. The real Ludwig had an outsize nose and a pockmarked complexion, but in Angelica's portrait all the visible blemishes have been smoothed over: his haughtiness is mingled with charm and an ambivalent physical attractiveness. She has also included a flattering allusion to his burgeoning interest in classical antiquity by depicting him against a background showing the Colosseum and the foothills of the Albano mountains. The famous Medici vase that she had introduced into her portrait of Lord Berwick stands on a pedestal to Ludwig's right, and he drapes an arm over it in an almost proprietorial way.

Despite her age and tiredness, Angelica relished doing this commission. Her enjoyment is evident in the virtuoso handling of the black silk, the white lace of the jabot Ludwig wears, the gold-embroidered trimmings and the white feather in his hat. The trouble she took over the details paid off handsomely, for this swansong is one of her most gorgeous and accomplished performances.

Her painting of the dimly outlined Albano mountains acquired added meaning after Angelica spent time there in 1806. On 20 September that year she wrote to George Bowles:

I find myself in this delightful place since August 20th last. This change of air was necessary for the better restoration of my health, which has suffered so much by the long lasting rheumatic pains suffered in my breast, but now, thank God, the air has been

so beneficial to me that all my complaints are vanished and my spirits recovered.[49]

But long stays at Tivoli and Castel Gandolfo this year and the following one did little to help, and even she began to wonder if she was suffering from the accumulated effects of years of overwork. In September 1806 she wrote from Albano:

Many years' study and close application are the cause for the indisposition I now and then suffer. Yet my passion and inclination for the art are as vigorous as ever, and it is with force [sic] that I am, by my friends, now and then taken away from my studies for a few days in the country, else I should never quit the same.[50]

This was nothing new, of course; as early as 1774 John Morgan had told Pelham that Angelica's health was being run down by her constant industry. But she knew only how to work to her limits and beyond. She saw no purpose in saving herself for another day when the impetus to continue made itself felt so imperiously in the present.

Still she could not shake off illness. At the beginning of 1807 she was sure that she had not long to live: her pulse was high and her body constantly racked with coughing. Being unwell made her deeply depressed, though friends tried to cheer her up. Even laughter sapped her strength, though; her face became almost cadaverous, only her eyes retaining the vivacity that her whole being had once displayed. Occasionally the relief she experienced after a violent fit of coughing gave her hope, but it was soon dispelled.[51]

In October she took to her bed and did not get up again. On the 28th Müller wrote to Ludwig:

Madame Angelica is dangerously ill; her friends call the condition which has gripped her a violent fever of the chest, but generally it is believed that she is suffering from consumption. I visited her yesterday; I am afraid that this worthy woman and estimable artist may have given art her swansong with the magnificent picture of Your Majesty she finished recently.[52]

As she weakened, Angelica was twice given the holy sacraments, the second time just two days before she died. She also asked Johann Kauffman to read aloud from Gellert's *Geistliche Oden und Lieder*. When he began to read the ode on the dying, Angelica repeated her original request for the ode to the infirm,[53] but it was clear that she was slipping away.

She died on 5 November 1807, after being confined to bed for about twenty days, tranquil and with all her mental faculties intact.[54] There were no children to mourn her as she had mourned Johann Joseph, and according to a letter of 19 December from Müller to Ludwig her death caused less of a stir in Rome than might have been expected:

> The death of our estimable Angelica has unfortunately ensued only too rapidly. Her passing would have made a deeper impression on the minds of art lovers under any other circumstance. But the news of the sale of the priceless collection of antiquities which were kept at the Villa Borghese has impressed the general public here too much, and makes it impossible for them to feel any other pain.[55]

(Prince Camillo Borghese had sold the famous collection to his brother-in-law Napoleon.)[56] But if it seemed almost as if Angelica was being upstaged in death as her modesty and gentleness had sometimes threatened to sideline her in life, the impression was erroneous. Just as her reserve never led to her being ignored in the world, but instead flattered and attracted those she dealt with, so contemporary sources make clear that her death was very far from leaving the capital indifferent. Her will had stipulated that on the day it occurred, or immediately after, a hundred masses for the salvation of her soul should be said, accompanied by almsgiving to the poor, and that this was to be repeated over the following days.[57] These were the spiritual marks of respect, but the funeral itself was a lavish affair that seemed to sum up all the paradoxes of this retiring woman's worldly fame.

Her friends from the Accademia di San Luca, the Academy of France in Rome (whose director, Guillaume Guillon Lethière, had shown her every attention when she became bedridden) and the Academy of Portugal made up the funeral train for this 'Raphael among women'. At ten o'clock in the morning her body was

accompanied by two very numerous brotherhoods, fifty Capuchin monks and fifty priests, to its final resting place in the parish church of S. Andrea delle Fratte on the Via di Propaganda, where Zucchi was buried. The bier was carried by some of the brotherhood, and the four corners of the pall by four girls 'properly dressed for the occasion'.[58] The great train of human mourners, an 'immeasurable concourse' of Romans, was supplemented by the highly regarded pictures *David and Nathan* and *Christ and the Samaritan Woman*, carried in triumph by Academicians and virtuosi, along with a model of Angelica's hand carved in marble by Canova.

At Angelica's request, she was laid beside her husband in the third small chapel there, though later on Zucchi's body was removed on the instructions of Angelica's executors to a grave nearby. It was they, too, who had resolved to make the funeral itself an elaborate and impressive occasion. Angelica's will had left the details of the ceremony to be settled by them, and it would perhaps have seemed disconcertingly grand to a woman who had never, except in her idealised portraits, been happy practising self-advertisement. But her old friend Canova was master of ceremonies, and he had decided to make the event unforgettable.

Other honours followed. On 23 December Giuseppe Bonomi's homage to Angelica was read out by Benjamin West, the President of the Royal Academy, to the assembled Academicians in London. Peter Kauffman received permission in March 1808 to have his portrait bust of Angelica placed in the Pantheon, where it was installed in a magnificent ceremony. In 1809 the friends and heirs of this 'great benefactress of the poor' and 'ornament of her native land' had a marble tablet bearing an epitaph to her set in the wall of the church at Schwarzenberg. Later on the bust that Hewetson had done of her in Rome during her lifetime, and which had passed to Johann Kauffman on her death, was left to the church too. Friederike Brun, finally, expressed her grief at Angelica's death in a poem, 'On Angelica's Urn':

As gentle as the blue ripeness which scents autumnal grapes
Was the elderly woman, maiden-like with her silver hair!
No, you do not age, you ripen like golden ears of wheat,
And your head is bowed beneath the weight of the fruit.[59]

313

It is inept even in the original, but Germaine de Staël, who requested a copy of the poem, said that it was the first piece of writing to poeticise old age.

Of course not all of Angelica's last years had been poetic. She had continued to be tormented by the dwindling of her investment income and had taken to living more frugally than before. She remained fearful of not being able to provide as generously as she had hoped for her poor Bregenz Woods relatives, and must have been confirmed in her belief that she had acted rightly in sending the idle Joseph Anton away after one and a half years of living with her. She had never forgotten what she regarded as her duty to family members who were genuinely in need.

Her will made provision for the usual gifts of bed linen, bedding and clothes to her servants, provided that they were still in her service when she died, and presents of money.[60] She left to Dr Francesco Zucchi a legacy of 100 gold ducats, all her English books and a few French ones, the clock she had brought with her from London and two globes she had also purchased there. Some other things in her possession – silver, paintings, frames and figurines – were given to Zucchi to dispose of as he wished. His daughter Angelica and his wife Elisabetta each received a ring.

The stocks and shares deposited in a London bank were left to Rosa Bonomi. From the interest they yielded Rosa was to pay her husband £100 per annum for the trouble he had taken looking after Angelica's business affairs. Rosa also received her few remaining jewels – some bracelets made of oriental pearls, 'not very big but very fine', clasps made of miniatures of her father and second husband, and diamond earrings, necklaces and hair ornaments. Besides these, she inherited Angelica's tea service and some silverware.

Other stocks and securities passed to her cousins Casimir and Johann and to her nephew Joseph Anton (with whom she had seemingly become reconciled), with £100 of the interest they had generated going to her London friend Daniel Braithwaite. Her property in Austria, whose value was estimated at about 17,790 florins, was to be divided up between the cousins who were domiciled there and Rosa's brother, Johann Anton Florini, who lived in Morbegno. But there was nothing for her half-brother Joseph, and he later complained bitterly at the fact.

Johann Kauffman, the companion of Angelica's last years, inherited all her German and Italian books, her copperplate engravings, her Paris-made mannequins, her drawings and the portrait Reynolds had done of her in London, along with the paintings by her found in her studio when she died. These he was instructed to sell as advantageously as possible (at prices that potential customers like Crown Prince Ludwig judged to be too high) and share the proceeds with Casimir or his neediest sister. The interest on the sum realised by the sale of her own collection of paintings, from Titian to Canaletto, was to be paid to the impoverished families of her male and female cousins. Her Roman apartment on the Via Sistina was put up for rent. For six years it was used as a *pensione,* and changes to its internal structure were made. Nowadays Via Sistina 72 is an expensive international hotel, and no trace of the decoration and fittings that graced it in Angelica's day remains. Goethe's pine tree, as we know, did not long survive her.

Yet her reputation in posterity stood her in good stead. Pope Pius VII exempted her estate from all inheritance tax and death duties in recognition of the 'honourable endeavours' through which it had been acquired. A cabal of jealous artists may once have spoilt Angelica's chances of obtaining a papal commission, but she triumphed over them from beyond the grave.

Conclusion

Was she really worth it? The brilliance of her reputation has undeniably dimmed since the century when the whole world was Angelicamad, and criticism of her accomplishments has continued to be freely voiced. She slipped into oblivion after her death in 1807, seeming too fey and classical to the Romantic era and too playfully insubstantial to the solid age of bourgeois materialism. John Constable thought her symbolic of everything that should be rejected in art, and critics contemporary with him said that the English school would make no progress until she and her influence had been thoroughly forgotten.

Her history paintings remained as alien to British (if not continental) tastes as they had always been, and even her portraits appeared sketchy or lightweight in comparison with the brio of Lawrence and the pictorial mastery of David and Ingres. The more dramatic and emphatic West became technically more proficient than she had ever been, even if his work was less likeable; Reynolds could achieve more brilliant effects, and Gainsborough, although he resembled her in his painterliness, possessed more genius. Romney, whose anatomical ignorance was never lampooned as Angelica's was, grew more accomplished in other ways, and Dance's figures were simply better constructed.

Then there is the literary verdict. Anne Thackeray's *Miss Angel* presents a typically Victorian view of her as over-praised and over-loved, an artist whose 'absurd' draughtmanship provoked mockery and condescending laughter. Nineteenth-century German critics were almost all antagonistic, regarding Angelica as a traitor to the fatherland – whatever that was taken to be – because of her preference for England and Italy, although the stream of *biographies romancées* in German over recent years suggests that that antagonism has passed. Even her best-known twentieth-century biographers in English found it hard to rank her highly. Manners and Williamson announced in 1924

that 'no-one would call her a great painter', although she had some
saving graces:

> By reason of her complete acquiescence in the artistic taste of her
> own period, and her skill in rendering it in charming fashion, and
> with bright, fresh colour, she made a mark upon the art of that
> time, which could be recognised and appreciated down almost to
> our own period.[1]

(The 'almost' may have seemed appropriate in the 1920s, but the late
twentieth and the early twenty-first centuries have viewed the matter
differently.) The daring of Angelica's decorative painting was often
interpreted as weakness, as though the true aim of art could be
attained only in the elevated academic genres of history and mythology
– despite the continuing British enthusiasm for portraits – and as
though beautifying domestic interiors was by definition a minor
undertaking. Nor has much of her work remained sufficiently
accessible to guarantee her universal fame. Too many canvases are
hidden away in remote country houses; the vogue for decorative or
'furniture' prints has waned; and her designs for china and porcelain
have been cheapened by the production of innumerable fakes bearing
her name.

And finally there are the personality attacks, the assertions that
Angelica's fame rested on her ability to hoodwink a gullible public,
flatter susceptible patrons, overcharge grotesquely and seek professio-
nal advancement by underhand means. The bald statement that she
had got where she was by flirting was the most predictable of these
calumnies – Fuseli repeated it, Garrick half-suggested it (but surely
playfully) when he begged the young Angelica to 'leave [his] heart
alone', Farington gave it fresh currency and later critics damned her in
its name. Was there any need, in more broad-minded, less moralistic
times, to resort to it all over again? So it seems, for in the 1960s
Claudia Helbok was still wondering, precisely in the spirit of Manners
and Williamson, whether the reason why Angelica withdrew from her
collaboration with Ryland was her alarmed discovery that this
charming but unreliable man was married. There has, of course, been a
constant emphasis in art history on the attractiveness or otherwise of
female painters and the relation between their looks and the celebrity

they enjoyed: so in the later eighteenth and the nineteenth centuries commentators were puzzled by the success of Rosalba Carriera, a success unaccompanied by beauty of person and the feminine charms that had come to be the (dubious) passport to acceptance by the male establishment,[2] and Diderot's disabused assessment of the decidedly plain Anna Therbusch's chances of winning real favour in eighteenth-century France continues to ring unpleasantly in the ear. Conversely, Louise Vigée Le Brun was perpetually under suspicion of using her beauty as a ticket to worldly fame and fortune.

Setting such prejudice aside, how else should we look at Angelica now? 'She was of the time, and the time was made for her,'[3] said Flaxman. Yet Angelica is still remembered, while the other female founding member of the Royal Academy, Mary Moser, is practically forgotten. If Flaxman's statement, paralleling Fuseli's verdict on Romney,[4] still raises the question whether Angelica's talent was impressive enough to shine in other ages than her own, the fate that her works met with after her death might seem to suggest a negative answer. When Wanstead Grove, George Bowles's house, was sold around 1850 together with its art collection, the Kauffman paintings went to Lady Cockerell for a mere £500.[5] Since she was a cousin, however, this was obviously a family transaction that is unlikely to have reflected the commercial value of the work; and when, after the death of Lady Cockerell's grandson in 1879, the collection was again auctioned, some pictures – though not the histories – fetched relatively high prices. (The Earl of Rosebery, for instance, paid £850 for the portrait of Lady Rushout with her daughter Anne, whereas the picture of *Cornelia, Mother of the Gracchi* that Goethe had so admired was sold for only £47.)[6] A London dealer who had bought some of Angelica's works there got into financial difficulties that led to the compulsory sale of his house in Norfolk Street along with its contents, and on this occasion pictures by Angelica were 'sacrificed' for almost nothing, ending up no one knows where – though one was later found in a labourer's cottage in Devon.[7] Angelica herself might have been upset at this development, even if she had always approved of the fact that her art was available to the relatively poor in the form of prints.

In April 1808, within a few months of Angelica's death, Müller was telling Prince Ludwig about the extravagant notions then circulating in Rome of the Munich court's interest in acquiring Kauffmans.[8] Johann

Kauffman was asking 500 louis d'or for the two funeral pictures, a price so high that negotiations to buy them were speedily dropped. Two years later he wanted considerably less, but the works still remained unsold.[9] Rumour had it that Müller's enemies were accusing him of scheming with Johann to cheat Ludwig, though the facts scarcely support this contention.[10] What is clear is that Angelica's works seemed far from essential to the fledgling collector, however enthusiastic he had been about her portrait of him.

It was, as ever, the portraits and the charming mythologies that people wanted to possess. Angelica's ornamental work for furniture, walls and domestic fittings never really lost favour, but its popularity has spectacularly increased in our own time as that of the 'sweet antiquity' of the eighteenth century in general has done. Sufficiently modern-minded and pragmatic to absorb what she wanted from neo-classicism, wedded enough to *ancien régime* values not to want them swept away in a fit of high-minded politicised austerity, she was able to keep on proclaiming the value of her learned and decorative art in the most practical terms. Although she was the perfect artist for a world of ordered interiors and quiet gentility, such favour as her large-scale historical paintings enjoyed has waned as domestic spaces have shrunk and the taste for certain kinds of sentimental dramatic effect has lessened.

There can be little question, surely, that the experiment conducted by Reynolds, West, Barry, Angelica and others in educating the British to a liking for historical scenes was a failure. Whatever incidental interest Angelica's works in this genre possess, they do not speak as loudly as her *Winckelmann* and *Garrick*, her middle-period 'turquer-ies' of society women, her late studies of intellectuals and princes, and the whole glorious range of her self-portraits. Her conversation-pieces and decorative designs, the first so attractively human and the second so quintessentially Adamesque, effortlessly trump the histories, which are neither frivolous nor particularly decorative, and whose relative learnedness limits their general appeal to cognoscenti who are already aware of their remarkably innovative style.

On the other hand, it says much for Angelica's ambition and merit as an artist that she should have become a member of an academy on the strength of history paintings rather than portraits. All the other notable female painters of the time, Mary Moser, Louise Vigée Le Brun and

Adélaïde Labille-Guiard among them, were admitted either unspecifi-
cally or as practitioners of the lesser genres of portraiture and still life.
Many commentators, of course, thought that it was improper for
women to try their hands at 'serious' work at all, irrespective of their
success in doing so. Fuseli, who disliked Angelica's work – 'An attempt
to unite the most discordant contrasts of attitude with the most
tiresome monotony of features uniformly mark [sic] the performances
of this fair artist'[11] – considered that her sex as well as her art confined
her to 'mere negative excellence', and upbraided Mary Moser for
daring to step outside her own genre and rank with a picture on a
subject from Ovid's *Metamorphoses*:

> It is to be lamented that a decided talent should be neglected for
> unattainable excellence: to relax from flower painting in history;
> to neglect her own roses and lilies in order to make Atalanta
> stoop for a golden apple could enter only into the head of a
> female genius.

A more balanced view of women's art in general, and Angelica's art in
particular, would conclude differently. It would, for example, avoid
facile judgements on what is specifically feminine, an 'essence' that
often turns out to infuse art by men as well as women. Thus softness,
grace and roundness of form characterise rococo art in general
irrespective of gender, and stridency of colour (or harmony of tone) is
found on both sides of the sexual divide. Androgyny too, that familiar
quality of Angelica's forms, features in the work of such male
contemporaries as Fragonard, Flaxman and David. It can, in fact, be as
hard to attribute a sex to an unknown artist on a blind sampling of his
or her work as to determine whether a particular piece of unattributed
writing has been done by a man or a woman. Whether or not
Angelica's *Winckelmann* is the homosexual sublimation Oscar Sandner
takes it to be, it is by any unprejudiced reckoning a startlingly good
psychological study of a scholar at work, a portrait that could only have
been painted by someone who possessed a deep understanding of what
scholarship and professional devotion entailed. How revealingly, one
wonders, might Angelica the portraitist have painted 'Horn', the
impotent/impatient husband? How tantalising that her picture of the
famous hermaphrodite, the Chevalier d'Eon, was simply a copy of

someone else's![12] Herder, however besotted, knew how reductive the common view of Angelica was: although she was as angelic as her name, yet 'for all her tenderness [she has] a very masculine soul', 'she is a man in her degree of activity, and has done more than fifty men could do and would want to do in the same time'.[13] At her best Angelica met all the expectations she aroused, and then gave more, something extra that involved feeling, sympathy, analytical depth and imagination.

But hostile critics still invoked stereotypical views of female emotionality as a way of demeaning her art, denying her acceptance as a sober technician or an authoritative analyst. It was Fuseli's declared opinion, for instance, that women were emotionally rampant and thus, by implication, incapable of genuine greatness, their characters as disfigured by intellectual vagabondage as spoiled by sensory weakness. Such a view of the sex was anathema to Angelica, though it is exemplified in the wanton and even pornographic images of woman-kind conveyed in Fuseli's own painting. (When he set up his Milton Gallery Mary Wollstonecraft remarked that his version of *Paradise Lost* was unlikely to yield an Eve that would please her, except an Eve after the Fall.)[14] There must have been more to Fuseli than this misogyny suggests, for otherwise Wollstonecraft's attraction to him, let alone Angelica's friendship, would be incomprehensible.[15] But his conviction that women were incapable of solid creation – uncomfort-ably reminiscent of Goethe's opinions on female undulism – explains why Angelica's anacreontic fancies, if not her serious studies of male intellectuals, should have seemed pitiful to him. She must, in return, have found Fuseli grotesquely patronising, unless he took care to make all his attacks on her anonymous. It is ironic, incidentally, that they should have been published in the same journal, the *Analytical Review*, as gave the feminist Wollstonecraft her most stable source of income.

To the lay observer it may seem a blessing that patronage for monumental historical paintings dried up rapidly in Britain, and that Angelica was soon sidetracked into producing works of a quite different sort – anacreontic fancies with cupids and nymphs, decora-tions after Tasso and Sterne, and subject paintings after Ovid rather than Homer. Yet it is easy to understand why she should have yearned to impress (male) critics with the learnedness of her histories. If the

grand genre was more prestigious, however, it was neither as widely desired nor as easy to live with, and it is difficult to deny that some of Angelica's attempts in this mode are dreadful – Charles Robert Leslie called them wishy-washy, a comparatively mild verdict for the biographer of Constable to have passed. Yet had Angelica's work, particularly her ornamental work, not been ignored by so many of the Victorians, she might, as Germaine Greer has argued, have saved them from their worst excesses of pomposity and vulgarity.[16] Her wit and worldliness are very effective counters to the bloatedness of nineteenth-century didacticism.

Some of her admirers, it is true, thought her most successful as a portraitist when she managed to confer a historical grandeur on contemporary sitters. Matthisson wrote to Germaine de Staël's friend Bonstetten about Angelica's picture of Countess Reventlow, the wife of the Danish Ambassador to Stockholm who sat to her in 1784.[17] The Countess, a worshipper of Klopstock, a campaigner for the abolition of slavery and an author of educational books for rural readers, epitomised the eighteenth-century concept of the beautiful soul, and Angelica's ravishing portrait of her against a background of spreading tree and sky shows her moving welcomingly and with outstretched arms to greet some acquaintance or object of compassion, brimming with sympathy and driven by the beating pulse of humanity.[18] It is an almost iconic image of charity and loving-kindness, a blend of elevated pictorial theory and personal record that inspired Matthisson to remark:

> The artist has in this picture, following the example of the great Reynolds, very successfully raised a simple portrait to the level of interest of a historical subject, with the grace and softness of conception that is peculiar to her.

And, he added, without sacrificing resemblance.

The temperate or rococo-tinged classicism of this picture does not always feature in her portraiture. The only antique echo may be the urn against which the young Grand Tourist languidly leans or the vague Roman ruins that form a background to his musings, while the central image itself is simply of a character in fancy costume. Angelica's antiquity, like that of Louise Vigée Le Brun, is less sculptural than

painterly, less David's than Vien's, and always mingled with ahistorical motifs of the kind Reynolds encouraged painters to employ. Intellectual coherence is not the main point of her classicism. She painted to please and to sell, and knew that learned, even aggressive severity was less saleable than sweetened antiquity. Yet at different times she exhibited the divergent kinds of neo-classicism associated respectively with David (austere rectilinearity), Fuseli (high emotionality), Canova and Ingres (high manneredness) and Vien and Cipriani (seductive picturesqueness). She was well served as an artist by her eclecticism. When she found patrons to support her, as the Parkers of Saltram did, she was boldly innovative; but the temptation to make easy money by painting in a more conformist way was ever-present, whether or not she was encouraged to do so by an avaricious elderly husband or by a personal (female) need to prove herself.

One of Angelica's greatest strengths, paradoxically, marches ill with the medium that helped her to achieve international fame. Her use of colour was astonishing – according to Friederike Brun, it actually improved with age[19] – but is lost in engraving, though engraving may accurately reproduce the delicate lines of her compositions and the harmonious arrangement of their component parts. In his 'Briefe aus Rom' of 1785 Alois Hirt asks rhetorically:

> Is it enough to know this artist from good or bad engravings? To be sure, engraving reproduces the composition, shows the sweet thoughts and flowing outlines of the 'paintress of the Graces'; but whereas many an artist who lacks a sense of colour seems to gain in the engraved form, with Angelica's works quite the opposite is the case. Let full justice be done to her with respect to all other areas of art; yet her chief merit consists in doing what the Venetian and Lombard schools excelled at. The colour of her paintings is striking, the principal tones are true, the middle tints merging so softly and the whole brought to such harmony through a happy blending of broken colours that this charm of coloration is what really gives her heads their quietly joyful air and sweet expressions.[20]

This is not the whole story: tonal qualities may also be effectively conveyed by the dots and short strokes of stipple, which Bartolozzi and

other engravers of Angelica's work favoured, and the engravings done after her work were often coloured. Because stipple does not aim to create grand effects or the light-and-dark drama of mezzotint or line, it is almost perfectly suited to the intimate images sought by the late eighteenth century. *Almost* perfectly, because no engraving, not even a coloured one, can possibly do justice to a Kauffman painting; the very sketches she did specifically for engravers to work from are hardened by it. Yet contemporaries still loved these versions, as the success of print after print based on her work shows.

Few would deny that her *œuvre* generally lacks sublimity, the brooding horror or awesome magnitude that Klopstock wanted her to explore. But why should she have obliged him by providing it? The beauty and charm she preferred precluded raw shock, and her solution to the problem of combining decorum with momentousness in her histories was to make characters who embodied sternly virile qualities softly approachable, if not necessarily bashful and yielding – Hector torn by Andromache's beseeching, or Coriolanus moved by family entreaties. Measured against the yardstick of austerely classical art this is anodyne, but Angelica was temperamentally unprepared to be otherwise. When she gave up the idea of illustrating *Der Messias* it was as much because she could not match the *terribilità* of Klopstock's imaginings as on account of the author's pernickety interference.

If she occasionally felt like a bird in a gilded cage, her adoring public hardly saw the imprisonment as confinement. Nor is there much evidence that she tried to escape: she needed her equally captive admirers. As sentiment characterised her public and the effects she wrought, so 'feeling' rather than heroic subjects were the thematic constituents of her style – even in her histories – and gentle fluidity was its governing idiom. In this sense there is a perfect match in her work between artistic instinct and commercial intent.

Her ability to feel the pulse of fashion served her as well as her technical skills and artistic imagination, and belongs with the versatility that marked her entire career. When she began to paint national subjects a vaguely troubadour style was modish, so in Joseph II's picture of *Hermann and Thusnelda* Hermann's head was adorned with a feather toque; but since Ossian was the rage, Hermann found himself flanked by a venerable bard who was clearly intended to recall Macpherson's creation. Because Angelica liked tempering the heroic

and the romantically gloomy with the charming, Thusnelda and her ladies were shown crowning the warrior with flowers. When tastes moved on and Greek vases, to take one example, were the height of fashion, Angelica found on one of them the motif of Penelope weaving, and made it into a picture.

She was as much influenced by eighteenth-century artists as classical ones, and given that she knew countless painters directly or indirectly it would have been surprising if she had learnt nothing from them in either stylistic or technical terms. Her early debt to Boucher, whose works she saw in Paris in 1766 on her way to England, blended easily with her absorption of Batoni's rococo classicism; Reynolds's insistence on the timeless appeal of unspecific costume, as well as the bold dash of his style, gave a certain grandeur to her histories; and the influence of Mengs, so highly rated by his friend and confidant Winckelmann, translated itself into such works as the portrait of Ferdinand, Maria Carolina and their children.

She influenced other artists too.[21] The charm of some of Canova's works – his Chatsworth *Hebe*, for example – seems indebted to Angelica, and it is highly likely that Tischbein's 1788 *Orest und Iphigenie* draws on her illustration to Goethe's play. Often, however, her forms are softer and gentler than theirs. Similarly, although there are some links between her work and David's, her later productions never approach the sternness of his. Even the restrained, almost monochrome simplicity of her *Cornelia Knight* portrait is prettier – less uncompromising, less dramatic.

Nor is there is any reason why this should be counted against her. It is dismayingly easy to denigrate her work for its attractiveness, to say that it appealed to the same world as swooned over Emma Hamilton's 'attitudes' and thus to imply that Angelica appealed to the late eighteenth century's censurable taste for being duped by a decorative pseudo-antiquity. This is far more unfair to Angelica than to Emma. Antiquity in its recently rediscovered form was there to provide patterns for imitation, not simply be a source for re-presentation in museums and private or public collections. To despise artistic reworking because it was an inauthentic *calque* was (and is) to misunderstand artistic regeneration, which occurs against as well as in the spirit of consecrated norms and rules.

Equally, to complain that Angelica's brand of adaptation is little

more than charming and alluring is to deny that reinterpretation may be creative in almost any way it chooses. It also suggests that art should always prefer authenticity – whatever that can mean in such a context – to a 'popular' or commercially driven approximation. But Angelica refused to regard commercial considerations as a taint on the unsullied soul of art. If her sentimentality seems untrue to the ideal of antiquity, the implication is perhaps that we should try to look at what she did with more modern, less prejudiced eyes. Although for a critic such as Sternberg she epitomised the coquettish sweetness of her benighted times –

A feeble talent, but an attractive appearance. Her fame is more a salon and coterie fame than a rational one, and it was the vanity of the century to which she belonged rather than her own merit that led to her being called significant[22]

– for others she triumphantly captured the inimitable flavour of a civilised, decorous age. To bracket her with the *Pamelas* and *Sentimental Journeys* of her day is to do no more than register the unobtrusive skill with which she harnessed her art to the great populist mediums of the eighteenth century.

So the question whether she dominated her age, or it her, needs to be qualified, if not reformulated. Angelica may have suffered from some of the constraints her time imposed, such as its refusal to allow women proper artistic training, but she benefited from its tolerance in others. No one tried to stop her, a female artist, from engaging in commercial activities such as engraving, and she won as much custom because of her attractive social character as she suffered disparagement and obloquy on account of her perceived female weaknesses. And while she was made for times that liked discreet, charming, skilfully executed ornaments, the age of industrial expansion and new commercial money was also made for her.

Although it is invidious to discuss Angelica's art in terms of her person and nothing else, it is wrong to exclude her person from any critical assessment. She undeniably did some of what she did because of her conditioning as well as her instincts as a woman, and in that sense her artistic production is clearly gendered. At the same time, the woman

behind the art does not sufficiently explain the quality of the production, for what she did was the consequence of a wide range of social and artistic influences. A part of her success as an artist was certainly due to her sex, her ability to perform impressively in a male-dominated world, but she was reluctant to concede that she enjoyed any special privileges because she was a woman. Rather, she liked to underline her triumph against the odds of sexual and social expectation. Her 1787 Uffizi self-portrait shows her wearing a belt with a cameo of Minerva winning a competition against Neptune to establish the most useful gift that could be offered to the people: Neptune created a salt spring, but Minerva conjured up an olive tree.[23] The cameo is an implicit comment on the issue of women's artistic rivalry with men, and it tacitly alludes to Angelica's extraordinary success in a profession where men had traditionally ruled. It is the statement of a quietly confident woman, who despite being embarrassed at having Michelangelo beside her in the gallery (as he no longer is) was sure that she deserved some position in the hall of fame.

Is it a paradox to suggest that she was a remarkable painter who did not belong to the first rank of artists? Was she less, or more, talented than the other great female 'names' in the history of eighteenth-century art, Rosalba Carriera and Louise Vigée Le Brun? She was very different from them, technically less skilled than either, but more various and adaptable. She never, as far as we know, divulged what she thought of them, while Louise Vigée Le Brun passed a seemingly admiring but actually rather slighting judgement on her. To say that Angelica was more famous than either is perhaps not to say very much; the fact is that during her lifetime she was more famous than any artist in Europe, Reynolds included. Yet for all her pride in the academic honours she had earned, she was, like Louise Vigée Le Brun, lacking in the self-belief that helped painters such as Reynolds and David to the top of their profession. The melancholy that periodically gripped her was sometimes attributable to particular circumstances – her failed first marriage, Goethe's departure from Rome, the French invasion of Italy – and certain memories, according to one witness, seemed to trigger in her the sadness of a lifetime:

the loss of the great English engraver Ryland, who had particularly made his mark with excellent prints of her drawings,

and the dreadful manner of his death, saddened her greatly, and when such recollections surfaced she would often speak of disappointed hopes and vain wishes of her life with an emotion that seemed mixed with the recollection of her own sufferings.[24]

But often her depression derived from fairly unspecific conditions – a lack of self-trust, a feeling of worthlessness, a sense that she worked too busily to achieve greatness. 'Everything I do is sheer foolishness, that is well known,' as she wrote to Goethe, bereft at his absence.

This almost existential despondency is frequently reflected in her work, where women absorbed in grief or melancholic reflection characteristically figure: Penelope mourning over Odysseus' bow, La Penserosa sadly thinking, Poor Maria lamenting, Ariadne fearing the worst after her desertion on the rock. Ariadne's lonely suffering will be cured by the arrival of the sinewy Bacchus, it is true, and Penelope's unhappiness be dispelled by the return of her husband. But other women in Angelica's histories are about to be permanently deserted (Andromache will lose Hector for ever, though she does not know it), or have already lost their man to death. If Cornelia, the mother of the Gracchi, finds glory as well as pride in her brood of children, nothing can really compensate for the loss of a loved partner; and too often one death simply generates another, as Julia's history illustrates. On the evidence of her work, Angelica did identify femaleness with specific types of suffering: desertion, bereavement and other forms of irremediable solitude.

However grand the conceptual sweep of history paintings such as *Cornelia, Mother of the Gracchi*, they did not always strike contemporaries, any more than later observers, as the most notable of her achievements. Kotzebue remarked, less unfairly than he often did about Angelica's work:

She seems at her best in portraits, and perhaps women, if they want to become painters, are peculiarly fitted to this branch of art, for in truth they have been naturally endowed with a strong instinct for reading physiognomies, quickly grasping and interpreting man's entire play of features. It is a gift which nature lent them out of preference as a weapon of the weaker sex.[25]

This is an entirely familiar judgement, but for all its sexism and ambivalence it is at least a reasonable rebuttal of Pasquin's remarks on woman's fatal incapacity to capture facial appearance. Angelica made her name as much through her portraits of intellectuals (mostly men, though *Cornelia Knight* is an exception) as through her images of leisurely aristocrats on the Grand Tour or women in exotic dress, dreaming and imagining. In certain respects, too, she moved outside the conventions of her adoptive courtly world.

As we know, she was never universally praised for her ability to capture likenesses. If Lady Knight was struck by the resemblance of her daughter's portrait, and Robert Dalrymple's acquaintance (as well as the sitter himself) by his painted truth to life, others were less sure. Without being as dismissive as Goethe or Lady Exeter, they knew that Angelica often idealised beyond recognition. In the case of clients like Anna Amalia or Crown Prince Ludwig of Bavaria, this might have been because of the sitter's rank, but in others it was probably the consequence of aesthetic preference. In any case, truth to life is not a stable concept. Portraits embody two intentions, one to resemble and the other to typify, to show what the sitter shares with humankind in general.[26] So many of the women Angelica painted from 1790 onwards look like her self-portraits as to suggest that she habitually imposed a prototype or followed a recipe, perhaps because her sitters wanted her to. Even so, admirers did not find her work monotonous or unduly uniform. Hirt rather heavily remarked:

> Everything I saw by her has, beside the merit of striking similarity in which the first duty of a portrait-painter consists, a true and pleasing colour. The great art which distinguishes her from other artists in this respect is her very personal touch in removing a certain stiffness from portraits after life, which confers an unforced quality on pictures, something peculiar to itself, something natural . . .[27]

So in this respect as in others, the verdict passed on Angelica is mixed. It is likely enough that, in common with many other celebrities, she did not truly deserve the fame she won. In a sense, though, that fame was its own justification. Whether or not she had come to public attention because of her carefully tended reputation as a child prodigy, because

she astutely cultivated influential patrons, because she was an unusually good woman painter or because she deftly caught the mood of her times, she produced what people evidently wanted to buy. In some respects, too – as with the history paintings she did in Britain – she managed to please at least some contemporaries with her innovativeness. Although she may be disparaged for her graciousness and charm, the prettiness of her history paintings simply belongs with her art. She takes from neo-classicism what she needs (formality of setting, antiquity of motif, clarity of image), but adds to it a softness or sentimentality that is quintessentially the Kauffman style.

Although a fleeting eroticism colours many of her works, she herself was celebrated for her reserve and sense of decency. Her lightly mythological paintings never offended or reached beyond playfulness, and when she was asked to tackle risqué subjects – as she once was by a wayward beauty 'from abroad'[28] – she declined. Instead she painted a nymph surprised at the moment when she begins to dress, covering herself with a white veil to preserve appearances. The lusty bacchante for which Louise Vigée Le Brun would happily accept a commission was a type Angelica frowned upon, and when she painted Emma Hamilton it was not as Louise's luscious odalisque, but as a relatively anodyne Muse of Comedy. Whether for reasons of propriety or not, she never painted a completely nude body. Perhaps she felt that her deficient anatomical knowledge would have been cruelly exposed by it, but it is just as likely that it offended against her sense of propriety. Yet this, too, may have had its limits. Would she have been in sympathy with Pope Clement XIII, 'Sua Scrupulosità', who had the Vatican's naked statues adorned with the fig leaves they still bear?[29] We cannot be sure; but it does seem undeniable that Angelica's addiction to seemliness sometimes damaged her art. When painting Truth in an allegory linking that virtue with the quality of mercy, for instance, she refused to depict it as *naked* for reasons of modesty: 'To avoid [this] *unnecessary* indelicacy,' she noted, '[. . .] I have clothed her in white, as significant of Purity'.[30] This is surely protesting too much.

Cardinal de Bernis called Angelica 'the Tenth Muse of Rome', and she undoubtedly liked depicting herself in such mythical terms. In the Kenwood self-portrait that shows her as Painting inspired by the Muse of Poetry, Painting is not less than Poetry, but equal to her. She 'listens

eagerly to the suggestions of Poetry', as the *Memorandum of Paintings* has it, because she knows that they are sister arts. Angelica's debt to poetry or to literature in general is evident throughout her work. The early tension with music had been caused by love, not antagonism, and expressed a choice: *either* painting *or* music, or rather *mostly* painting and *less* music. Angelica's affinities with literature had different consequences. They spelt inclusion rather than exclusion, because words could so readily be translated into images.

Of course, as with Angelica's lifelong devotion to music, matters were less straightforward than that suggests. Her difficulties with Klopstock and *Der Messias* had highlighted the problem of incompatibility or non-equivalence between the different arts, the fact that what can be merely suggested in one medium by the indirect resources at its disposal has to be made concrete through the graphic tools of the other, which may change its character and meaning radically. In such cases, as Diderot had noted, 'pictura poesis *non* erit' (painting will *not* be poetry). Angelica was well aware of the fact: she knew that choosing the right moment for depiction was paramount, and won Goethe's admiration for having done so in the *Iphigenie* illustration. In other cases she gives only a partial account of literary objects and moments because of her preference for certain iconic images: not the full-blooded heroes of Homer, for instance, but the manifestly suffering men and the weeping, almost yielding women. It adds up to a personal reading of great works whose essence may appear to different readers or artists quite other. But Angelica never attempted to be anything but personal, certain that the 'fruitful moment' strikes each consciousness differently, and that all matters of interpretation are subjective.

Up to a point, this may account for the uninsistent quality of her adaptations from literature, which critics have sometimes judged negatively. According to one, Angelica

> could arrange any subject you liked to name, but [. . .] had [no] feeling whatever for the human drama which renders interesting the narratives of Homer, Shakespeare or Klopstock. Every subject, no matter what its size, was reduced to the spirit of a decorative vignette . . . [31]

It would be pointless to deny that her work lacks the uncompromising

drama of David or the massive nobility of other contemporary history painters. All her instincts rebelled against such austerity or weightiness, diverting her instead to the gentle presentation of human uncertainties and fluctuations. She achieved a richly emphatic depiction in some of her late religious paintings – *Christ and the Samaritan Woman* rather than the rhetorical *David and Nathan* – but the force of the human drama she conveys is still qualified or muted, and when she attempts overt statement she strays into the minefield of emphatic eighteenth-century sensibility. It is less, perhaps, that she lacked all feeling for human drama than that she simply felt unequal to depicting it. The implied conclusion that her sex and nature conditioned her artistic response seems inescapable.

This is not to say that a female artist has to forsake such dramatic effects; Artemisia Gentileschi's work, for example, conveys plenty of them. But the evidence of Angelica's painting and writing suggests that she resisted them for psychological reasons related to her sex. Equally, her 'feminine' portrayals of men may be interpreted less in terms of anatomical ignorance – she possessed a very complete knowledge of artistic tradition and hence of human depiction – than as the product of choice.[32] Choice smoothed out aberration, prettified the shocking or ugly and forbade certain kinds of direct representation. (For compara-ble reasons, her finished paintings repair the roughness of her preparatory sketches, often removing life and vigour in the process.) The species of androgyny she was drawn to could not accommodate anatomical forthrightness, and as a result her bodily images may seem neither one thing nor the other – not full-blooded but not unequivo-cally feminine, neither dramatic nor static, but somewhere in between. Hazlitt felt that this indeterminacy, 'a sort of hermaphroditic softness', reflected a natural convergence of male and female tastes: the painter Westall made all his women look masculine, he claimed, while Angelica made all her men look feminine. Both, though, were guilty of 'effeminate performances',[33] as though the taint of the female principle were the stronger and more lasting. Yet this vague territory still has an unmistakably mixed character.

Although Catherine II's preferring Angelica to Louise Vigée Le Brun was a preference for the creator of ideal images over worldly ones, Angelica was not averse to depicting worldlings when they presented their custom. However, she still liked interpreting their

characters on her own terms, just as she would depict Goethe as *she* saw him, and not as he liked to think of himself. If exact mimesis was not aimed at – and it can scarcely be conceived of in portraiture – then a personal interpretation had to be acceptable; it was all a matter of degree. Goethe objected to his portrait because it was too characteristically Angelica's, and so offensive to his virility. He could not see that the type of image Angelica had produced was inevitable; or perhaps he did see, but still wanted to quarrel with it, forgetting what Angelica had taught him in Rome about the different ways of seeing and the best way to get the mysterious 'it' into his field of vision. This might also explain why his praise of her, which selective quotation can present as fulsome, should in reality be so temperate. She had a style that was only occasionally to his liking.

Luckily for Angelica, she had countless other admirers. Her detractors were irritated by what they saw as uncritical popular acceptance of her art, but her manner answered to the taste of her times, and in some respects continued to appeal after the times had passed. Even traduced by forgery, her spirit lived on. Endlessly recycled and reproduced, she simply continued the pattern set in her own day; for during her lifetime her art was more widely seen by the general public than that of any contemporary, particularly in its engraved form.

In some respects she was a thoroughly populist artist, one who enthusiastically embraced new techniques that assured a wide propagation of her designs (more than seventy-five engravers copied her paintings and drawings), and there is no evidence that she disparaged any of the available methods of mass reproduction. This was because of her essential adaptability. The journeyman-artist ethos she had learnt from her father never left her, and she was happy to go wherever work could be found, or wherever she could create conditions that allowed her art and her self to prosper. The market drove her, therefore, as much as she drove the market. She came to London for commercial reasons that cannot be dissociated from artistic ones, and she may have left it in something of the same spirit. Idealist though she was, her idealism was shored up by solid realism – realism of attitude if not of execution. It was, she repeatedly discovered, a very satisfactory compromise.

Angelica's fame remains widespread today, in the sense that her

works are to be found in far-flung corners of the civilised world; yet the prints that so effectively spread her reputation are no longer popular, and there is no connoisseur with the means and power to assemble and preserve a huge haul of Kauffman paintings in a single location, as George Bowles did at Wanstead Grove. She is – which would have delighted her – at last truly at home in her father's corner of Austria (however infrequently she visited it during her lifetime), richly represented in the Vorarlberger Landesmuseum in Bregenz. She might have been slightly less gratified at discovering the important place she occupies in the Bündner Kunstmuseum in Chur, though one hopes and assumes that the passage of time would have converted her ambivalent feelings about her mother's native town and her own birthplace into benign acceptance. A European artist who retained a strong sense of regional identity, she would presumably also have approved of the way her works have often clung to the native land of their original owners or sitters. The terrifying Jane Maxwell and her husband Alexander, Duke of Gordon, are settled on the right side of the border in the Scottish National Portrait Gallery in Edinburgh, though the architect Michael Novosielski might have been puzzled to find himself close by in the National Gallery of Scotland. After all, he had been born in Rome (where Angelica painted him sitting over the ground plans for the King's Theatre in London's Haymarket) and from there took up residence in England, where he practised his profession. It was his daughter-in-law's bequest that made him an honorary Scot, a member of a race Angelica loved depicting in its national costume and glory.

Political events, of course, often accounted for some shifts in location, as the story of the Earl-Bishop of Derry's art collection illustrates. Princess Bariatinsky's portrait of Angelica at the crossroads, hesitating between painting and music, was transferred after the Russian Revolution from the family collection at Ivanskoe, near Kursk, and since 1924 has been displayed at the Pushkin Museum in Moscow. In countries where the political climate has been less turbulent, Angelica's paintings have more often stayed put, although evolving fashions in hanging may have prompted more minor migrations: so the history paintings which in John Parker's day hung as overdoors in the Grand Saloon at Saltram now line its main staircase. Yet however settled the English scene may have been in comparison with the

Russian, one change in economic circumstance and politico-cultural practice has disturbed (usually for the better) the pattern of artistic ownership and hence visibility. Louise Vigée Le Brun and others may have deplored the fondness of the English landed aristocracy for secreting great works of art in rural properties far from the metropolis, but more recent arrangements have often made them available for general inspection in national and regional galleries, in the countless privately owned castles, mansions and country houses whose owners admit paying visitors in the interests of financial solvency, and in the properties of the National Trust. When Ickworth was made a national property in 1956, and Saltram likewise a year later, they both became established stops on the tourist route that has since become, in some respects at least, the modern world's equivalent of the eighteenth-century Grand Tour – more demotic, less sex-specific but almost as instructive.

Even so, the passage of time has inevitably affected the homes of art along with the works they sheltered and still shelter. The Earl-Bishop's paintings were confiscated in 1798, and only a copy of Angelica's portrait of him, intended for the grandiose house he would never see, can be inspected at Ickworth. John Parker's collection was depleted as a result of his son's experiments with ambitious but costly engineering and industrial projects, which left the family so heavily in debt that the son's grandson, the third Earl of Morley, had to sell several of Saltram's finest paintings to survive. Happily, however, the Kauffmans remain. They survive elsewhere too, despite latter-day pillaging that brings to mind the eighteenth-century spoliation of the Earl-Bishop's collection: the denuding of the Althorp collection by the eighth Lord Spencer's second wife, for instance, mercifully left Angelica's picture of Georgiana and Harriet with Viscount Althorp *in situ* in the library. Lord Exeter's descendants preserve his *Garrick* and *Poor Maria* at Burghley House, and the histories Angelica painted for John Byng remain at Wrotham. And however much we may lament the absence of a George Bowles of the twenty-first century, we should no doubt rejoice that there can never be another Northwick sale resulting in the loss of an entire collection – even though some of the works dispersed in the great auction of 1859 are hard to regret, the histories in particular.

Then there are the self-portraits. One of them is at the National

Portrait Gallery in London, where it surely belongs; others have been sold and spread about the world, though Angelica did so many that none of 'her' nations is deprived of its own. Many, indeed, have shifted from private to public collection – the self-portrait with pen and drawing block, for instance, from King Ludwig I to Munich's Neue Pinacothek, another with the bust of Minerva from unnamed private hands to the Chur Bündner Kunstmuseum. As far as other portraits are concerned, Goethe has stayed in Weimar, as he should have done, but Herder – still a touch petulant at his fate, perhaps – has gone to Frankfurt.

Elsewhere the pattern of heritage, inheritance, sale and dispersion remains, but discontinuously. Will Angelica's works ever be deemed so vital to the nation – and to which nation? – that their threatened departure abroad must be halted by state intervention? It may seem unlikely, however great her favour has become in our own times. Modest as she invariably was, she herself believed that since she could not rank with Michelangelo she should not in all decency be hung next to him at the Uffizi, and similarly might have blenched at considering her work to be of national importance. But there is no need to judge her by the yardstick of genius. She remains a great *representative* artist by virtue of her sex and cultural affinities, and one whose work has significance both in its own right and in terms of the varied background(s) that helped to generate it, and which it reflects. Is it simply because of the uncertainty over *patria* – Switzerland? Austria? Italy? England? – that no national gallery has set aside separate space for her work, as the Louvre has done for Louise Vigée Le Brun? Or is a Kauffman still looked at askance by the guardians of high art?

Then there is, not unrelatedly, the matter of her association with works of applied as well as 'pure' art, a variousness in production that in the eyes of some dilutes her claims to greatness, but for others confirms her status as a major artist of her times, one whose work was equally at home in galleries, halls, drawing-rooms, dining-rooms, boudoirs, parlours, bedrooms and kitchens, an artist of historic cultural significance who at the start of the industrial age applied her talents to popular as well as elite mediums. Was she the first (female) creator of an artistic *Gesamtkunstwerk*, not in the sense of a total production possessing internal coherence and unity, but in terms of sheer range – a range comprising paintings, prints, decorative art, household wares

and other kinds of domestic article, and represented by all the mediums through which art and fame were, and are, propagated?

She continues to speak to a public wherever her work is gathered and displayed. Bregenz has been organising Kauffman shows from the beginning of the last century, as one might have expected, and Chur has mounted exhibitions despite her ambivalence about the place. In 1992 Milan, so crucial to her artistic development, saw a homage to Angelica consisting of a selection of her works together with a range of later artistic offerings testifying to her influence. In the same year a collection of Kauffman creations, pure and applied, assembled from galleries and public collections in America, Germany, Switzerland and Austria as well as from English country houses, museums and a bank, was exhibited in Brighton, a fittingly Georgian setting for this quintessentially Georgian artist. In western Europe there is usually a Kauffman within travelling distance except, perhaps, in France; in Russia she is concentrated in Moscow and St Petersburg, while in the United States she can be found wherever public or private buyers, and the occasional European emigrant, have chosen to take her. In New Haven, as a final national irony, she can be viewed in a famous collection of 'British' art whose junior branch exists under the same title in London.

When Herder called the house by Trinità dei Monti 'a veritable shrine to the Muses', he meant that it seemed sacred to all the arts – not just to painting and music, but also to lyric poetry (of the kind that Terpsichore/Fantastici spontaneously composed), to song (which both Angelica and the soprano Sarah Harrop/Erato, whose portrait she painted in 1781, performed there), to comedy (as embodied in Emma Hamilton/Thalia) and to epic (which Cornelia Knight/Kalliope may have represented). These women are all Muses who guard the flame of art, bringing inspiration to others; and Angelica finds in portraying them a stimulus to artistic creation itself, as well as the subject of creativity.

The nine women in Richard Samuel's National Portrait Gallery painting *The Nine Living Muses of Great Britain* (1779),[34] which makes Angelica into an honorary British Muse, appear to have gathered before the temple of Apollo to worship the god himself, whose gracile figure stands on a massive plinth at its entrance. But if

one of them gestures towards him, others are looking more raptly at a Muse singing to the lyre, while others again seem detached, meditatively sitting over an unfurled scroll, playing a mandolin or conversing among themselves without any evident interest in the deity who supposedly presides over their activities. And Angelica, the painter, sits with her back to the statue, paying it no attention at all. She is flanked by women, her preferred subjects, and seems to be considering the group of three to her left appraisingly. She has her models, and needs no further inspiration.

Of the nine Muses Samuel depicted, the classical scholar Elizabeth Carter, the writer and translator Elizabeth Griffith and the historian and radical Catherine Macaulay had been well known for decades. The author and editor Anna Barbauld (of whom Fanny Burney wrote, 'I think highly of both her talents and her character'),[35] the religiously minded Hannah More, a friend of William Wilberforce, and the singer Elizabeth Linley, the playwright Richard Brinsley Sheridan's wife (on whose account Lord North once suggested that Sheridan should be awarded an honorary degree 'uxoris causa'), were at the start of their fame. Other 'Muses' – Charlotte Lennox, a minor author and friend of Dr Johnson who inspired Mrs Thrale to remark that 'everybody admired her but nobody liked her', and the Queen of the Blues Elizabeth Montagu, who 'never invite[d] idiots to [her] house' – seem to have had no very compelling claim to the title, though Mrs Montagu was celebrated for diffusing quantities of knowledge.

Angelica Kauffman remains the most famous. Some of the paintings she rated most highly may be hidden away undisplayed in remote country houses; she may even suffer the indignity of storage and seclusion in the reserves of national collections; but she is still a name. In her own time she was perceived as an extraordinary being, however much her celebrity owed to scandal or facile appeal, and her life is still being fictionalised like a true romance. To this day she is regarded as a national treasure in Switzerland, Austria and, more contestably, Britain. She may never provoke another epidemic, but her phenomenal success was on balance well founded. She has lasted better than most crazes.

Notes

One: A Craze

1 Anthony Pasquin [John Williams], *Memoirs of the Royal Academicians* (London, 1796), reprinted London, 1970, 113.
2 I shall follow the spelling of her surname that Angelica herself most commonly used.
3 Quoted in a letter of 19 October 1781 from the Danish Ambassador to London, Count Schönborn, to Klopstock, Klopstock, *Werke und Briefe*, 17 vols (Berlin and New York, 1974–99), VII.223.
4 Quoted in Lady Victoria Manners and Dr G. C. Williamson, *Angelica Kauffmann, R.A. Her Life and Her Works* (London, 1924), 20.
5 On Anne Thackeray Ritchie, see Henrietta Garnett, *Anny* (London, 2004).
6 *Miss Angel, The Works of Miss Thackeray*, vol. VIII (London, 1884), 5.
7 See Helfrich Peter Sturz, *Briefe im Jahre 1768 auf einer Reise (durch England und Frankreich) im Gefolge des Königs von Dänemark geschrieben, Schriften*, new edn, 2 vols (Vienna, 1819), I.125–6; also quoted in Eugen Thurnher, *Angelika Kauffmann und die deutsche Dichtung* (Bregenz, 1966), 87–8.
8 See Roszika Parker and Griselda Pollock, *Old Mistresses: Women, Art and Ideology* (London, 1981), 90.
9 See J. T. Smith, *Nollekens and His Times* (London, 1949), 34.
10 Denis Diderot, *Salons*, ed. Jean Seznec and Jean Adhémar, 4 vols (Oxford, 1957–67), III.250–52.
11 Pasquin 115.
12 John Wolcot, *The Works of Peter Pindar, Esq.* (London, 1809), I.28.
13 This observation is commonly, but wrongly, attributed to his brother August Wilhelm.
14 Friedrich von Schlegel, 'Angelika Kauffmann', *Athenaeum: eine Zeitschrift*, vol. 1, part 2 (1798, reprinted Berlin, 1960).
15 Johann Heinrich Meyer, 'Entwurf einer Kunstgeschichte des 18. Jahrhunderts', in Goethe, *Sämtliche Werke*, 46 vols (Frankfurt am Main, 1987–99), 19.116.
16 William Hazlitt, *Conversations of James Northcote, R.A.*, ed. Edmund Gosse (London, 1894), 62.
17 James Northcote, *The Life of Sir Joshua Reynolds*, 2 vols (London, 1819), II.100.
18 Pasquin 113.
19 *Herders italienische Reise*, ed. Albert Meier and Heide Hollmer (Munich, 1988), 401 (to Caroline Herder, 28 March 1789). Emphasis added.
20 John Wilkes, *Correspondence*, ed. J. Almon, 5 vols (London, 1805), II.178 (to Fanny Wilkes, 10 July 1765).

21 Quoted in Peter S. Walch, 'Angelika Kauffmann und England', in Oscar Sandner (ed.), *Angelika Kauffmann und ihre Zeitgenossen* (Bregenz, 1968), 19.

22 Discussed by Walter Shaw Sparrow, 'Angelica Kauffman's Amazing Marriage', *Connoisseur* XCII (1933).

23 She was christened Marie Elisabeth Louise, but never used the first name and more commonly signed herself by the third than the second.

Two: Father and Daughter

1 Johann Isaac von Gerning, *Reise durch Österreich und Italien*, 3 vols (Frankfurt am Main, 1802), III.141.

2 Joseph [Giuseppe] Baretti, *An Account of the Manners and Customs of Italy*, 2 vols (London, 1768), I.279.

3 Quoted in Winifred Friedman, *Boydell's Shakespeare Gallery* (New York and London, 1976), 79.

4 Hester Lynch Piozzi, *Observations and Reflections Made in the Course of a Journey through France, Italy and Germany*, 2 vols (London, 1789), II.140–1, quoted in Wendy Wassyng Roworth, 'Painting for Profit and Pleasure: Angelica Kauffman and the Art Business in Rome', *Eighteenth-Century Studies* 29, 2 (1995–6), 225.

5 Winckelmann to Franke, 18 August 1764, in Winckelmann, *Briefe*, ed. Walther Rehm, 4 vols (Berlin, 1952–7), III.54.

6 Daniel Crespin to James Grant of Grant, Rome, 11 March 1763, Seafield Papers, Scottish Record Office GD 248/49/2.

7 See Josef Langl, 'Das Testament der Angelika Kauffmann', *Zeitschrift für bildende Kunst* XXIV (1888–9), 294.

8 Friederike Brun, *Tagebuch über Rom*, 2 vols in 1 (Zurich, 1800–1), II.7.

9 Angelica Kauffman to Casimir Kauffman, 11 December 1790, in Waltraud Maierhofer (ed.), *Angelika Kauffmann: Briefe einer Malerin* (Mainz, 1999), 143.

10 Germaine de Staël, *De l'Allemagne*, ed. Comtesse Jean de Pange with Simone Balayé, 5 vols (Paris, 1958), I.286–7.

11 Brun II.7.

12 Elisabeth Vigée Le Brun, *Souvenirs*, ed. Claudine Herrmann, 2 vols (Paris, 1984), I.24.

13 See Claudia Helbok, *Miss Angel. Angelika Kauffmann: eine Biographie* (Vienna, 1968), 11.

14 However, Helmut Swozilek, *Johann Joseph Kauffmann (1707–1782)* (Bregenz, 1993), argues that he was a better artist than is normally allowed (6).

15 See William T. Whitley, *Artists and their Friends in England, 1700–1799*, 2 vols (London and Boston, 1928), I.374.

16 Joseph Moser, 'Memoir of the Late Angelica Kauffman, R.A.', *The European Magazine* (April 1809), 260.

17 Giovanni Gherardo De Rossi, *Vita di Angelica Kauffmann pittrice* (Florence, 1810), 4.

18 Ibid. 8.

19 See Helbok, *Miss Angel* 232–3.

20 See, for example, August von Kotzebue, *Bemerkungen auf eine Reise aus Liefland nach Rom und Neapel*, 3 vols in 1 (Cologne, 1810), II.221.

21 See Swozilek 36ff.
22 See Rossi 94–5, n. 25.
23 Ibid. 9.
24 Vigée Le Brun I.262.
25 Rossi 12.
26 Ibid. 13.
27 See Hermann Eggart, 'Die blossgelegten Fresken der Angelika Kauffmann in Schwarzenberg', *Feierabend* 12 (1932), 680.

Three: 'A Little German Paintress'
1 Quoted in Siegfried Obermeier, *Die Muse von Rom: Angelika Kauffmann und ihre Zeit* (Frankfurt am Main, 1987), 26.
2 The first is Macaulay's description and the second Henry Angelo's.
3 Pasquin 165–6.
4 Piozzi I.248.
5 Helbok, *Miss Angel* 50.
6 Giuseppe Carlo Zucchi, *Memorie istoriche di Maria Angelica Kauffman Zucchi riguardanti l'arte della pittura da lei professata*, ed. Helmut Swozilek (Bregenz, 1999), 44–5.
7 See Anthony Clark, 'Roma mi è sempre in pensiero', *Studies in Roman Eighteenth-Century Painting*, ed. Edgar Peters Bowron (Washington, DC, 1981), 125.
8 Goethe, *Italienische Reise, Hamburger Ausgabe*, ed. Erich Trunz, new edn, 14 vols (Munich, 1981), 11.384–5.
9 Quoted in John Ingamells, *A Dictionary of British and Irish Travellers in Italy, 1701–1800* (New Haven and London, 1997), 809.
10 Horace Walpole, *Correspondence with Sir Horace Mann*, ed. W. S. Lewis, Warren Hunting Smith and George C. Lam, 11 vols (New Haven and London, 1954–71), II.532–3.
11 Whitley II.309 (letter of 18 April 1778).
12 Président de Brosses, *Lettres familières écrites d'Italie en 1739 et 1740*, 2 vols (Paris, 1861), II.69.
13 Quoted in St John Gore, 'Prince of Georgian Collectors: The Hoares of Stourhead – I', *Country Life* CXXXV (1964), 212.
14 See Steffi Röttgen, *Anton Raphael Mengs and His British Patrons* (London, 1993), 12.
15 Helbok, *Miss Angel* 56.
16 Brinsley Ford, 'The Grand Tour', *Apollo* CXIV (1981), 394.
17 See Stephen Lloyd, *Richard and Maria Cosway: Regency Artists of Taste and Fashion* (Edinburgh, 1995), 41.
18 See Arthur S. Marks, 'Angelica Kauffman and Some American Artists on the Grand Tour', *American Art Journal* XII (1980), 12; Peter Walch, 'Angelica Kauffman', Ph.D. thesis, Princeton University, 1968, 16.
19 Joseph Farington, *Diary*, ed. K. Garlick, A. Macintyre, K. Cave and E. Newby, 16 vols (New Haven and London, 1978–98), III.763.
20 Bettina Baumgärtel (ed.), *Retrospektive Angelika Kauffmann* (Ostfildern-Ruit, 1998), 187.

21 Quoted in Walch, 'Angelica Kauffman' 18.

22 François René de Chateaubriand, *Œuvres romanesques et voyages*, ed. Maurice Regard, 2 vols (Paris, 1969), II.1476.

23 Piozzi I.378.

24 Germaine de Staël-Holstein, *Corinne ou l'Italie*, ed. Simone Balayé (Paris, 1985), 47.

25 Edward Gibbon, *Memoirs of My Life*, ed. Georges A. Bonnard (New York, 1969), 134.

26 Walch, 'Angelica Kauffman' 29.

27 John Moore, *A View of Society and Manners in Italy*, 2 vols (London, 1781), II.73.

28 Johann Fiorillo, *Geschichte der zeichnenden Künste in Deutschland und den vereinigten Niederlanden*, 5 vols (Hanover, 1817), III.323ff; Helbok, *Miss Angel* 54.

29 John Ramsay, 'Journal for 1782 and 1783', National Library of Scotland, MSS 1833/4.

30 See Albert Boime, *Art in an Age of Revolution 1750–1800* (Chicago and London, 1987), 110.

31 On Fuseli's life see John Knowles, *The Life and Writings of Henry Fuseli*, 3 vols (London, 1831), I.22–8, and Friedrich Antal, *Fuseli Studies* (London, 1956), p. 23 n. 12.

32 Johann Caspar Füssli, *Geschichte und Abbildung der besten Maler in der Schweiz*, 2 vols (Zurich, 1757), I.224, quoted in Ruth Nobs-Greter, *Die Künstlerin und ihr Werk in der deutschsprachigen Kulturgeschichtsschreibung* (Zurich, 1984), 80.

33 Boime 110.

34 Oscar Sandner (ed.), *Angelika Kauffmann und Rom* (Rome, 1998), 22.

35 Carl Justi, *Winckelmann*, 2 vols (Leipzig, 1866–72), II.72; Nobs-Greter 140.

36 Friedrich von Matthisson, *Briefe*, 2 vols in 1 (Zurich, 1795), I.73 (letter of 15 August 1787).

37 Fernow's description, quoted in Otto Jahn, *Biographische Aufsätze* (Leipzig, 1866), 87.

38 Baumgärtel, *Retrospektive* 25.

39 Letter of 18 August 1764, quoted by Manners and Williamson 14.

40 See Basil Skinner, *Scots in Italy in the Eighteenth Century* (Edinburgh, 1966), 17; Marks 11; Ingamells xlvi ('William Patoun's *Advice on Travel in Italy*, 1766') and 420–1.

41 Quoted in Ingamells 7.

42 James Barry, *An Inquiry into the Real and Imaginary Obstructions to the Acquisition of the Arts in England* (London, 1775), 75–6.

43 Daniel Webb, *Inquiry into the Beauties of Painting*, 3rd edn (London, 1769), vi–vii.

44 Quoted in Skinner, *Scots* 14.

45 Quoted in Ingamells 170.

46 See Ingamells 679–81.

47 Ingamells 717–18; Peter Walch, 'An Early Neoclassical Sketchbook by Angelica Kauffman', *Burlington Magazine* CXIX (1977), 102.

48 Skinner, *Scots* 15.

49 Thomas Jones, *Memoirs*, ed. Brinsley Ford, *Publications of the Walpole Society* XXXII (1946-8), 54.

Four: Italian Journeys

1 See Geneviève Gennari, *Le Premier Voyage de Mme de Staël en Italie et la genèse de 'Corinne'* (Paris, 1947), 78.
2 Goethe, *Italienische Reise* 337.
3 Comte d'Espinchal, *Journal d'émigration*, ed. Ernest d'Hauterive (Paris, 1912), 83.
4 Ingamells xlvii.
5 Richard de Saint-Non, *Voyage pittoresque de Naples et de Sicile*, 5 vols (Paris, 1781–6), I.224–5.
6 On Jamineau, see Ingamells 551.
7 On this portrait, see Baumgärtel, *Retrospektive* 124.
8 Quoted in Helbok, *Miss Angel* 60.
9 See Peter Walch, 'David Garrick in Italy', *Eighteenth-Century Studies* III (1970).
10 Quoted in Ingamells 392.
11 Stendhal, *Rome, Naples et Florence*, ed. Henri Martineau (Paris, 1950), 40.
12 See Walch, 'Angelica Kauffman' 35.
13 Clark, 'Roma' 128.
14 On Martin, see Ingamells 645.
15 See Wendy Wassyng Roworth, 'The Art of Painting', in Wendy Wassyng Roworth (ed.), *Angelica Kauffman: A Continental Artist in Georgian England* (London, 1992), 20–1.
16 Ibid. 21.
17 'Here lies a brusque, sour-tempered antiquarian. Oh how well he's lodged in this Etruscan jug!'
18 On all these matters, see Jean Seznec, *Essais sur Diderot et l'antiquité* (Oxford, 1957), 86–96.
19 Walch, 'Angelica Kauffman' 21; Manners and Williamson 13.
20 Winckelmann, 'Freundschaftliche Briefe', *Werke*, ed. Joseph Eiselein, 12 vols (Osnabrück, 1965), X.169.
21 Quoted in Bettina Baumgärtel, *Angelika Kauffmann (1741–1807): Bedingungen weiblicher Kreativität in der Malerei des 18. Jahrhunderts* (Weinheim and Basel, 1990), 258–9.
22 On Morgan, see Whitfield J. Bell, Jr, *John Morgan, Continental Doctor* (Philadelphia, 1965), and Brandon Brame Fortune with Deborah J. Warner, *Franklin and his Friends* (Washington, 1999), 34ff.
23 Quoted in Fortune 62.
24 James Boswell, *On the Grand Tour: Italy, Corsica and France*, ed. Frank Brady and Frederick A. Pottle (London, 1955), 50, quoted in Walch, 'Angelica Kauffman' 33.
25 Farington III.938.
26 Smith 139–40.
27 See David Goodreau, *Nathaniel Dance 1735–1811* (catalogue to Kenwood exhibition, London, 1977), unnumbered pages.
28 Farington III.763.
29 Ibid. IX.3192.

30 Pasquin 45.
31 Quoted in Marks 23.
32 Ibid. 24, emphasis added.
33 Ibid. 20.
34 Quoted in Baumgärtel, *Retrospektive* 147.
35 Piozzi I.91.
36 Quoted in Marks 23 (31 August 1765).
37 Helbok, *Miss Angel* 70.
38 Winckelmann, *Werke* X.129, 155.
39 Arthur Young, *Travels in France and Italy during the Years 1787, 1788 and 1789* (London, 1911), 256.
40 Piozzi I.202.
41 Lady Mary Wortley Montagu, *Complete Letters,* ed. Robert Halsband, 3 vols (Oxford, 1965–7), III.127 (30 May 1757); Ingamells 691.
42 Giacomo Casanova de Seingalt, *Histoire de ma vie*, 6 vols (Wiesbaden, 1960–2), IV.136, 138.
43 PRO, State Papers Foreign, 105/315, f.557 (28 April 1764); Ingamells 691.
44 Rossi 24.

Five: Celebrity and Scandal

1 Quoted in Manners and Williamson 20. The letter is now lost.
2 See Marcia Pointon, 'Portrait-Painting as a Business Enterprise in London in the 1780s', *Art History* 7 (1984), and her *Hanging the Head: Portraiture and Social Formation in Eighteenth-Century England* (New Haven and London, 1993).
3 Quoted in Adeline Hartcup, *Angelica: The Portrait of an Eighteenth-Century Artist* (London, 1954), 9.
4 Quoted in Wilhelm Schram, *Die Malerin Angelika Kauffmann* (Brünn, 1890), 45–7.
5 See Angela Rosenthal, *Angelika Kauffmann: Bildnismalerei im 18. Jahrhundert* (Berlin, 1996), 177ff.
6 Quoted in Roy Porter, *London: A Social History* (London, 1994), 97.
7 *Lichtenberg's Visits to England*, ed. and trans. Margaret L. Mare and W. H. Quarrell (Oxford, 1938), 111.
8 Jean-André Rouquet, *The Present State of the Arts in England* (London, 1755), 42–3.
9 Farington I.90.
10 Virginie Ancelot, *Les Salons de Paris* (Paris, 1858), 22.
11 John Hoppner (trans.), *Oriental Tales* (London, 1805), xviii.
12 Gerald Reitlinger, *The Economics of Taste*, 3 vols (London, 1961–70), I.61.
13 Quoted in Helbok, *Miss Angel* 85 n.1. English in original.
14 Klopstock to Gleim, *Werke und Briefe* V.1.185–6 (2 September 1769).
15 See Alex Kidson, *George Romney,1734–1802* (London, 2001), 18.
16 See A. Rosenthal, *Angelika Kauffmann* 110.
17 J. W. von Archenholz, *A Picture of England*, 2 vols (London, 1789), I.4.
18 Zucchi 51.
19 Hugh Phillips, FSA, *Mid-Georgian London* (London, 1964), 238.
20 See Frances A. Gerard, *Angelica Kauffmann: A Biography* (London, 1892), 59–60.

21 See Peter Ackroyd, *London: The Biography* (London, 2000), 532.

22 Ibid. 533.

23 There is confusion in William Sandby, *The History of the Royal Academy of Arts*, 2 vols (London,1862), I.35, about the two societies of art that preceded the establishment of the Royal Academy. The Society of Artists, the longer-standing institution, took to calling itself the *Free* Society to distinguish itself from the (Incorporated) Society of Artists, a splinter body of artists (including Reynolds, Hogarth, Gainsborough, Roubiliac and Stubbs) at the pinnacle of their profession who saw the charging of an entrance premium as the best means of attracting suitable members of the public to their exhibitions and excluding *hoi polloi*. (The Free Society of Artists had a fundamental objection to charging an entrance fee.) The secessionists were reluctant to exhibit alongside prizewinners whose efforts often had little or no aesthetic value and whose presence seemed to demean their more elevated work. See Derek Hudson and Kenneth W. Luckhurst, *The Royal Society of Arts* (London, 1954), 35ff.

24 *Letters and Journal of Lady Mary Coke*, 5 vols (Edinburgh, 1889–96), I.25.

25 Quoted in Alfred Morrison, *The Hamilton and Nelson Papers, Vol.I (1756–1797)* (London, 1893), 77.

26 Thackeray 296.

27 See Elizabeth Mainwaring, *Italian Landscape in Eighteenth-Century England* (London, 1925), 31.

28 J. W. von Archenholz, *England und Italien*, 5 vols (Karlsruhe, 1791), III.127–8.

29 Rossi 27.

30 See Oliver Millar, *The Later Georgian Pictures in the Collection of Her Majesty the Queen*, 2 vols (London, 1969), I.59.

31 *Mémoires du chevalier d'Eon*, ed. Frédéric Gaillardet (Paris, 1935), 266.

32 See Christopher Hibbert, *George III* (London, 1998), 46.

33 Quoted in Michael Levey, *A Royal Subject: Portraits of Queen Charlotte* (London, 1977), 5.

34 Quoted in Hibbert 40.

35 Mrs Papendiek, *Court and Private Life in the Time of Queen Charlotte*, ed. Mrs V. Delves-Broughton, 2 vols (London, 1887), I.9–10.

36 Quoted in Levey 3.

37 MS of *The Narrative of the Illness and Death of General d'Arblay*, quoted in Joyce Hemlow, *The History of Fanny Burney* (Oxford, 1958), 404.

38 Quoted in Olwen Hedley, *Queen Charlotte* (London, 1975), 91.

39 Papendiek I.14–15.

40 W. C. Oulton, *Authentic and Impartial Memoirs of Her Late Majesty Charlotte* (London, 1819), I.iii.

41 Quoted in Hemlow 418.

42 Baumgärtel, *Retrospektive* 159.

43 On the various reports on Christian VII's visit, see Aileen Ribeiro, 'The King of Denmark's Masquerade', *History Today* 27 (1977), 385ff.

44 See Gerard 71.

45 Mary Wollstonecraft, *A Short Residence in Sweden, Norway and Denmark*, ed. Richard Holmes (London, 1987), 167.

46 Archenholz, *Picture* I.5.

47 See Nicholas Penny (ed.), *Reynolds* (London, 1986), 339–40.
48 *Diary and Letters of Mme d'Arblay*, ed. by her niece, 7 vols (London, 1842–6), I.108.
49 See Desmond Shawe-Taylor, *Genial Company: The Theme of Genius in Eighteenth-Century British Portraiture* (London, 1987), 29.
50 Penny 340.
51 Ibid. 344ff.; Martin Butlin, 'An Eighteenth-Century Art Scandal: Nathaniel Hone's *The Conjuror*', *Connoisseur* CLXXIV (1970), 1–9.
52 For the foregoing see Smith 70–4.
53 Whitley I.372.
54 Quoted in Manners and Williamson 27.
55 Rossi 27. Was this in fact the proposal from 'Horn', which she seems to have accepted by February that year?
56 Rossi 33ff. See Sparrow for the only sceptical account of the story to date.
57 See Helbok, *Miss Angel* 375.
58 Quoted in Whitley, I.373.
59 Sturz I.126.
60 Quoted in Whitley I.372.

Six: Stepping into History

1 Quoted in William Vaughan, 'The Englishness of British Art', *Oxford Art Journal* 13 (2) (1990), 12.
2 See Paul Langford, *A Polite and Commercial People: England 1727–1783* (Oxford, 1989), 2–4.
3 A. von Sternberg, *Berühmte deutsche Frauen des 18. Jahrhunderts*, 2 vols in 1 (Leipzig, 1848), I.165.
4 Archenholz, *Picture* I.131–2.
5 See Frank Herrmann, *The English as Collectors* (London, 1972), 9.
6 Vigée Le Brun II.120.
7 See Linda Colley, *Britons: Forging the Nation 1707–1837* (New Haven and London, 1992), 90–1.
8 Quoted in C. R. Leslie and T. Taylor, *The Life and Times of Sir Joshua Reynolds*, 2 vols (London, 1865), I.299–300.
9 See Ilaria Bignamini and Martin Postle, *The Artist's Model* (Nottingham, 1991), 8.
10 Smith 34.
11 See C. H. S. John, *Bartolozzi, Zoffany and Kaufmann* (London, 1924), vi.
12 Quoted in Shearer West, 'Xenophobia and Xenomania', in Shearer West (ed.), *Italian Culture and Northern Europe in the Eighteenth Century* (Cambridge, 1999), 137.
13 See Sidney H. Hutchison, *The History of the Royal Academy 1768–1986*, 2nd edn (London, 1986), 245.
14 Sir Joshua Reynolds, *Letters*, ed. John Ingamells and John Edgcumbe (New Haven and London, 2000), 201–2 (to Joseph Bonomi, 11 February 1790).
15 Anne Puertz, 'Foreign Exhibitors and the British School at the Royal Academy, 1768–1823', in David H. Solkin (ed.), *Art on the Line* (New Haven and London, 2001), 234–6.
16 British Library Add. MSS 48, 218.

17 Quoted in Ceri Johnson, *Saltram (The National Trust)* (London, 1998), 48.

18 Ibid. 47.

19 Penny 60 (Joshua Reynolds to Daniel Daulby, 9 September 1777).

20 *Memorandum of Paintings*, in Manners and Williamson 163.

21 Johnson 45.

22 Mary Delany, *Autobiography and Correspondence*, ed. Lady Llanover, 3 vols (London, 1862), I.322.

23 Quoted in Sandby I.27.

24 See Peter Cannon-Brookes (ed.), *The Painted Word: British History Painting 1750–1830* (Woodbridge, 1991), 8.

25 On this well-worn topic, see Shearer West, *Portraiture* (Oxford, 2004), 12.

26 See Iain Pears, *The Discovery of Painting* (New Haven and London, 1988), 120.

27 On this and the following matters, see Shearer West, 'Thomas Lawrence's "Half-History" Portraits and the Politics of Theatre', *Art History* 14 (1991), 227ff.

28 See Michael Rosenthal, *The Art of Thomas Gainsborough* (New Haven and London, 1999), 72, quoting from *The Letters of Thomas Gainsborough*, ed. M. Woodall (London, 1963), 95–7.

29 Quoted in David Irwin, 'English Neo-Classicism and Some Patrons', *Apollo* LXXVIII (1963), 360.

30 Ibid., loc. cit.

31 Barry 132–4.

32 Martin Myrone, 'The Sublime as Spectacle', in Solkin, *Art on the Line* 78.

33 See Helmut von Erffa and Allen Staley, *The Paintings of Benjamin West* (New Haven and London, 1986), 68.

34 Quoted in David H. Solkin, *Painting for Money: The Visual Arts and the Public Sphere in Eighteenth-Century England* (New Haven and London, 1993), 181.

35 William Henry Bowles, *Records of the Bowles Family* (London, 1918), 97.

36 Ibid. 138–40.

37 See Gisold Lammel, *Kunst im Aufbruch* (Stuttgart and Vienna, 1998), 47.

38 Walch, 'Angelica Kauffman' 225.

39 See Roy Strong, *And When Did You Last See Your Father?* (London, 1978), 13.

40 Colley 1ff.; Vaughan 12.

41 See Walter Pape and Frederick Burwick (eds), *The Boydell Shakespeare Gallery* (Essen, 1996), 114.

42 For an imaginative treatment of this story, see Peter Ackroyd's *The Lambs of London* (London, 2004).

43 See David Alexander, 'The Print Market', in Wassyng Roworth, *Angelica Kauffman* 172.

44 Ibid. 174.

45 See Matthew Craske, *Art in Europe 1700–1830* (Oxford, 1997), 26.

46 Quoted in Wendy Wassyng Roworth, 'The Art of Painting', in Wassyng Roworth, *Angelica Kauffman* 44.

47 See Karl Kindt, *Klopstock* (Berlin and Spandau, 1941), 435.

48 Erich Schmidt, *Charakteristiken*, 2 vols (Berlin, 1886 and 1901), I.118.

49 See Kevin Hilliard, 'Philosophy, Letters and the Fine Arts in Klopstock's Thought', D. Phil. thesis, University of Oxford, 1984, 49, 167–9.

50 Klopstock to Funk, 17 December 1771 (*Werke und Briefe* V.1.259).

51 For a more detailed version of the discussion, see my article 'Angelica Kauffman: Attenuating the Body', in Angelica Goodden (ed.), *The Eighteenth-Century Body: Art, History, Literature, Medicine* (Oxford, Bern, etc., 2002).

52 See Walch, 'Angelica Kauffman' 149.

53 Gotthold Ephraïm Lessing, *Laokoon, Schriften*, 3 vols (Frankfurt am Main, 1967), II.19.

54 Winckelmann, *Gedanken über die Nachahmung der griechischen Werke in der Malerei und Bildhauerkunst, Werke*, ed. Helmut Holtzhauer, 3rd edn (Berlin and Weimar, 1982), 17.

55 Klopstock, *Werke und Briefe* VII.1.155 (14 March 1780).

56 Klopstock to Gleim, *Werke und Briefe* IX.256 (18 July 1798).

57 See Robert Rosenblum, *Transformations in Late Eighteenth-Century Art* (Princeton, NJ, 1967), 11, quoting from catalogue to 1957 British Museum exhibition *William Blake and his Circle*.

58 Matthisson to Princess Luise von Anhalt-Dessau, quoted by Isidore Hopfner, 'Angelika Kauffmann und die deutschen Klassiker', *Alemania* I (1926–7), 176.

59 Walch questions whether Angelica was given carte blanche to choose a subject, noting that Klopstock had dedicated *Hermanns Schlacht* to Joseph ('Angelica Kauffman' 332).

60 Karl Philipp Moritz, *Reise eines Deutschen in England im Jahre 1782* (Frankfurt am Main and Leipzig, 2000), 32.

61 Moser 254.

62 James Boswell, *London Journal 1762–3*, ed. F. Pottle (London, 1950), 182 (8 February 1763); quoted in Fiona Stafford, *The Sublime Savage* (Edinburgh, 1988), 171.

63 William Hazlitt, *Complete Works*, ed. P. P. Howe, 21 vols (London, 1930–4), V.15; quoted in Stafford 1.

64 *Boswell's Correspondence with the Honourable A. Erskine*, ed. G. Birkbeck Hill (London, 1879), 39.

65 See Rudolf Tombo, *Ossian in Germany* (New York, 1901), 99.

66 See Margaret Jourdain, *English Interior Decoration 1500–1830* (London, 1950), 61.

67 Walch, 'Angelica Kauffman' 149.

Seven: Pretty Women

1 Vigée Le Brun II.146; Angelica Goodden, *The Sweetness of Life: A Biography of Elisabeth Louise Vigée Le Brun* (London, 1997), 252.

2 Vigée Le Brun I.171; Goodden, *Sweetness* 105.

3 Margravine of Anspach, *Memoirs*, 2 vols (London, 1826), II.115.

4 Ibid. 116.

5 See Brian Dolan, *Ladies of the Grand Tour* (London, 2001).

6 See Amanda Foreman, *Georgiana, Duchess of Devonshire* (London, 1998), 219.

7 Ibid. 7.

8 Ibid. 4.

9 Ibid. 19–20.

10 See Annegret Friedrich, 'Lady Elizabeth Foster und Georgiana, Duchess of

Devonshire. Überlegungen zu einer Ikonographie der Freundschaft unter Frauen im 18. Jahrhundert', *Jenseits der Geschlechtergrenzen* (Hamburg, 2001), 58.

11 Angela Rosenthal, 'Portraiture', in Wassyng Roworth, *Angelica Kauffman* 106.

12 See Viktoria Schmidt-Linsenhoff (ed.), *Sklavin oder Bürgerin? Französische Revolution und neue Weiblichkeit 1760–1830* (Frankfurt am Main and Marburg, 1989), 335.

13 Quoted in Foreman 4.

14 Ibid. 257.

15 Archenholz, *Picture* I.38.

16 Vigée Le Brun II.122.

17 See Ivy Leveson Gower, *The Face Without a Frown: Georgiana, Duchess of Devonshire* (London, 1944), 173.

18 Goodden, *Sweetness* 244.

19 See Leveson Gower 34.

20 Archenholz, *Picture* I.38.

21 Foreman 190.

22 Baumgärtel, *Retrospektive* 65, and A. Rosenthal, *Angelika Kauffmann* 227–8, offer divergent interpretations.

23 See Aileen Ribeiro, *The Art of Dress: Fashion in England and France, 1750–1800* (New Haven and London, 1995), 223.

24 See Ellen Spickernagel, 'Zur Anmut erzogen – Weibliche Körpersprache im 18. Jahrhundert', in Ilse Brehmer et al. (eds), *Frauen in der Geschichte IV* (Düsseldorf, 1983), 313.

25 See Philip Mansel, *Constantinople: City of the World's Desire 1453–1924* (London, 1995), 108.

26 Ribeiro, *Art of Dress* 224.

27 Baumgärtel, *Retrospektive* 62.

28 Wortley Montagu I.350.

29 Delany III.185.

30 Quoted in Ribeiro, 'Masquerade' 387.

31 Goodden, *Sweetness* 178.

32 Jean-Jacques Rousseau, *Emile, Œuvres complètes*, ed. Bernard Gagnebin and Marcel Raymond, 5 vols (Paris, 1959–95), IV.700–1.

33 Quoted in Gerard 140.

Eight: The Sweetness of Life

1 See Malise Forbes Adams and Mary Mauchline, 'Kauffman's Decorative Work', in Wassyng Roworth, *Angelica Kauffman* 113.

2 Northcote II.306.

3 Reynolds, *Letters* 45 (20 July 1773).

4 Northcote 309.

5 Ibid. 311.

6 Ibid. 309.

7 Reynolds, *Letters* 181 (to the Duke of Rutland, 13 February 1787); see also Marcia Pointon, 'Portrait! Portrait! Portrait!', in Solkin, *Art on the Line* 93.

8 On these paintings, see Wassyng Roworth, 'The Art of Painting' in idem, *Angelica Kauffman* 68–72.

9 Quoted by Forbes Adam and Mauchline in Wassyng Roworth, *Angelica Kauffman* 119.

10 Ibid. 134.

11 On Kauffman and Wedgwood, see Robin Reilly, *Wedgwood*, 2 vols (London, 1989), I.15, 415 n.

12 See Thilo Tuchscherer (ed.), *Verrückt nach Angelika: Porzellan und anderes Kunsthandwerk nach Angelika Kauffmann* (Düsseldorf, 1998), 82–3.

13 See Natalia Kasakiewitsch, 'Reproduktionen von Bildern Angelika Kauffmanns auf Wiener Porzellan', *Keramos* 136 (1992), 9–10; Margaret Zimmermann, 'Angelica Kauffman, 1741–1807: Painter and Source of Ceramic Decoration', *International Ceramics Fair and Seminar, 1995* (London, 1995), 36ff.

14 See Sarah Richards, *Eighteenth-Century Ceramics* (Manchester, 1999), 1–2.

15 Ibid. 4.

16 Ibid. 54–5.

17 Wilhelm Tischbein, *Collection of Engravings from Ancient Vases in the Possession of Sir William Hamilton, Published by Mr Wilhelm Tischbein, Director of the Royal Academy of Painting at Naples* (Naples, 1781), I.68–70.

18 See Peter Bradshaw, *Derby Porcelain Figures 1750–1848* (London, 1990), 143.

19 Ibid. 454.

20 Helbok, *Miss Angel* 117; Kasakiewitsch 9.

21 See Claudia Maué, 'Angelika Kauffmann invenit – Bildvorlagen für Wiener Porzellan', *Keramos* 90 (1980), 22.

22 Zimmermann 38.

23 See Waltraud Neuwirth, *Wiener Porzellan: Original, Kopie, Verfälschung, Fälschung* (Vienna, 1979), 381.

24 Maué 24.

25 See Tuchscherer 11.

26 23 March 1781, quoted in G. Wooliscroft Rhead, *History of the Fan* (London, 1910), 192.

27 Forbes Adams and Mauchline in Wassyng Roworth, *Angelica Kauffman* 140.

28 Wooliscroft Rhead 193.

29 Ibid. 194.

30 Quoted in ibid. 185.

31 Zimmermann 41.

32 Langford 68–9.

33 Lichtenberg 97.

34 See Margaret Jourdain, 'Matthew Boulton: An Artist in Ormolu', *Country Life Annual* (1950), 52.

35 See Eric Robinson and Keith R. Thompson, 'Matthew Boulton's Mechanical Paintings', *Burlington Magazine* CXII (1970), 502ff.

36 Quoted in Dolan 254.

37 Ibid., loc. cit.

38 Quoted in Walter S. Scott, *The Bluestocking Ladies* (London, 1947), 194.

39 Quoted in Hemlow 137.

40 See Sylvia Myers, 'Learning, Virtue and the Term "Bluestocking"', *Studies in Eighteenth-Century Culture* 15 (1986); also her *Bluestocking Circle* (Oxford, 1990).

41 See Whitley I.374 on Angelica's salon.
42 Klopstock, *Werke und Briefe* VII.1.223 (Schönborn to Klopstock, 19 October 1781).
43 Quoted in Helbok, *Miss Angel* 102.
44 Zucchi 58.
45 Goethe, 'Philipp Hackert. Biographische Skizze', *Schriften zur bildenden Kunst, Berliner Ausgabe*, 22 vols (Berlin and Weimar, 1965–78), XIX.545.
46 Quoted in Whitley II.312.
47 See Elena Cazzulani and Angelo Stroppa, *Maria Hadfield Cosway: Biografia, diarie scritti della fondatrice del Collegio delle dame inglese in Lodi* (Milan, 1989), 13.
48 George C. Williamson, *Richard Cosway, R.A., and his Wife and Pupils* (London, 1897), 10–11.
49 Quoted in Williamson 15.
50 Quoted in Lloyd 41.
51 Ibid. 42.
52 Williamson 16.
53 Lloyd 47.
54 Williamson 27.
55 Both letters quoted in Helbok, *Miss Angel* 129.
56 Schönborn to Klopstock, Klopstock, *Werke und Briefe* VII.1.170 (30 June 1780).
57 See Dorothy Moulton Mayer, *Angelica Kauffmann, R.A.* (Gerrards Cross, 1972), 55.
58 Sturz I.126–9.

Nine: 'Roma mi è sempre in pensiero'

1 Schönborn to Klopstock, Klopstock, *Werke und Briefe* VII.1.139 (18 October 1779).
2 Rossi 51.
3 Quoted in Manners and Williamson 120.
4 Ibid. 50; Helbok, *Miss Angel* 136.
5 Rossi 84 n. 20.
6 Pasquin 133.
7 See Julius Bryant, *The Iveagh Bequest: Kenwood* (London, 1990), 18.
8 Ibid. 20.
9 Ibid. 19.
10 Baumgärtel, *Retrospektive* 179–80.
11 See John Robinson, 'No. 20 St James's Square, London', *Country Life* CLX (1989), 154.
12 Schönborn to Klopstock, Klopstock, *Werke und Briefe* VII.1.223 (19 October 1781).
13 Farington I.108.
14 Ibid. I.74.
15 Ibid. I.109.
16 Ibid. I.74.
17 Ibid., loc. cit.
18 Rossi 51.

19 Quoted in Gerard 172–4.
20 See Manners and Williamson 122.
21 Rossi 53.
22 Schönborn to Klopstock, Klopstock, *Werke und Briefe* VII.1.223 (19 October 1781).
23 Quoted in Manners and Williamson 107; English in original.
24 Rossi 52.
25 See Peter Meadows and John Cornforth, 'Joseph Bonomi, Draughtsman Decorator', *Country Life* CLXI (1990), 164–7.
26 Zucchi 184 n.129.
27 Kauffman to Metzler, 23 July 1782, in Maierhofer, *Briefe* 82.
28 Baumgärtel, *Retrospektive* 232.
29 Helbok, *Miss Angel* 150 n. 23.
30 Quoted in Helbok, *Miss Angel* 152 (22 February 1782).
31 Ibid., loc. cit.
32 Kauffman to Metzler, 23 July 1782, in Maierhofer, *Briefe* 82.
33 Quoted in Helbok, *Miss Angel* 155, and Baumgärtel, *Retrospektive* 34 (but misdated there to January 1782).
34 Jones 115.
35 Quoted in Baumgärtel, *Retrospektive* 34.
36 Ibid. 155.
37 See Ursula Tamussino, *Des Teufels Grossmutter* (Vienna, 1991), 2.
38 Catherine Wilmot, *An Irish Peer on the Continent*, ed. Thomas U. Sadleir (London, 1920), 141.
39 Kauffman to Metzler, 29 September 1782, in Maierhofer, *Briefe* 85.
40 Wilmot 148.
41 Anspach I.291.
42 William Beckford, *Italy; With Sketches of Spain and Portugal*, 2nd rev. edn, 2 vols (London, 1834), I.249, quoted in Duncan Bull (ed.), *Classic Ground: British Artists and the Landscape of Italy* (New Haven, 1981), 12.
43 Wilmot 148.
44 Vigée Le Brun I.226.
45 Goodden, *Sweetness* 128.
46 Ramsay, 'Journal'.
47 Wilmot 148.
48 Maierhofer, *Briefe* 89.
49 Joseph Forsyth, *Remarks on Antiquities, Arts, and Letters during an Excursion in Italy in the Years 1802 and 1803*, 3rd edn, 2 vols (London, 1824), I.290.
50 British Library Egerton MS 2169.
51 See Friedrich Noack, *Deutsches Leben in Rom 1700 bis 1900* (Stuttgart and Berlin, 1967), 367.
52 British Library Egerton MS 2169.
53 See Wassyng Roworth, 'Profit' 225.
54 Kotzebue II.220.
55 Gerning II.141.
56 Baumgärtel, *Retrospektive* 249.

57 See Helbok, *Miss Angel 156*; Sabine Hammer, 'Angelika Kauffmann als Porträtistin', MA thesis, University of Vienna, 1989, 72.

58 Wilmot 170.

59 Helbok, *Miss Angel* 169; Sandner, *Angelika Kauffmann und Rom* 110.

60 Maierhofer, *Briefe* 160.

61 3 December 1784, quoted in Baumgärtel, *Retrospektive* 34.

Ten: Command Performances

1 Goethe, *Italienische Reise* 471.

2 Antoine Schnapper, *David: témoin de son temps* (Paris, 1980), 80.

3 Alois Hirt, *Briefe aus Rom hauptsächlich neue Werke jetzt daselbst lebender Künstler betreffend, Der teutsche Merkur* (December 1785), 258.

4 See Edgar Peters Bowron and Joseph J. Rishel, *Art in Rome in the Eighteenth Century* (Philadelphia, 2000), 385.

5 See Hermann Mildenberger, 'Cornelia und Julia als Vorbilder', in *Angelika Kauffmann: 'Julia, die Gattin des Pompeius, fällt in Ohnmacht' und 'Cornelia, die Mutter der Gracchen'*, Patrimonia 90 (Kunstsammlungen zu Weimar, Weimar, 1996), 20–1.

6 A. Morrison, 117.

7 Ibid. 130–1, 133 (4 August 1787).

8 Ibid. 119.

9 Quoted in Ingamells 456.

10 Gouverneur Morris, *Diaries and Letters*, ed. Anne Cary Morris, 2 vols (London, 1889), I.453; Dorothy Margaret Stuart, *Dearest Bess: The Life and Times of Lady Elizabeth Foster* (London, 1955), 59 (letter of 10 August 1791).

11 Quoted in Stuart, loc. cit.

12 J. B. S. Morritt, *A Grand Tour: Letters and Journeys 1794-96*, ed. G. E. Marindin (London, 1985), 282 (14 February 1796).

13 Ibid. 268.

14 Vigée Le Brun I.202.

15 A. Morrison I.197 (18 December 1794).

16 See Flora Fraser, *Beloved Emma: The Life of Emma Lady Hamilton* (London, 1986), 114.

17 Sir Gilbert Elliot, *Life and Letters from 1751 to 1806*, ed. Countess of Minto, 3 vols (London, 1874), II.364; quoted in Ingamells 457–8.

18 Farington IV.1557.

19 Ibid. VI.2280.

20 Morritt 281 (14 February 1796).

21 Juliana de Krüdener, *Valérie (1803)*, ed. Michel Mercier (Paris, 1974), 66.

22 Quoted in Baumgärtel, *Angelika Kauffmann* 149 (to Sir William Hamilton, 17 May 1790). English in original.

23 See Ian Jenkins and Kim Sloan, *Vases and Volcanoes* (London, 1986), 272.

24 Maierhofer, *Briefe* 151 (31 December 1793); also Manners and Williamson 87. English in original.

25 Jenkins and Sloan 273.

26 Foreman 126.
27 Ibid. 132.
28 Ibid. 259.
29 See N. Brooke, *Observations on the Manners and Customs of Italy* (London, 1798), 295–6.
30 Piozzi II.64.
31 Ingamells 129; W. S. Childe-Pemberton, *The Earl-Bishop*, 2 vols (London, 1924), II.577; Vere Foster, *Two Duchesses* (Bath, 1972), 152–3.
32 Childe-Pemberton II.418; Ingamells 128.
33 Ingamells 128.
34 Childe-Pemberton I.1.
35 Morritt 288.
36 British Library Add. MSS 41200 (29 May 1798).
37 Wilmot 178.
38 Quoted in Brinsley Ford, 'The Earl-Bishop: An Eccentric and Capricious Patron of the Arts', *Apollo* XCIX (1974), 426.
39 Wilmot 179.
40 Vigée Le Brun I.197.
41 Comte de Ségur, *Mémoires, ou souvenirs et anecdotes*, 3 vols (Stuttgart, 1829), II.245.
42 Princesse Daschkoff, *Mémoires*, ed. Pascal Portremoli (Paris, 1989), 122.
43 Friedrich Melchior Grimm, *Correspondance artistique avec Catherine II*, ed. L. Réau, *Archives de l'art français*, nouvelle période, XVII (1932), 199.
44 Quoted in Helbok, *Miss Angel* 160–1 (17 February 1784).
45 Moulton Mayer 110.
46 Dieter Ulrich, 'Alexander Trippel et Angelika Kauffmann: deux personnalités artistiques centrales à Rome à la fin du XVIIIe siècle', in *Entre Rome et Paris: œuvres inédites du XIVe au XIXe siècle* (Lausanne, 1996), 39.
47 Quoted in Baumgärtel, *Retrospektive* 292.
48 See C. H. Vogler, *Der Bildhauer Alexander Trippel* (Schaffhausen, 1892–3), 31.
49 Ulrich 39–40.
50 Baumgärtel, *Angelika Kauffmann* 185.
51 Moore I.386.
52 Vigée Le Brun I.248.
53 Ibid. I.267.
54 Goethe, *Italienische Reise* 368–9.
55 See *Voyage de deux Français dans le nord de l'Europe*, 5 vols (Paris, 1796), V.192.
56 Quoted in Ingamells 586 (letter of 27 August 1797).
57 William Beckford, *Dreams, Waking Thoughts and Incidents* (London, 1783), 215; see also Fraser 36.
58 James Irvine, quoted in Ingamells 72.
59 Beckford, *Dreams* 204.
60 Louis Melville, *Life and Letters of William Beckford of Fonthill* (London, 1910), 157; Ingamells 72.
61 Quoted in Manners and Williamson 60 n.1.

Eleven: Goethe and the Undulist

1 Goethe, *Briefe*, ed. Karl Robert Mandelkow, 4 vols (Hamburg, 1968), II.94 (5 June 1788).

2 See Jeffrey Morrison, *Winckelmann and the Notion of Aesthetic Education* (Oxford, 1996), 218.

3 Ibid. 218–19.

4 See Nicholas Boyle, *Goethe: The Poet and the Age*, I: *The Poetry of Desire* (Oxford, 1991), 446.

5 Goethe, *Italienische Reise* 205.

6 Boyle 446.

7 See Friedrich Noack, 'Aus Goethes römischer Kreise', *Goethe-Jahrbuch* XXV (1904), 187.

8 *Goethe in vertraulichen Briefen seiner Zeitgenossen*, ed. Wilhelm Bode, new edn, ed. Regine Otto and Paul Gerhard Wenzlaff, 3 vols (Berlin and Weimar, 1982), I.321–2 (9 December 1786).

9 Friedrich (who usually called himself 'Maler', Painter) Müller led the double life that Angelica's 'Herculean' self-portrait shows her rejecting, though the arts he cultivated were painting and literature. He came to Rome in 1778 to develop his skills as a painter and never returned to Germany.

10 Goethe, *Vertrauliche Briefe* I.335.

11 Goethe, *Briefe* II.49 (7–10 [?] February 1787).

12 *Briefe an Goethe*, ed. Karl Robert Mandelkow, 2 vols (Hamburg, 1965), I.78.

13 See Johannes Nohl, *Goethe als Maler Möller in Rom* (Weimar, 1955), 18–19.

14 Letters of 4 November 1788 and 21 February 1789; Noack, 'Aus Goethes römischer Kreis' 186; see also Boyle I.259–65, 301, 576, 578.

15 Goethe, *Italienische Reise* 370.

16 Ibid. 371.

17 Ibid. 372.

18 Ibid. 390.

19 Ibid. 388.

20 Quoted in Nobs-Greter 19.

21 Ibid. 27–8, 34.

22 Ibid.130–1.

23 Goethe, *Der Sammler und die Seinigen, Goethes Werke, Weimarer Ausgabe*, 55 vols (Weimar, 1887–1919), XLVII.200.

24 Goethe, *Italienische Reise* 353.

25 *Herders italienische Reise* 360 (27 February 1789). Baumgärtel points out (*Retrospektive* 83 n. 31) that earlier editions of Herder's *Italienische Reise* incorrectly have him declaring that there is a definite *lack* of resemblance in the portrait.

26 See Sabine Schulze, 'Goethe und die Kunst', in Sabine Schulze (ed.), *Goethe und die Kunst* (Ostfildern, 1994), 9.

27 Gudrun Körner, 'Über die Schwierigkeit der Porträtkunst. Goethes Verhältnis zu Bildnissen', in idem, 155–6.

28 Ulrich 37.

29 Goethe, *Italienische Reise* 418.

30 Ibid. 421.

31 Ibid. 419.
32 Ibid. 416.
33 Quoted in Irmgard Smidt, 'Angelika Kauffmann, Goethes Freundin in Rom', *Jahrbuch des Wiener Goethe-Vereins* 67 (1963), 112.
34 Goethe, *Italienische Reise* 521.
35 Boyle I.488.
36 Goethe, *Italienische Reise* 444.
37 Quoted in Baumgärtel, *Retrospektive* 35.
38 Goethe, *Italienische Reise* 432.
39 Goethe, *Vertrauliche Briefe* I.344 (Göschen to Bertuch, 28 November 1787).
40 Goethe, *Italienische Reise* 459.
41 Ibid. 431.
42 Ibid. 432.
43 Ibid. 459.
44 'Freilich ist die Poesie nicht für's Auge gemacht', Goethe, *Italienische Reise* 164 ('Admittedly poetry is not made for the eye').
45 See Goodden, 'Angelica Kauffman', in idem, *The Eighteenth-Century Body*.
46 Goethe, *Italienische Reise* 164.
47 Quoted in *Schriften der Goethe-Gesellschaft: Tagebücher und Briefe Goethes aus Italien an Frau von Stein und Herder*, ed. Erich Schmidt (Weimar, 1886), 413 (n. to p. 237).
48 Goethe, *Italienische Reise* 165.
49 Ibid., loc. cit.
50 Ibid. 169.
51 Ibid. 205.
52 To Philipp Seidel, Goethe, *Briefe* II.60 (8 June 1787).
53 Quoted in Thurnher 112 (15 August 1787).
54 Ibid. 113 (27 October 1787).
55 Ibid. 60.
56 Ibid. 61 (23 May 1789).
57 *Briefe an Goethe* I.95–6.
58 Boyle I.504ff.
59 Goethe, *Briefe* II.112 (2 March 1789).
60 *Herders italienische Reise* 410 (4 April 1789) and 414 (8 April 1789).
61 Quoted in Thurnher 55.
62 Goethe, *Werke, Weimarer Ausgabe* IV.XI.91.
63 Ibid. IV.XII.14–16 (18 January 1797).
64 *Briefe an Goethe* I.102
65 Goethe, *Italienische Reise* 546.
66 Ibid. 154.
67 Ibid. 551.
68 Goethe, 'Der Verfasser teilt die Geschichte seiner botanischen Studien mit', *Werke, Hamburger Ausgabe* 13.165.
69 Quoted in Thurnher 54.
70 *Herders italienische Reise* 444 .
71 Quoted in Thurnher 64 (10 October 1789); also Baumgärtel, *Angelika Kauffmann* 225.

Twelve: The World from the Studio

1 See Vernon Lee, *Studies of the Eighteenth Century in Italy* (London, 1880), 7–16; Hanns Gross, *Rome in the Age of Enlightenment* (Cambridge, 1990), 294–5.

2 Samuel Sharp, *A View of the Customs, Manners, Dramas &c. of Italy* (London, 1768), 16.

3 J. Christopher Herold, *Mistress to an Age: A Life of Madame de Staël* (Indianapolis and New York, 1958), and Moulton Mayer 113.

4 See Wilhelm Bode, *Amalie, Herzogin von Weimar*, 3 vols (Berlin, 1908), III.19.

5 See Paul Weizsäcker, *Anna Amalia, Herzogin von Sachsen-Weimar, die Begründerin des Weimarischen Musenhofes* (Hamburg, 1892), 31.

6 Goethe to Karl August, quoted in Thurnher 109 (25 January 1788).

7 Matthisson, *Erinnerungen*, quoted in Thurnher 168.

8 Quoted in Bode III.18 (5 November 1788).

9 *Herders italienische Reise* 181.

10 Quoted in Weizsäcker 39 (23 April 1789).

11 Quoted in Bode III.183 (7 September 1789).

12 Ibid. 18.

13 Ibid. 21 (27 December 1788).

14 Quoted in Weizsäcker 41 (to Anna Amalia, 1 January 1806).

15 See Hermann Mildenberger, 'Angelika Kauffmanns Bildnis der Anna Amalia Herzogin von Sachsen-Weimar-Eisenach', in *Das Römische Haus in Weimar* (Munich and Vienna, 2001), 75–81.

16 Goethe, 'Zur Nachgeschichte der italienischen Reise', in *Schriften der Goethe-Gesellschaft* V.106.

17 Anna Amalia to Knebel, 18 November 1788, quoted in Thurnher 158.

18 Matthisson, *Briefe* II.193 (27 May 1794).

19 Quoted in Bode III.33–4.

20 See Andrew Wilton and Ilaria Bignamini (eds), *Grand Tour: The Lure of Italy in the Eighteenth Century* (London, 1996), 76.

21 *Herders italienische Reise* 306.

22 Ibid. 388.

23 Ibid. 362.

24 Ibid. 502.

25 See Bode II.96.

26 *Briefe an Goethe* I.111–12 (3 December 1788).

27 Goethe, 'Zur Nachgeschichte der italienischen Reise' 106 (Anna Amalia to Goethe, 29 November 1788).

28 *Herders italienische Reise* 333.

29 Ibid. 413.

30 Ibid. 434.

31 Ibid. 438.

32 Ibid. 480.

33 See Waltraud Maierhofer, *Angelika Kauffmann* (Hamburg, 1997), 108.

34 Herder, *Briefe zur Beförderung der Humanität*, *Werke*, ed. Hans Dietrich Irmscher, 10 vols (Frankfurt am Main, 1991), VIII.395.

35 *Herders italienische Reise* 448 (2 May 1789).

36 Nobs-Greter 126.

37 Quoted in Weizsäcker 39 (Anna Amalia to Goethe, 23 April 1789).
38 *Herders italienische Reise* 395.
39 Ibid. 300.
40 Weizsäcker 10.
41 Quoted in Thurnher xxx.
42 Lady Knight, *Letters from France and Italy*, ed. Lady Eliott-Drake (London, 1905), 137.
43 Ibid. 190–1.
44 Ibid. 216.
45 Fraser 376.
46 Knight 190.
47 Quoted in Ingamells 583.
48 Ibid.
49 Shawe-Taylor 19.
50 Ingamells 307–8.
51 Smith I.250–1.
52 Quoted in Ingamells 556.
53 Quoted in Whitley II.308.
54 See Brinsley Ford, 'Thomas Jenkins, Banker, Dealer and Unofficial English Agent', *Apollo* XCIX (1974), 416.
55 Jones 94.
56 Mariane Kraus, *Für mich gemerkt auf meiner Reise nach Italien im Jahre 1791. Reisetagebuch der Malerin und Erbacher Hofdame*, ed. Helmut Brosch (Buchen, 1996), 98, 135–6; see Bärbel Kovaleski (ed.), *Zwischen Ideal und Wirklichkeit: Künstlerinnen der Goethe-Zeit zwischen 1750 und 1850* (Ostfildern-Ruit, 1999), 26.
57 Kraus 140.
58 Shearer West, 'Gender and Internationalism: The Case of Rosalba Carriera', in idem, *Italian Culture* 53.
59 Quoted in Thurnher 51.
60 See Angela Rosenthal, 'Angelika Kauffmann Mas[k]ing Claims', *Art History* 15 (1992), 478.
61 Both quotations in Moser 259.
62 Quoted in Thurnher 196.
63 Friedrich Johann Lorenz Meyer, *Darstellungen aus Italien* (Berlin, 1792), 137.
64 Kotzebue II.219.
65 See Maierhofer, *Angelika Kauffmann* 126.
66 Piozzi I.318–19.
67 See Paola Giuli, 'Tracing a Sisterhood: Corilla Olympica as Corinne's Unacknowledged Alter Ego', in Karyna Szmurlo (ed.), *The Novel's Seductions* (London, 1999), 165.
68 Piozzi I.321.
69 Rossi 76.
70 Vigée Le Brun I.171.
71 Quoted in Farington VI.2287.
72 Hoppner xi.
73 Goethe, *Italienische Reise* 378.

74 Vigée Le Brun I.179.
75 See Joseph Govani, *Mémoires secrets et critiques des cours, des gouvernements et des mœurs des principaux états de l'Italie*, 3 vols (Paris, 1893), II.158.
76 Lady Anne Miller, *Letters from Italy in the Years 1770 and 1771*, 2 vols (London, 1776), II.193.
77 D'Espinchal 74.
78 *Bergeret et Fragonard: Journal inédit d'un voyage en Italie* , 1773–4, ed. A. Tornézy (Paris, 1895), entry for 10 December 1773; d'Espinchal 75.
79 Quoted in Thurnher 192.
80 Goethe, *Italienische Reise* 378–9.
81 Rossi 74–5.
82 Goethe, *Italienische Reise* 517–18.
83 See Helbok, *Miss Angel* 188.
84 See Baumgärtel, *Retrospektive* 36 (letter of 20 April 1785).

Thirteen: 'These Happy Times Are Over'

1 Reynolds, *Letters* 181 (13 February 1787).
2 Ibid. 229–30.
3 Friedman 4–5.
4 See T. S. R. Boase, 'Illustrations of Shakespeare's Plays in the Seventeenth and Eighteenth Centuries', *JWCI* 10 (1947), 96.
5 Northcote, quoted in Friedman 116.
6 See Pape and Burwick 9 and *passim*.
7 Angelica to Goethe, 21 September 1788, quoted in Baumgärtel, *Retrospektive* 221.
8 Friedman 90.
9 Boase 102–3.
10 Quoted in Manners and Williamson 97.
11 Both quotations in Moser 258. English in original.
12 Quoted in Baumgärtel, *Retrospektive* 434–5, where the transcription has 'W. Forbes'. English in original.
13 Rossi 74.
14 Helbok, *Miss Angel* 206.
15 See G. H. Pilo, 'Lettere di Pellegrini a Canova', *Paragone* 185 (1965), 54, quoted in Baumgärtel, *Angelika Kauffmann* 115.
16 Quoted in Thurnher 125 (24 November 1795).
17 Quoted in Thurnher 192.
18 See Maierhofer, *Angelika Kauffmann* 125.
19 Quoted in Moulton Mayer 167–8. English in original.
20 Quoted in Baumgärtel, *Retrospektive* 37.
21 Gross 369.
22 Quoted in Manners and Williamson 101.
23 Ibid. 102.
24 Quoted in Helbok, *Miss Angel* 208.
25 Ibid. 211.
26 Quoted in Maierhofer, *Angelika Kauffmann* 127.
27 Manners and Williamson 102.

28 See Schmidt-Linsenhoff 119.
29 Baumgärtel, *Retrospektive* 137.
30 Kotzebue 221.
31 Wilmot 178.
32 Quoted in Norman H. MacDonald, *The Clan Ranald of Knoydart and Glengarry* (Edinburgh, 1979), 143–4.
33 Baumgärtel, *Retrospektive* 435. English in original.
34 Helbok, *Miss Angel* 201.
35 Rossi 92.
36 Quoted in Manners and Williamson 103.
37 Matthisson, *Erinnerungen*, 5 vols (Vienna, 1815), IV.122.
38 Quoted in Manners and Williamson 103–4.
39 Rossi 93.
40 Manners and Williamson 107.
41 Vigée Le Brun I.255.
42 Wilmot 178.
43 Baumgärtel, *Retrospektive* 38.
44 Quoted in ibid., loc. cit.
45 Maierhofer, *Briefe* 7.
46 Germaine de Staël, *Correspondance générale*, ed. Béatrice Jasinski, 6 vols (Paris, 1962–93), V.543.
47 Ibid. VI.522.
48 On this and the following, see Baumgärtel, *Retrospektive* 91ff.
49 Quoted in Manners and Williamson 109. English in original.
50 Quoted in Moser 251.
51 Rossi 100–1.
52 Quoted in Baumgärtel, *Retrospektive* 94.
53 Rossi 104.
54 Manners and Williamson 111.
55 Quoted in Baumgärtel, *Retrospektive* 94.
56 See Ferdinand Boyer, *Le Monde des arts en Italie et la France de la révolution et de l'Empire* (Turin, 1970), 197–202.
57 See Joseph Langl, 'Das Testament der Angelika Kauffmann', *Zeitschrift für bildende Kunst* XXIV (1888–9), 295.
58 Details supplied by Dr Borsi in his letter to Giuseppe Bonomi, quoted in Moser 262.
59 Friederike Brun, *Neue Gedichte* (Darmstadt, 1812), 124–5, quoted in Helbok, *Miss Angel* 25.
60 For these and the following details, see Langl 295ff.

Conclusion

1 Manners and Williamson 4.
2 See Parker and Pollock 29.
3 John Flaxman, quoted in Moulton Mayer 35.
4 See Kidson 6: 'he was made for the times, and the times were made for him' (from *Pilkington's Dictionary* (1805)).
5 Bowles 126.

6 Manners and Williamson, 231, provide a list of representative prices up to the early twentieth century.

7 See Gerard 361.

8 Baumgärtel, *Retrospektive* 96.

9 Ibid. 435.

10 Ibid. 96.

11 See *The Analytical Review*, June 1788, 220, for this and the following quotation.

12 See Oscar Sandner (ed.), *Hommage an Angelika Kauffmann* (Milan, 1992), 15.

13 Quoted in idem 45.

14 See Lyndall Gordon, *Mary Wollstonecraft: A New Genus* (London, 2005), 177–8.

15 For other ambiguities in Fuseli's work see Annegret Friedrich, 'Variationen eines Alptraums: *The Nightmare* von Johann Heinrich Füssli', in Volker Kapp et al. (eds), *Subversive Romantik* (Berlin, 2004).

16 Germaine Greer, *The Obstacle Race* (London, 1979), 80.

17 Matthisson, *Briefe* II.159 (15 April 1794).

18 See also Baumgärtel, *Retrospektive* 302.

19 Friederike Brun, *Römisches Leben*, quoted in Thurnher 182.

20 Hirt 254.

21 See Irwin, 'Angelica Kauffman and her Times', *Burlington Magazine* CX (1968), 254.

22 Sternberg 185.

23 See Louise Rice and Ruth Eisenberg, 'Angelica Kauffman's Uffizi Self-Portrait', *Gazette des beaux-arts* 117 (1991), 125.

24 F. Meyer, quoted in Thurnher 196.

25 Kotzebue 221.

26 See West, *Portraiture* 24, quoting Erwin Panofsky.

27 Hirt 265.

28 Baumgärtel, *Angelika Kauffmann* 137.

29 Obermeier 48.

30 Quoted in Gerard 74.

31 Ellis Waterhouse, *Painting in Britain 1530 to 1790*, 4th edn (Harmondsworth, 1978), 268–9.

32 See Peter Gorsen in Gislind Nabakowki et al., *Frauen in der Kunst*, 2 vols (Frankfurt am Main, 1980), II.120ff.

33 See Pape and Burwick 154 (quoting from Hazlitt's essay 'On Egotism').

34 On this painting see also Elizabeth Eger, 'Representing Culture. The Nine Living Muses of Great Britain (1779)', in Elizabeth Eger et al. (eds), *Women, Writing and the Public Sphere 1700–1830* (Cambridge, 2001), and Annegret Friedrich, ' "The Nine Living Muses of Great Britain" – Zu Selbstinszenierungen weiblicher Intellektualität in der Porträtmalerei des 18. Jahrhunderts', in Daniela Hack (ed.), *Frauen in der Stadt. Selbstzeugnisse des 16.–18. Jahrhunderts* (Ostfildern, 2004).

35 Fanny Burney (Mme d'Arblay), *Journals and Letters*, ed. Joyce Hemlow et al., 12 vols (Oxford, 1972–84), III.141 (to Dr Burney, 4 June 1798).

Select Bibliography

Abbreviations
JVL Jahrbuch des Vorarlberger Landesmuseumsvereins
JWCI Journal of the Warburg and Courtauld Institutes
PMLA Publications of the Modern Language Association of America

Manuscript Sources
1 Britain

(London) British Library, Add. MSS 48, 218, 35639, 37077, 39577, 40714, 40715, 41197, 41200, 42069; Egerton MSS 1621, 2169, 2638, 2641
National Art Library, MSL/1998/7/11
National Register of Archives, Hardwicke Court 10000.
Public Record Office (PRO), WORK 14/1743; State Papers Foreign, 105/315, f. 557

(Edinburgh) National Library of Scotland MSS 1833/4, 1998/7/11
Scottish Record Office, Seafield Papers GD 248/49/2

2 Austria

(Vienna) Haus-, Hof- und Staatsarchiv Kabinettsarchiv, Zinzendorf, *Tagebuch*
(Bregenz) Vorarlberger Landesmuseum, Zucchi MS, inv.n. A. G. 10

3 Germany

(Munich) Geheimes Hausarchiv, NL, Ludwig 1.90/i/L
(Weimar) Thüringisches Hauptstaatsarchiv, HAA XVIII.64, f. 78

4 Switzerland

(Chur) Staatsarchiv, Briefe der Angelika Kauffmann an Carl Ulysses von Salis-Marschlins

5 United States
(Santa Monica) Getty Research Institute: Romagnoli MSS, Special Collections 90–A136M

Printed Sources

Ackroyd, Peter, *The Lambs of London* (London, 2004)

—*London: The Biography* (London, 2000)

Alewyn, Richard, ' "Klopstock!" ', *Euphorion* 73 (1979)

Alexander, David (ed.), *Affecting Moments: Prints of English Literature made in the Age of Sensibility, 1775–1800*, revised edn (York, 1992)

Allen, Brian, 'Conspicuous by its Absence: British History Painting', *Apollo* LXXVIII (1963)

Angelica Kaufmann: 'Julia, die Gattin des Pompeius, fällt in Ohnmacht' und 'Cornelia, die Mutter der Gracchen', *Patrimonia* 90 (Kunstsammlungen zu Weimar, Weimar, 1996)

Anspach, Margravine of, *Memoirs*, 2 vols (London, 1826)

Archenholz, J. W. von, *England und Italien*, 5 vols (Karlsruhe, 1791)

—*A Picture of England*, 2 vols (London, 1781)

Ashby, Thomas, 'Thomas Jenkins in Rome', *Papers of the British School in Rome* 6 (1913)

Ashelford, Jane, *The Art of Dress* (London, 1996)

D'Ayala, Michelangelo, 'A. Kaufmann a Napoli', *Napoli nobilissima* 7 (1898)

Barry, James, *An Inquiry into the Real and Imaginary Obstructions to the Acquisition of the Arts in England* (London, 1775)

Barta, Ilsebill, et al. (eds), *FrauenBilderMännerMythen* (Berlin, 1987)

Battersby, Christine, *Gender and Genius: Towards a Feminist Aesthetics* (London, 1989)

Baumgärtel, Bettina, *Angelika Kauffmann (1741–1807): Bedingungen weiblicher Kreativität in der Malerei des 18. Jahrhunderts* (Weinheim and Basel, 1990)

—'Angelika Kauffmann: une Européenne à Rome', in *Entre Rome et Paris: Œuvres inédites du XIVe au XIXe siècles* (Lausanne, 1996)

—'Die Attitüde und die Malerei – Paradox der stillen Bewegtheit in Synthese von Erfindung und Nachahmung', *Zeitschrift des deutschen Vereins für Kunstwissenschaft* 46 (1992)

—'Freiheit – Gleichheit – Schwesterlichkeit', in Viktoria Schmidt-Linsenhoff (q.v.)

—'Die Ohnmacht der Frauen – Sublimer Affekt in der Historienmalerei des 18. Jahrhunderts', *Kritische Berichte* 18 (1990)

—(ed.), *Retrospektive Angelika Kauffmann* (Ostfildern-Ruit, 1998)

—and Silvia Neysters (eds), *Die Galerie der starken Frauen: Die Heldin in der französischen und italienischen Kunst des 17. Jahrhunderts* (Düsseldorf, 1995)

Beaucamp, Edouard, 'Klopstock contra Winckelmann', in Herbert Beck et al. (eds), *Ideal und Wirklichkeit der bildenden Kunst im späten 18. Jahrhundert* (Berlin, 1984)

Bell, Whitfield J., Jr, *John Morgan, Continental Doctor* (Philadelphia, 1965)

Benjamin, Walter, 'The Work of Art in the Age of Mechanical Reproduction', *Illuminations*, ed. Hannah Arendt, trans. Harry Zohn (London, 1955)

Benkowitz, Miriam J., 'Some Observations on Woman's Conception of the Self in the Eighteenth Century', in Paul Fritz and Richard Morton (eds), *Women in the Eighteenth Century* (Toronto, 1976)

Berckenhagen, Ekhart, 'Anna Dorothea Therbusch', *Zeitschrift des deutschen Vereins für Kunstwissenschaft* 41 (1987)

Bermingham, Ann, 'The Aesthetic of Ignorance: The Accomplished Woman in the Culture of Connoisseurship', *Oxford Art Journal* 16 (1993)

—and John Brewer (eds), *The Consumption of Culture 1600–1800: Image, Object, Text* (London and New York, 1995)

Betteridge, H. T., 'Herder's Letters to Klopstock', *PMLA* 69 (1954)

Bignamini, Ilaria, and Martin Postle (eds), *The Artist's Model* (Nottingham, 1991)

Biondi, Claire-Lise, 'Angelika Kauffmann', *L'Œil* 447 (December 1992)

Boase, T. S. R., 'Illustrations of Shakespeare's Plays in the Seventeenth and Eighteenth Centuries', *JWCI* 10 (1947)

Bock, Henning, 'Zwei mythologische Gemälde von Angelika Kauffmann für die Gemäldegalerie', *Jahrbuch preussischer Kulturbesitz* XXIII (1986)

Bode, Wilhelm, *Amalie Herzogin von Weimar*, 3 vols (Berlin, 1908)

Boime, Albert, *Art in an Age of Revolution 1750–1800* (Chicago and London, 1987)

Borzello, Frances, *Women's Self-Portraits* (London, 1998)

Bovenschen, Silvia, *Die imaginierte Weiblichkeit* (Frankfurt am Main, 1979)

Bowles, William Henry, *Records of the Bowles Family* (London, 1918)

Bowron, Edgar Peters, *Pompeo Batoni (1708–1787) and His British Patrons: The Iveagh Bequest, Kenwood* (London, 1982)

—and Joseph J. Rishel (eds), *Art in Rome in the Eighteenth Century* (Philadelphia, 2000)

Boydell, John, and Josiah Boydell, *Alphabetical Catalogue of Plates ... Which Compose the Stock of John and Josiah Boydell* (London, 1803)

Boyle, Nicholas, *Goethe: The Poet and the Age* I: *The Poetry of Desire* (Oxford, 1991)

Bradshaw, Peter, *Derby Porcelain Figures 1750–1848* (London, 1990)

Brewer, John, and Roy Porter (eds), *Consumption and the World of Goods* (London, 1993)

British Artists in Rome 1700–1800: The Iveagh Bequest, Kenwood (London, 1974)

Brun, Friederike, *Römisches Leben*, 2 vols in 1 (Leipzig, 1833)

—*Tagebuch über Rom*, 2 vols in 1 (Zurich, 1800–1)

Bruntjen, Sven H. A., *John Boydell, 1719–1804* (New York and London, 1985)

Bryant, Julius, *The Iveagh Bequest: Kenwood* (London, 1990)

Bull, Duncan (ed.), *Classic Ground: British Artists and the Landscape of Italy, 1740–1830* (New Haven and London, 1981)

Busch, Werner, *Das sentimentalische Bild. Die Krise der Kunst im 18. Jahrhundert und die Geburt der Moderne* (Munich, 1993)

Busiri-Vici, A., 'L'amicizia di Angelica Kaufmann per Volfgango Goethe', *Palatino* VI (1962)

—'Angelica Kaufmann and the Bariatinskis', *Apollo* LXXVII (1963)

Cannon-Brookes, Peter (ed.), *The Painted Word: British History Painting 1750–1830* (Woodbridge, 1991)

Carpanetto, Dino, and Giuseppe Ricuperati, *Italy in the Age of Reason*, trans. Caroline Higgitt (London and New York, 1987)

Cazzulani, Elena, and Angelo Stroppa, *Maria Hadfield Cosway: Biografia, diari e scritti della fondatrice del Collegio delle dame inglese in Lodi* (Orio Litta, 1989)

Chard, Chloë, and Helen Langdon (eds), *Transports: Travel, Pleasure and Imaginative Geography, 1600–1830* (New Haven and London, 1996)

Chateaubriand, François René, Vicomte de, *Œuvres romanesques et voyages*, ed. Maurice Regard, 2 vols (Paris, 1969).

Clark, Anthony, 'Neo-Classicism and the Roman Eighteenth-Century Portrait', *Apollo* LXXIII (1963)

—*Pompeo Batoni: A Complete Catalogue of the Works*, with an introductory text by E. P. Bowron (Oxford, 1985)

—'Roma mi è sempre in pensiero', in Edgar Peters Bowron (ed.), *Studies in Roman Eighteenth-Century Painting* (Washington, DC, 1981)

Colley, Linda, *Britons: Forging the Nation 1707–1837* (New Haven and London, 1992)

Constantine, David, 'Winckelmann and Sir William Hamilton', *Oxford German Studies* 22 (1993)

Craske, Matthew, *Art in Europe 1700–1830* (Oxford, 1997)

Croft-Murray, Edward, 'Decorative Painting for Lord Burlington and the Royal Academy', *Apollo* LXXXIX (1969)

—*Decorative Painting in England, 1537–1837*, 2 vols (London, 1962 and 1970)

Cross, Anthony, 'The Duchess of Kingston in Russia', *History Today* 27 (1977)

Cust, Lionel (ed.), *Catalogue of the Collection of Fans and Fan-Leaves Presented to the Trustees of the British Museum by Lady Charlotte Schreiber* (London, 1893)

Delany, Mary Granville, *Autobiography and Correspondence*, ed. Lady Llanover, 3 vols (London, 1862)

Deutsch, O. E., 'Sir William Hamilton's Picture Gallery', *Burlington Magazine* LXXXII (1943)

Dolan, Brian, *Ladies of the Grand Tour* (London, 2002)

Eckermann, Johann Peter, *Gespräche mit Goethe in den letzten Jahren seines Lebens* (Munich, 1984)

Edwards, Edward, *Anecdotes of Painters* (London, 1808)

Eger, Elizabeth, 'Representing Culture. The Nine Living Muses of Great Britain (1779)', in Elizabeth Eger et al. (eds), *Women, Writing and the Public Sphere 1700–1830* (Cambridge, 2001)

Eggart, Hermann, 'Die blossgelegten Fresken der Angelika Kauffmann in Schwarzenberg', *Feierabend* Jahrgang 12 (1932)

Erffa, Helmut von, and Allen Staley, *The Paintings of Benjamin West* (New Haven and London, 1986)

Fächer: Kunst und Mode aus fünf Jahrhunderten (Munich, 1987)

Farington, Joseph, R. A, *The Farington Diary*, ed. K. Garlick, A. Macintyre, K. Cave and E. Newby, 10 vols (New Haven and London, 1978–98)

Fillitz, Hermann (ed.), *Der Traum von Glück: Die Kunst des Historismus in Europa*, 2 vols (Vienna, 1996)

Fleming, John, 'Lord Brudenell and His Bear-Leader', *English Miscellany* 9 (1958)

—'Some Roman Cicerones and Artist Dealers', *Connoisseur Year Book* (1939)

Fletcher, Ronald, *The Parkers at Saltram, 1769–89: Everyday Life in an English Country House* (London, 1970)

Forbes Adam, Malise, and Mary Mauchline, 'Attingham Park, Shropshire', *Country Life* CLXXXVI (1992)

—' "Ut pictura poesis": Angelica Kauffmann's Literary Sources', *Apollo* CXXXV (1992)

Ford, Brinsley, 'The Earl-Bishop: An Eccentric and Capricious Patron of the Arts', *Apollo* XCIX (1974)

—'The Grand Tour', *Apollo* CXIV (1981)

—'Thomas Jenkins, Banker, Dealer and Unofficial English Agent', *Apollo* XCIX (1974)

Foreman, Amanda, *Georgiana, Duchess of Devonshire* (London, 1998)

Fortune, Brandon Brame, with Deborah J. Warner, *Franklin and His Friends* (Washington, 1999)

Forty, Adrian, *Objects of Desire* (London, 1986)

Fowler, John, and John Cornforth, *English Decoration in the Eighteenth Century* (London, 1974)

Fraser, Flora, *Beloved Emma: The Life of Emma Lady Hamilton* (London, Basingstoke and Oxford, 1994)

Friedman, Winifred H., *Boydell's Shakespeare Gallery* (New York and London, 1976)

Friedrich, Annegret, 'Lady Elizabeth Foster und Georgiana, Duchess of Devonshire: Überlegungen zu einer Ikonographie der Freundschaft unter Frauen im 18. Jahrhundert', in Ulf Heidel et al. (eds), *Jenseits der Geschlechtergrenzen* (Hamburg, 2001)

—' "The Nine Living Muses of Great Britain" – Zu Selbstinszenierungen weiblicher Intellektualität in der Porträtmalerei des 18. Jahrhunderts', in Daniela Hack (ed.), *Frauen in der Stadt. Selbstzeugnisse des 16.–18. Jahrhunderts* (Ostfildern, 2004)

—'Variationen eines Alptraums: *The Nightmare* von Johann Heinrich Füssli', in Volker Kapp et al. (eds), *Subversive Romantik* (Berlin, 2004)

Garber, J., 'Die blossgelegten Fresken der Angelika Kauffmann', *Alemania* 4 (1930)

Garnett, Henrietta, *Anny: A Life of Anne Isabella Thackeray Ritchie* (London, 2004)

Gennari, Geneviève, *Le Premier Voyage de Mme de Staël en Italie* (Paris, 1947)

Gerard, Frances A., *Angelica Kauffmann: A Biography* (London, 1892)

Gerning, Johann Isaac von, *Reise durch Österreich und Italien*, 3 vols (Frankfurt am Main, 1802)

Goethe, Johann Wolfgang von, *Briefe*, ed. Karl Robert Mandelkow, 4 vols (Hamburg, 1968)

—*Briefe an Goethe*, ed. Karl Robert Mandelkow, new edn, 2 vols (Munich, 1982)

—*Farbenlehre* (Tübingen, 1953)

—*Goethe in vertraulichen Briefen seiner Zeitgenossen*, ed. Wilhelm Bode, new edn Regine Otto and Paul-Gerhard Wenzlaff, 3 vols (Berlin and Weimar, 1982)

—*Italienische Reise*, in *Werke, Hamburger Ausgabe*, ed. Erich Trunz, new edn, 14 vols (Munich, 1981), 11

—'Philipp Hackert. Biographische Skizze', *Schriften zur bildenden Kunst, Berliner Ausgabe*, 22 vols (Berlin and Weimar, 1965–78), 19

—*Sämtliche Werke*, ed. Hendrik Birus et al., 46 vols (Frankfurt am Main, 1987–1999)

—*Schriften der Goethe-Gesellschaft V: Zur Nachgeschichte der italienischen Reise*, ed. Otto Harnack (Weimar, 1890)

—*Tagebücher und Briefe Goethes aus Italien an Frau von Stein und Herder*, ed. Erich Schmidt (Weimar, 1886)

—'Der Verfasser teilt die Geschichte seiner botanischen Studien mit', *Werke, Hamburger Ausgabe* 1

—*Winckelmann und sein Jahrhundert*, *Goethes Werke, Weimarer Ausgabe*, edn commissioned by Grand-Duchess Sophie von Sachsen, 55 vols (Weimar, 1887–1919), 46

Goodden, Angelica, 'Angelica Kauffman: Attenuating the Body', in Angelica Goodden

(ed.), *The Eighteenth-Century Body: Art, History, Literature, Medicine* (Oxford, Bern, etc., 2002)

—*The Sweetness of Life: A Biography of Elisabeth Louise Vigée Le Brun* (London, 1997)

Goodreau, David, *Nathaniel Dance 1735–1811* (London, 1977)

Gordon, C. M., *British Painting of Subjects from the English Novel, 1740–1870* (New York, 1988)

Gore, St John, 'Prince of Georgian Collectors: The Hoares of Stourhead – I', *Country Life* CXXXV (1964)

Graves, Algernon, *The Royal Academy of Arts, 1769–1904*, 8 vols (London, 1905-6)

Greer, Germaine, *The Obstacle Race* (London, 1979)

Gross, Hanns, *Rome in the Age of Enlightenment* (Cambridge, 1990)

Gutwirth, Madeleine, 'The Engulfed Beloved: Representations of Dead and Dying Women in the Art and Literature of the Revolutionary Era', in Sara E. Melzer and Leslie W. Rabine (eds), *Rebel Daughters: Women and the French Revolution* (New York, 1991)

Hagen, A., 'Johann Friedrich Reiffenstein', *Altpreussische Monatsschrift* II (1865)

Hagen, Rose-Marie, 'Eine seltene Frau, eine deutsche Malerin', *Art* 11 (1991)

Hammer, Sabine, 'Angelika Kauffmann als Porträtistin', MA thesis, University of Vienna, 1989

Hardy, John, 'Robert Adam and the Furnishing of Kedleston Hall', *Connoisseur* CXCVIII (1978)

Hartcup, Adeline, *Angelica: The Portrait of an Eighteenth-Century Artist* (London, 1954)

Haskell, Francis, and Nicholas Penny, *Taste and the Antique* (New Haven and London, 1981)

Hautecœur, Louis, 'Les Arts à Naples au XVIIIe siècle', *Gazette des beaux-arts*, 53rd year, 4th period, vols 5 and 6 (1911)

—*Rome et la renaissance de l'antiquité à la fin du XVIIIe siècle* (Paris, 1912)

Hazlitt, William, *Conversations of James Northcote, R.A.*, ed. Edmund Gosse (London, 1894)

Hearder, Harry, *Italy in the Age of the Risorgimento 1790–1870* (London and New York, 1983)

Hedley, Olwen, *Queen Charlotte* (London, 1975)

Helbok, Claudia, *Miss Angel. Angelika Kauffmann: eine Biographie* (Vienna, 1968)

—'Shakespeare-Themen im Œuvre von Angelika Kauffmann', *JVL* (1966)

Hemlow, Joyce, *The History of Fanny Burney* (Oxford, 1958)

Herder, Johann Gottfried, *Briefe zur Beförderung der Humanität*, *Werke*, 10 vols, ed. Hans Dietrich Irmscher (Frankfurt am Main, 1991), VIII

—'Briefwechsel über Ossian und die Lieder alter Völker', *Von deutscher Art und Kunst*, ed. Edna Purdie (Oxford, 1924)

—*Italienische Reise*, ed. Albert Meier and Heide Hollmer (Munich, 1988)

—'Von der Bildhauerkunst fürs Gefühl', *Sämmtliche Werke*, ed. Bernhard Suphan, 33 vols (Berlin, 1877–1913), VIII

Herrmann, Frank, *The English as Collectors* (London, 1972)

Hess, D., I. Hussmann and H. Musner, *Begleitheft zur Ausstellung Angelika Kauffmann. Restaurierungen* (Bregenz, 1991)

Hibbert, Christopher, *George III* (London, 1998)

Hilliard, Kevin, 'Philosophy, Letters and the Fine Arts in Klopstock's Thought', D. Phil. thesis, University of Oxford, 1984

Hirt, Alois, 'Briefe aus Rom hauptsächlich neue Werke jetzt daselbst lebender Künstler betreffend', *Der teutsche Merkur* (December 1785)

Hogarth, William, *The Analysis of Beauty*, ed. Ronald Paulson (New Haven and London, 1997)

Hopfner, Isidor, 'Angelika Kauffmann und die deutschen Klassiker', *Alemania* I (1926–7) and II (1927)

Howard, W. G., 'Reiz ist Schönheit in Bewegung', *PMLA* 24 (new series 17) (1909)

Hudson, Derek, and Kenneth W. Luckhurst, *The Royal Society of Arts* (London, 1954)

Hyde, Sarah, 'Angelica Kauffman', *Print Quarterly* 10 (1993)

Ingamells, John (ed.), *A Dictionary of British and Irish Travellers in Italy 1701–1800* (New Haven and London, 1997)

Irwin, David, 'Angelica Kauffman and Her Times', *Burlington Magazine* CX (1968)

—'English Neo-Classicism and Some Patrons', *Apollo* LXXVIII (1963)

Jackson-Stops, Gervase, 'Tissington Hall, Derbyshire: III', *Country Life* CLX (1976)

Jaffé, Patricia, *Lady Hamilton* (London, 1972)

Jahn, Otto, *Biographische Aufsätze* (Leipzig, 1866)

Jenkins, Ian, and Kim Sloan, *Vases and Volcanoes: Sir William Hamilton and His Collection* (London, 1996)

John, C. H. S., *Bartolozzi, Zoffany and Kauffman* (London, 1924)

Jones, Thomas, *Memoirs*, ed. Brinsley Ford, *Publications of the Walpole Society* XXXII (1946–8)

Jourdain, Margaret, 'Matthew Boulton: An Artist in Ormolu', *Country Life Annual* (1950)

Justi, Carl, *Winckelmann und seine Zeitgenossen*, 3 vols (Leipzig, 1932)

Kasakiewitsch, Natalia, 'Reproduktionen von Bildern Angelika Kauffmanns auf Wiener Porzellan', *Keramos* 136 (1992)

Kauffman, Angelica, *Memorie delle pitture* (MS Royal Academy, RA: KAU), i.e. *Memorandum of Paintings*, trans. Stella Vitelleschi

Kindt, Karl, *Klopstock* (Berlin, 1941)

Klopstock, Friedrich Gottlieb, 'Die deutsche Gelehrtenrepublik', *Sämmtliche Werke*, 10 vols in 5 (Leipzig, 1856–7), VIII

—'Von dem Range der schönen Künste und der schönen Wissenschaft', ibid. X

—'Von der heiligen Poesie', ibid. X

—*Werke und Briefe*, 17 vols (Berlin, 1974–99)

Knight, Cornelia, *Autobiography*, ed. Roger Fulford (London, 1960)

Knight, Lady, *Letters from Italy*, ed. Lady Eliott-Drake (London, 1905)

Knowles, John, *Life and Writings of Henry Fuseli*, 3 vols (London, 1831)

Kotzebue, August von, *Bemerkungen auf eine Reise aus Liefland nach Rom und Neapel*, 3 vols in 1 (Cologne, 1810)

Kovalevski, Bärbel (ed.), *Zwischen Ideal und Wirklichkeit: Künstlerinnen der Goethe-Zeit zwischen 1750 und 1850* (Ostfildern-Ruit, 1999)

Kraus, Mariane, *Für mich gemerkt auf meiner Reise nach Italien im Jahre 1791. Reisetagebuch der Malerin und Erbacher Hofdame*, ed. Helmut Brosch (Buchen, 1996)

SELECT BIBLIOGRAPHY

Lammel, Gisold, *Angelika Kauffmann* (Dresden, 1987)

—*Kunst im Aufbruch* (Stuttgart and Vienna, 1998)

—*Die Malerei des Klassizismus* (Leipzig, 1986)

Langford, Paul, *A Polite and Commercial People: England 1727–1783* (Oxford, 1989)

Langl, Josef, 'Das Testament der Angelika Kauffmann', *Zeitschrift für bildende Kunst* XXIV (1888–9)

Lee, Vernon, *Studies of the Eighteenth Century in Italy* (London, 1880)

Leisching, Paul, 'Von böser und von guter Ehe. Die beiden Heiraten der Angelika Kauffmann', *JVL* (1991)

Leonhardi, John [i.e. Johannes], *An Account of the Grisons* (London, 1711)

Leslie, C. R., and T. Taylor, *The Life and Times of Sir Joshua Reynolds*, 2 vols (London, 1865)

Lessing, Gotthold Ephraïm, 'Laokoon', *Schriften*, 3 vols (Frankfurt am Main, 1967), II

Levey, Michael, *A Royal Subject: Portraits of Queen Charlotte* (London, 1977)

Lewis, Lesley, *Connoisseurs and Secret Agents in Eighteenth-Century Rome* (London, 1961)

[Lichtenau,] *Apologie der Gräfin Lichtenau*, 2 vols (Leipzig and Gera, 1808)

Lichtenberg, Georg Christoph, *Lichtenberg's Visits to England*, trans. and ed. Margaret L. Mare and W. H. Quarrell (Oxford, 1938)

—*London-Tagebuch*, ed. Hans Ludwig Gumbert (Hildesheim, 1979)

—*Werke*, ed. Carl Brinitzer Hoffmann (Hamburg, 1967)

Liebmann, Michael, 'Gemälde der Angelika Kauffmann im staatlichen Puschkin-Museum der bildenden Künst in Moskau', *JVL* (1963)

Lloyd, Stephen, 'Angelica Kauffman', *Burlington Magazine* CXXXV (1993)

—*Richard and Maria Cosway: Regency Artists of Taste and Fashion* (Edinburgh, 1995)

MacDonald, Norman H., *The Clan Ranald of Knoydart and Glengarry* (Edinburgh, 1979)

McEwan, Robin and Dorothea, 'Ob blaue Strümpfe einer berühmten Vorarlbergerin zustehen', *Montfort* 41 (1989)

McKendrick, Neil, John Brewer and J. H. Plumb, *The Birth of a Consumer Society* (London, 1982)

Maierhofer, Waltraud, *Angelika Kauffmann* (Hamburg, 1997)

—'Krieg und Frieden in Gemälden und Briefen Angelika Kauffmanns', *JVL* (1997)

—(ed.), *Angelika Kauffmann: Briefe einer Malerin* (Mainz, 1999)

Mainwaring, Elizabeth, *Italian Landscape in Eighteenth-Century England* (London, 1925)

Manners, Lady Victoria, and Dr G. C. Williamson, *Angelica Kauffmann, R.A. Her Life and Her Works* (London, 1924)

Marks, Arthur S., 'Angelica Kauffman and Some Americans on the Grand Tour', *American Art Journal* XII (1980)

Matthisson, Friedrich, *Briefe* (Zurich, 1795)

—*Erinnerungen*, 3 vols (Zurich, 1810)

—*Erinnerungen*, 5 vols (Vienna, 1815)

Maué, Claudia, 'Angelika Kauffmann invenit – Bildervorlagen fur Wiener Porzellan', *Keramos* 90 (October 1980)

Mavor, Elizabeth, *The Grand Tour of William Beckford* (London, 1986)

Maylender, Michele, *Storia delle accademie d'Italia*, 5 vols (Bologna, n.d.)

Meadows, Peter, and John Cornforth, 'Joseph Bonomi, Draughtsman-Decorator', *Country Life* CLXI (1990)

Mellor, Anne K., 'British Romanticism and Gender', in Bermingham and Brewer (q.v.)

Meyer, Friedrich Johann Lorenz, *Darstellungen aus Italien* (Berlin, 1792)

Meyer, Johann Heinrich, *Entwurf einer Kunstgeschichte des 18. Jahrhunderts*, in Goethe, *Sämtliche Werke* (q.v.), 40

Mildenberger, Hermann, 'Angelika Kauffmann: Bemerkungen zum Stil', in *Angelika Kauffmann: 'Julia, die Gattin'* (q.v.)

—'Angelika Kauffmanns Bildnis der Anna Amalia Herzogin von Sachsen-Weimar-Eisenach', in *Das römische Haus in Weimar*, ed. Andreas Beyer (Weimar, 2002)

Millar, Oliver, *The Later Georgian Pictures in the Collection of Her Majesty the Queen*, 2 vols (London, 1969)

Moffitt, John, 'The Poet and the Painter: Tischbein's "Perfect Portrait" of Goethe', *Art Bulletin* 65 (1983)

Monk, Samuel, 'A Grace Beyond the Reach of Art', *Journal of the History of Ideas* 5 (1944)

Moore, John, *A View of Society and Manners in Italy*, 2 vols (London, 1781)

Moritz, Karl Philipp, *Reise eines Deutschen in England im Jahre 1782* (Frankfurt am Main and Leipzig, 2000)

Morrison, Alfred, *Collection of Autograph Letters and Historical Documents (2nd Series, 1882–1893): The Hamilton and Nelson Papers, vol. I (1756–1797)* (London, 1893)

Morrison, Jeffrey, *Winckelmann and the Notion of Aesthetic Education* (Oxford, 1996)

Morritt, J. B. S., *A Grand Tour: Letters and Journeys 1794–1796*, ed. G. E. Marindin (London, 1985)

Moser, Joseph, 'Memoir of the Late Angelica Kauffman, R.A.', *The European Magazine* 55 (1809)

Moulton Mayer, Dorothy, *Angelica Kauffman, R.A., 1741–1807* (Gerrards Cross, 1972)

Muncker, Franz, *Klopstock* (Berlin, 1888)

—*Lessings persönliches und literarisches Verhältnis zu Klopstock* (Frankfurt am Main, 1880)

Muthman, Ruth-Maria (ed.), *Angelika Kauffmann und ihre Zeit. Graphik und Zeichnungen von 1760 bis 1810* (Düsseldorf, 1979)

Nabakowki, Gislind, Helke Sander and Peter Gorsen, *Frauen in der Kunst*, 2 vols (Frankfurt am Main, 1980)

Neuwirth, Waltraud, *Wiener Porzellan: Original, Kopie, Verfälschung, Fälschung* (Vienna, 1979)

Nisbet, H. B., 'Laocoon in Germany: The Reception of the Group since Winckelmann', *Oxford German Studies* 10 (1979)

Noack, Friedrich, 'Aus Goethes römischen Kreis', *Goethe-Jahrbuch* XXIV (1903)

—*Deutsches Leben in Rom 1700 bis 1900* (Stuttgart and Berlin, 1907)

Nobs-Greter, Ruth, *Die Künstlerin und ihr Werk in der deutschsprachigen Kunstgeschichtsschreibung* (Zurich, 1984)

Nohl, Johannes, *Goethe als Maler Möller in Rom* (Weimar, 1955)

Northcote, James, *The Life of Sir Joshua Reynolds*, 2 vols (London, 1819)

Obermeier, Siegfried, *Die Muse von Rom: Angelika Kauffmann und ihre Zeit* (Frankfurt am Main, 1987)

Okun, Henry, 'Ossian in Painting', *JWCI* 30 (1967)

Oppermann, Andreas, *Aus dem Bregenzer Wald* (Breslau, 1859)

Ossian in der Kunst um 1800 (Hamburger Kunsthalle Mai–Juni 1974) (Munich, 1974)

Oulton, W. C., *Authentic and Impartial Memoirs of Her Late Majesty Charlotte* (London, 1819)

Palleske, Richard, 'Der greise Klopstock nach der Darstellung Schack von Staffeldts', *Euphorion* 11 (1904)

Pape, Walter, and Frederick Burwick (eds), *The Boydell Shakespeare Gallery* (Essen, 1996)

Papendiek, Mrs, *Court and Private Life in the Time of Queen Charlotte*, 2 vols (London, n.d.)

Parissien, Steven, *The Adam Style* (London, 1992)

Pasquin, Anthony [John Williams], *Memoirs of the Royal Academicians* (London, 1796, reprinted London, 1970)

Pawlowska, Magdalena, 'A propos de deux portraits féminins d'Angelika Kauffmann', *Bulletin du musée national de Varsovie* VIII (1967)

Pears, Iain, *The Discovery of Painting* (New Haven and London, 1988)

Penny, Nicholas (ed.), *Reynolds* (London, 1986)

Perry, Gill, ' "The British Sappho": Borrowed Identities and the Representation of Women Artists in Late Eighteenth-Century British Art', *Oxford Art Journal* 18 (1995)

Phillips, Hugh, FSA, *Mid-Georgian London* (London, 1964)

Pieth, Friedrich, 'Ungedruckte Briefe der Malerin Angelika Kauffmann an Karl Ulysses von Salis-Marschlins', *Davoser Blatt* 47 (1908)

Piozzi, Hester Lynch, *Journey Through France, Italy and Germany*, 2 vols (London, 1789)

Plumb, J. C., 'The Public, Literature and the Arts in the Eighteenth Century', in Paul Fritz and David Williams (eds), *The Triumph of Culture* (Toronto, 1972)

Poch-Kalous, Margarethe, 'Heinrich Friedrich Fügers Illustrationen zu Klopstocks "Messias" ', *Mitteilungen der Gesellschaft für vergleichende Kunstforschung in Wien*, 27th Year, no. 4 (1975)

Pointon, Marcia, *Hanging the Head: Portraiture and Social Formation in Eighteenth-Century England* (New Haven and London, 1993)

—'Portrait-Painting as a Business Enterprise in London in the 1780s', *Art History* 7 (1984)

Postle, Martin, 'Sex and the Singular Woman', *Apollo* CXXXVII (1993)

Poth, Claudia, 'Die inszenierte Künstlerin: Angelika Kauffmann in ihren Selbstporträts', MA thesis, University of Salzburg, 1999

Prosperi, Gioacchino, 'Gli ultimi 26 anni di Angelica Kauffman a Roma 1781–1807', ed. G. Castellani, *Strenni dei Romanisti* 27 (1966)

Radisisch, Paula Rea, 'Reframing Art History: Gender', *Eighteenth-Century Studies* XXV (1992)

Recke, Elisa von der, *Tagebuch einer Reise durch einen Teil Deutschlands und durch Italien in den Jahren 1804 bis 1806*, ed. Hofrat Böttiger, 4 vols (Berlin, 1815-17)

Redford, Bruce, *Venice and the Grand Tour* (New Haven and London, 1996)

Reilly, Robin, *Wedgwood*, 2 vols (London, 1989)

—and G. Savage, *Wedgwood: The Portrait Medallions* (London, 1973)

Reitlinger, Gerald, *The Economics of Taste*, 3 vols (London, 1961–70)

Reynolds, Sir Joshua, *Discourses* (London, 1778)

—*Letters*, ed. John Ingamells and John Edgcumbe (New Haven and London, 2000)

Ribeiro, Aileen, *The Art of Dress* (New Haven and London, 1995)

—'The King of Denmark's Masquerade', *History Today* 27 (1977)

—'Turquerie: Turkish Dress and English Fashion in the Eighteenth Century', *Connoisseur* CCI (1979)

Rice, Louise, and Ruth Eisenberg, 'Angelica Kauffman's Uffizi Self-Portrait', *Gazette des beaux-arts* CXVII (1991)

Richards, Sarah, *Eighteenth-Century Ceramics* (Manchester, 1999)

Richter, H. M., *Aus der Messias- und Werther-Zeit* (Vienna, 1882)

Robinson, Eric, 'Matthew Boulton: Patron of the Arts', *Annals of Science* IX.4 (1953)

—and Keith R. Thompson, 'Matthew Boulton's Mechanical Paintings', *Burlington Magazine* CXII (1970)

Robinson, John, 'No. 20 St James's Square', *Country Life* CIX (1989)

Robson-Scott, W. D., *German Travellers in England, 1400–1800* (Oxford, 1953)

Roettgens, Steffi, *Anton Raphael Mengs*, I (Munich, 1999)

—*Anton Raphael Mengs and His British Patrons* (London, 1993)

—'Die "Mengsische Akademie" in Rom', in Baumgärtel, *Retrospektive* (q.v.)

Rosenthal, Angela, *Angelika Kauffmann: Bildnismalerei im 18. Jahrhundert* (Berlin, 1996)

—'Angelica Kauffman Ma[s]king Claims', *Art History* 15 (1992)

—'Double-Writing in Painting', *Kritische Berichte* 3 (1993)

—'Die Zeichnungen der Angelika Kauffmann im Vorarlberger Landesmuseum, Bregenz', *JVL* (1990)

Rosenthal, Michael, *The Art of Thomas Gainsborough* (New Haven and London, 1999)

Rossi, Giovanni Gherardo De, *Vita di Angelica Kauffman pittrice* (Florence, 1810)

Rudé, George, 'The Gordon Riots: A Study of the Rioters and their Victims', *Transactions of the Royal Historical Society*, series 5, vol. 6 (1956)

Ruland, C., 'Einige ältere Illustrationen zu Goethes *Iphigenie*', *Goethe-Jahrbuch* IX (1888)

Sandby, William, *The History of the Royal Academy of Arts*, 2 vols (London, 1862)

Sandner, Oscar (ed.), *Angelika Kauffmann und ihre Zeitgenossen* (Bregenz, 1968)

—(ed.), *Angelika Kauffmann und Rom* (Rome, 1998)

—(ed.), *Hommage an Angelika Kauffmann* (Milan, 1992)

Schiller, Friedrich von, *Über naive und sentimentalische Dichtung, Werke*, 3 vols (Munich, 1966), II

Schlegel, Friedrich von, 'Über Angelika Kauffmann', in August Wilhelm and Friedrich von Schlegel (eds), *Athenaeum: eine Zeitschrift*, vol. I, part 2 (1798, reprinted Berlin, 1960)

Schmidt, Erich, *Charakteristiken*, 2 vols (Berlin, 1886 and 1901)

Schmidt-Linsenhoff, Viktoria (ed.), *Sklavin oder Bürgerin? Französische Revolution und neue Weiblichkeit 1760–1830* (Frankfurt and Marburg, 1989)

Schnorr von Carolsfeld, Ludwig Ferdinand (ed.), 'Bruchstücke aus Fügers Nachlass', *Archiv für Geographie, Historie, Staats- und Kriegskunst*, 10. Jahrgang (1819)

Schorsch, Anita, 'Mourning Art: A Neoclassical Reflection in America', *American Art Journal* VIII.1 (1976)

Schram, Wilhelm, *Die Malerin Angelica Kauffmann* (Brünn, 1890)

Schulte-Wülwer, Ulrich, 'Gräfin Catherine Skavronska und Fürst Grigori Alexandrowitsch Potemkin', *Nordelbingen* 45 (1976)

Schulze, Sabine (ed.), *Goethe und die Kunst* (Ostfildern, 1994)

Seuffert, Bernhard, 'Der Herzogin Anna Amalia Reise nach Italien', *Preussischer Jahrbuch* 65 (1890)

Seume, J. G., *Spaziergang nach Syrakus im Jahre 1802 I: Von Leipzig nach Syrakus*, 3rd edn (n.p., 1811)

Sharp, Samuel, *A View of the Customs, Manners, Drama &c of Italy as They Are Described in the Frustra letteraria; and in the Account of Italy in English Written by Mr Baretti; Compared with the Letters from Italy Written by Mr Sharp* (London, 1768)

Shawe-Taylor, Desmond, *Genial Company: The Theme of Genius in Eighteenth-Century British Portraiture* (London, 1987)

Skinner, Basil, *Scots in Italy in the Eighteenth Century* (Edinburgh, 1966)

—'Some Aspects of the Work of Nathaniel Dance in Rome', *Burlington Magazine* CI (1959)

Smidt, Irmgard, 'Angelika Kauffmann, Goethes Freundin in Rom', *Jahrbuch des Wiener Goethe-Vereins* 67 (1963)

Smiles, Sam, *The Image of Antiquity: Ancient Britain and the Romantic Imagination* (New Haven and London, 1994)

Smith, J. T., *Nollekens and His Times* (London, 1949)

Solkin, David H., 'Great Pictures of Great Men? Reynolds, Male Portraiture and the Power of Art', *Oxford Art Journal* 9 (1986)

—*Painting for Money: The Visual Arts and the Public Sphere in Eighteenth-Century England* (New Haven and London, 1993)

—(ed.), *Art on the Line: The Royal Academy Exhibitions at Somerset House 1780–1836* (New Haven and London, 2001)

Sonnenfels, J., 'Von dem Verdienste des Porträtmalers', *Gesammelte Schriften*, 10 vols (Vienna, 1785), VIII

Sparrow, Walter Shaw, 'Angelica Kauffman's Amazing Marriage', *Connoisseur* XCII (1933)

Spear, Richard E., *The 'Divine Guido'* (New Haven and London, 1997)

Spengler, Walter, *Der Begriff des Schönen bei Winckelmann* (Göppingen, 1970)

Spickernagel, Ellen, 'Helden wie zarte Knaben oder verkleidete Mädchen: zum Begriff der Androgynität bei Johann Joachim Winckelmann und Angelika Kauffmann', in Renate Berger et al. (eds), *Frauen-Weiblichkeit-Schrift* (Berlin, 1985)

—'Zur Anmut erzogen – weibliche Körpersprache im 18. Jahrhundert', in Ilse Brehmer et al., *Frauen in der Geschichte* IV (Düsseldorf, 1983)

Stafford, Fiona, *The Sublime Savage: James Macpherson and the Poems of Ossian* (Edinburgh, 1988)

Steiner, Wendy, *Exact Resemblance to Exact Resemblance* (New Haven and London, 1978)

373

Sternberg, A. von, *Berühmte deutsche Frauen des 18. Jahrhunderts*, 2 vols in 1 (Leipzig, 1848), I

Stolberg, Friedrich Leopold Graf zu, *Reise in Deutschland, der Schweiz, Italien und Sicilien*, 2 vols in 1 (Königsberg und Leipzig, 1794)

Strong, Roy, *And When Did You Last See Your Father?* (London, 1978)

Sturz, Helfrich Peter, *Briefe im Jahre 1768 auf einer Reise (durch England und Frankreich) im Gefolge des Königs von Dänemark geschrieben, Schriften*, new edn, 2 vols (Vienna, 1819)

Summerson, John, *Kenwood: A Short Account* (London, 1953)

Sutton, Denys, 'Aspects of British Collecting: From Naples to Rome', *Apollo* CXVI (1982)

Swozilek, Helmut, ' " . . . kehrte sie nach Rom zurück, woselbst sie wahrscheinlich noch lebt." Echo auf Angelika Kauffmann', *JVL* (1991)

—'Zu den Grazien-Bildern der Angelika Kauffmann im Vorarlberger Landesmuseum', in D. Hess et al. (q.v.)

—et al. (eds), *Joseph Kauffmann (1707–1782)* (Bregenz, 1993)

Szymanski, Stanislas, 'Ein Bildnis der Krystyna Potocka von Angelika Kauffmann', *JVL* (1958–9)

—'Die Polonica der Angelika Kauffmann', *JVL* (1968)

Tamussino, Ursula, *Des Teufels Grossmutter: eine Biographie der Königin Maria Carolina von Neapel-Sizilien* (Vienna, 1991)

Thackeray, Anne, *Miss Angel, The Works of Miss Thackeray*, Vol. VIII (London, 1884)

Thurnher, Eugen, *Angelika Kauffmann und die deutsche Dichtung* (Bregenz, 1966)

Tickner, Lisa, 'Feminism, Art History and Sexual Difference', *Genders* 3 (1988)

Tischbein, Wilhelm, *Collection of Engravings from Ancient Vases in the Possession of Sir William Hamilton, Published by Mr Wilhelm Tischbein, Director of the Royal Academy of Painting at Naples* (Naples, 1781)

Tombo, Rudolf, *Ossian in Germany* (New York, 1901)

Tomory, Peter A., 'Angelica Kauffman – "Sappho" ', *Burlington Magazine* CXIII (1971)

Tuchscherer, Thilo (ed.), *Verrückt nach Angelika: Porzellan und anderes Kunsthandwerk nach Angelika Kauffmann* (Ostfildern-Ruit, 1999)

Tuer, Andrew W., *Bartolozzi and His Works*, 2 vols (London and New York, n.d.)

Turquan, Joseph, and Jules d'Auriac, *The Great Adventuress: Lady Hamilton and the Revolution in Naples, 1753–1815*, trans. L.Wiggins (London, 1914)

Ulrich, Dieter, 'Alexander Trippel et Angelica Kauffmann: deux personnalités artistiques centrales à Rome à la fin du XVIIIe siècle', in *Entre Rome et Paris: Œuvres inédites du XIVe au XIXe siècle* (Lausanne, 1996)

Vaughan, William, 'The Englishness of British Art', *Oxford Art Journal* 13 (1990)

Vigée Le Brun, Elisabeth, *Souvenirs* ed. Claudine Herrmann, 2 vols (Paris, 1984)

Vogelsang, Bernd, 'Bilder-Szenen: Kontexte der Weimarer "Historienbilder" Angelika Kauffmanns', in *Angelika Kauffmann: Julia, die Gattin* (q.v.)

Vogler, C. H., *Der Bildhauer Alexander Trippel* (Schaffhausen, 1892–3)

Wainwright, Clive, 'The "Distrest Poet" and His Architect: George Keate and Robert Adam', *Apollo* CXLIII (1996)

Walch, Peter, 'Angelica Kauffman', Ph.D. thesis, Princeton University, 1968

—'David Garrick in Italy', *Eighteenth-Century Studies* III (1970)

SELECT BIBLIOGRAPHY

—'An Early Neoclassical Sketchbook by Angelica Kauffman', *Burlington Magazine* CXIX (1977)

—'Foreign Artists at Naples 1750–1799', *Burlington Magazine* CXXI (1979)

Walker, John, 'Maria Cosway: An Undervalued Artist', *Apollo* CXXIII (1986)

Walpole, Horace, *Letters*, ed. Mrs Paget Toynbee, 16 vols (Oxford, 1905)

Wassyng Roworth, Wendy, 'Anatomy Is Destiny: Regarding the Body in the Art of Angelica Kauffman', in Gill Perry and Michael Rossington (eds), *Femininity and Masculinity in Eighteenth-Century Art and Culture* (Manchester, 1994)

—'Angelica Kauffman's *Memorandum of Paintings*', *Burlington Magazine* CXXVI (1984)

—'Biography, Criticism, Art History: Angelica Kauffman in Context', in Frederick M. Keener and Susan E. Lorsch (eds), *Eighteenth-Century Women and the Arts* (New York, 1988)

—'Painting for Profit and Pleasure: Angelica Kauffman and the Art Business in Rome', *Eighteenth-Century Studies* 29 (1995–6)

—(ed.), *Angelica Kauffman: A Continental Artist in Georgian England* (Brighton, 1992)

Waterhouse, Ellis, *Painting in Britain 1530 to 1790*, 4th edn (Harmondsworth, 1978)

—'Reynolds, Angelica Kauffman and Lord Boringdon', *Apollo* CXXII (1985)

Weatherill, Lorna, *Consumer Behaviour and Material Culture in Britain 1660–1760* (London and New York, 1988)

Webb, Daniel, *An Inquiry into the Beauties of Painting*, 3rd edn (London, 1769)

Weizsäcker, Paul, *Anna Amalia, Herzogin von Sachsen-Weimar-Eisenach, die Begründerin des Weimarischen Musenhofes* (Hamburg, 1892)

West, Shearer, *Portraiture* (Oxford, 2004)

—'Thomas Lawrence's "Half-History" Portraits and the Politics of Theatre', *Art History* 14 (1991)

—(ed.), *Italian Culture in North Europe in the Eighteenth Century* (Cambridge, 1999)

Weston, Helen, 'Angelica Kauffman', *Art History* 16 (1993)

Whitley, William T., *Artists and Their Friends in England, 1700–1799*, 2 vols (London and Boston, 1928)

Wilczek, Karl, 'Heinrich Friedrich Fueger, seine Gemälde und Zeichnungen', 2 vols, doctoral dissertation, University of Vienna, 1925

Wilkes, John, *Correspondence*, ed. John Almon, 5 vols (London, 1880)

Williams-Wood, Cyril, *English Transfer-Printed Pottery and Porcelain* (London, 1981)

Williamson, George C., *Richard Cosway, R.A., and His Wife and Pupils* (London, 1897)

Wilmot, Catherine, *An Irish Peer on the Continent (1801–1803)*, ed. Thomas U. Sadleir (London, 1920)

Wilton, Andrew, *The Swagger Portrait* (London, 1992)

—and Ilaria Bignamini (eds), *Grand Tour: The Lure of Italy in the Eighteenth Century* (London, 1996)

Winckelmann, Johann Joachim, *Briefe*, ed. Walther Rehm, 4 vols (Berlin, 1952–7)

—*Freundschaftliche Briefe, Werke*, ed. Joseph Eiselein, 12 vols (Osnabrück, 1965), X

—*Werke*, ed. Helmut Holtzhauer, 3rd edn (Berlin and Weimar, 1982)

Woolf, Stuart, *A History of Italy 1700–1860* (London and New York, 1979)

Wooliscroft Rhead, G., *A History of the Fan* (London, 1910)

Wortley Montagu, Lady Mary, *Complete Letters*, ed. Robert Halsband, 3 vols (Oxford, 1965–7)

Young, Hilary, *The Genius of Wedgwood* (London, 1995)

Zimmermann, Margaret, 'Angelica Kauffman, 1741–1807. Painter and Source of Ceramic Decoration', *International Ceramics Fair and Seminar, 1995* (London, 1995)

Zucchi, Giuseppe Carlo, *Memorie istoriche di Maria Angelica Kauffman Zucchi riguardanti l'arte della pittura da lei professata*, ed. and trans. Helmut Swozilek (Bregenz, 1999)

Index

377

To JAMES AND WEI

WISHING ALL THE BEST TO BOTH OF YOU.

AND TAKE CARE, ENJOY BAKING ALWAYS.

———

FROM:
"O" AND "G"
BERMUDA.
5/1/93.

TO JAMES AND YOU

WISHING ALL THE BEST.

AND TAKE CARE, ENJOY BEING